LOVING

LOVING

A Photographic History of Men in Love 1850s–1950s

Nini-Treadwell Collection

With text by
Paolo Maria Noseda

5
CONTINENTS

Love gives naught but itself and takes naught but from itself.
Love possesses not nor would it be possessed;
For love is sufficient unto love.

Kahlil Gibran, from the poem *On Love*, in *The Prophet*, Alfred A. Knopf, New York, 1923

Amantes Amentes

Paolo Maria Noseda

I worked a great deal on this essay, "Amantes Amentes," the title taken from *De rerum natura* by Lucretius and meaning "foolish lovers," or *amour fou* or obsessive passion causing the heart to beat furiously. I did not want it only to be a series of comments on a collection of photographs; these can and should be studied with the eyes. Nor did I want only to describe who or what had brought together this collection, as this would have been a mere chronicle of facts or persons. What I wanted was to narrate these works, and thus, draw our attention to Time, Nature, Talent, and Creative Genius—elements that each of us can identify in a photograph.

The true story is that of photographs which "let themselves be discovered," and through them, to understand more of the history of Man, who is the true vehicle of Life transmitted by various means, either deliberate or fortuitous—hence the "accidental collection"—day after day, year after year, millennium after millennium. The reference to Ain Sakhri is clear: the earliest sculpture that I recall that transfigures and immortalizes the profound gesture of love which, not by chance, was discovered near Bethlehem, the birthplace of a Prophet killed by the barbarity of Mankind.

The many photographs of people in uniforms are often a premise of the inevitability of Life progressing towards Death, the only true departure for all of us. Yet, in our brief voyage when attributing a personal value to our Existence, we celebrate the Beauty of the Body and Mind, the warmth of genuine and freely given Affection, and the need for Love. For Hugh & Neal, this research involved roaming without any fixed trajectory or interest to weave a dense network of relations to put together a blueprint of the world to be safeguarded and passed down to future generations. For others, this is a journey made of ideas, sentiments, discoveries, and the candid Truth which becomes the Pride of True Heroes, never ostentatious but something simply unavoidable.

Great courage is needed to embrace in front of the lens with the entire world in opposition: this involves relinquishing to the World a fragment of one's indomitable Soul. An embrace is also an indisputable test of Dedication and Devotion in accepting that another person can be so precious as to spurn separation and make them part of oneself. To savor Abandonment renders us Potent and fearless of the Blackest Seas we carry within from birth like a burden that often induces us to violent acts perpetrated as an ultimate and desperate justification in our Quest for Love.

A collection is also a Labor of Love for the collector who, sometimes unconsciously and driven exclusively by Intuition and the Senses, undertakes a journey of Discovery, Knowledge, Pride, and Love just like these two beings, here over a century, or elsewhere for millennia, render this collection something universal.

Photographs are the reawakening of our slumbering sentiments and not mere memories of the past harboring behind a long-shuttered passage. They are illusions of joyous times and images of distant, blurred recollections that we previously considered lost.

To pose means to unwittingly reveal who we are or who we desire to be, but in both cases, it is a training ground of sincerity. A light illuminating a face, deep hollowed eyes, an inclined neck, or abandoned limbs that no longer feel pride in being clothed; innocent nudity transformed into something familiar by a commonplace detail. A sock, a vest, a hand resting on an unbuttoned shirt, or the corner of a sheet tightly wrapping the body of a person who loves. Lips tenderly touching the person who holds us in a firm grip, thus sealing this loving embrace. An arm resting on a shoulder, curiously eternal across different ages and eras, characterizes the embrace of a person proud to display affection. A primordial gesture from the dawn of existence. The first act of two persons when lovingly reawakening is an embrace, and also the last when preparing for the final adieu. Containing, warming, and attentive in recreating the illusion of the infinite power of one's very own love. Have no fear; I am here to protect you; don't stop smiling if I wrap my arms around your shoulders.

To fall asleep in an embrace is a manifestation of absolute trust. To fall asleep between someone's arms is something a child would do. An embrace is all encompassing—a veritable voyage that reaches our inner depths, rendering one person joyous and the other anxious, while proffering an invitation of contentedness to both. This tenderness must be conserved and internalized so we can see that "foreverness" in the face, or crystallized in the entwined fingers, or embodied in a hand resting on the body of the other and which seem to whisper: "You are mine."

Let us immortalize this act, as this ever so fleeting joy is "ours," now. And thus, let us smile and embrace each other so that this state of joy can become a state of joy in togetherness. The backdrop is no longer important. There are two faces, the contours

of the lips, the position of the head, the powerful neck, and your arm resting on my shoulder in an embrace. The light in your eyes bubbles like the water of a brook flowing towards a future of uncertainty, and yet it is unscathed by this moment of certitude. Two different beings or identical uniforms that render us one, or the colors of our contrasting clothes are the only sign of belonging to the same world. Two names, and often even a date. Mere traces that characterize two different stories that for a fleeting moment have become one. Examine us closely and see how much we love one another. This is the force that fears neither derision nor criticism. Hope is reborn and with hope, life itself.

Yes, 1850 is the incipit of this collection. Faded faces, yet still imperiously present in their simplicity: one veiled and slightly uneasy while the other projects gaiety. Decades of smiles and faces that let themselves be revealed in an untroubled search as if the photographs themselves were waiting to be found, to be admired and caressed.

Observing them closely, one discovers habits and quirks. Sometimes lips are slightly opened, immortalized in an attempt to utter a word that will never be known. In other images, embarrassed joy predominates the setting, expressed in the words: "But I don't deserve all this!"

Their photograph was unearthed from who knows where; they are exhausted by hard manual labor and still grasping their tools, and yet ready to be part of a backdrop that distances them even more from the rest of the world. Wishing each other well, notwithstanding "all this." Emily Dickinson wrote: "When we feel the need of a hug, we must take the chance to ask." One also has to be able to embrace suffering.

Many miles travelled along paths that seem to slide inexorable into the furrows of time. During the course of a journey, there is always a moment in which the embrace is transformed into life. And yet, an embrace is as if life ceases in an undefinable moment and music enters the heart of each of us. An instant in which everything, including time, stops and for a moment we are transported elsewhere to be cosseted by the warmth of a heart that beats for us.

The image of the body seems to emerge from the background that recedes and almost fades away, leaving space for the faces, hands, and the serene and finally joyous gaze. Embraces are a

reawakening of our slumber and the absolute peace of our senses. Loving. Love knows no boundaries, country, race, age, or social class. Nevertheless, instants of tenderness followed by moments of tranquility are often premonitions or after-effects of a battle.

Sometimes they are crumpled up like old rags from which to be liberated; seemingly painted bodies ever-present and invariably unclothed but completely at ease in their nudity by not being subjected to the restrictions of clothes; gnarled, bodies proud as tree-trunks or sinuous as a bamboo cane. They recall the art of Egon Schiele who—like a rock-star of his age—transformed flesh, soul, and bones into a prodigious embrace that saved two beings from war and death. Theirs is the glorious Resistance of bodies and minds that he describes with these words: "Bodies have their own light which they consume to live: they burn, they are not lit from the outside." Perhaps the light of these photographs is generated from the delicate embrace, sweet like our memories ensconced within our clothes, a scent, a mass of hair that reminds us of our loved ones lost over time. Time is basically an illusion created by the mind to aid in our sense of temporal presence in the vast ocean of space. Without neurons creating a virtual perception of the past and the future based on our experiences, there is no true existence of the past and the future. All that exists is the present. *It's better to burn out than to fade away,* sang Neil Young, later quoted by Kurt Cobain in his final letter before committing suicide.

Sons, fathers, men: they are all human beings who seek and find each other in the deepest sentiments of affection, often tinged with love and branded with passion. If I embrace you, do not be afraid. If I embrace you, then accept me as I am; take me with you and transform yesterday into today; do not allow tomorrow's doubt to interfere between us. "Loving" is a gift for those who are not capable of suffocating their emotions or are afraid of being overwhelmed. It is the force of he who fears neither derision, nor criticism, as he has grasped the certitude of his own being as something Human and True. An embrace is a human who talks of sentiment and negates not the present.

Hope is kindled from an embrace, and as much as it is humanly possible to speak of certainty, no one can know their own beauty or perceive a sense of their own worth until it has been reflected back through the mirror of another loving, caring human being.

To embrace oneself while dancing is a miraculous union with music that is so profound as to challenge the intimacy that singers are capable of creating when they bring their voices into this union. Two hands, one resting on the nape of the other; two dancers who let themselves be led by the melody belonging to another more daring world. Perhaps not even the greatest singers are able to achieve this.

This fascinating vision is the perfect narration to rout out those fears harboring within the dark recesses of our infancy. After all, a hug is such a simple gesture and yet of such importance that can perhaps seal the end of a "cold war" between two lovers or between two people too shy to externalize their feelings, and thus mark the fragile beginning of love.

Before reaching the summit, we all desire a place where we can catch our breath and rejoice in the sensation that someone will take care of us, and will endeavor to help if we are lost or delayed in our descent to the plateau of reality.

Love is vulnerable. Love is family. Love is life. We hurt one another. We just do, but we also need each other. We all know that hurt people hurt people. Wounded people lash out in anger and fear. I like to call them porcupines. These are people who desperately want a hug, but if you dare hug them, you will probably be stabbed. To detach a piece of oneself so the other need no longer walk by himself can also cost a life. Timid, passionate, mythological, or surreal, the embrace is also the unfolding that Giorgio de Chirico used in his *Hector and Andromache*. Instead, Munch in his interpretation used shaded hues of black or pale blue to meld his two figures together: they lose their sexual connotations to become a marvelous single being. Only the pure of heart can come out alive from an embrace like the soaring souls of Chagall that fly upwards towards Infinity. Yes, it is true that there is a place in the world where the heart beats strongly—a place where one remains breathless for the sheer emotional experiences, and where time stops and has no age. That place is not a beach, a mountain peak, nor life's plateau, but within your embrace that never lets the heart age, nor the mind to cease dreaming. Often in life this becomes the most difficult gesture to undertake. It may be a gesture between the guilty and who is ready to pardon, or between he who is lost and he who has been found again. A story like a *mandala* but all encompassed within a single moment.

Rembrandt's embrace in his *Return of the Prodigal Son* is a gesture of benediction by a father pardoning his son. The challenge is to love like a father and let oneself be loved as a son. Those lips almost seem to say: *Every embrace that today I offer my son is an embrace that I wish I had received yesterday from my father, and that my father would have wished from his own father.* The first embrace that I recall giving was to my father on returning from a summer vacation by the sea. An embrace is not a mediation, but more an armistice which unites, even long after having been received. Embrace me with the *brachium* of Ancient Rome around the neck. Encircle me with tenderness like the Old Saxon *hog* or the *hugga* with *kjære* from distant Norway. Envelop me with precious Byzantine *spáō* or a radiant *aspázomai* from Hellas as Francesco Bruno and Sonia Canterini write in their volume *La Scienza degli Abbracci* (Franco Angeli, 2018). The amber-colored lovers of Ain Sakhri—almost void of aspect or gender—are perhaps the most symbolic representation of this collection of embraces. Again, anonymous and unearthed by chance in a grotto near Bethlehem, they are made from a single stone which almost magically takes on the veiled profile of two humans in the act of an eternal and glorious embrace. They have no face nor body nor genitals, and yet the sheer energy they give off is the same present in all these photographs.

They lived ten thousand years before Christ, while 2004 years after Christ in Brighton, Banksy on a wall outside a pub depicts two policemen kissing, locked in an embrace.

Between these two dates, a journey of a century, or perhaps a thousand, then a hundred, then another thousand, like the kisses of the Latin poet Catullus.

Non, je n'embrasse pas!

ACTA EST FABULA.

Thank you Hugh & Neal.

An Accidental Collection

Hugh Nini & Neal Treadwell

Our collection began twenty years ago when we came across an old photo that we thought was one of a kind. The subjects in this vintage photo were two young men, embracing and gazing at one another—clearly in love. We looked at that photo, and it seemed to look back at us. And in that singular moment, it reflected us back to ourselves. These two young men, in front of a house, were embracing and looking at one another in a way that only two people in love would do. Dating sometime around 1920, the young men were dressed unremarkably; the setting was suburban and out in the open. The open expression of the love that they shared also revealed a moment of determination. Taking such a photo, during a time when they would have been less understood than they would be today, was not without risk. We were intrigued that a photo like this could have survived into the twenty-first century. Who were they? And how did their snapshot end up at an antique shop in Dallas, Texas, bundled together with a stash of otherwise ordinary vintage photos?

About a year later, we came across a second photo through an online auction. It was a miniature portrait of two soldiers from the 1940s, approximately the size of a man's thumbnail. They were posed cheek to cheek, and their photo was in a small art deco glass frame with "Yours Always" etched into the glass. They had that same unmistakable look in their eyes as the first photo we'd collected so many months before. We thought we had now found the second, and last remaining, vintage photo of two men, like ourselves, who were in love. Thus began a twenty-year journey that neither of us saw coming—much less planned.

Our annual travels to Europe, Canada, and across the US gave us the opportunity to comb through boxes and piles of old photos at flea markets and antique shops. That, and the advances of the Internet, would grow our collection to more than 2,800 vintage photos of men who were in love. It is impossible to state how unexpected this is to us. Jokingly, we call this "the accidental collection." In the beginning, we acquired photos because they spoke to us personally. Soon, we were actively looking for them. As we came across more and more, there was a sense that we were involved in some kind of rescue mission. These photos had stood the test of time for somewhere between 70 and 170 years, and we were now the custodians of these unlikely survivors of a world that is only just beginning to catch up

with them. As the years and photos accumulated, we began to feel a sense of obligation to share them with others. That said, strangely, though we have many good friends and loving and supportive families, we never shared this collection with anyone until fairly recently. Our reason was simple: we didn't think anyone besides ourselves would find them interesting.

In the fall of 2012, shortly after moving to New York, a seller whom we had been working with for years contacted us by email about a potential addition to our collection. We liked the photo, agreed on a price, and notified him of our new address. He emailed back: "I live two blocks away from you. I'll slide it through the mail slot in your door." We'd never taken notice that he, like us now, was a New Yorker. Some time later, he presented us with another photo we liked, but this time we met for coffee. When possible, we like to meet and get to know the sellers we work with. On a whim, we took two of our black 12×12 albums with us. After concluding the business portion, and after assessing Tony to be a nice and genial man, we asked him if he'd like to see what we'd been doing with our photos. He said yes, and we handed him the first album. He went slowly and silently through it, often using a magnifying glass. When he finished, he said nothing and we handed him the second album. He repeated the same process of slowly—page by page, photo by photo—examining our collection. When he reached the last page of the second album, he closed it, looked at us with a kind of thunderstruck expression, and said: "You have to publish these." Of all the things we thought we might hear from someone, who has spent his entire life dealing in photos like ours, that wasn't one that we anticipated. We just took his call to action as a compliment. But even before this, a vague sense that we needed to share our collection had begun to settle in with us. We didn't have any ideas about how to share it, and we certainly didn't know anything about publishing a book. "You have to publish these"— that was the first time we'd heard those words. But it wouldn't be the last.

Collecting photos like these isn't clear-cut and simple. Social norms regarding what is an acceptable display of affection between two male friends has changed over time. One hundred years ago an affectionate embrace between male friends was not uncommon. Friendship photos like that are often presented by sellers as being a "couple." In some cases, they could be, but we

usually pass on those. When deciding whether or not to acquire a photo or snapshot, we have a rule that we follow. We call it the 50/50 rule: we have to believe that it's at least 50% likely that we're looking at two men who are romantically involved. There are few 50/50 images in our collection and none in our book. What determines whether or not we'll acquire a photo can sometimes be an embrace that leaves no doubt that the relationship exceeds friendship or fondness. When possible, though, there is one sure way to determine if a photo is "loving." We look into their eyes. There is an unmistakable look that two people have when they are in love. You can't manufacture it. And if you're experiencing it, you can't hide it.

In one instance, our self-imposed 50/50 guideline was put to an unexpected, and successful, test. We had collected a few photos of two World War II soldiers, stationed in Austria, whose togetherness was fairly subtle. Had these photos (p.110.2) been discovered during their lifetimes, the soldiers could have plausibly claimed to be "just buddies" posing together for a photo. But for anyone looking closer, they would have, as we did, seen that they had "that" look in their eyes. Weeks later, we came into possession of the most important photo of the group. In 1945, these two soldiers had hiked up into the Austrian Alps and a friend took their picture as they embraced romantically in the snow. With that photo, we not only have the unmistakable embrace and the tender look of love between them, but also validation for all of their other photos where their feelings for one another were only hinted at. This entire group of photos, collected over almost a year, numbers around 150. They were only ever intended for the soldiers themselves and no one else, but one of them kept these snap- shots hidden in a shoebox until the early 1990s when he handed them off to a relative, along with the ring that he was wearing in the Alps photo, with this request: "Please keep these safe for me." Based on our experience with collecting, we'd paraphrase that request to: "Please keep these safe 'after' me." According to the relative, the soldier, nearing the end of his life, wanted to preserve the one thing that meant more to him than anything else. He passed away two years later.

Because of the age of the photos in our collection, the likeli- hood of any of the subjects, or the person who took the photo, is still living is very small. Our youngest photos are seventy years old.

If the subjects were in their twenties, and most appear older, they would be in their nineties today. Is it possible that some, or one, of our subjects are still living? Yes, but highly unlikely. The unfortunate side to that is that there are no first-hand accounts of our subjects. Except one. We do have an account from a living relative of one of the two World War II soldiers mentioned above. The relative who was given the shoebox of photos and the ring for safe keeping was the nephew of one of the soldiers, John W. Moore. David, John's nephew, grew up living next door to his uncle. David describes his uncle as more of a second father to him. He told us that his uncle, while serving in World War II, was diagnosed with muscular dystrophy. After the war, he returned to his home state of Texas, married, and started a family. The marriage was short-lived, and so was John's independence, as he was soon confined to a wheelchair. David only knew of his uncle as being wheelchair bound. According to David, his uncle was gay and closeted. It's unclear whether the relationship between his uncle and the other soldier, Dariel, continued after the war, but John did have relationships with other men and shared some information about those relationships with his nephew.

John W. Moore and Dariel were both from Texas and during World War II served in the 42nd Infantry Division, the Rainbow Division. We have several photos of them posing proudly in uniform in front of their division headquarters with the large rainbow symbol behind them. We know what you're thinking because we thought it, too, but our research has informed us that the rainbow symbol didn't mean then what it means today. It's just a funny and ironic quirk of history. The Rainbow Division was named such following World War I and still exists today. Through our own research we've come to know that the 42nd Infantry Division, the Rainbow Division, is famous and has had two books written about it. In 1945, while making its way across Germany, the Rainbow Division headed for the town of Dachau. Some of the locals intercepted them and told them to go to the outskirts of the town instead where they would find a concentration camp. They didn't know exactly what a "concentration camp" was, but they would soon find out. On April 29, 1945, the 42nd Rainbow Division liberated Dachau Concentration Camp, and the word "horror" took on new meaning. Four days later John and Dariel, along with the entire Rainbow Division, moved on to Kitzbuhel, Austria. Eight days later, on May 7,

1945, Germany surrendered. And sometime during that month of May in 1945, John and Dariel, and a friend with a camera, hiked up into the Alps. There, the two soldiers posed romantically in the snow with John wearing the ring he cherished all his life (p. 110.1). David, in honor of his uncle, wears that ring every day.

One of the questions often asked is: "Who took the photos?" Sometimes you can see the shadow of the person taking the picture in the photo itself. The obvious assumption in that case is that it's a friend of the couple. Many photos in our collection show friends and family who were supportive of these men. In others, it's not clear, but we imagine that just like today, they had allies in the form of friends and family. In the absence of such loving support, one category that emerged early was that of the photo-booth photo. With the anonymity of the photobooth, a couple could act as the subject, photographer, and developer. The risk involved was significantly less when taking and developing your own picture together. We can only guess as to how others managed to have their photo taken and developed. Photographers and processors would have had to have been understanding and discrete toward the men. It could have simply been that they personally identified with them or had a greater capacity for understanding than was common at the time. One photo in our collection shows ingenuity on a remarkable scale. We think of the timer or remote control innovation as modern, but it isn't. A couple, dating from around 1900, placed a camera on a dresser in front of a mirror and photographed their reflection using what appears to be the Faries Shutter Tripper. Invented by Robert Faries and patented on January 14, 1902, it consisted of a metal cylinder mounted to the camera shutter that is connected by a rubber air hose and operated at the other end by a rubber squeeze balloon in the shape of a ball. When the ball was squeezed, air was forced into the mechanical linkage of the cylinder, which then caused a piston inside the cylinder to trip the shutter. And that is what appears to have been used in what we're calling "the first selfie" of a romantic male couple (p. 297). Below their picture, the two men wrote: "In the mirror."

Our collection reveals to the world, and even to us, for the first time and voluminously, that feelings of love, attachment, or longing between two people are the same—regardless of the gender make-up of the couple. Their images evoke as powerful

a sense of love and humanity as has ever been filmed, or written about, or acted out on a stage. They appear in many varied contexts that repeat across time and global geography. They pose together in the bow of a boat, on a tree branch, on a bicycle, at the beach, in a forest, leaning against a car, and even in, or on, a bed. From a social perspective, the range is extensive as the images reflect back nineteenth-century working class figures, fashionably dressed businessmen, university students, and soldiers and sailors of all ages—spanning the time between the Civil War, World War II, and into the 1950s.

Patterns emerge. Patterns crossing time, geography, and nationalities, we began to notice that the organic poses from one couple were an exact mimic of another, such as the way they held hands, embraced, or just leaned into one another. The numbers of repeated and identifiable poses can be counted in the tens. Identical poses from two, three, ten couples could span seventy years or more and be represented by several countries, over different decades, even in different centuries. Consider the couples of today who saw the movie *Titanic* and mimicked the "I'm the king of the world" scene on the bow of the ship. It has likely been recreated millions of times using conventional cameras and cell phone pics and video. The subjects of *Loving* would have had no such starting point for the spontaneous and instinctive poses that they assumed. They would not have seen each other's images and copied them for themselves. The mirror images of their poses arose organically from their common human nature. In our albums, where we have lovingly homed our photos, one can see pages of ten, fifteen, twenty photos, spanning decades and countries, with identical composition. They couldn't have known about each other. Their expressions of love—so identical, so similarly expressive— could only have emerged from their common humanity.

One unexpected recurring theme, beginning sometime in the mid-1800s and continuing into the late 1920s, is that posing together under an umbrella was a signal that two men were romantically involved. When we acquired our first "umbrella couple" photo (p. 307), we only chose it because they had "that" look in their eyes. Somewhere around the fifth umbrella photo, we came to understand that this was a deliberately coded message that crossed borders and time. We have about fifty "umbrella couples" now.

Our own understanding of our collection has evolved, and continues to do so, from when we first began. Until recently, a loving male couple, or individuals, had their relationships described, or reported, or narrated by leaders of religious organizations, politicians, and the legal system—even though they had never met our subjects. They, however, spoke about these people as if they knew them, and it was seldom in kind terms. Today, for us, it's different. As individuals, and as a married couple, we can narrate our own lives to our families, friends, co-workers, and the general public. The cost for doing that today is not insignificant, but it in no way carries the risks it once did. The subjects in our photos, with the publication of *Loving*, will narrate their own lives for the first time in history. Far from being ostracized or condemned, they will be celebrated, and the love that they shared will inspire others, as it has in us. Love does not have a sexual orientation. Love is universal.

The photos we've gathered over the past twenty years have come from all over the world—literally, from five of our seven continents. Africa and Antarctica are the only two continents that we've yet to collect a photo from. It is a fitting coincidence that 5 Continents Editions is publishing *Loving*. Though the majority of our collection is from the US, we do have a significant number from other countries. Through our travels and with the advances of the Internet, we've established connections with sellers who hunt and gather these photos for a living. For instance, we work with four sellers from Bulgaria, three from Croatia, one from Serbia, one from Estonia, and two from our home base, New York City. The Russian market has only just entered the scene in the last couple of years, and we now work with four Russian sellers. The countries our collection represents include the US, Great Britain, Canada, France, Italy, Germany, Bulgaria, Croatia, Serbia, Hungary, Australia, Japan, Singapore, China, Czechoslovakia, Estonia, Russia, Portugal, South America, Austria, and Denmark. For reasons we don't know, the greatest number of foreign photos come from Bulgaria. And like our domestic photos, the ones from foreign countries span many decades.

By the time anyone reads this, we will have been together for nearly thirty years. According to us, we've been married since 1992. There wasn't a ceremony with friends and family. It was just something we did on our own and it included exchanging rings.

In 2006, we went to the only place in the US where it was possible to get married—Massachusetts. It wasn't as simple as boarding a plane in Texas, landing in Boston, and spending a few hours at City Hall filling out papers. In opposition of his state's marriage equality law, then Governor Mitt Romney had revived a 1913 anti-miscegenation law that had lingered, forgotten, on the books. That law was originally enacted to prohibit any out of state bi-racial couples from marrying in Massachusetts if it was illegal for them to marry in their home state. Romney declared that: "Massachusetts should not become the Las Vegas of same-sex marriage. What's next, is Provincetown going to start marrying ten-year-olds in violation of the law." Applying specifically to same-gendered couples, it effectively excluded everyone from the other forty-nine states. So, we set up residence in Boston, with an address, utilities, phone service, and a bank account—and then got married at Boston City Hall.

Though none of the subjects in our photos had the legal option of marriage, they, like us in 1992, did have the private, personal option. They married themselves, to one another, and just as we did in 1992, they exchanged rings. One of our oldest photos, which is actually a tintype dating from around 1860 (p. 32), shows one of the men wearing a ring on his little finger. There is a sprinkling of various other photos where the men are wearing a ring, or rings. But it isn't until you get to the American military from World War II that you begin to see lots of wedding rings—and even a few bracelets. We have many World War II soldier couples posing affectionately, but it wasn't until fairly recently that we began to notice the many symbols of commitment, in the form of rings and other jewelry, worn by numerous soldiers and sailors. They were very subtle most of the time. In a few, however, one of them may be just barely pointing at the object of commitment as they smile into the camera. In the photo (p. 110.1) of John W. Moore and Dariel in the Alps in Kitzbuhel, Austria, Dariel's left arm is draped over John's left arm. Both are prominently displaying "wedding" rings.

As for weddings themselves, we have a few photos that indicate a marriage ceremony. One is of two Bulgarian soldiers during World War II who appear to be getting married. Officiating at their ceremony appears to be a very solemn higher-ranking officer. In an even earlier photo, we have what appears to be the first documented marriage between two men. It's a photo (pp. 312-13),

circa 1900, of two well-dressed young men sharing an umbrella. One is placing a wedding ring on the other's finger. A third man, acting as the officiate, stands opposite them with his right hand in the air in the "I declare" position, and what appears to be a Bible in his left hand. It is an astonishing photo. Even more astonishing is a photo strip from about the same time period of another well-dressed young couple. They look to be in their late teens or early twenties. Two of their photos, from a photo strip of five photos, appear in this book. Three of the five are playful and ordinary: incorporating a variety of hats, or no hats. However, it's the second and third images that reveal the fullness of their relationship. In the second (p. 88), they're holding an umbrella together, looking into one another's eyes, with one's little finger embracing the other's index finger on the stem of the umbrella. And in the third, the middle photo, they're holding a preprinted message, and looking to us, the viewers. Together, in that middle photo, approximately 120 years ago, they each held the opposite edge of a sign that reads: "Not Married But Willing To Be." They posed for that photo (p. 89) in a very different world than the one we live in today.

Set aside for a moment the umbrellas, beaches, cars, bicycles, and boats, even the embrace—it's their gaze. Whether to the viewer, to one another, or averted, it always conveys the kind of romantic love that everyone knows about and is singular and special. Holding one of these photos in the palm of your hand as they once did, feeling its age, and seeing how they look at one another, or back to us, their emotions are palpable even today, so many years later. Beyond their message of love, they seem to be calling out, saying: "We mattered to one another and we wanted to memorialize our feelings through a photograph. Even if only for ourselves." Surely, these couples couldn't have imagined a day when their secret photographic testament would become part of a book that celebrates them and the profound feelings that they had for one another. We've only recently begun to imagine it ourselves.

One enduring philosophical question is: "If a tree falls in a forest, and no one is there to hear it, does it make a sound?" The correct answer is yes—or no. If these couples loved each other, memorialized their love with a photo, but no one else saw it, did their love exist, or matter? This book is filled with fallen trees whose sound, though delayed, is now being heard for the first time. They are the sounds of an embrace, a lingering glance, the touch

of a hand, the softness of a brow, two figures lounging in the grass, a cheek pressed against another's cheek. These pages contain the images of loving male couples that were, until now, largely kept secret from their families, their friends, and the world. They memorialized their feelings for one another in these photos at great risk. All of them are examples of love, affection, attachment, and bravery. What we as collectors, personally, have come to understand from these photos is that couples like us have always existed. They were the trees falling in the forest that no one heard. Until now. These photos have taught us something that we instinctually understood, but hadn't yet formed into a thought: that the human heart has never conformed to the strictures of society as it stumbles awkwardly through something it doesn't immediately understand. The heart will always find its way to the light, and in this case, into daylight. Until this collection, we thought that the notion of us as a loving couple was "new." What we have learned from our collection is that we're not new. We, and other couples like us, both male and female, are a continuation of a long line of loving couples who have probably existed since the beginning of time.

The Hugh Nini & Neal Treadwell Collection, our collection, spans a century of time between the 1850s and the 1950s, and hits many notes in a rich chord. Thematically, it represents pure love. Photographically, it documents, from nearly its beginning, the first one hundred years of photo taking. One can also see the evolution of fashion, hairstyles, and societal norms as they relate to these subjects. The result is a romantic depiction of a special category of human beings, in all their diversity, that has been shown to be overwhelming for some, but certainly eye-opening for all. The intensity of their expressions, the purity of their passion, the simplicity of their emotions all serve to communicate a message as old as time, but from an unexpected, and heretofore hidden, source. *Loving* is a book that is intended to usher in a new sensibility, a fresh humanism of love. Rather than categorizing individuals, the collection brings us all together, "accidentally," under one —if we may—"umbrella." It shines new light on the universality of the most written about, enacted, or filmed emotion—love. Its message is for everyone.

Nini-Treadwell Collection

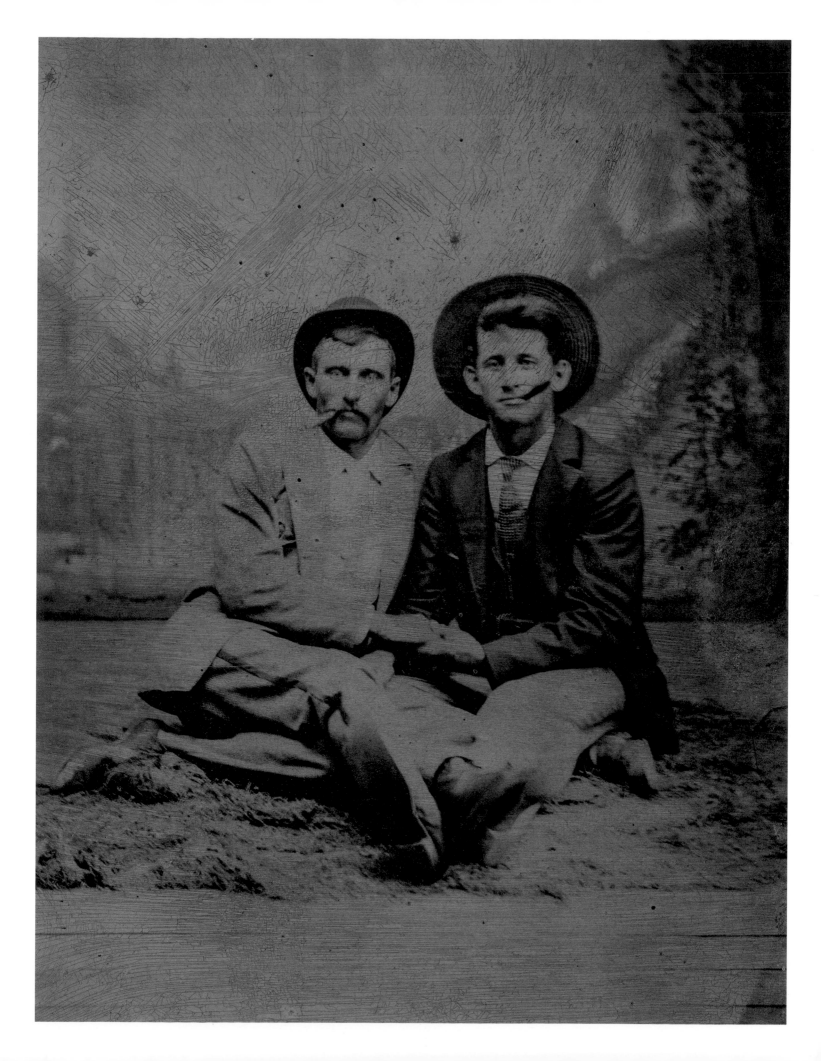

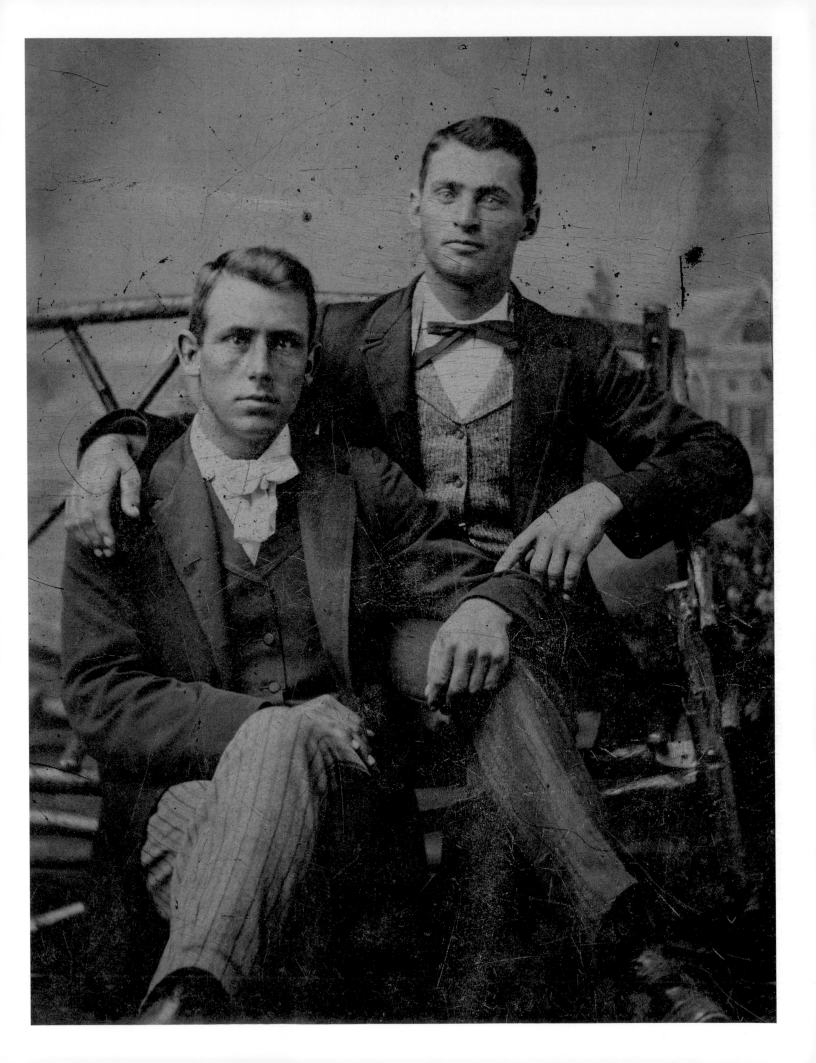

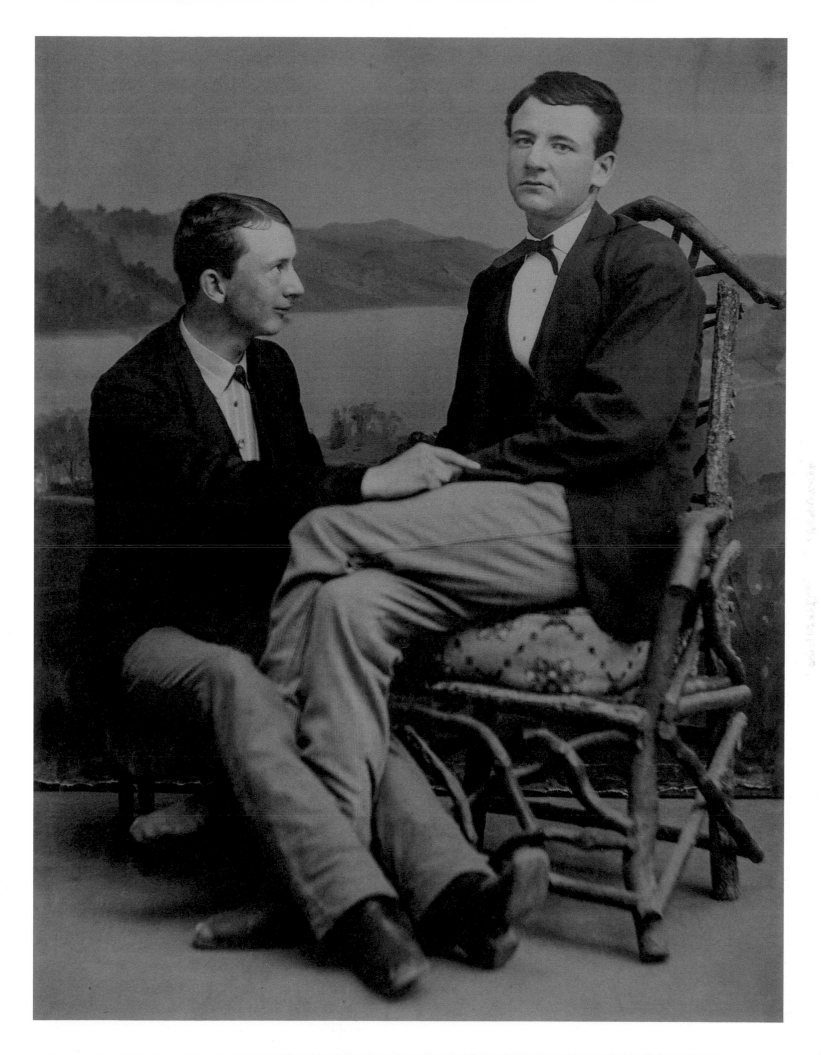

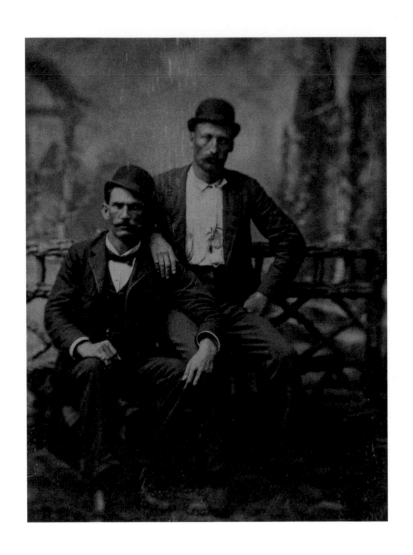

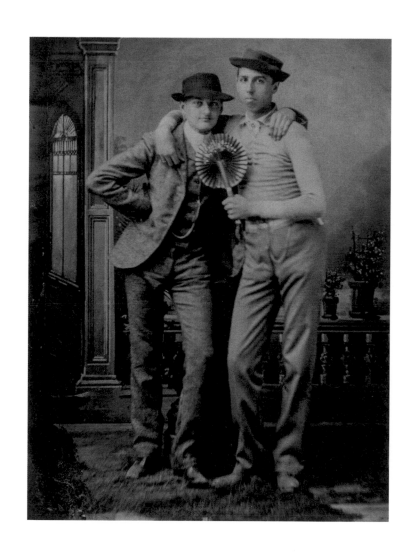

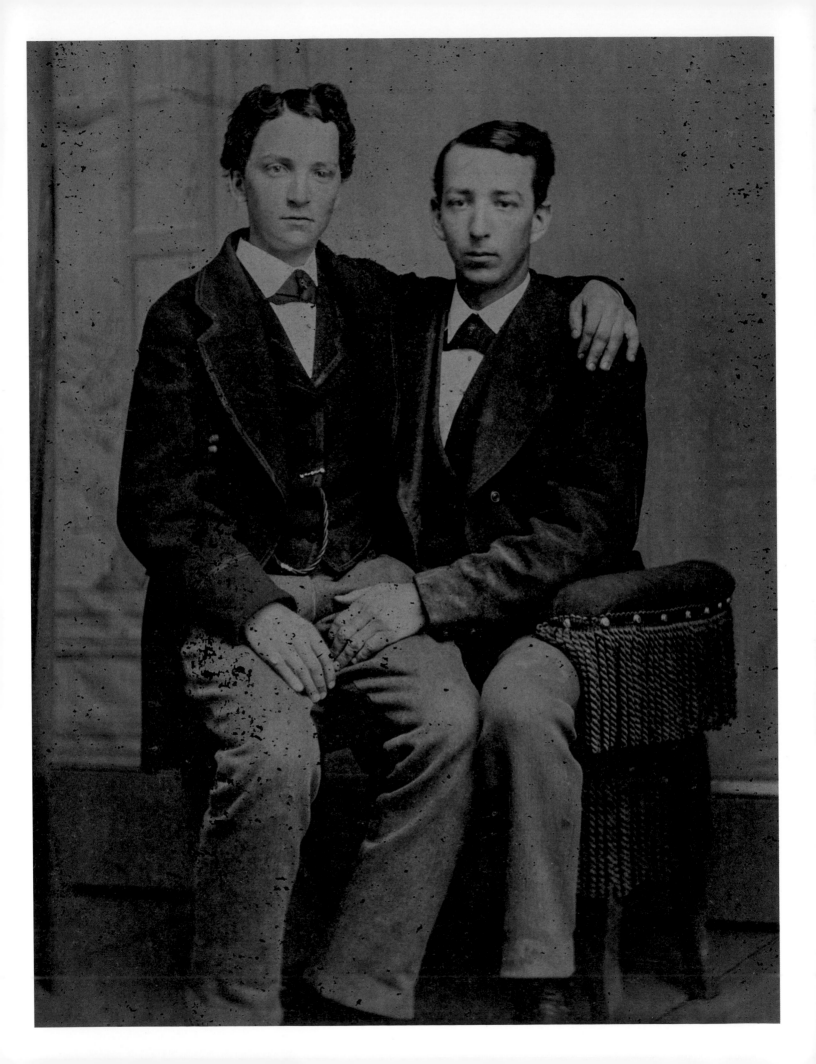

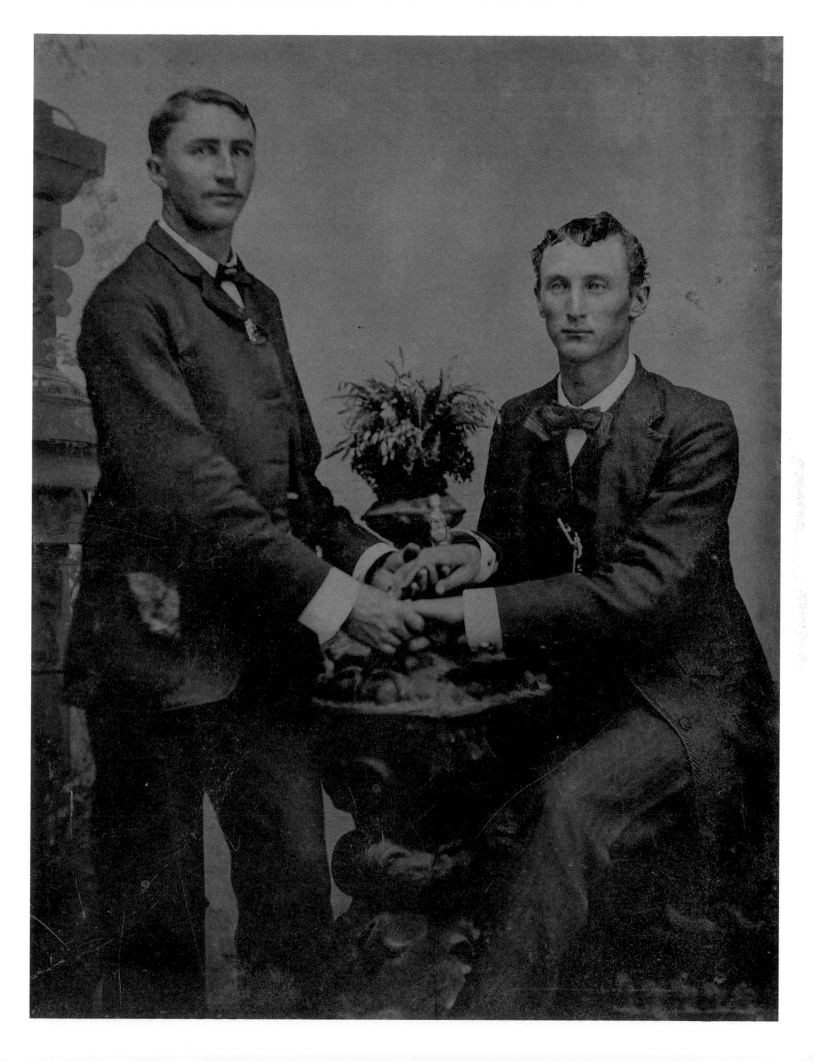

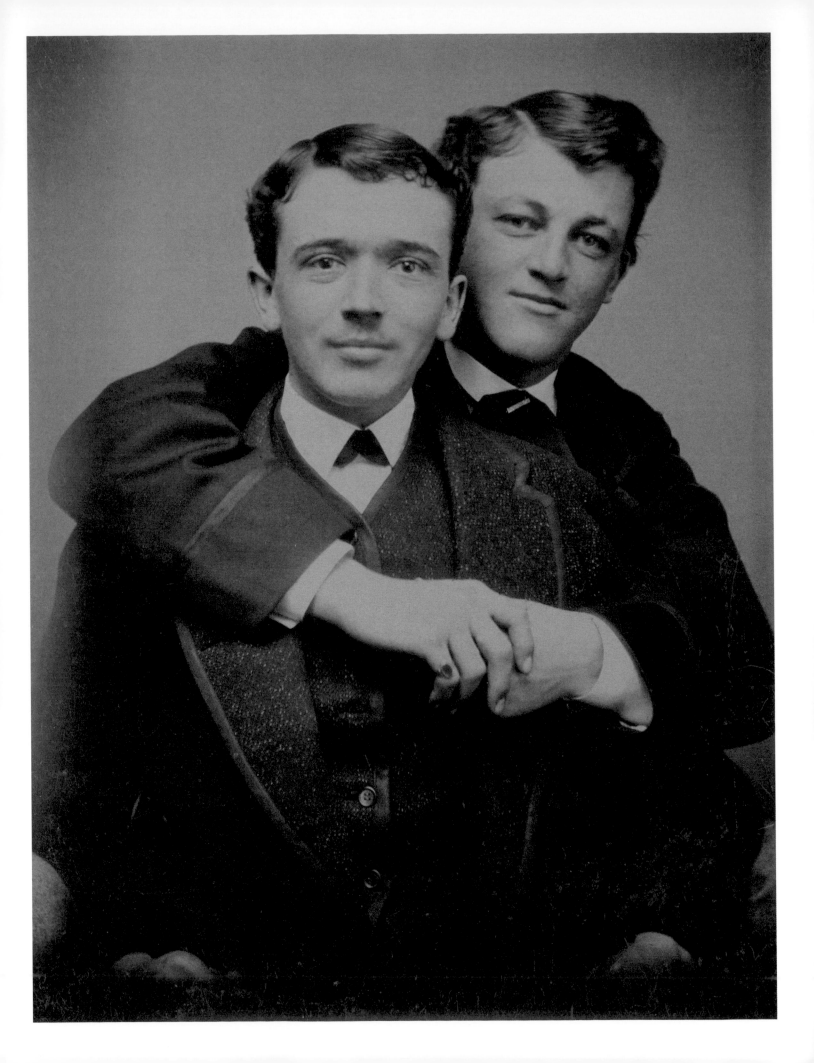

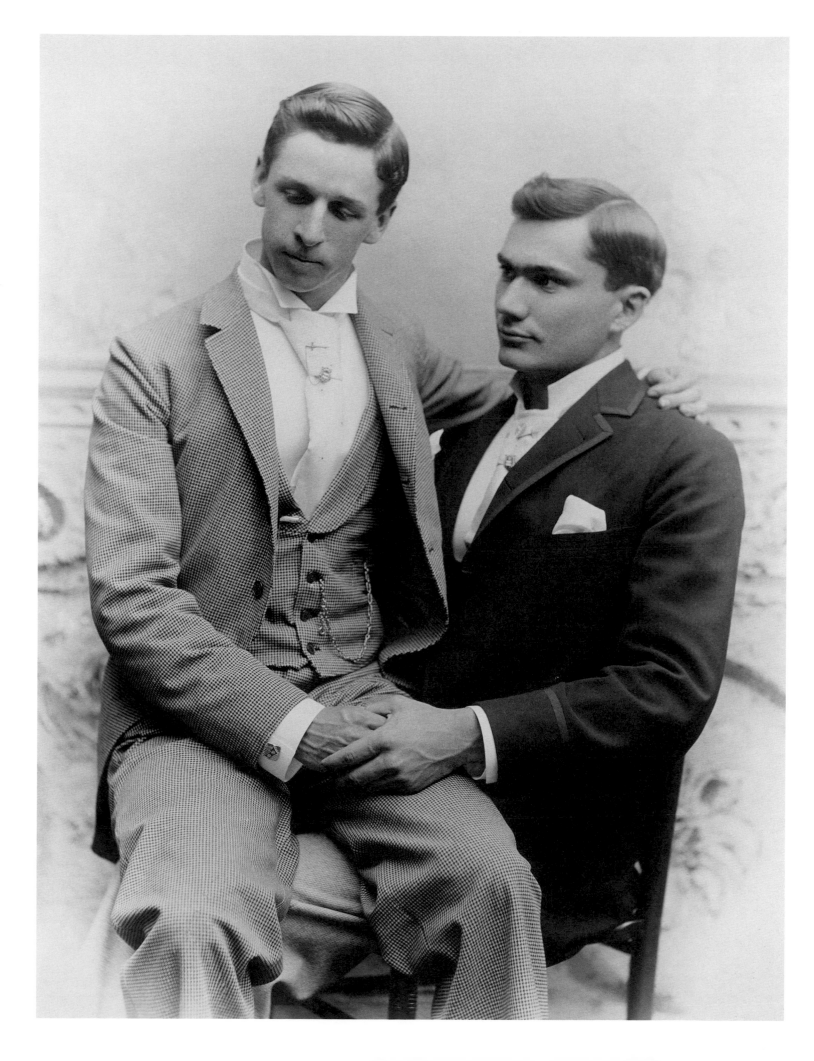

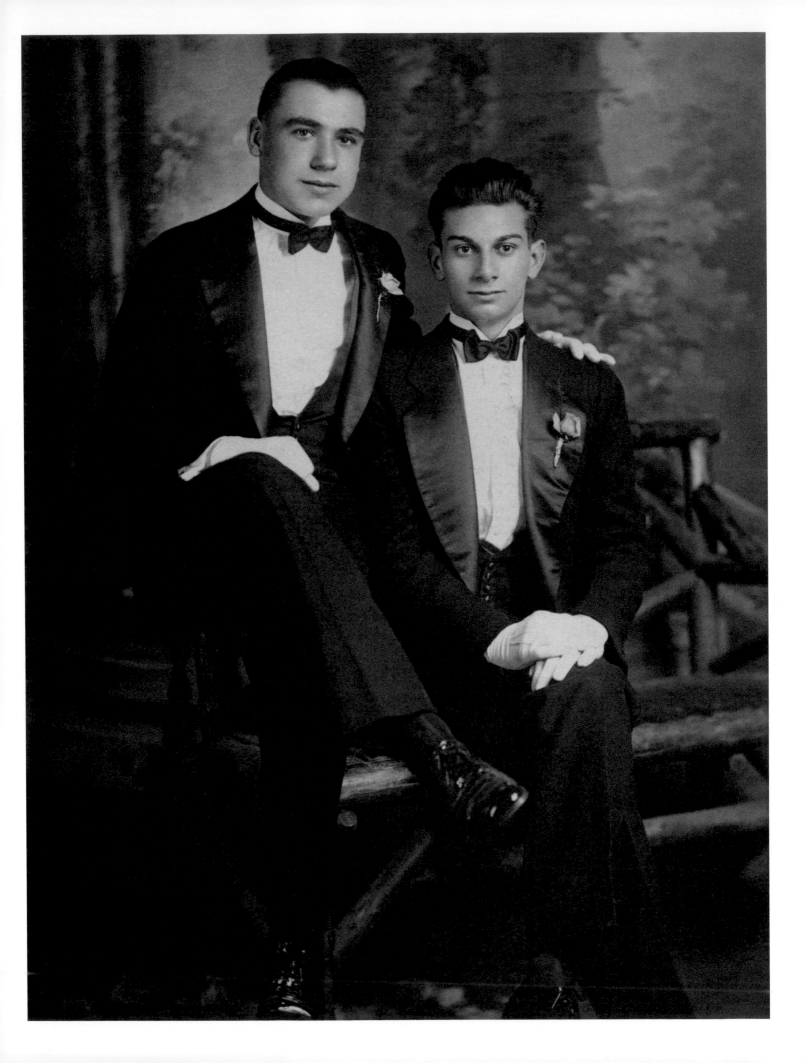

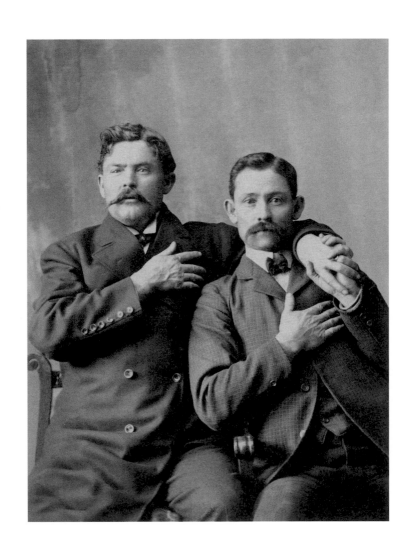

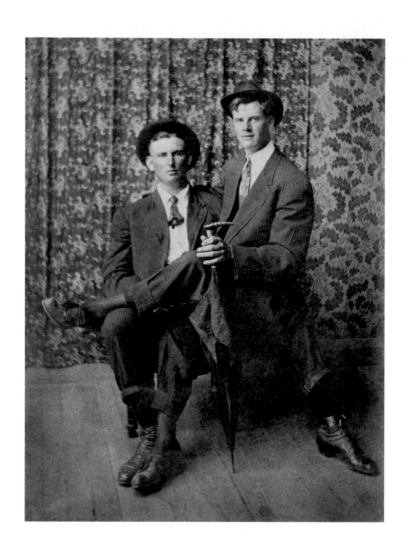

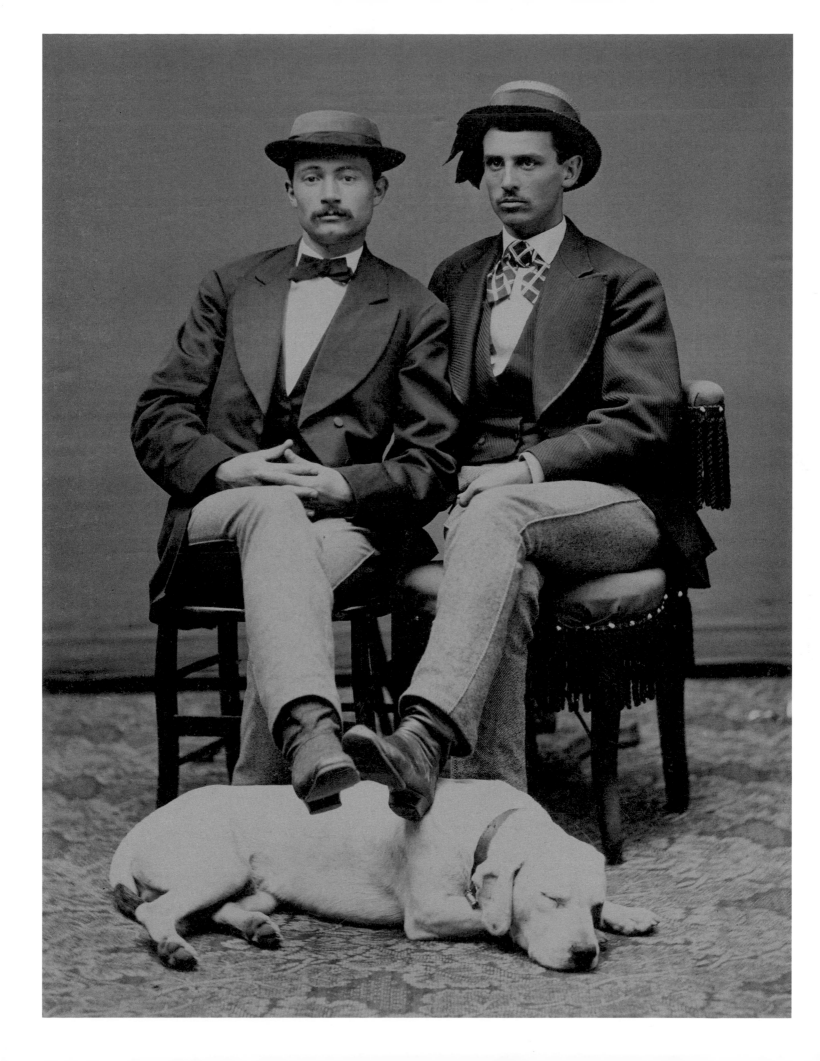

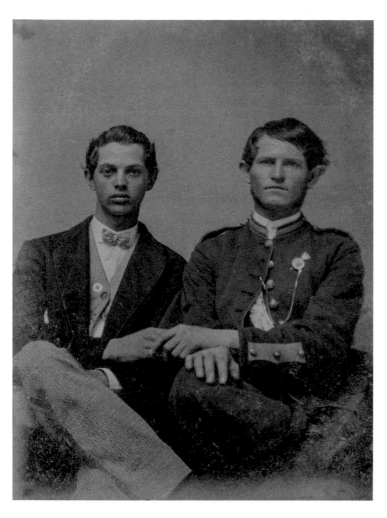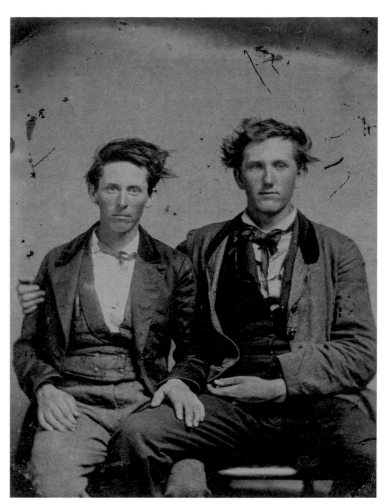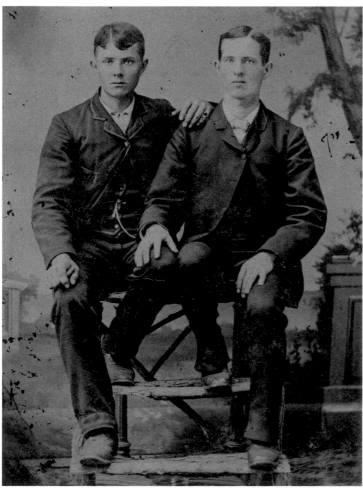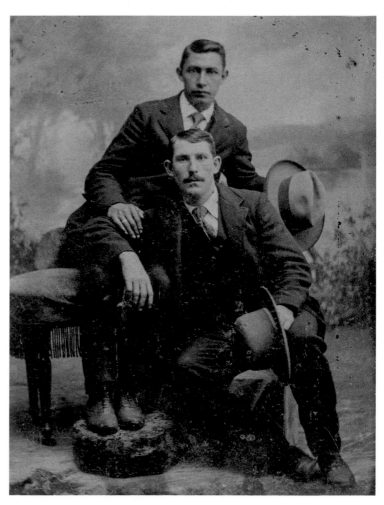

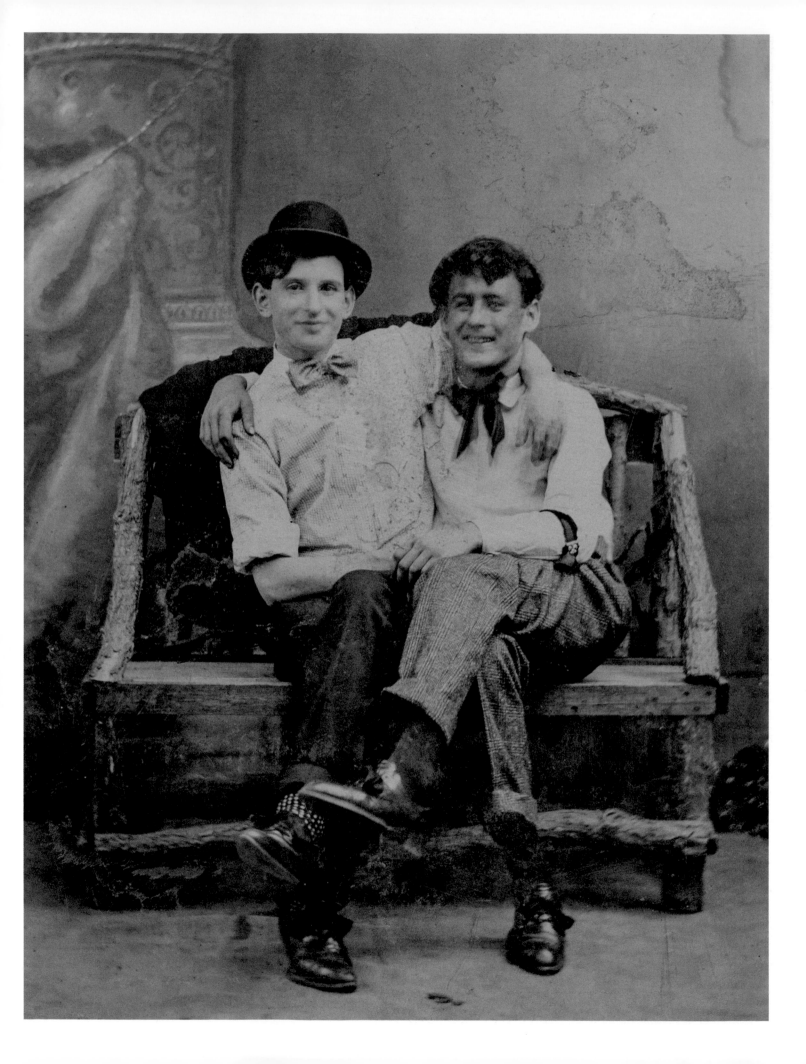

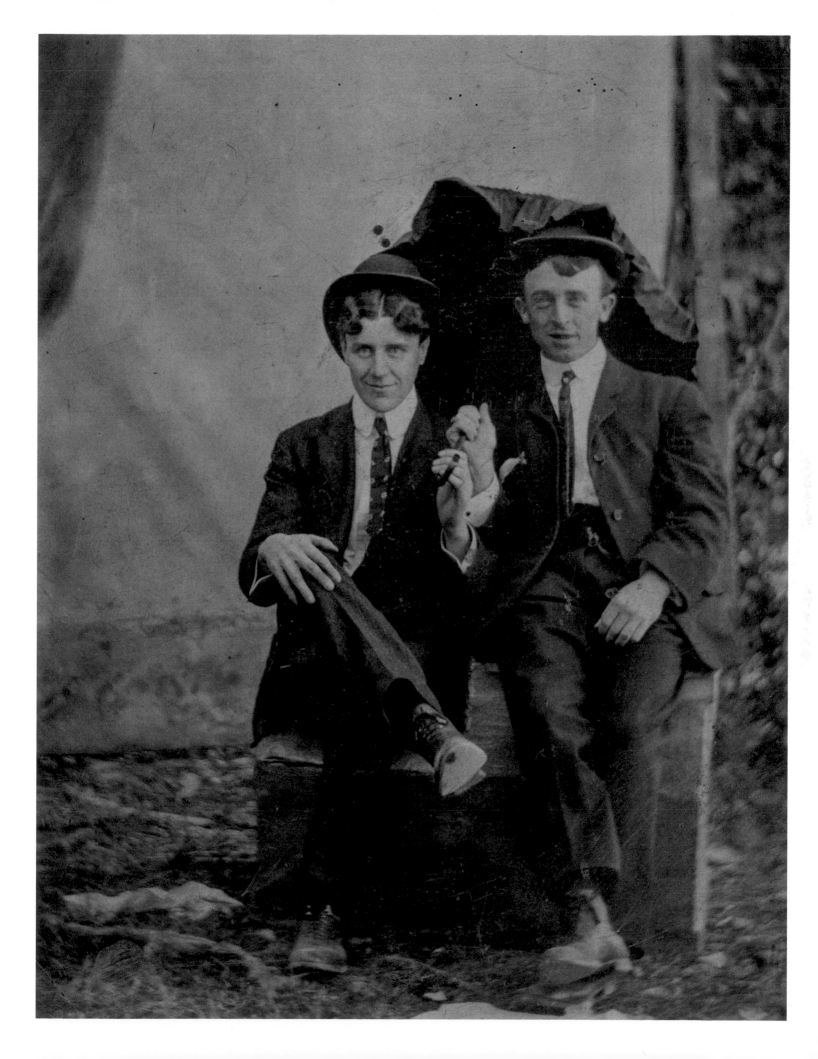

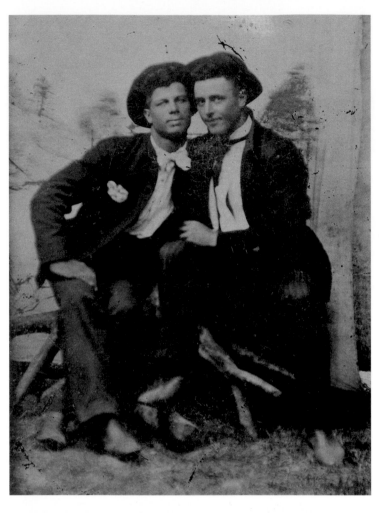
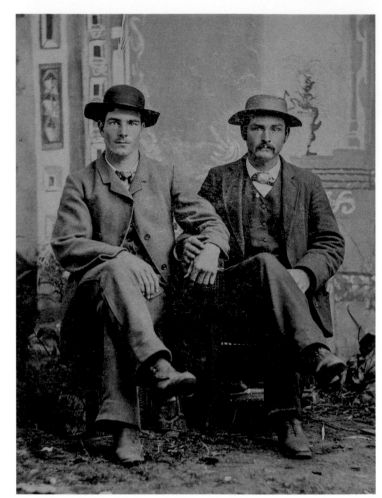
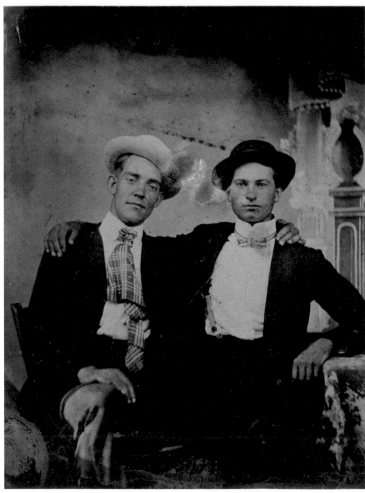
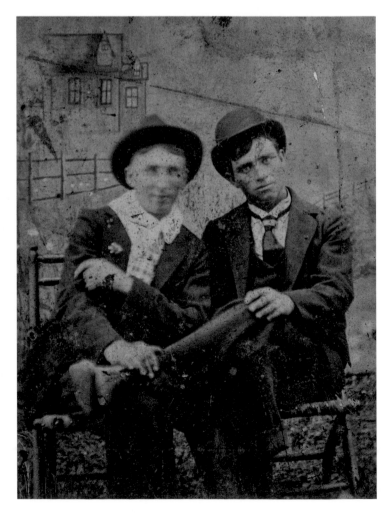

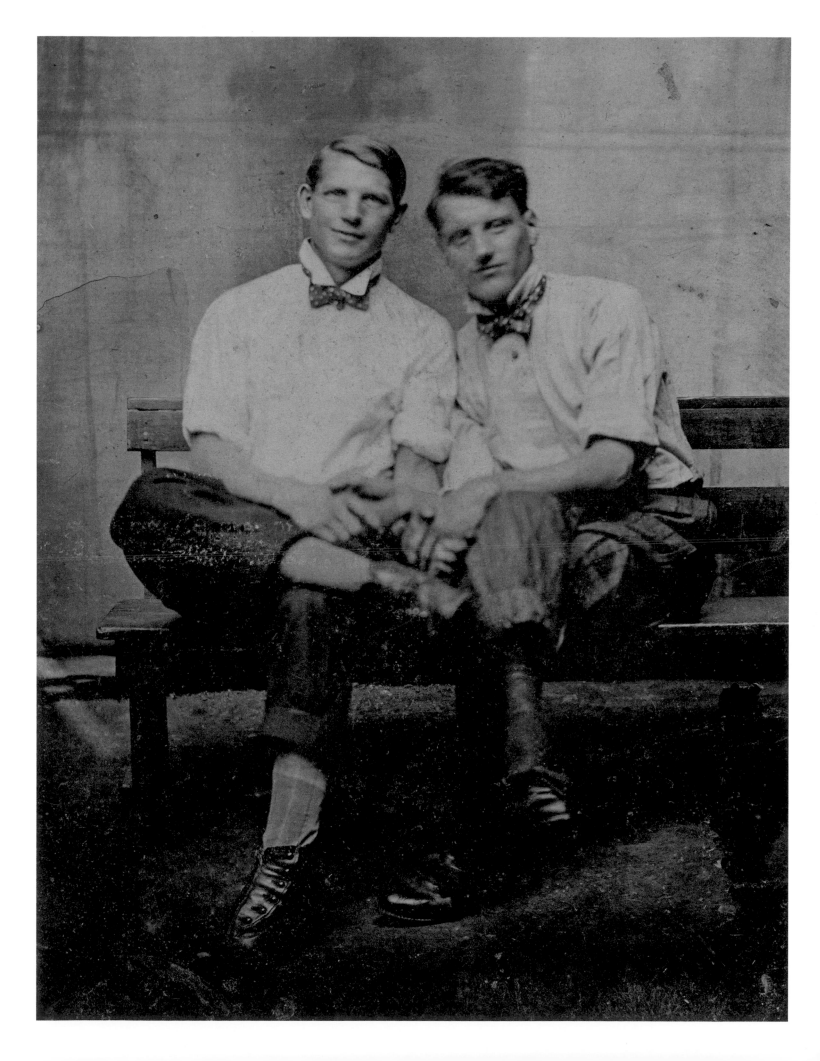

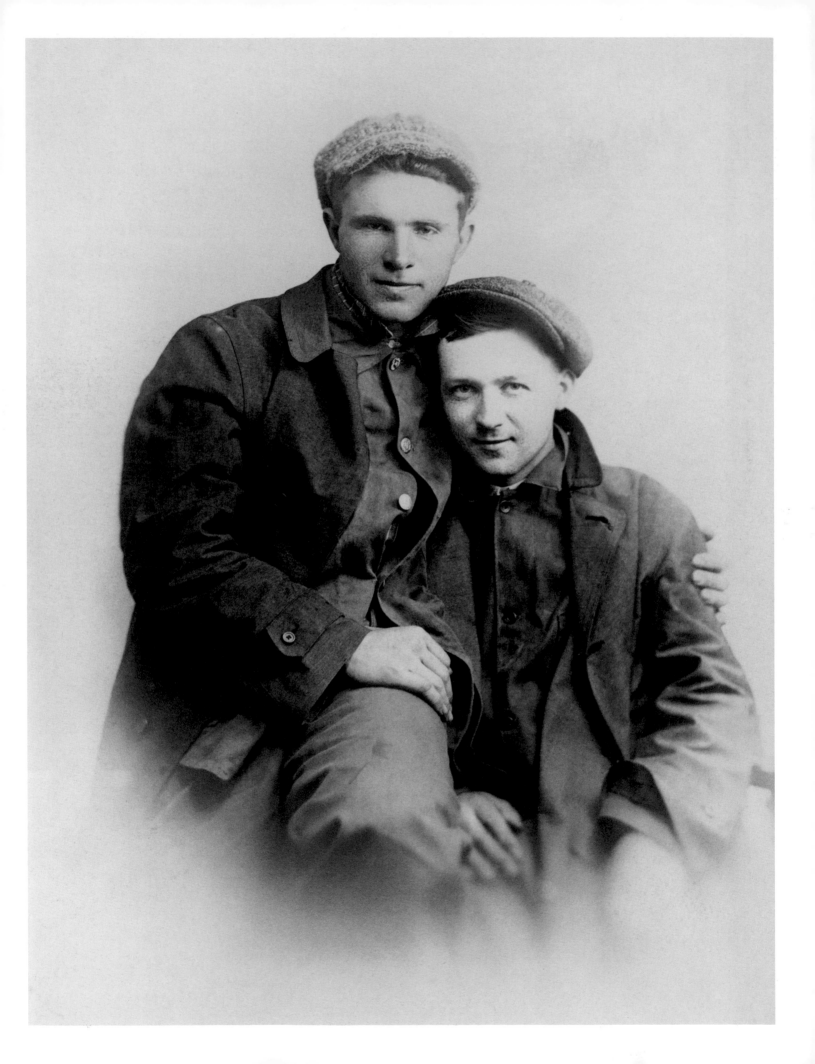

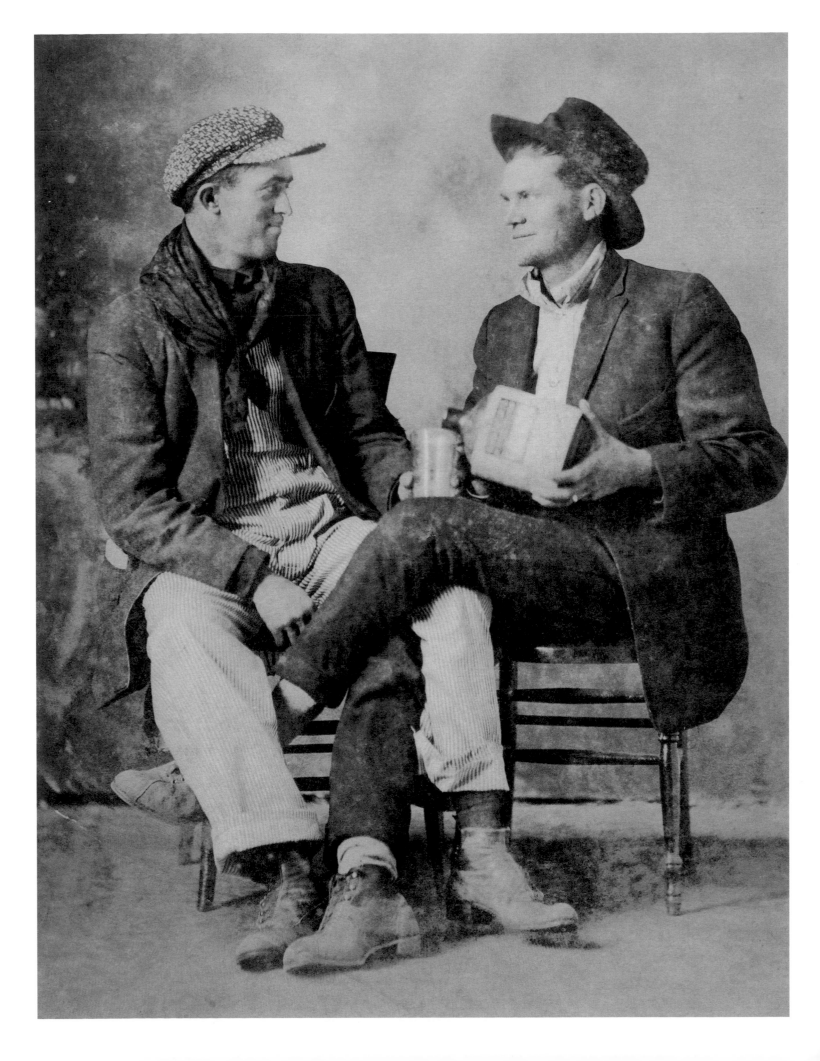

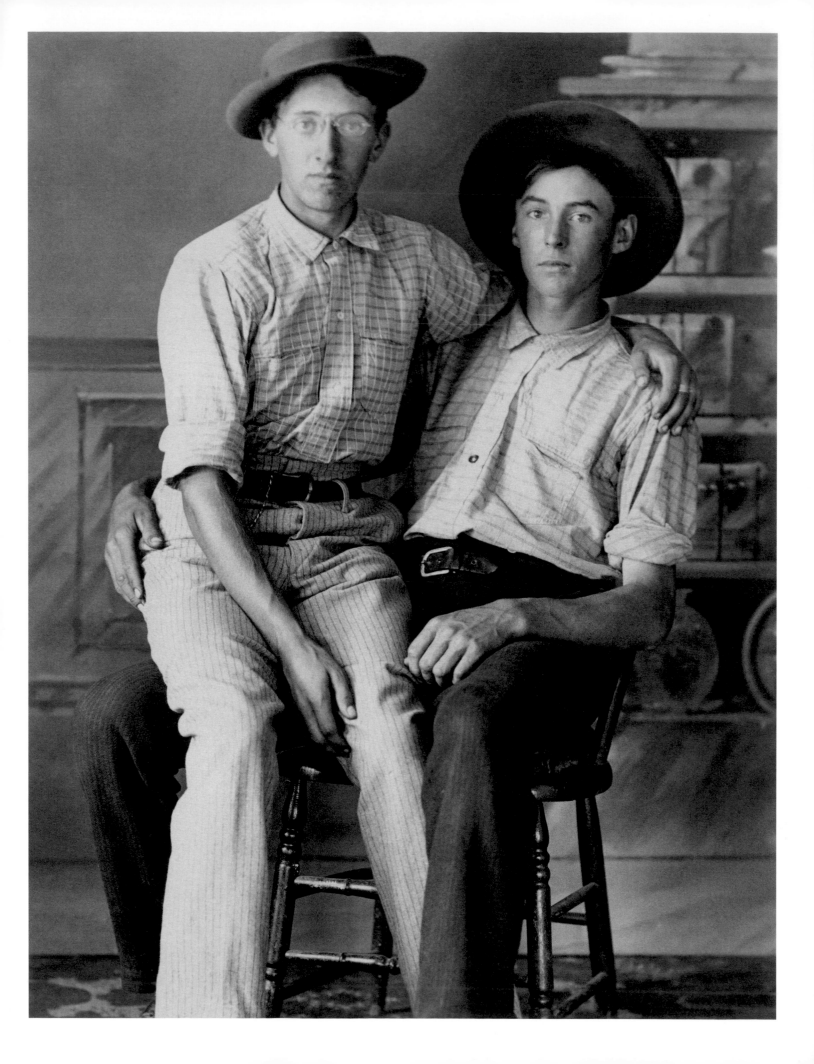

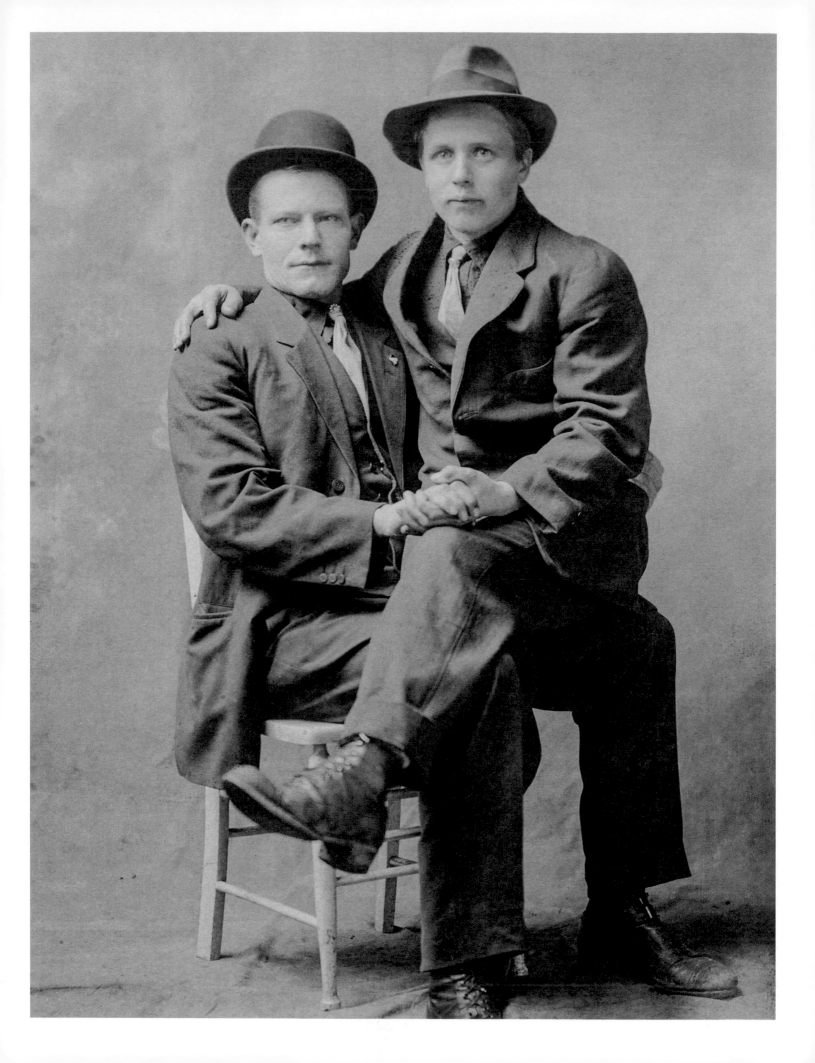

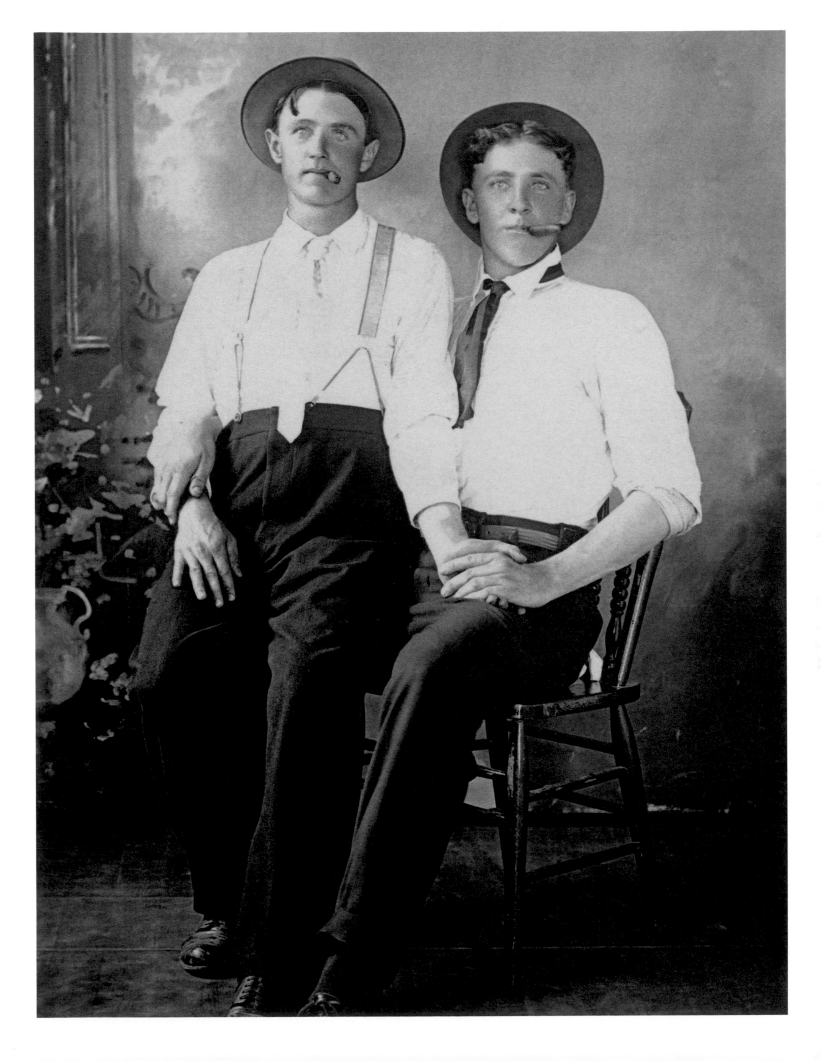

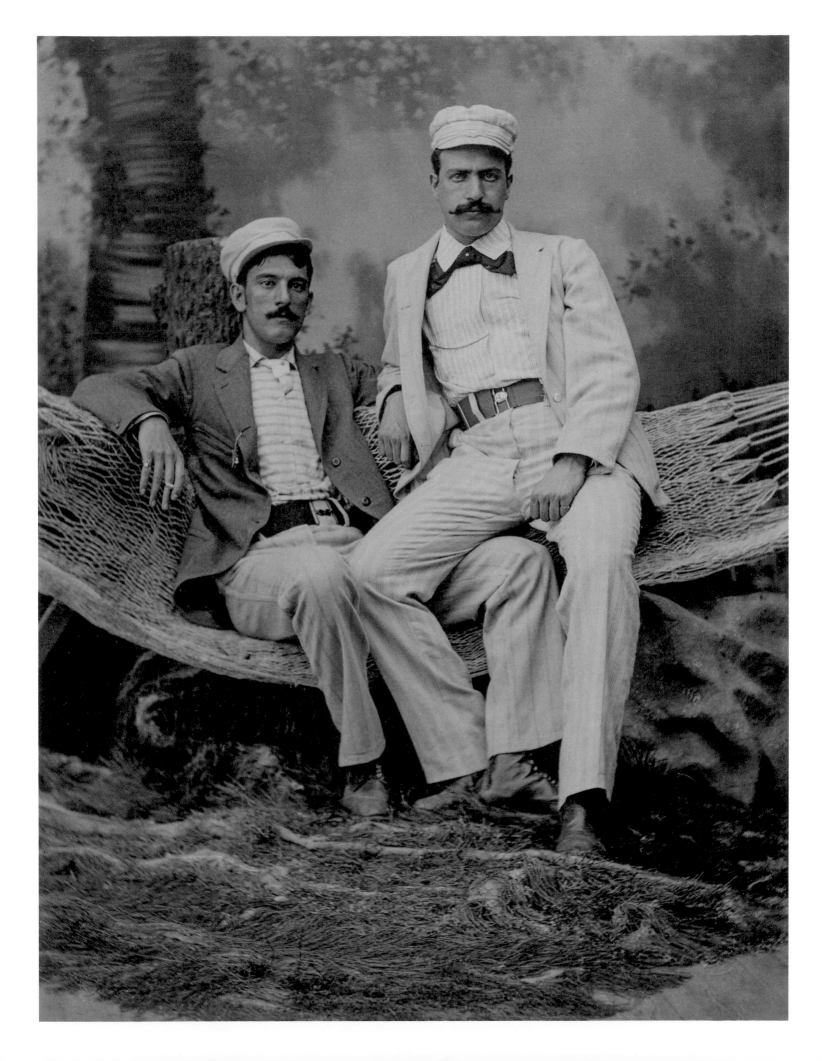

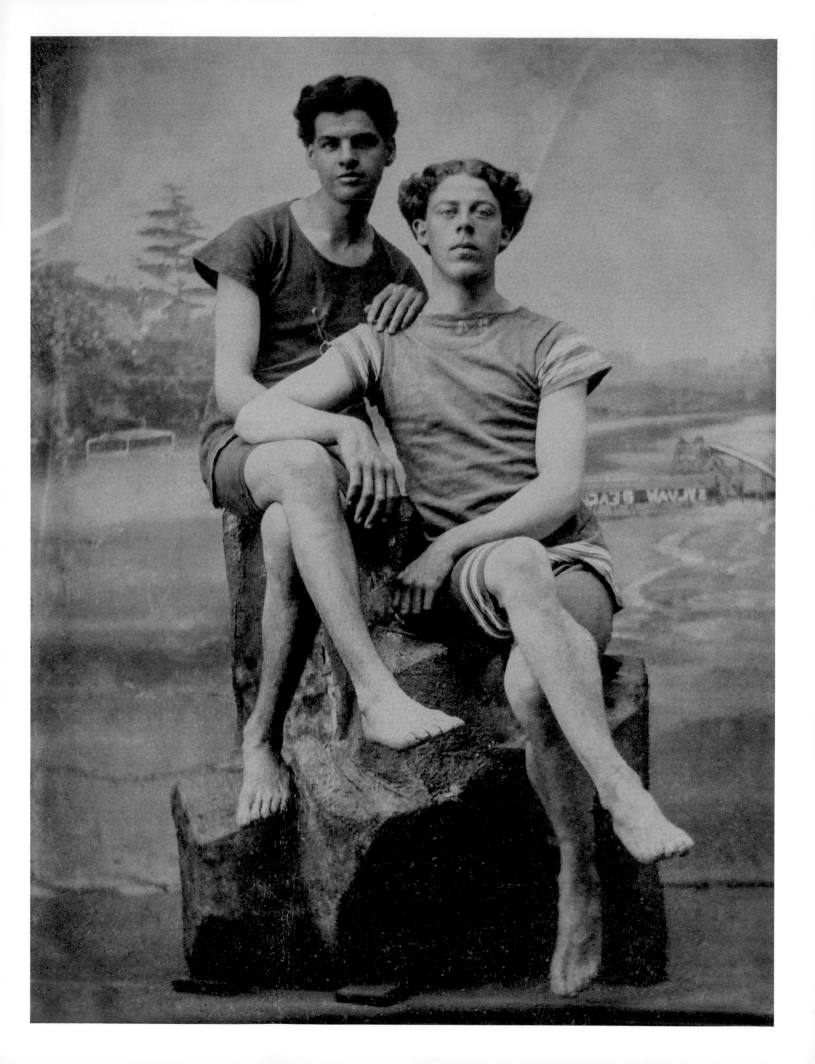

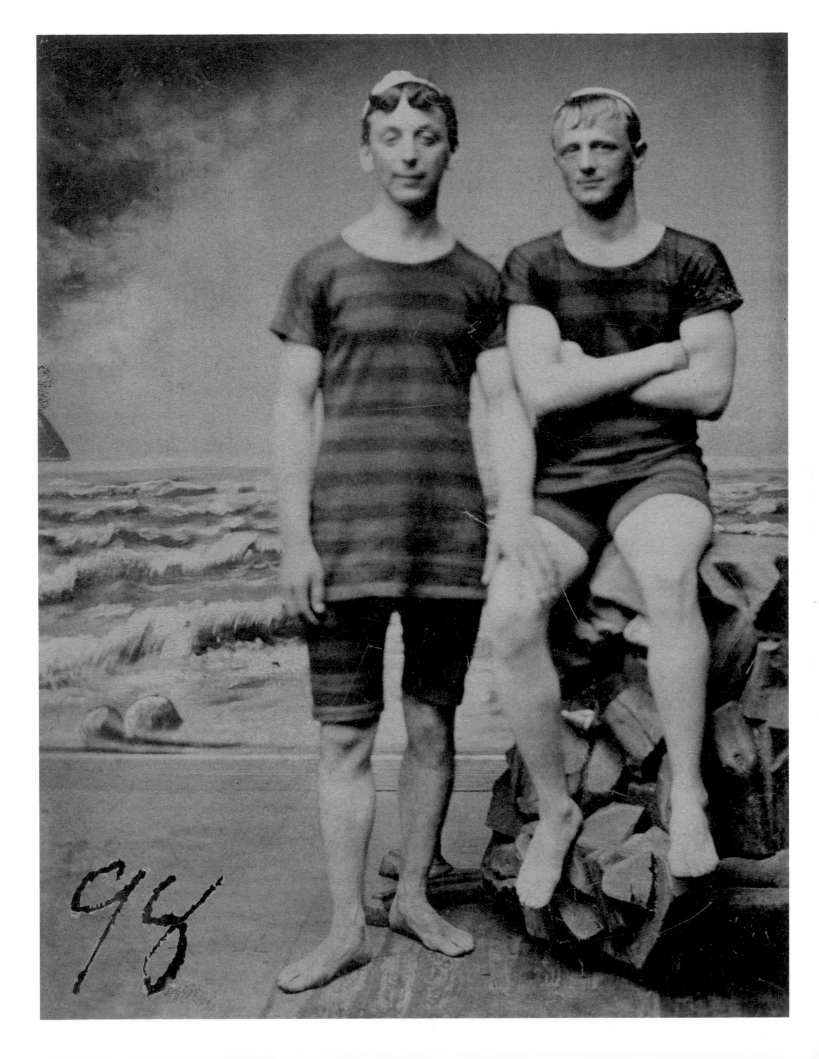

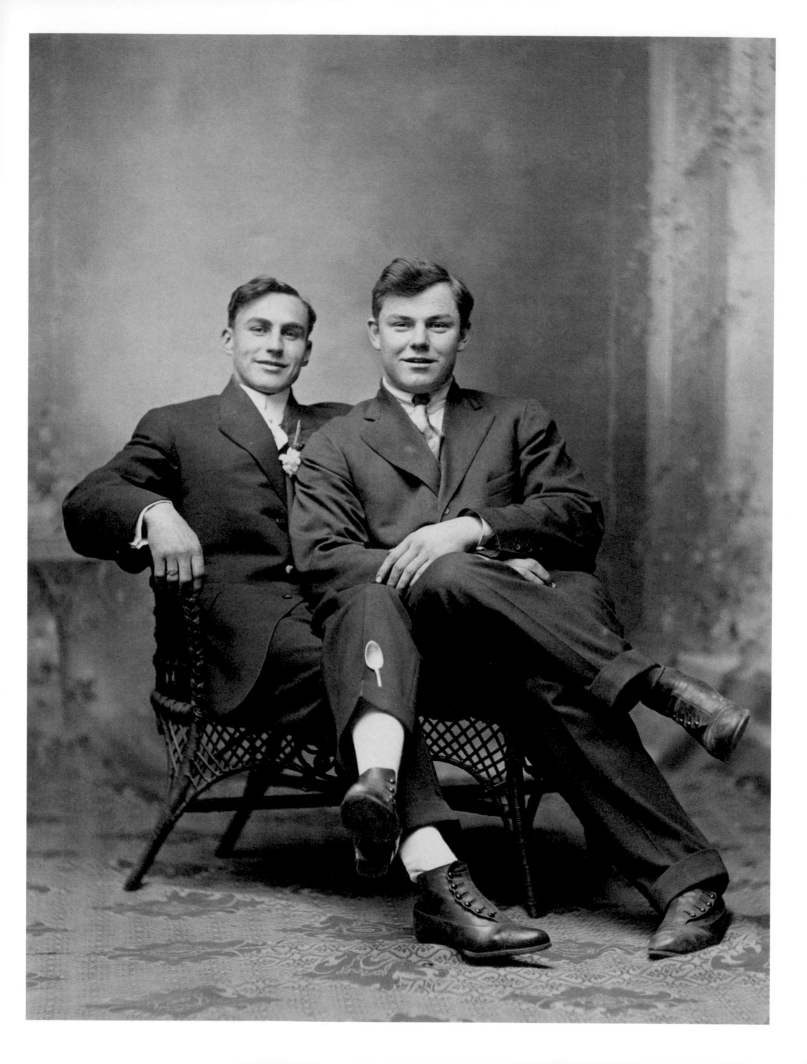

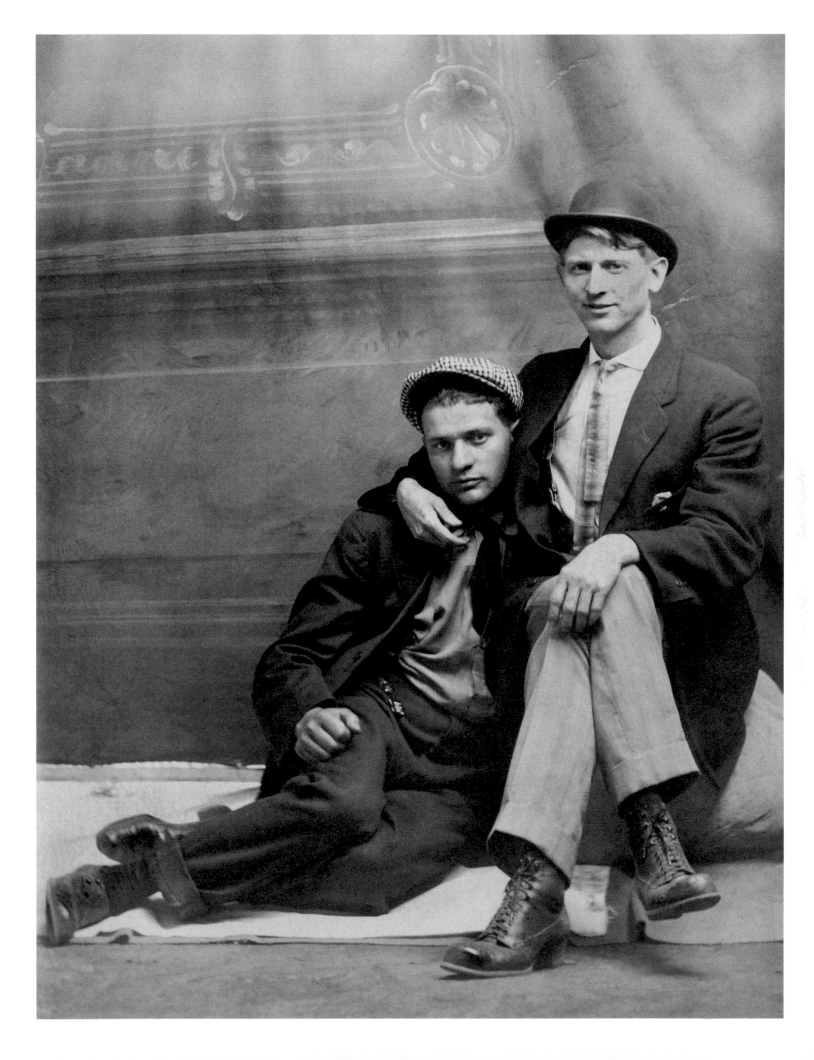

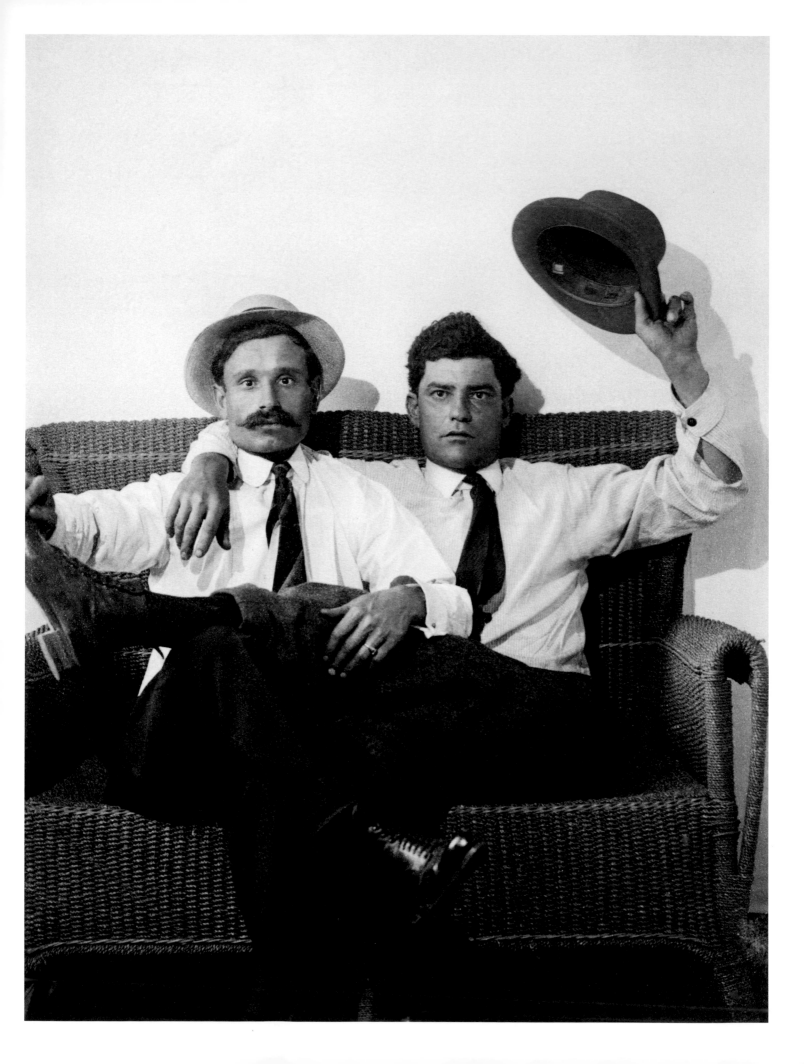

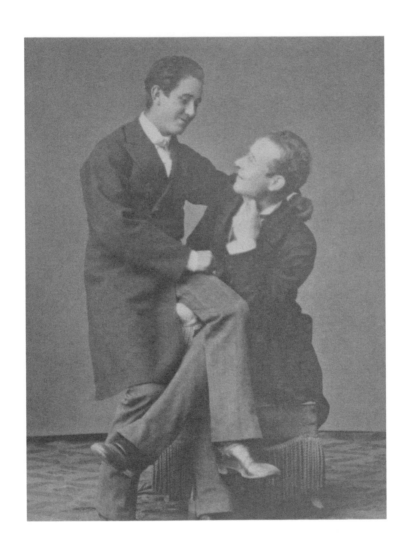

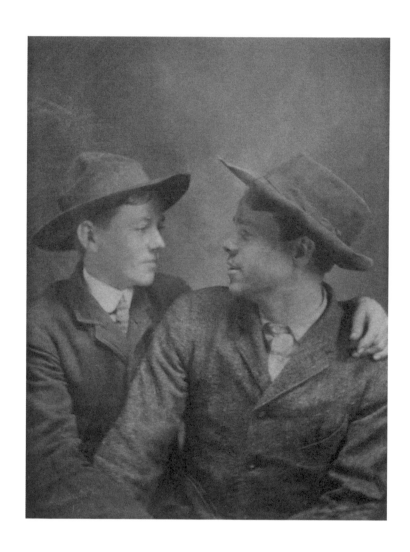

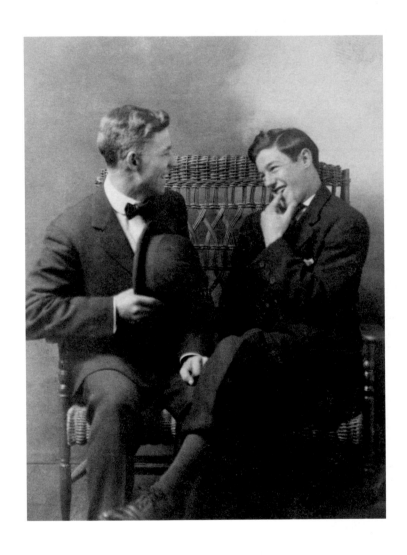

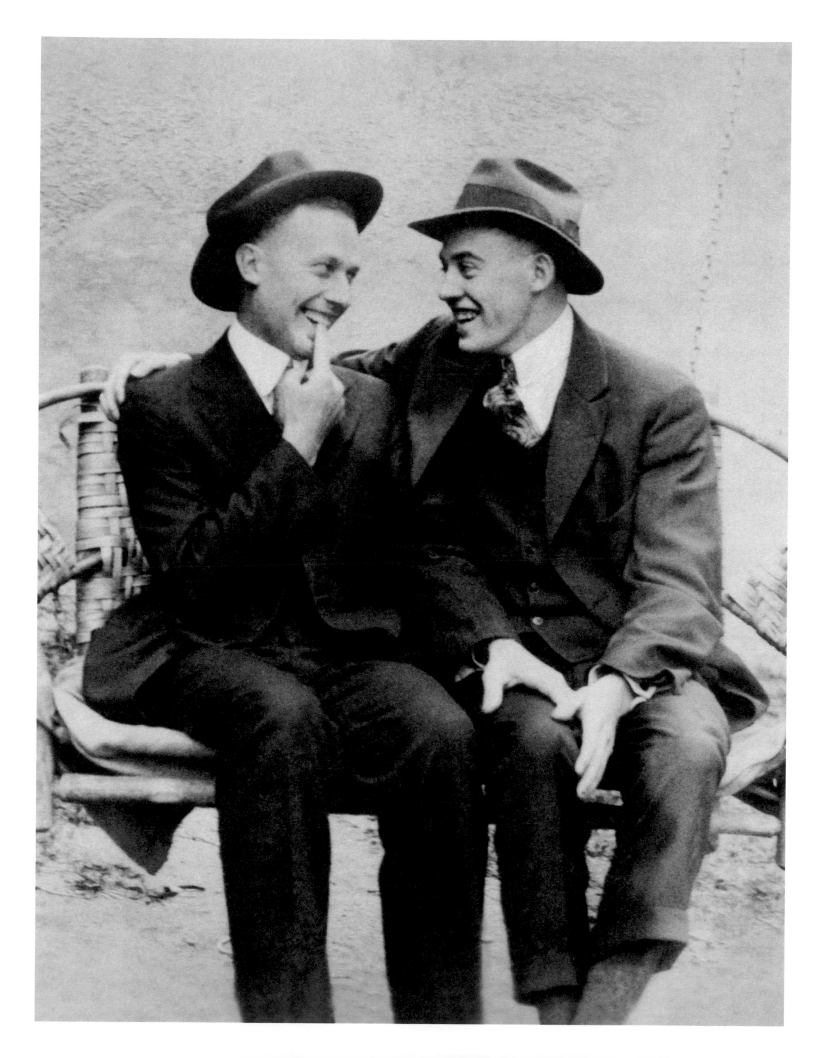

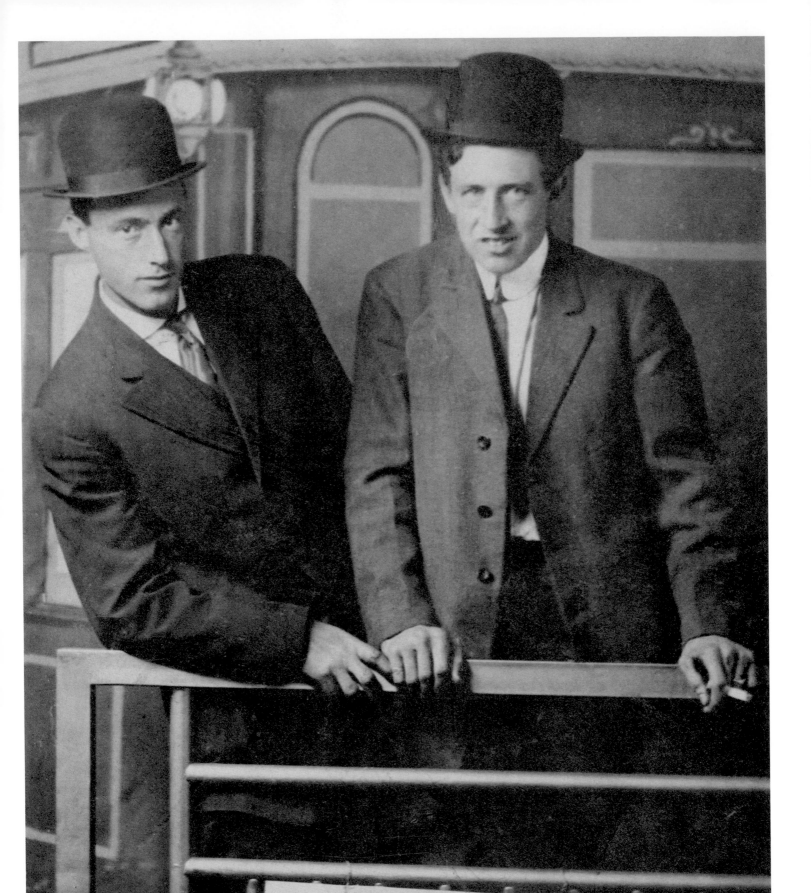

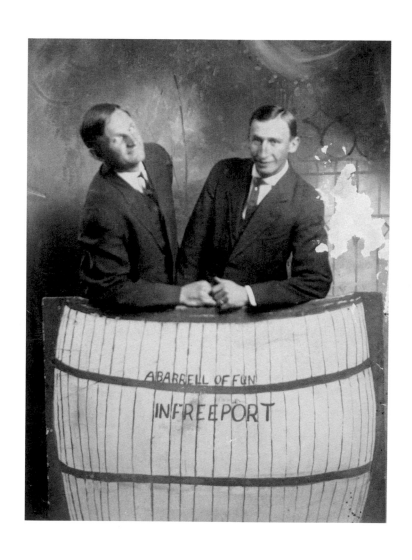

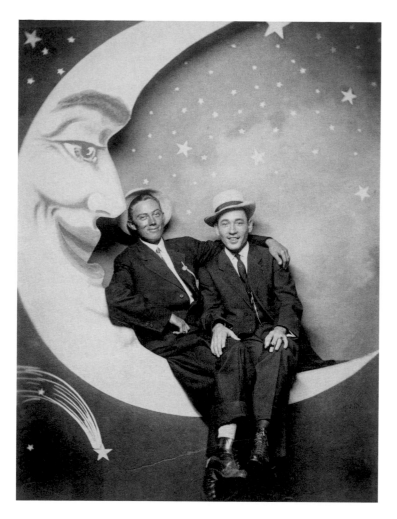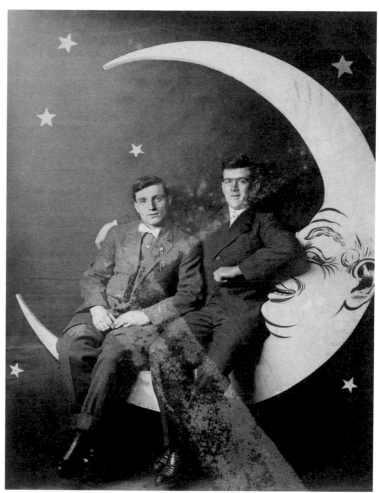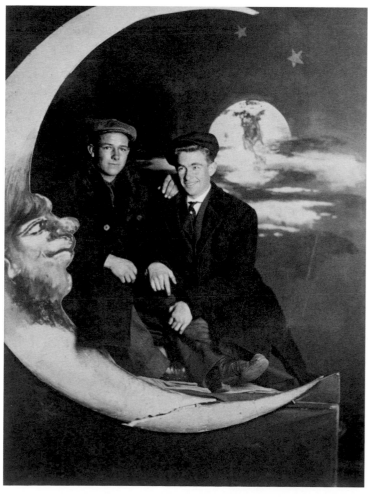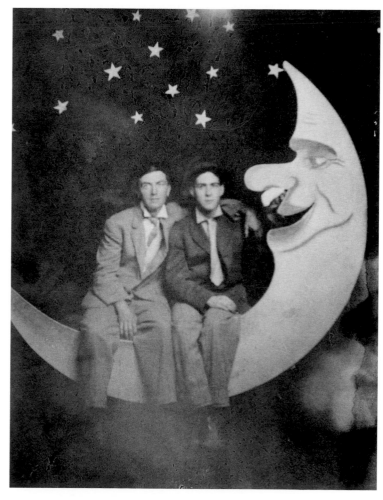

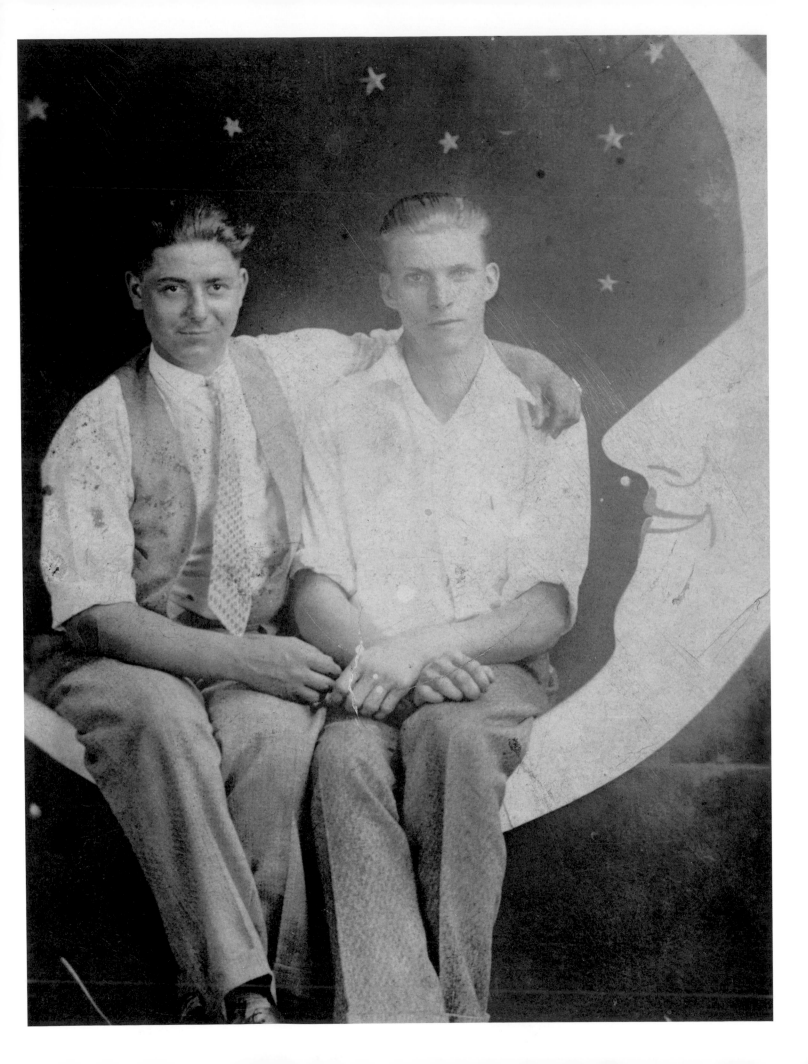

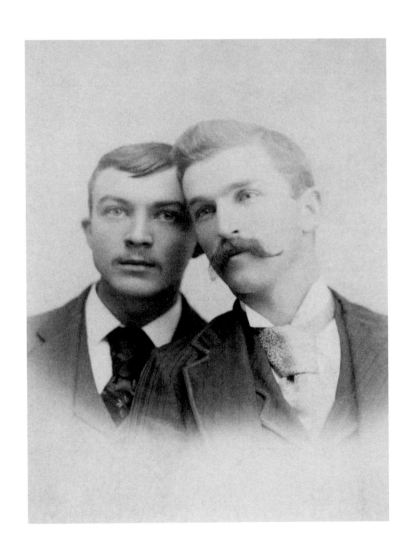

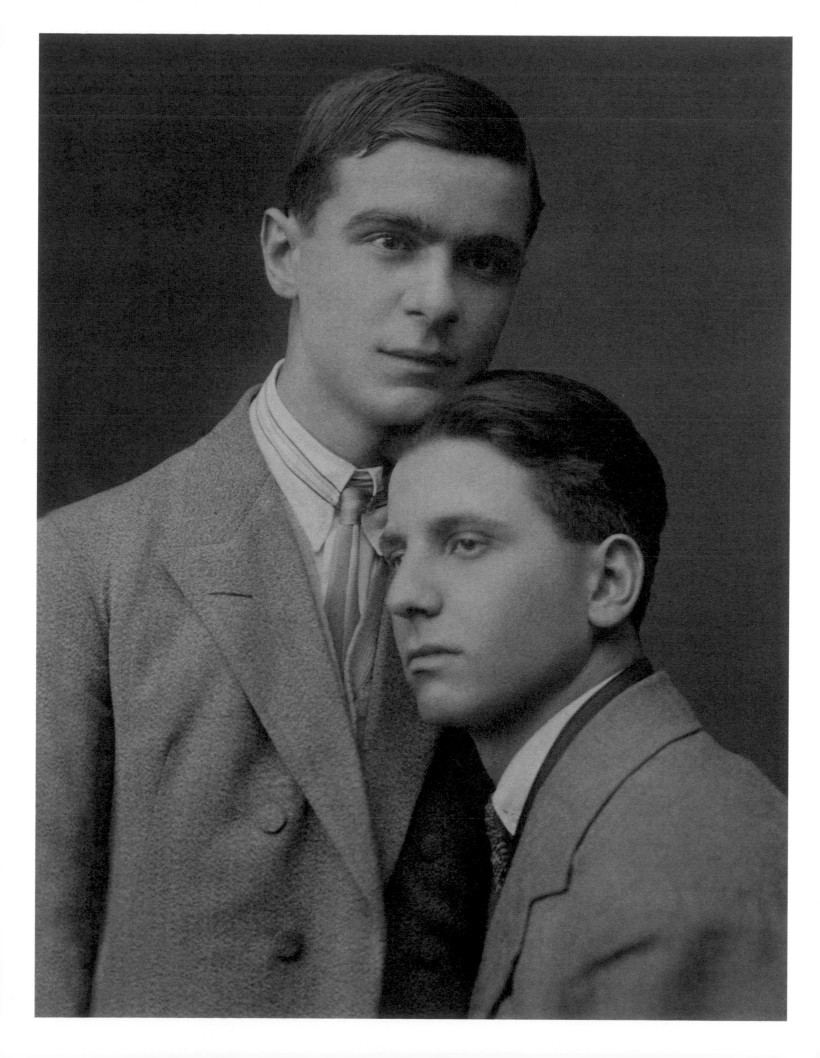

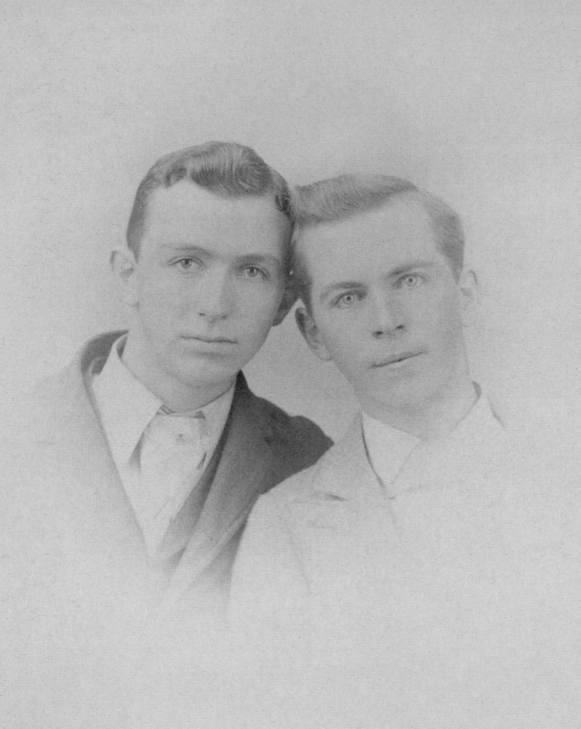

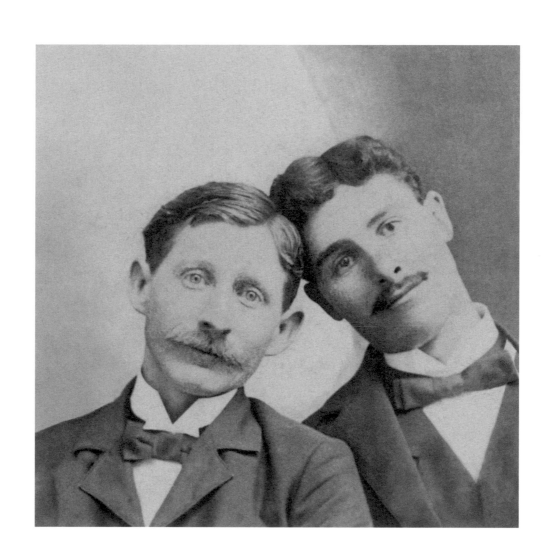

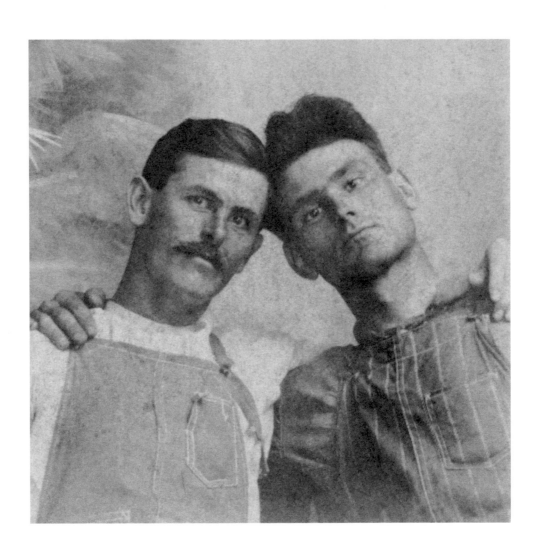

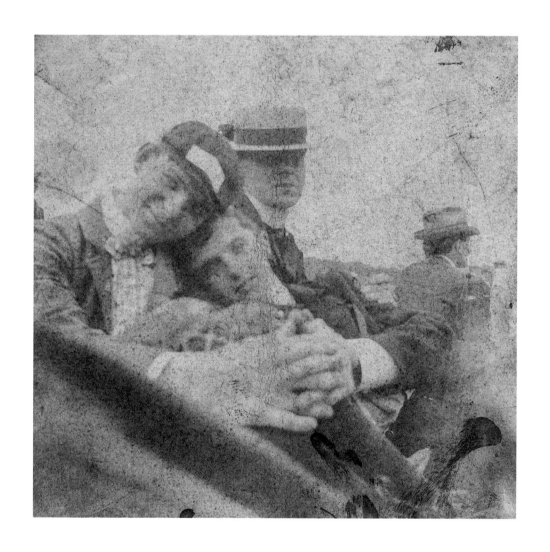

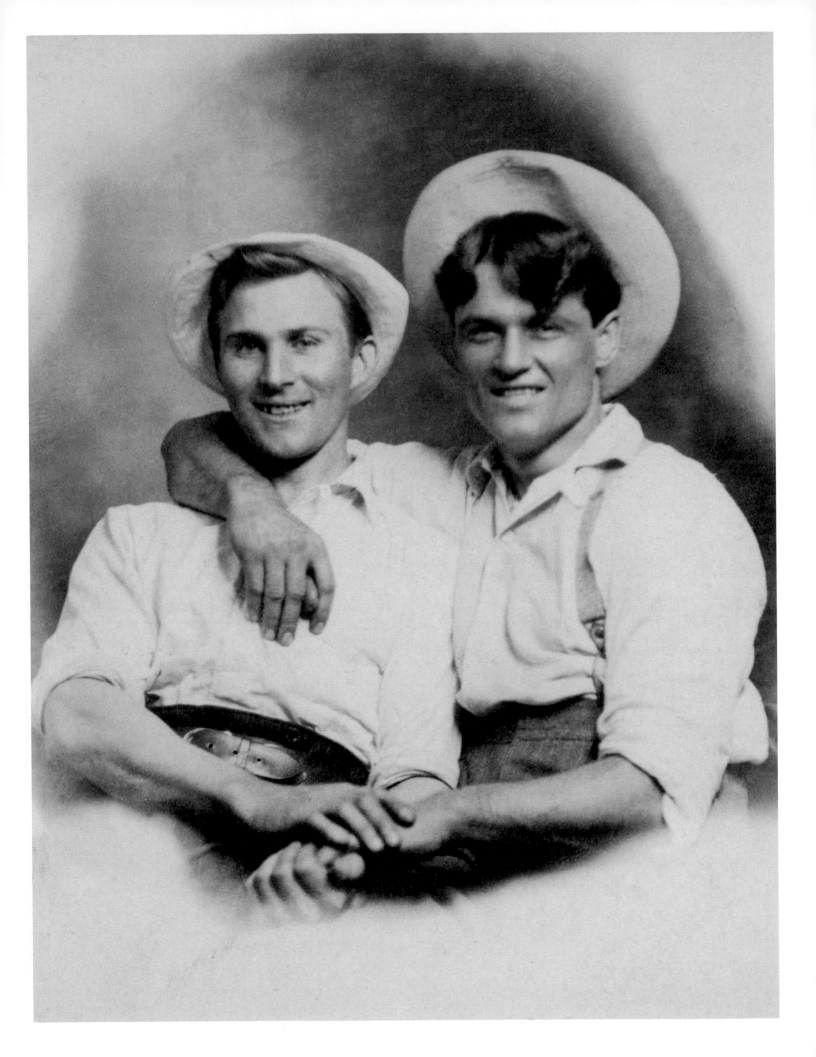

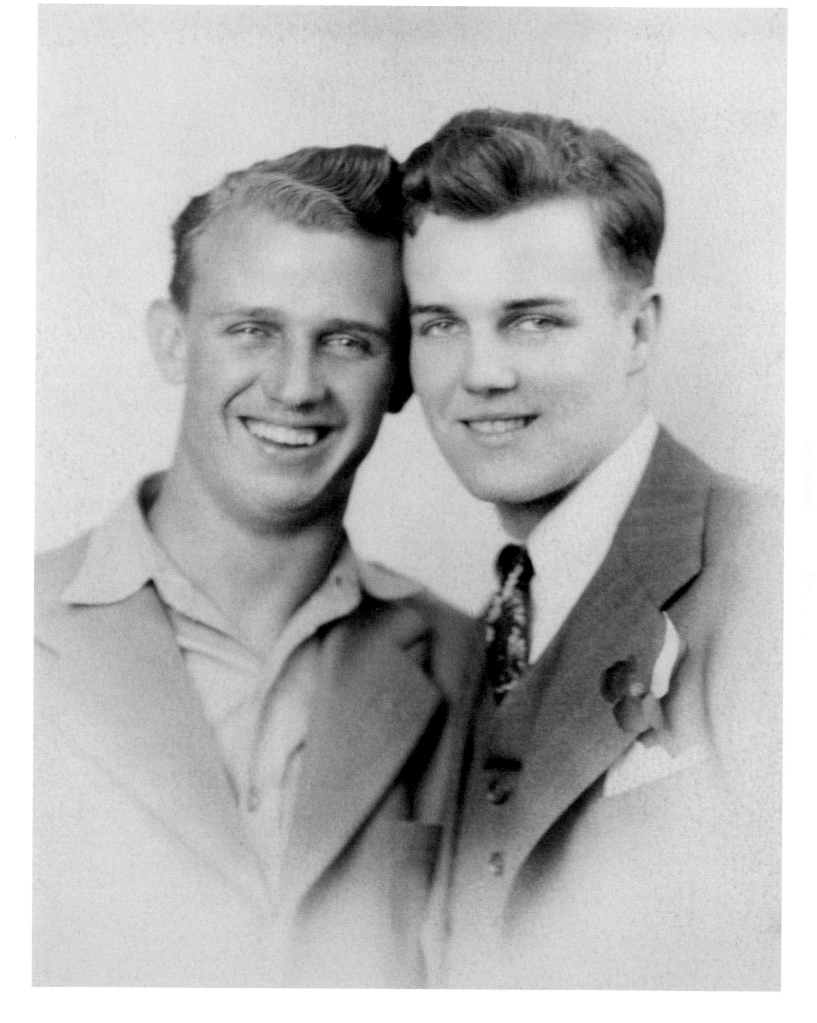

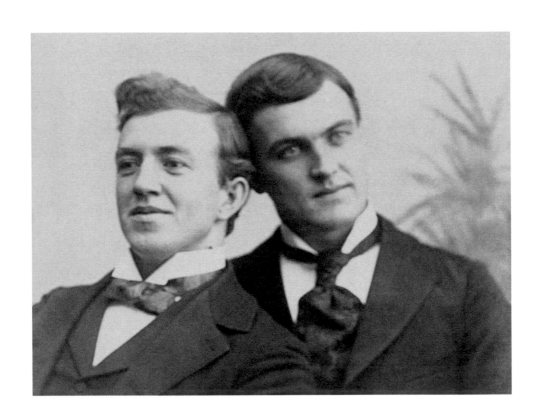

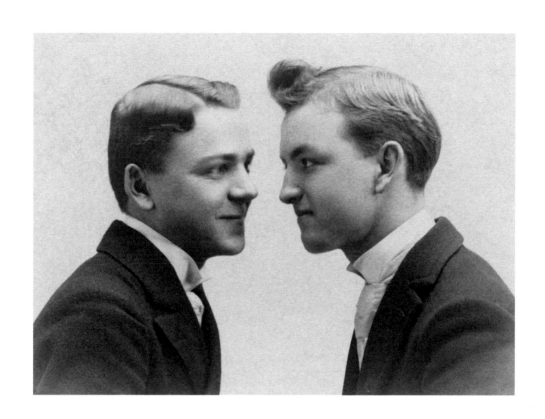

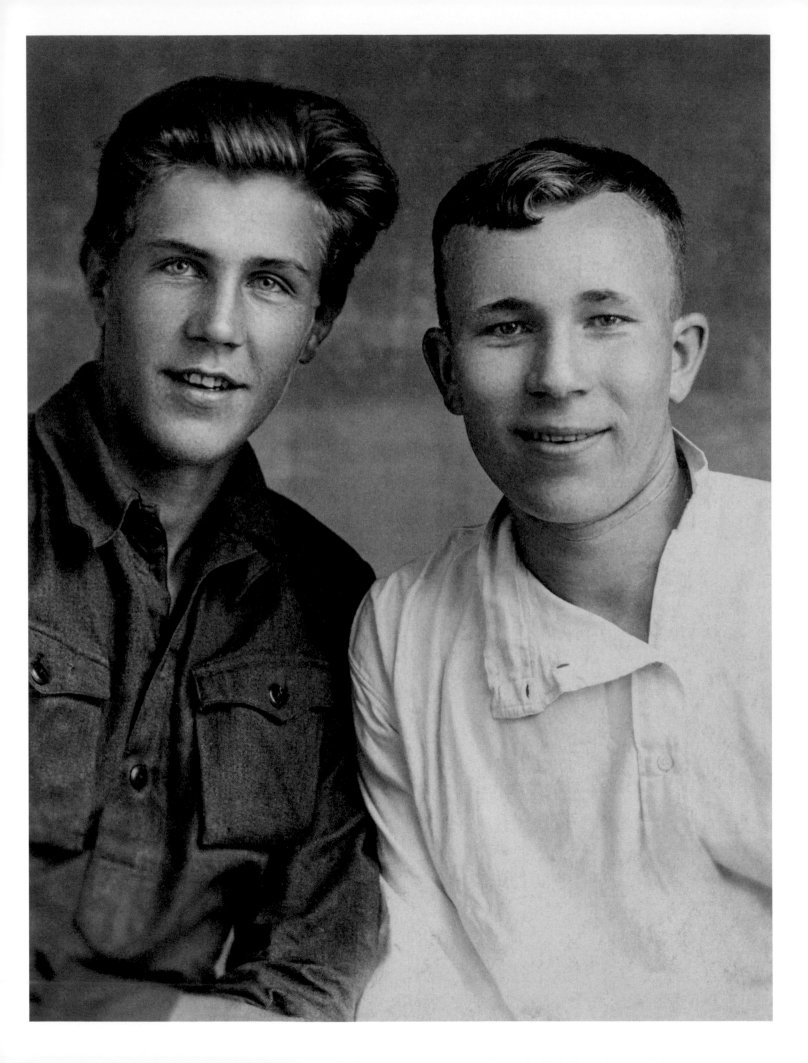

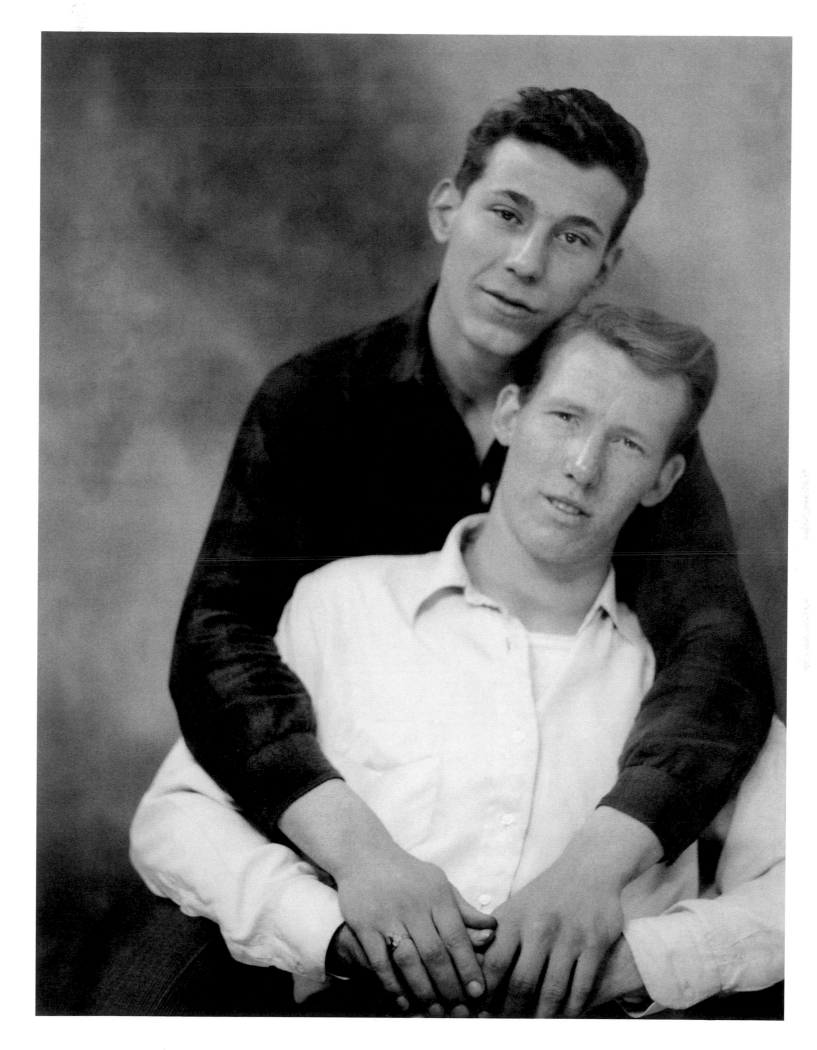

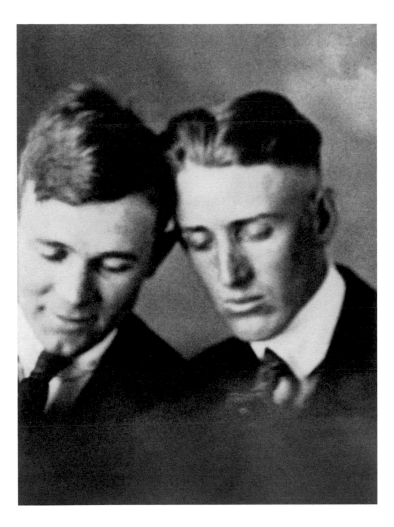

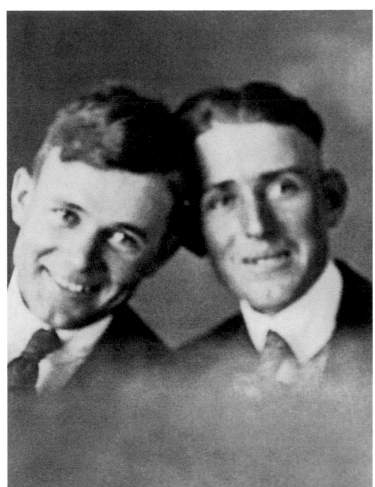

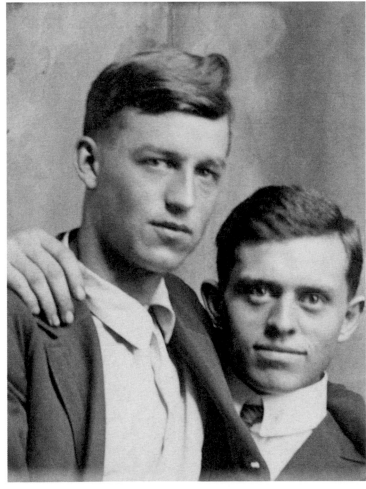

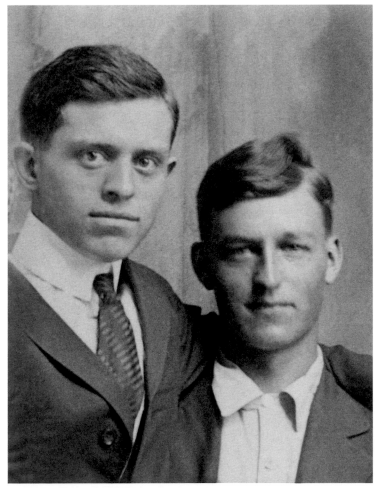

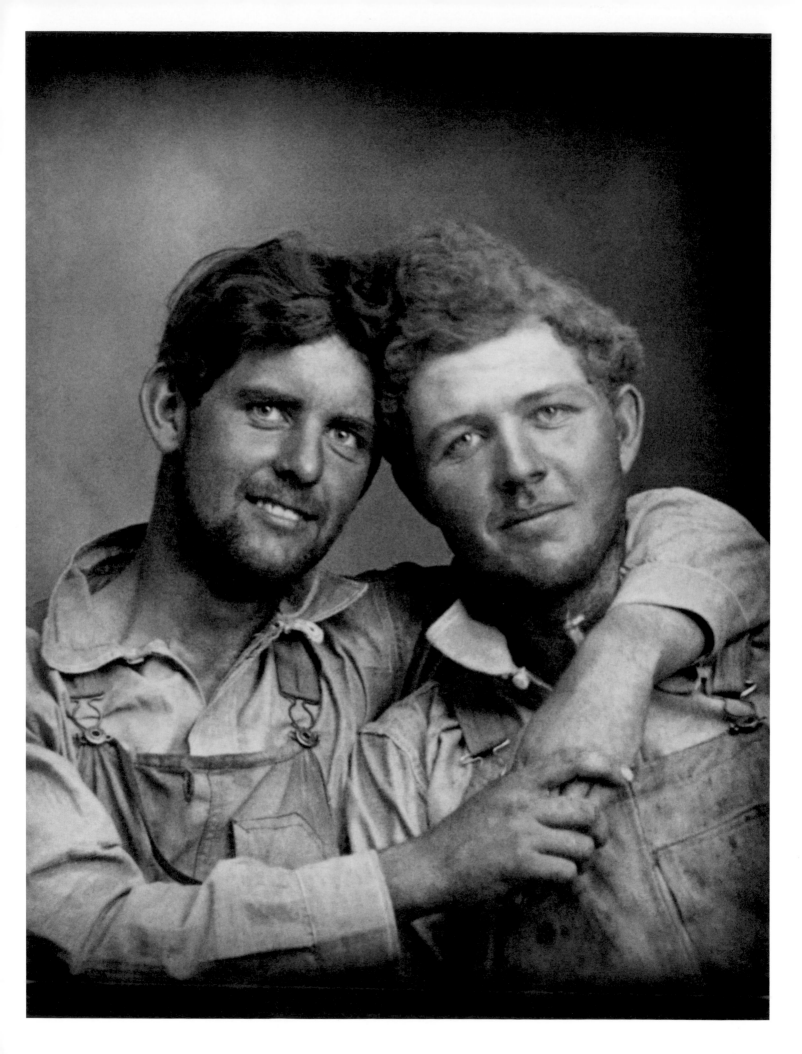

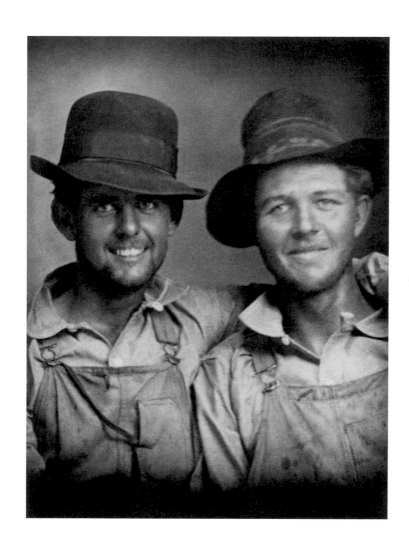

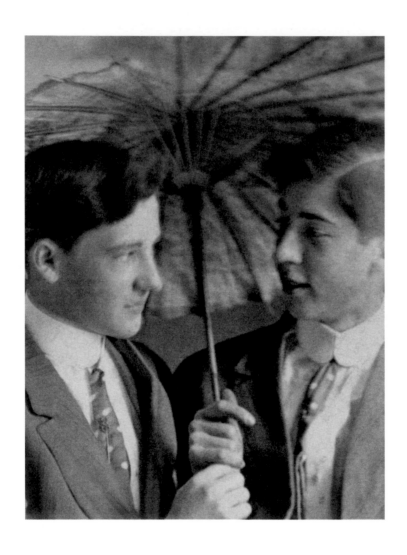

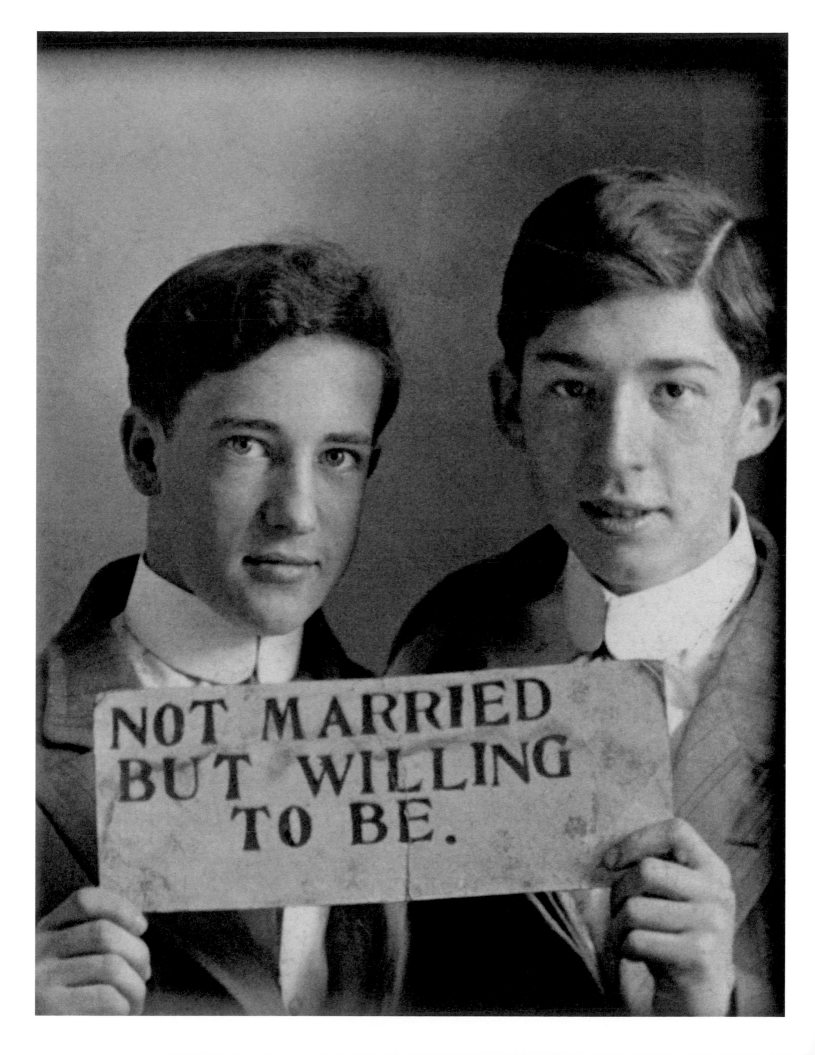

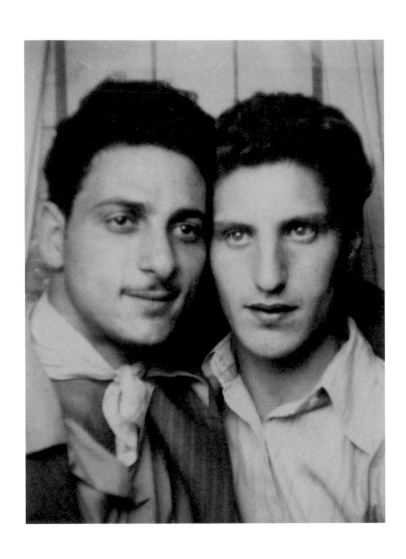

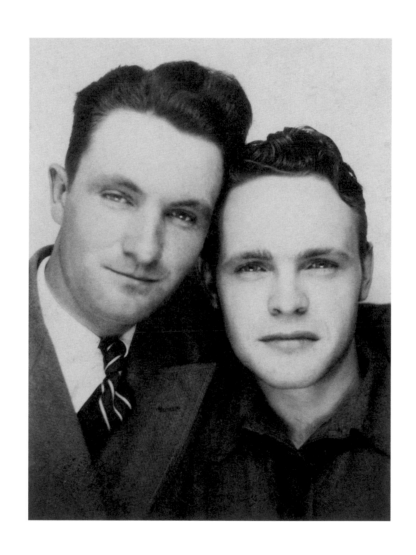

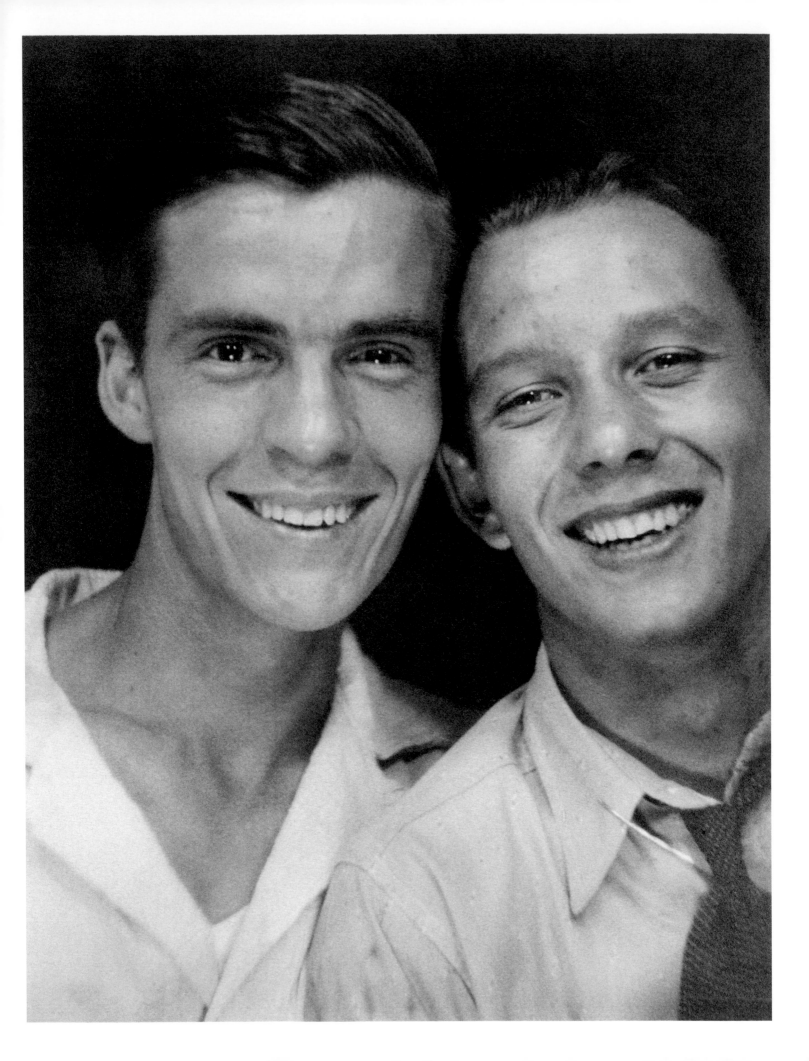

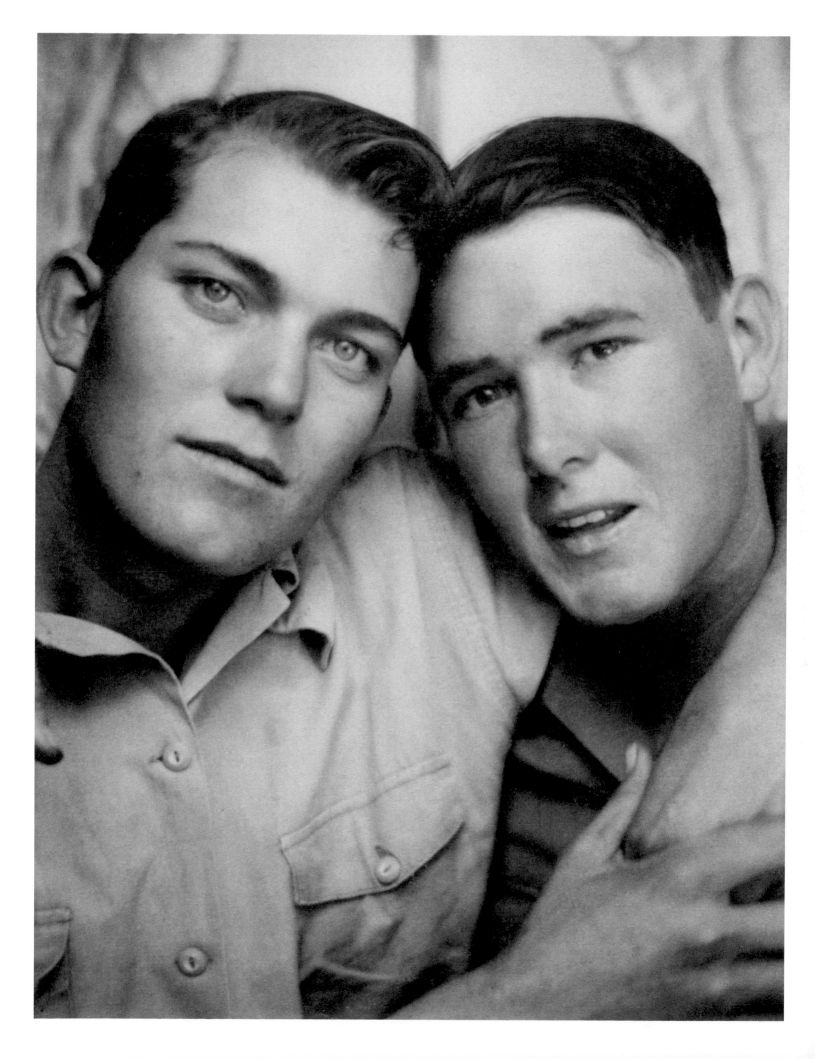

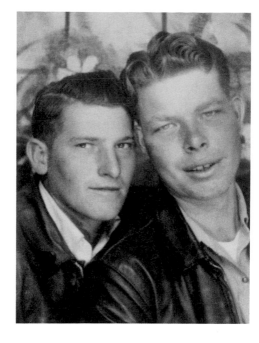
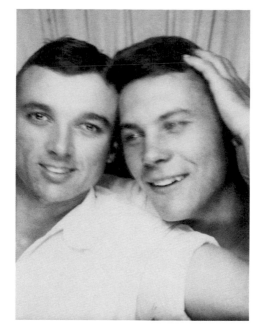
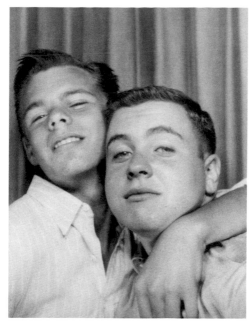
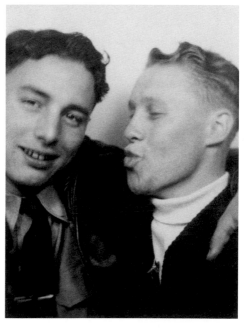
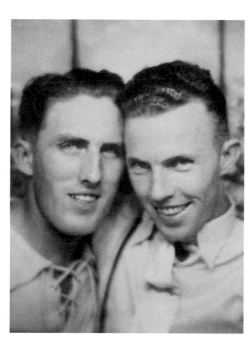
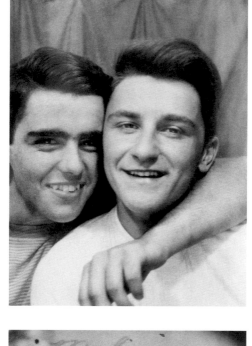
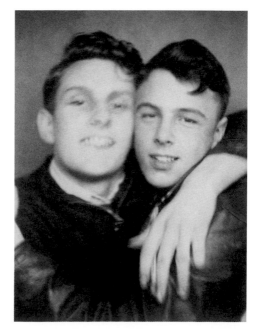
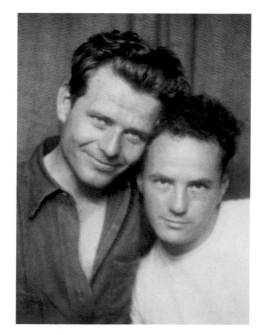
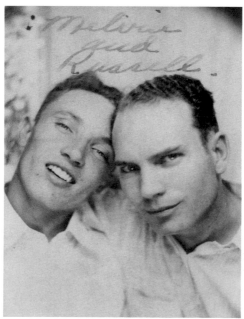

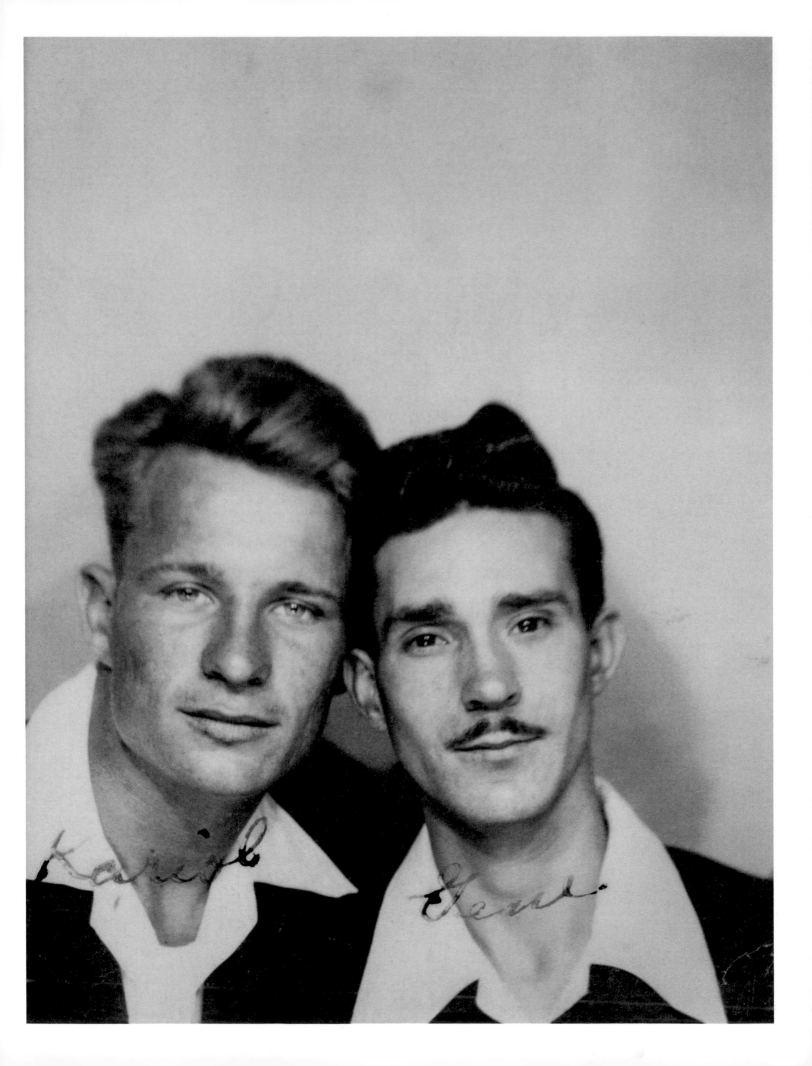

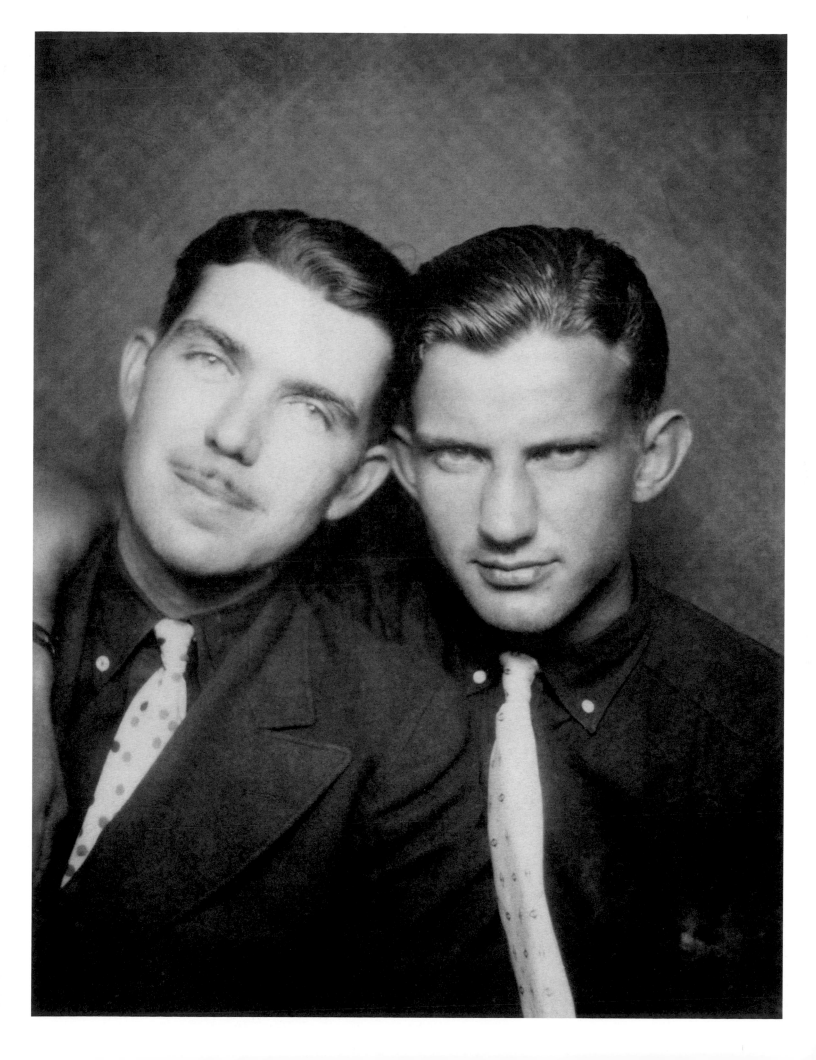

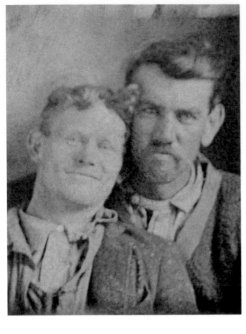 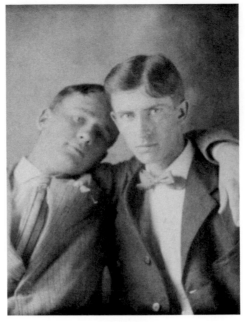 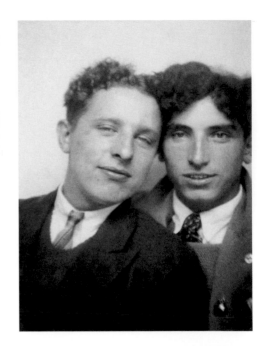

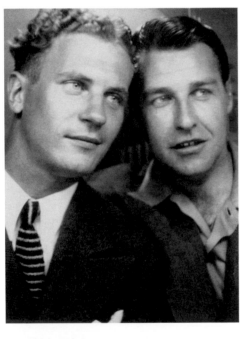 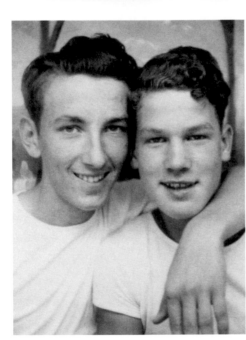 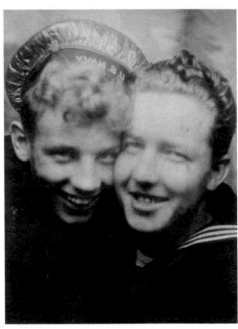

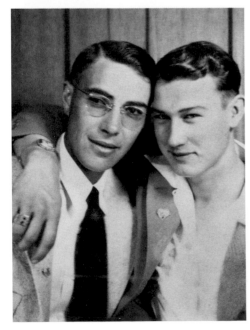 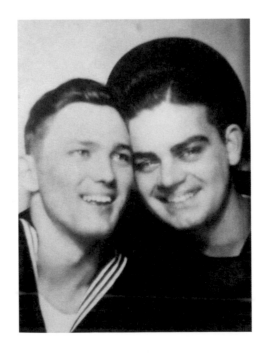 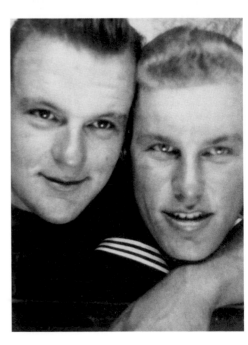

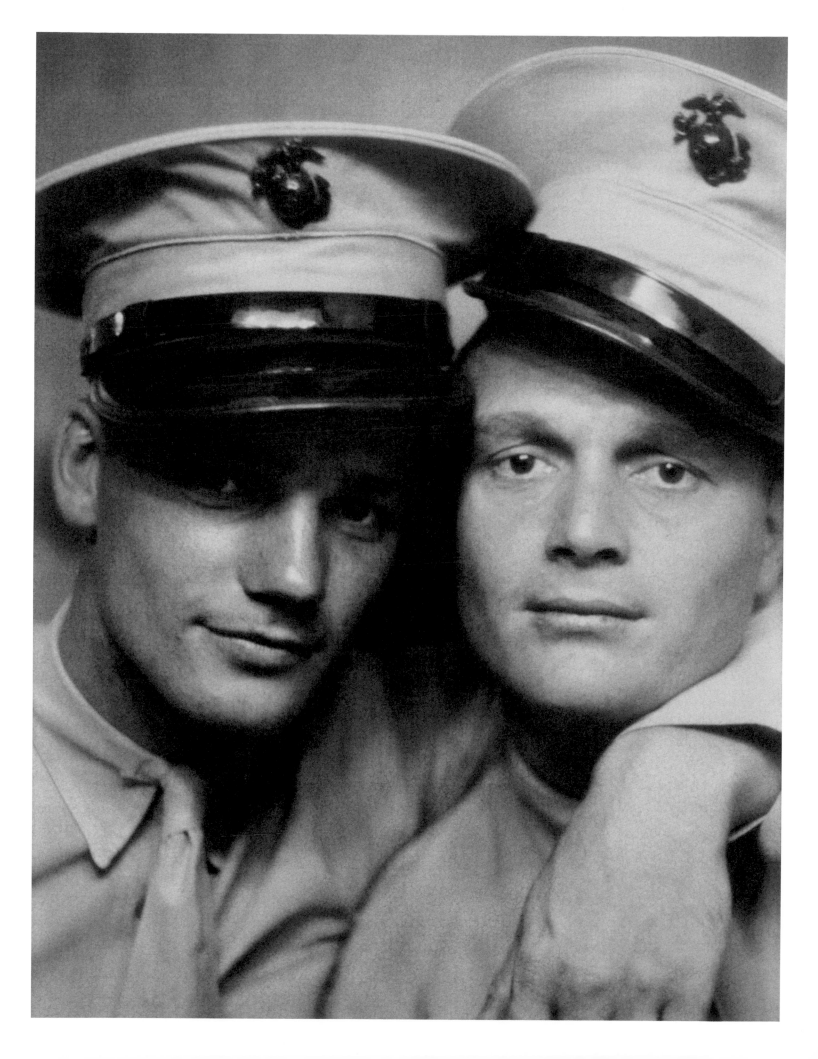

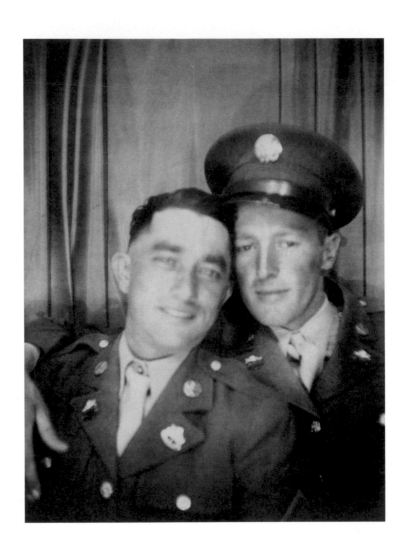

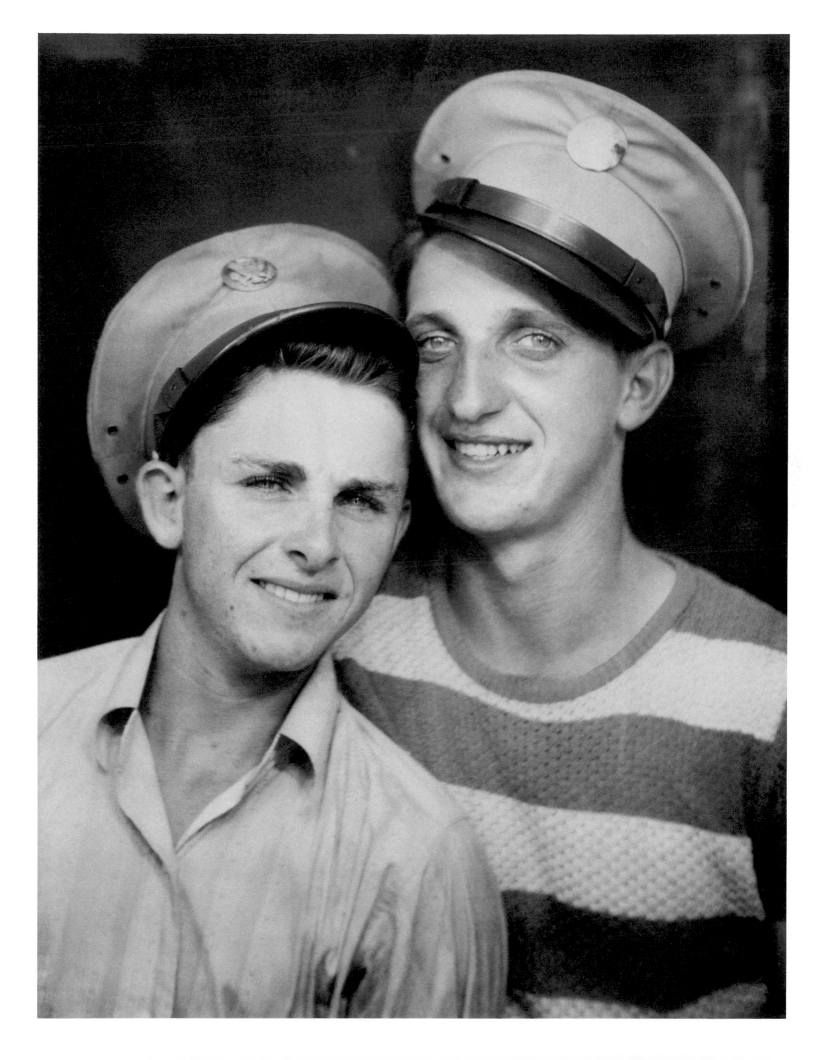

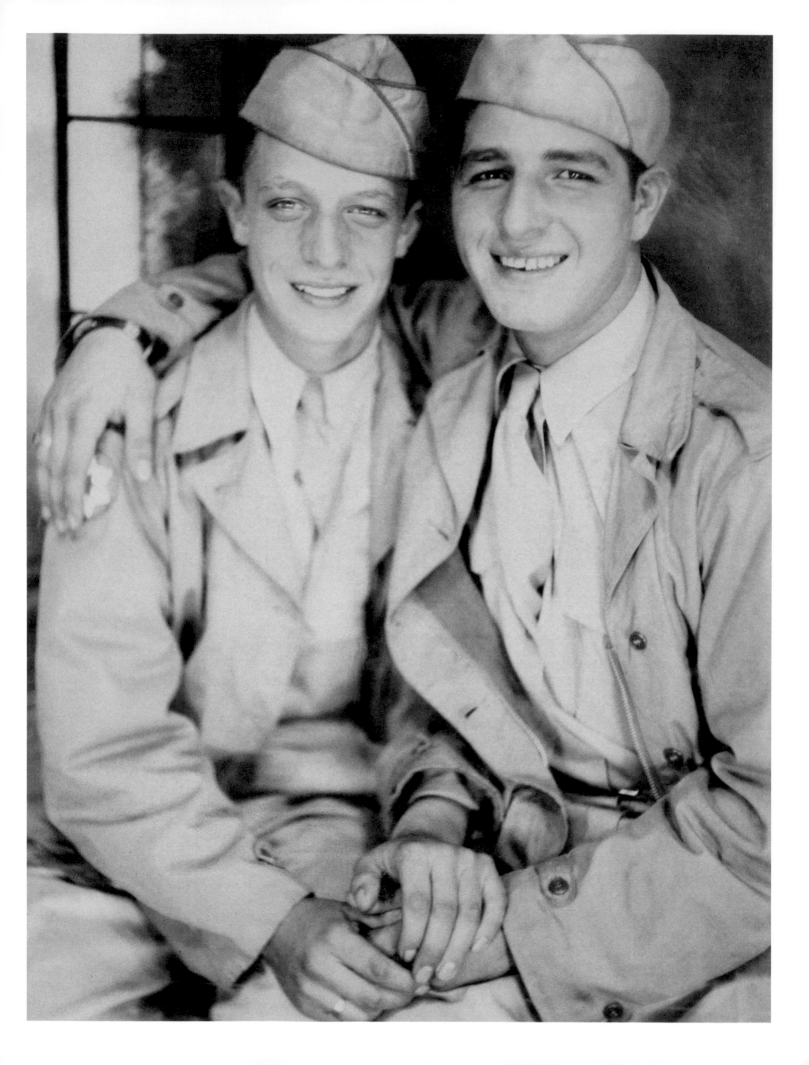

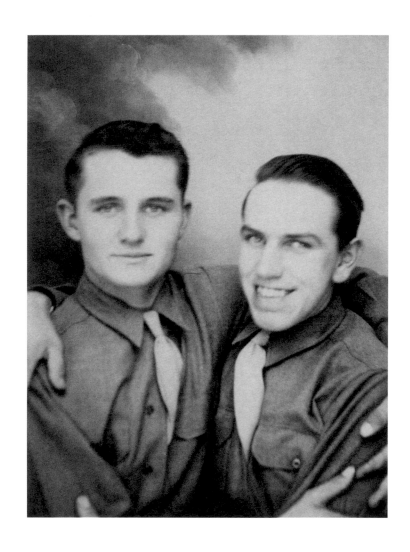

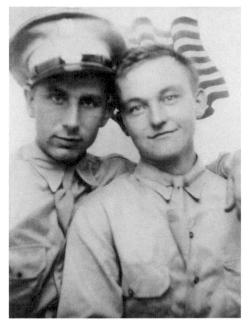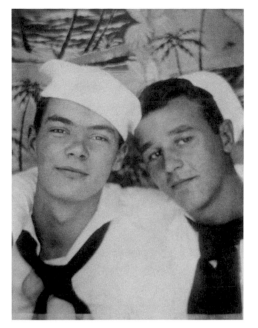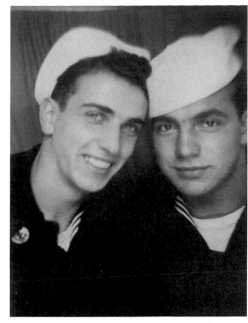
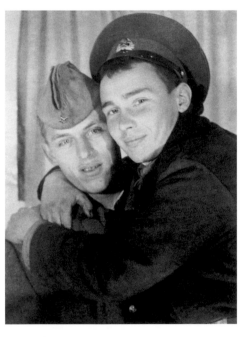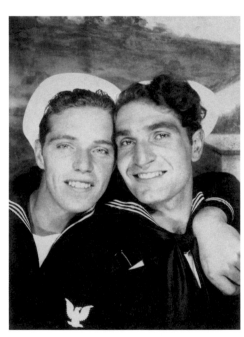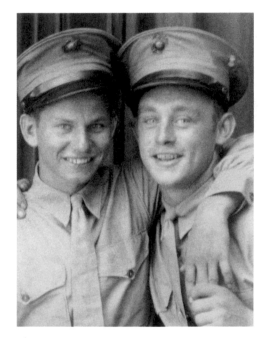
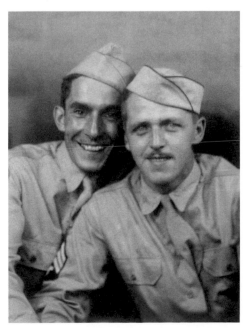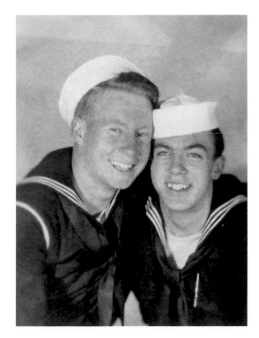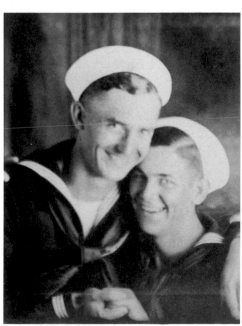

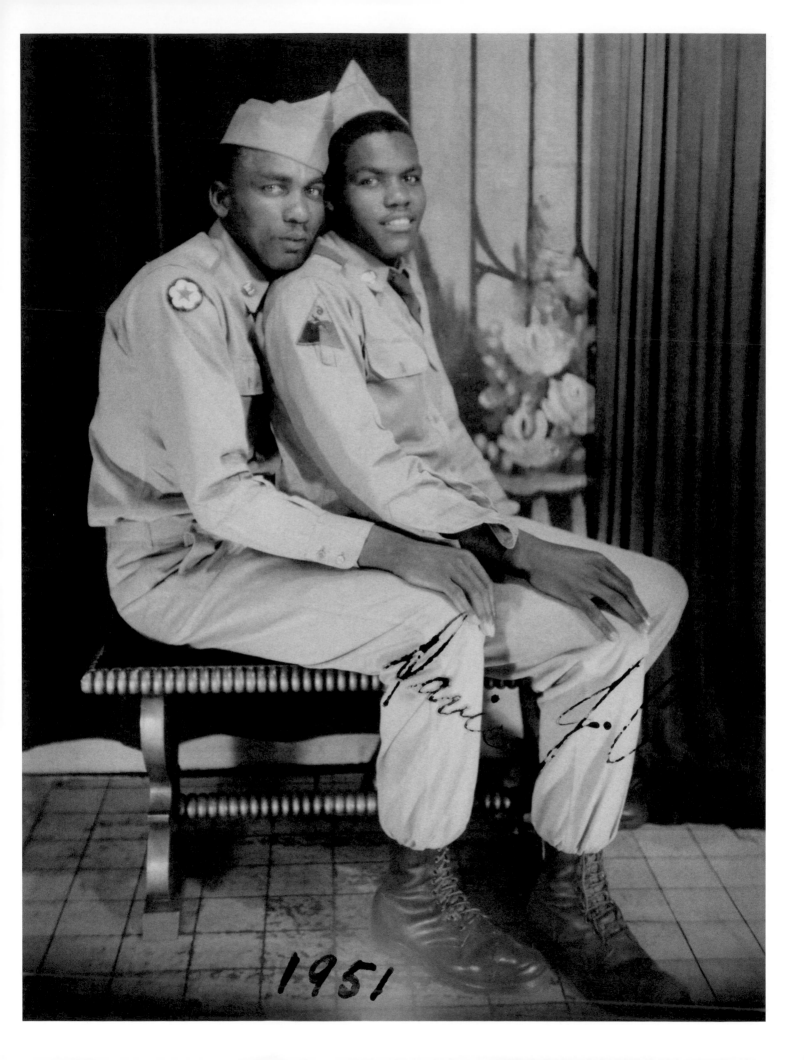

1951

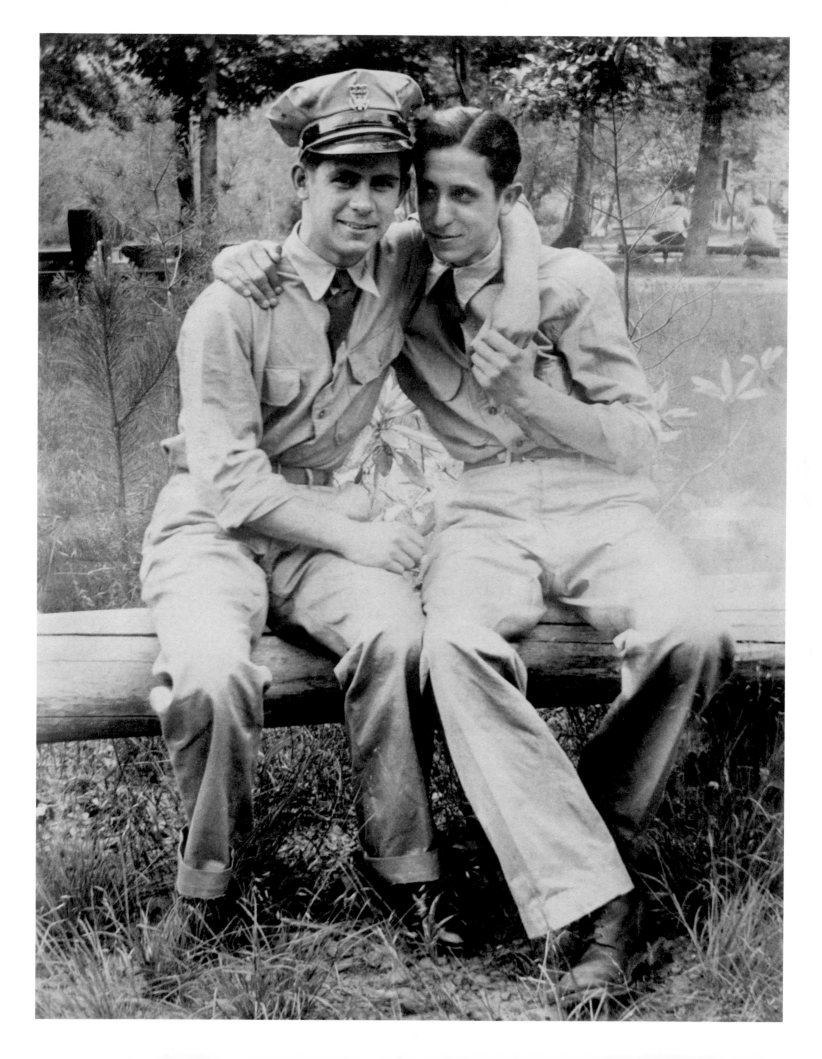

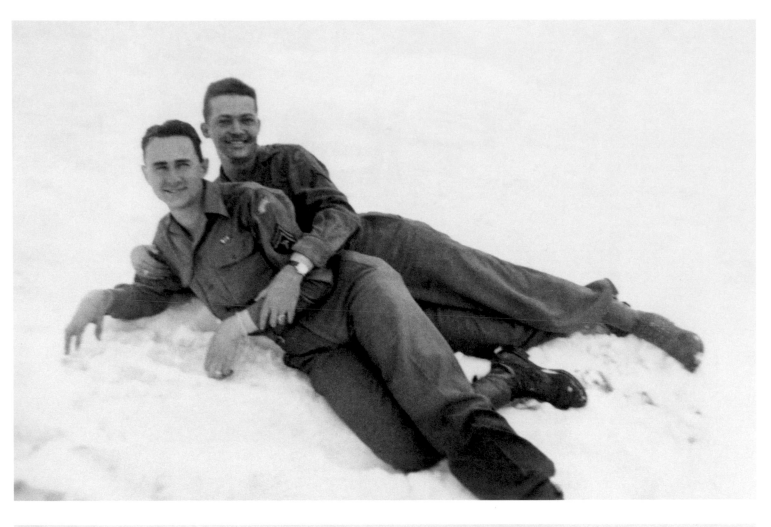

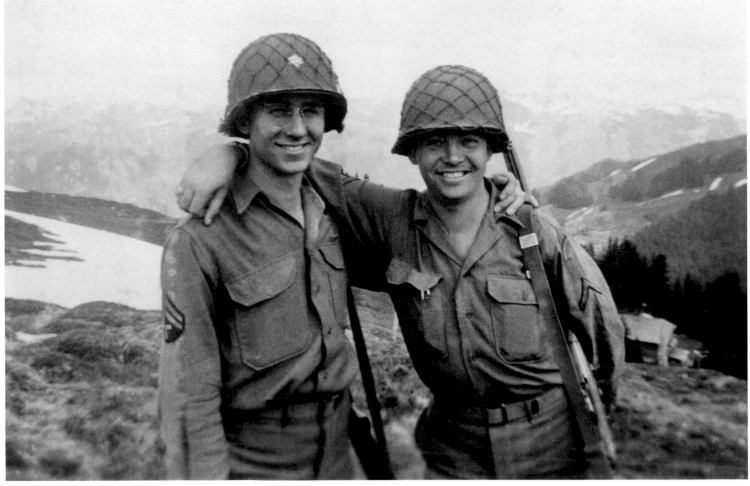

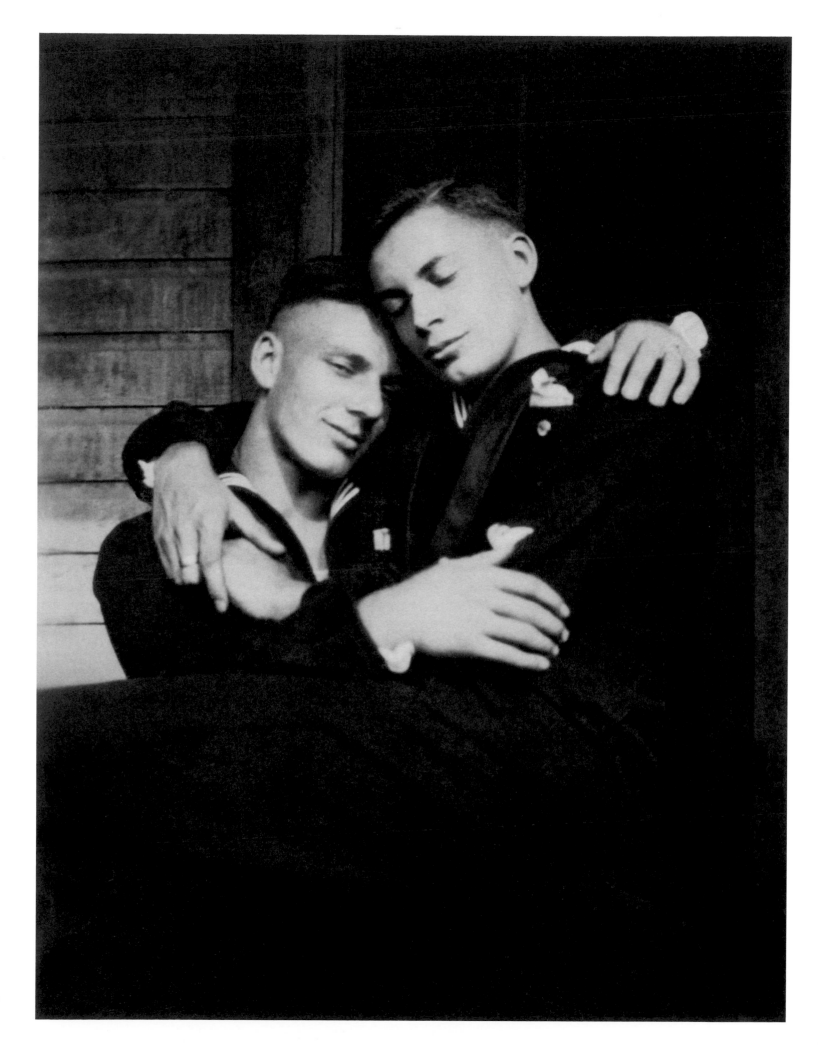

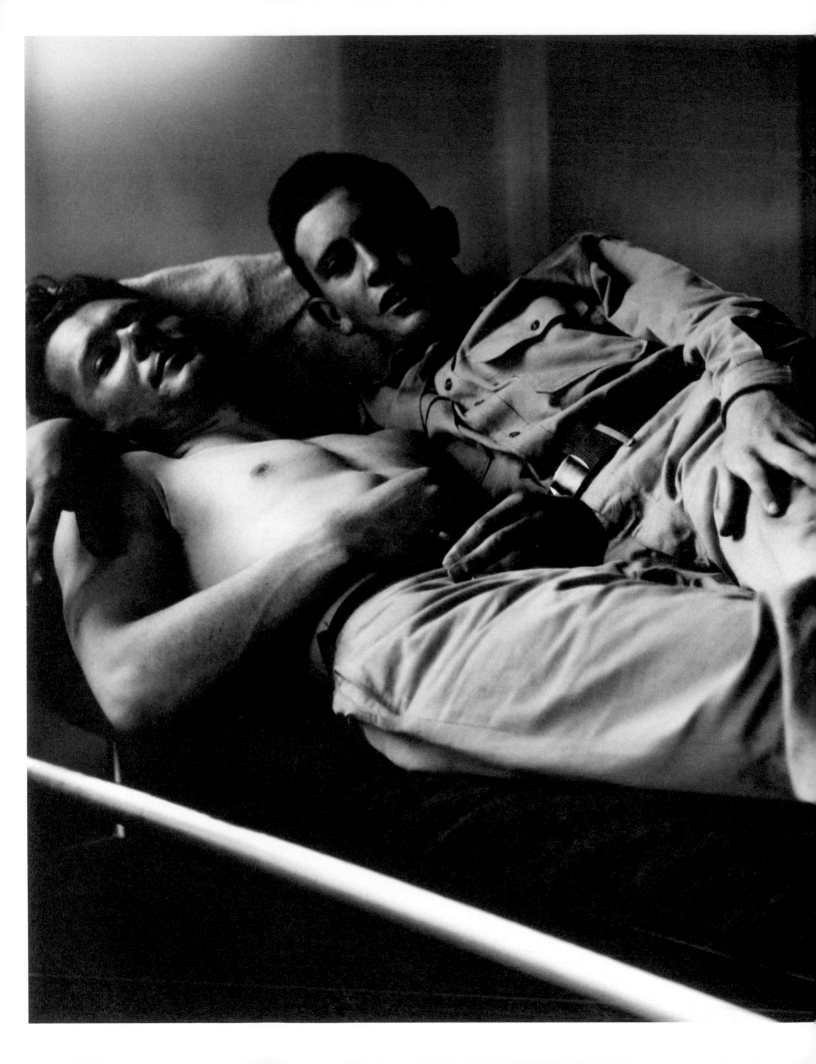

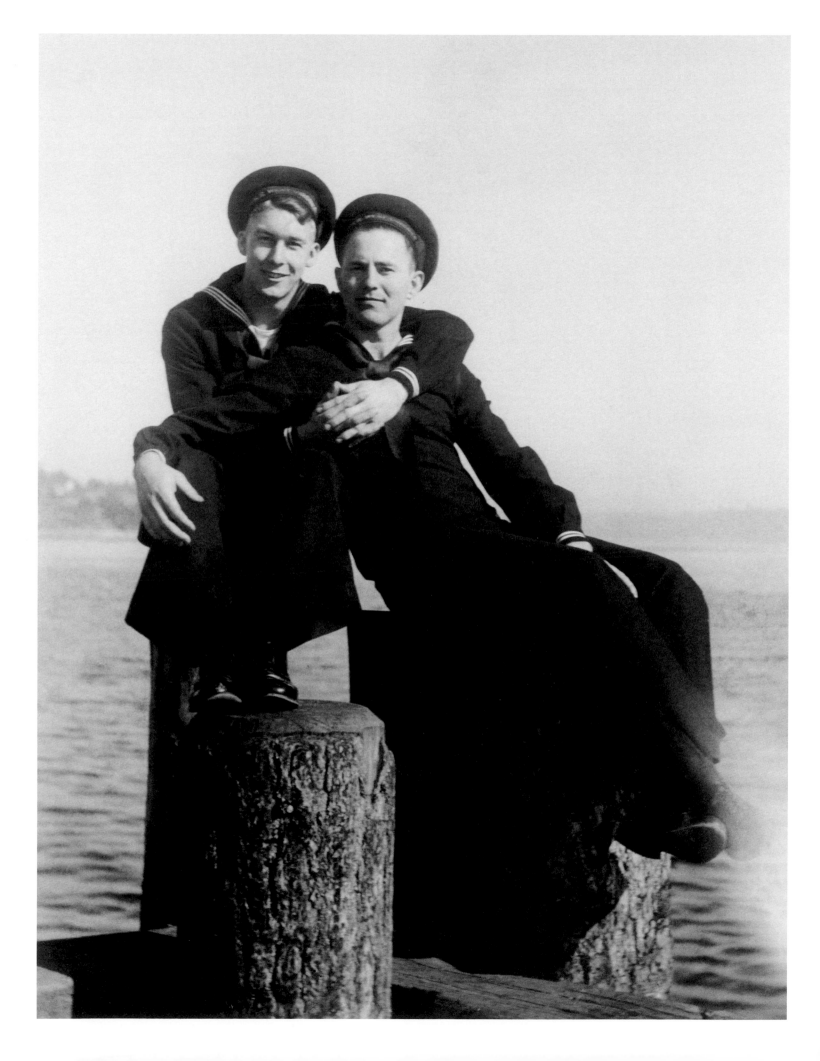

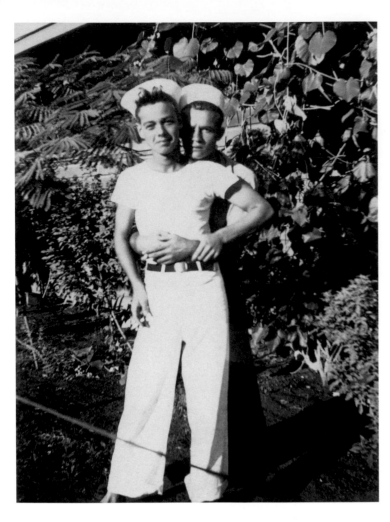
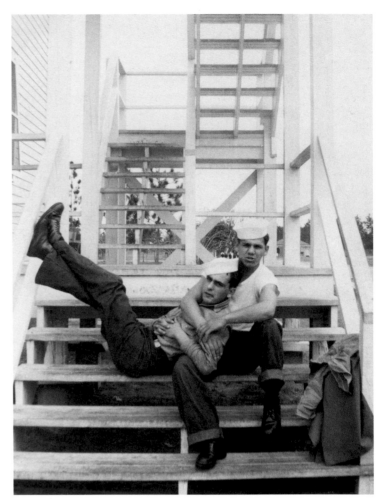
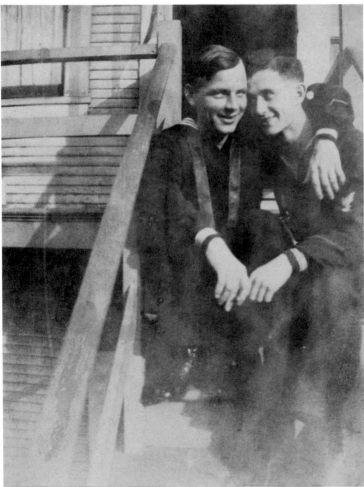
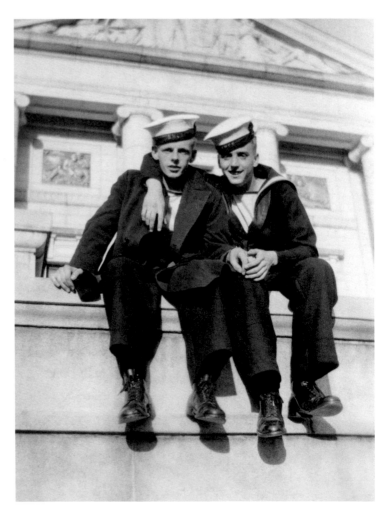

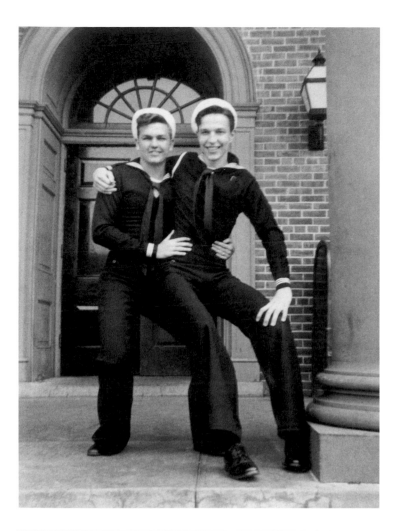
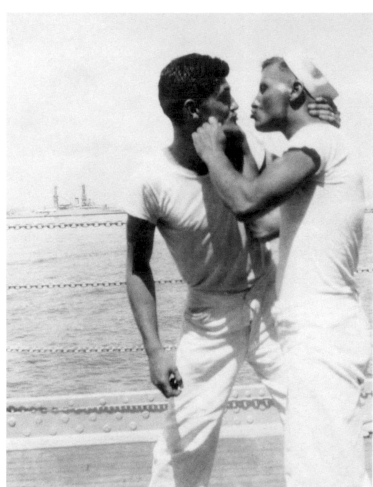
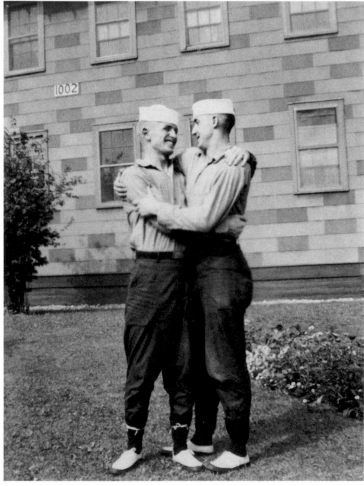
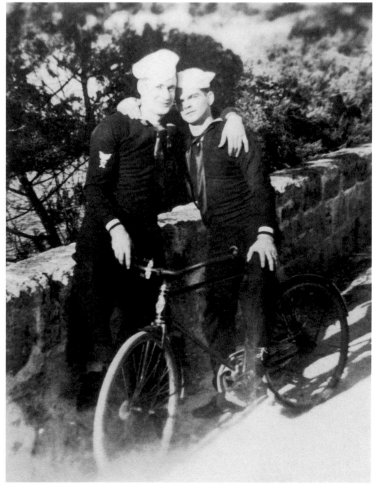

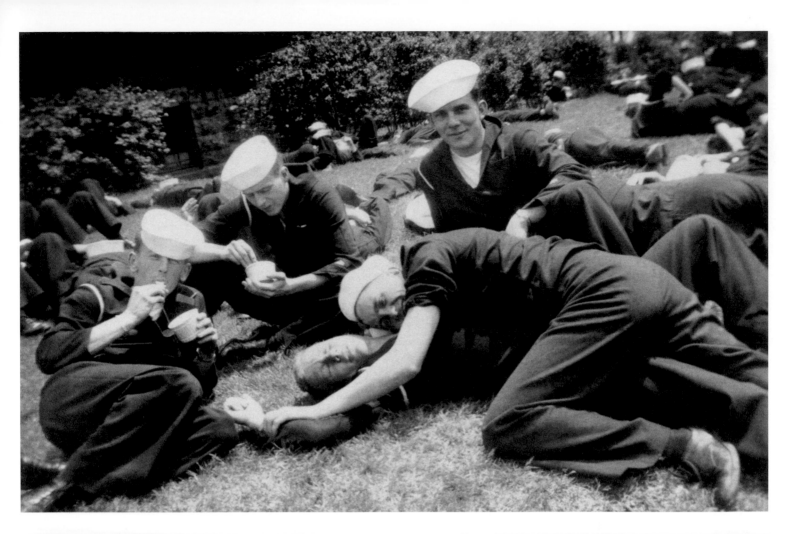

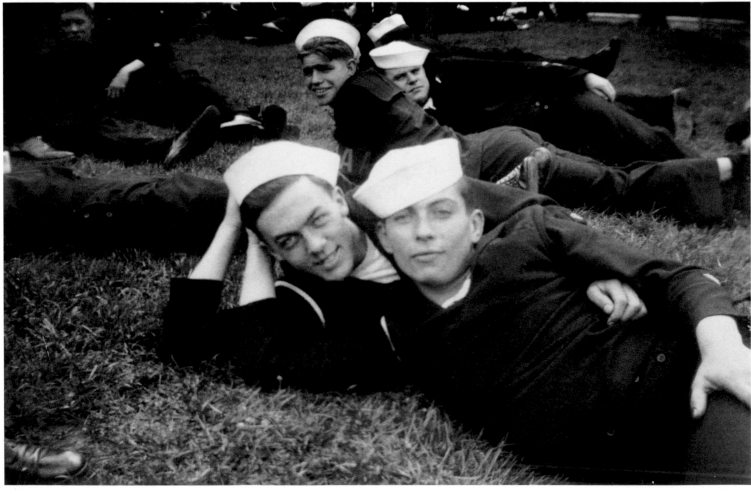

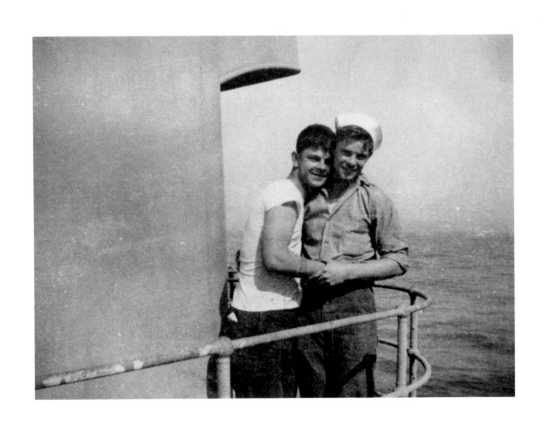

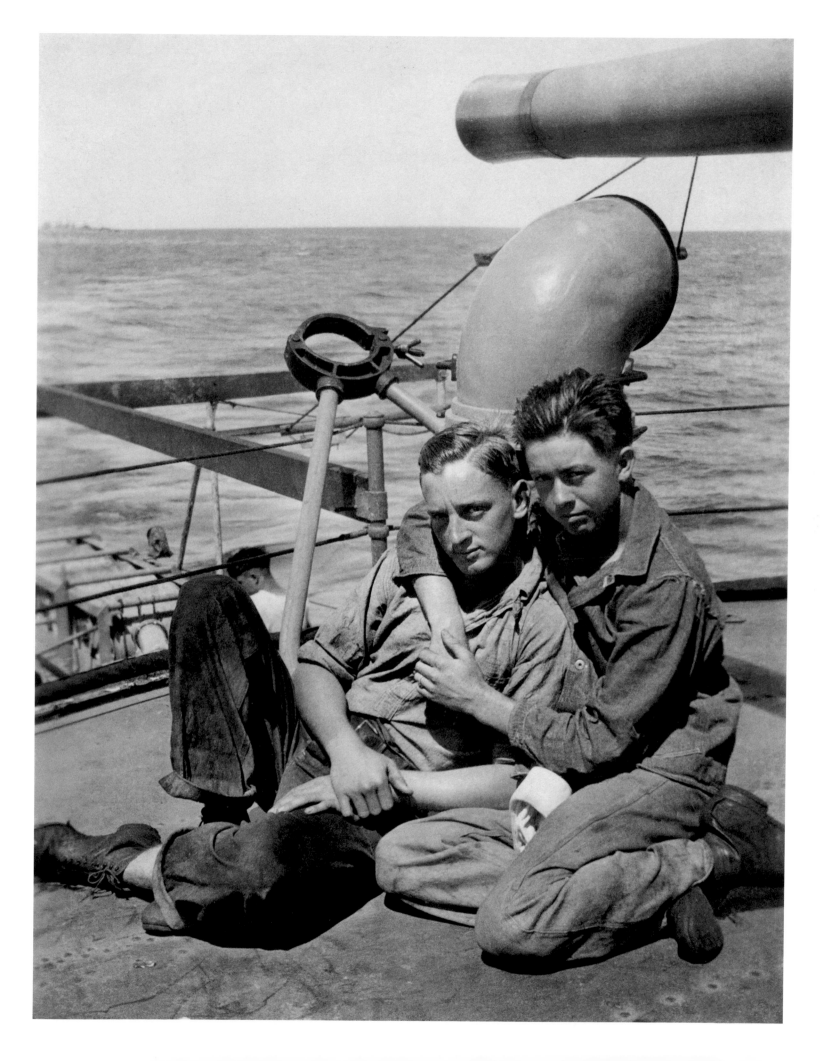

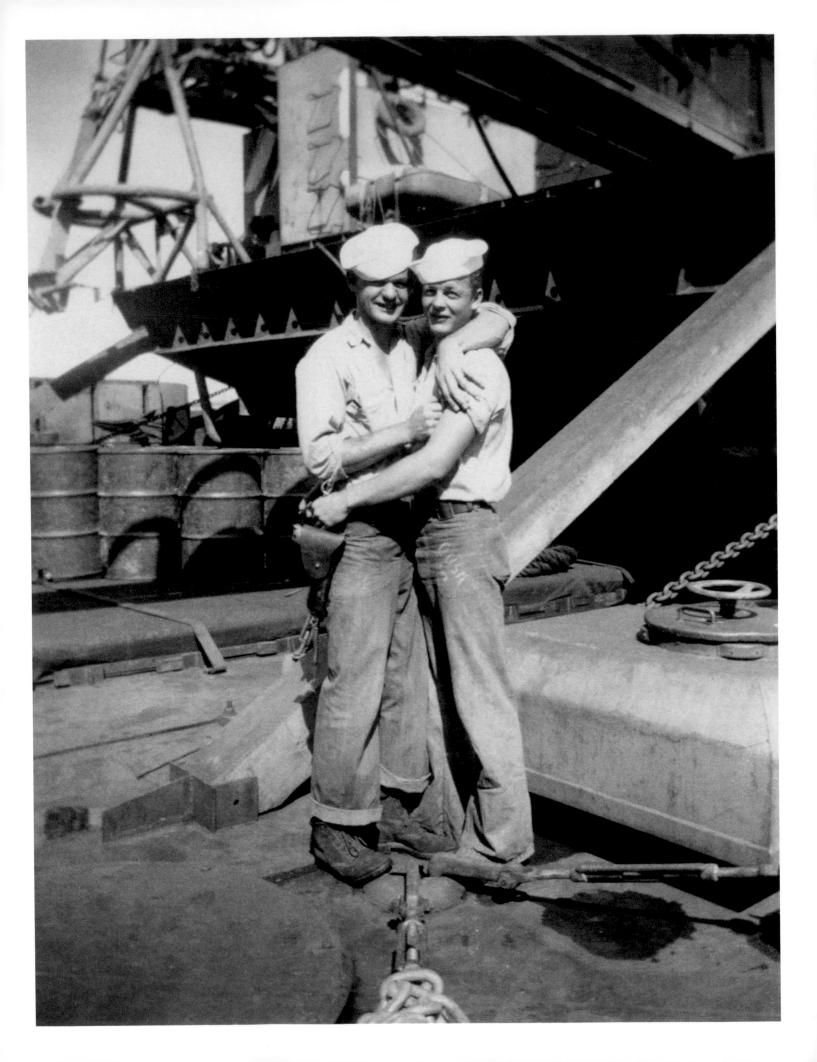

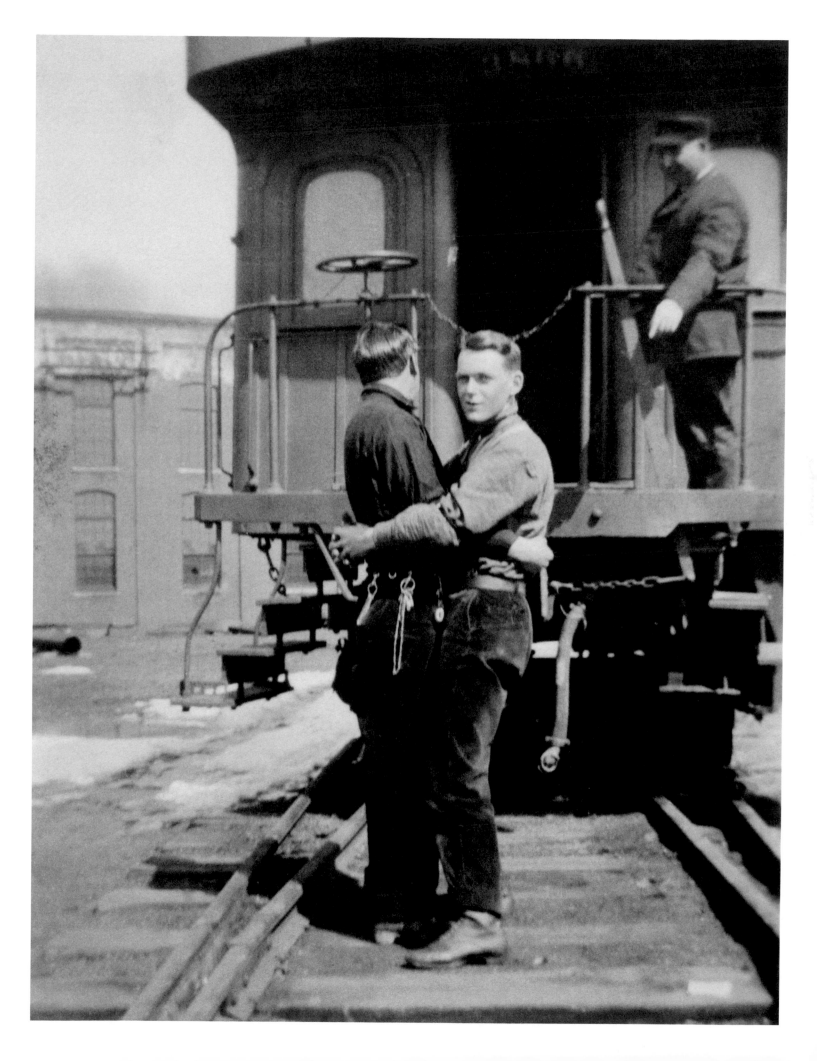

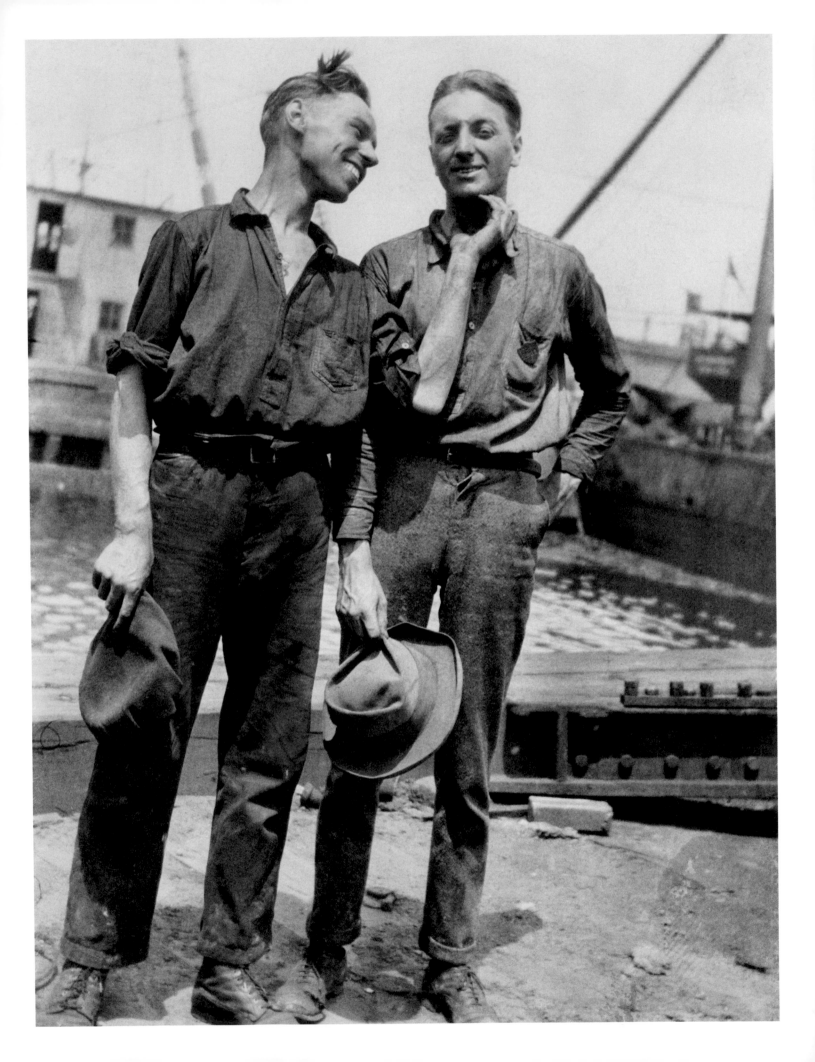

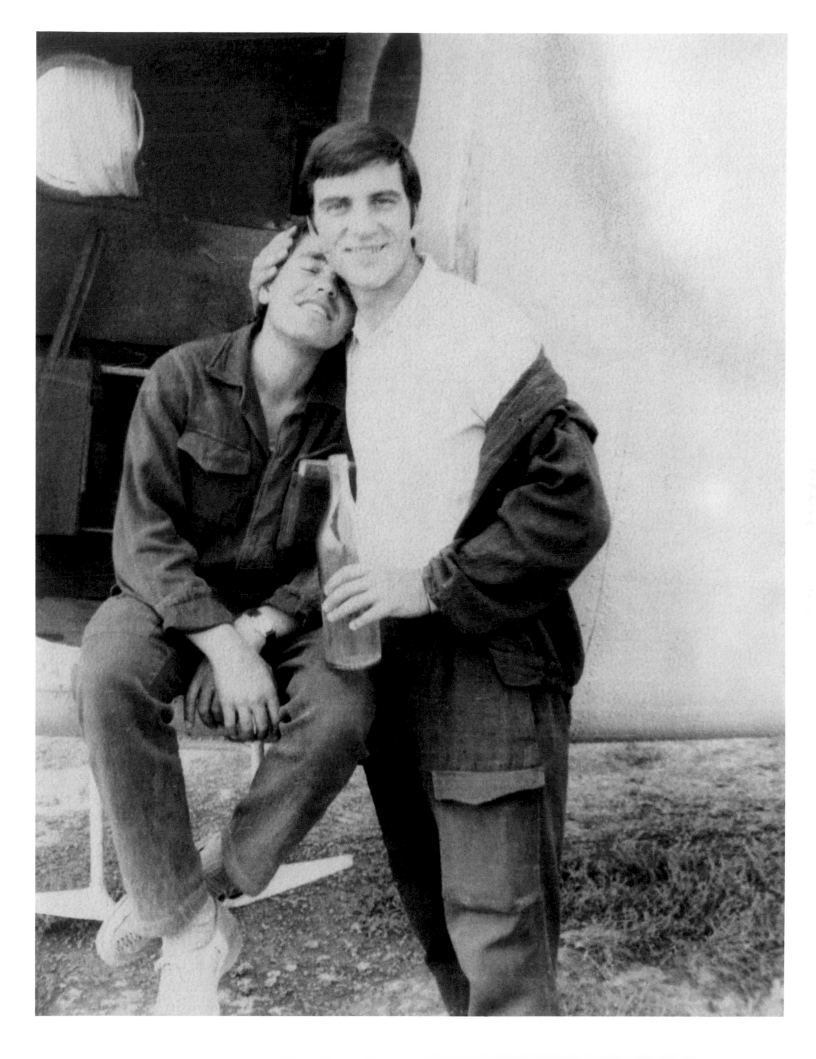

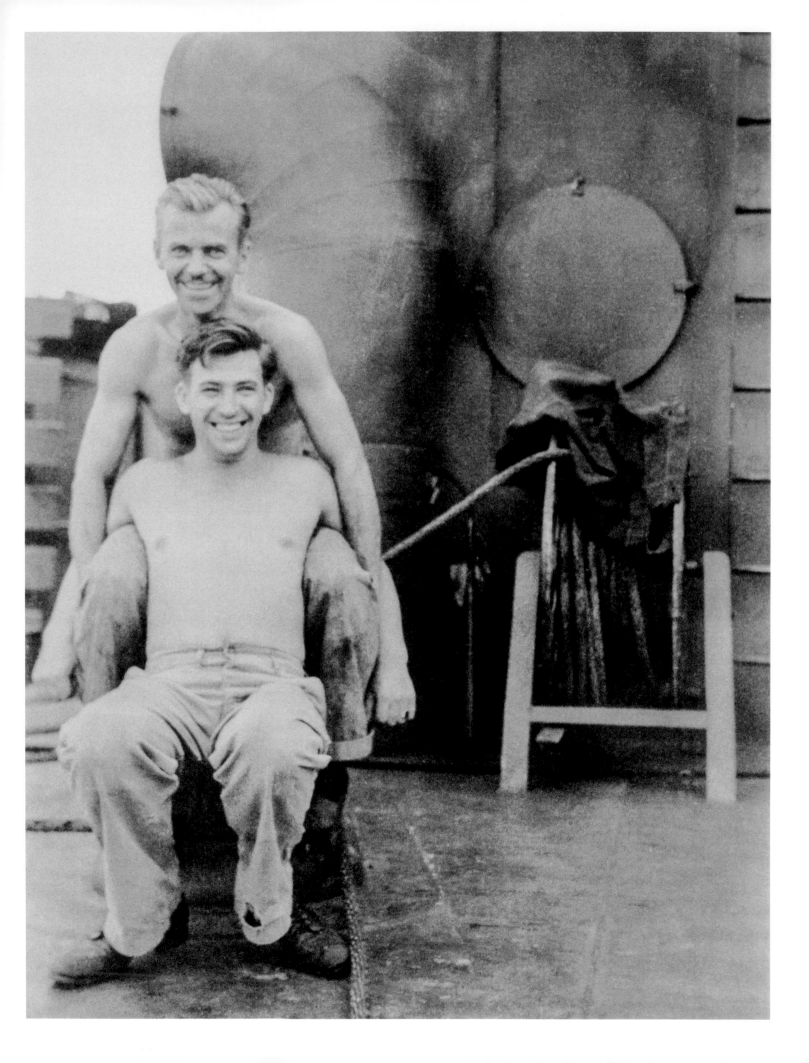

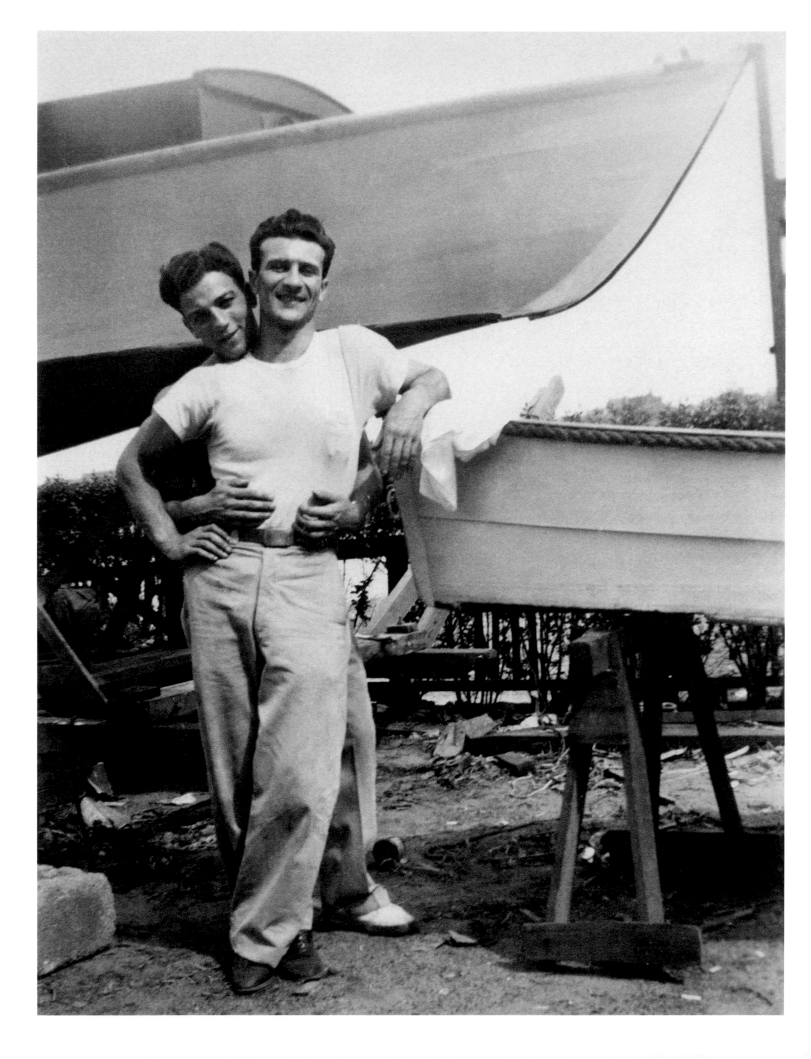

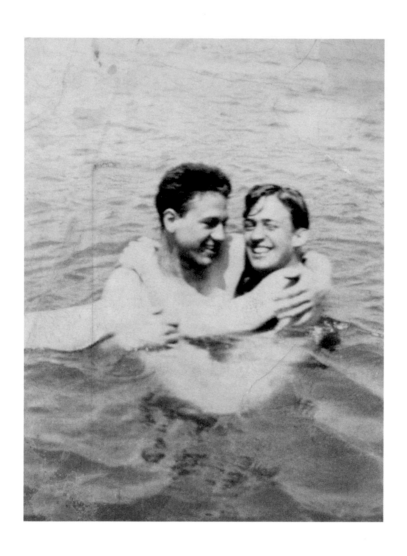

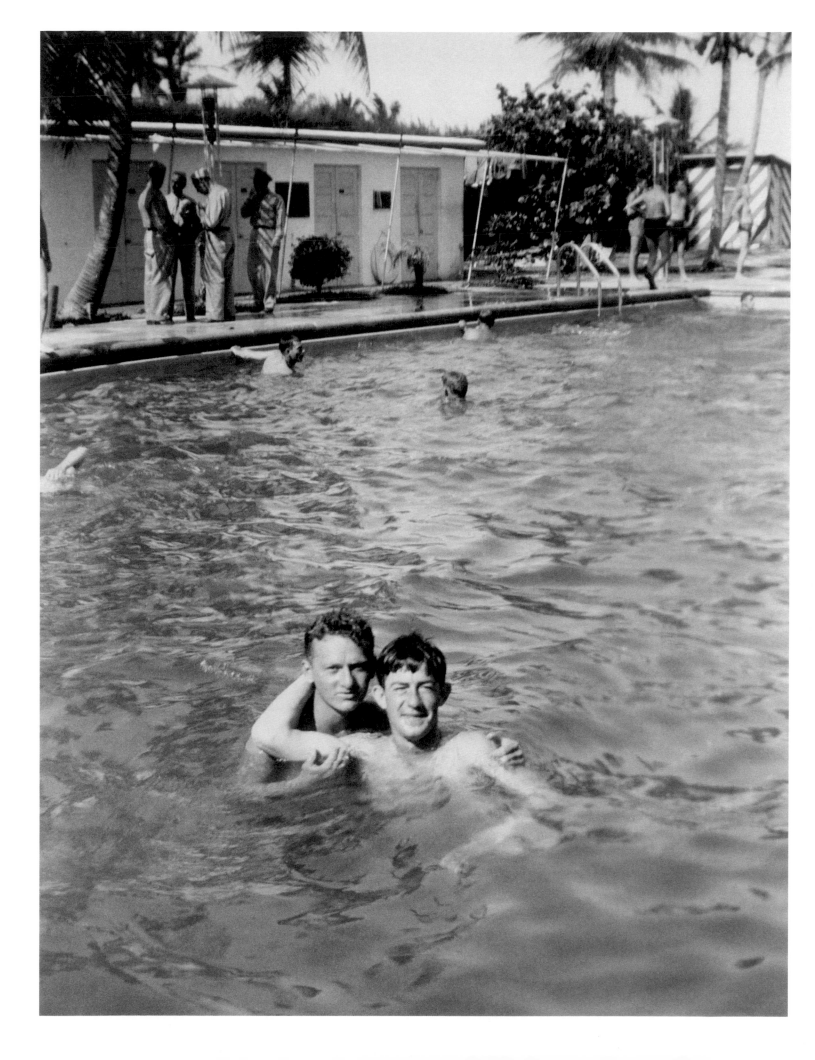

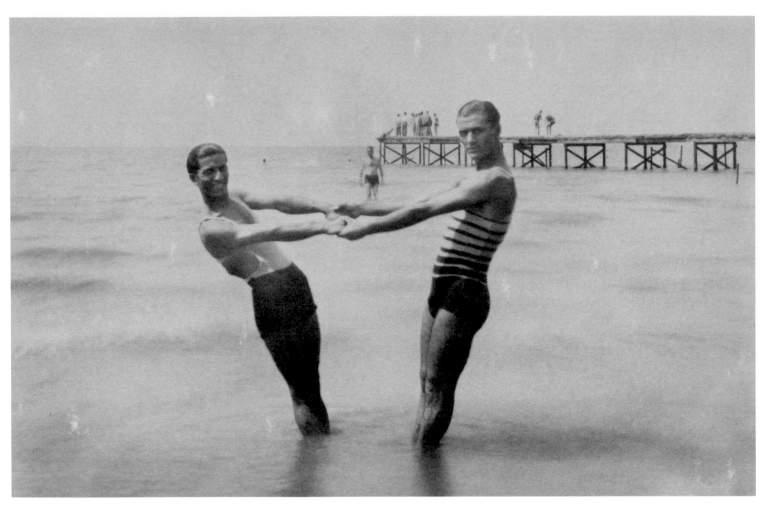
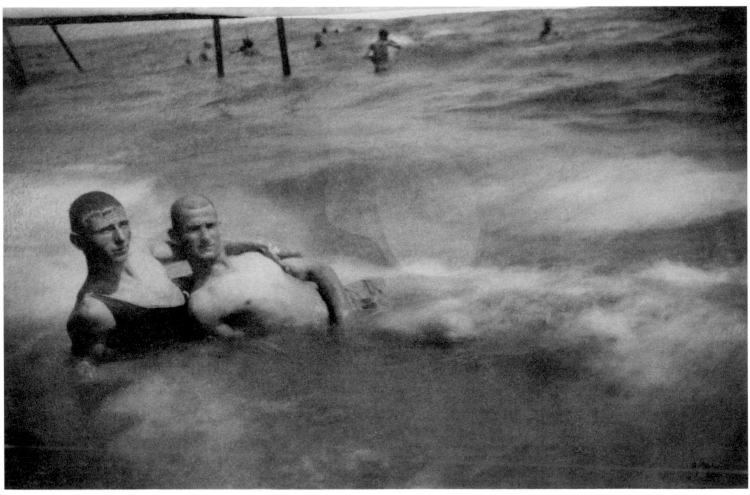

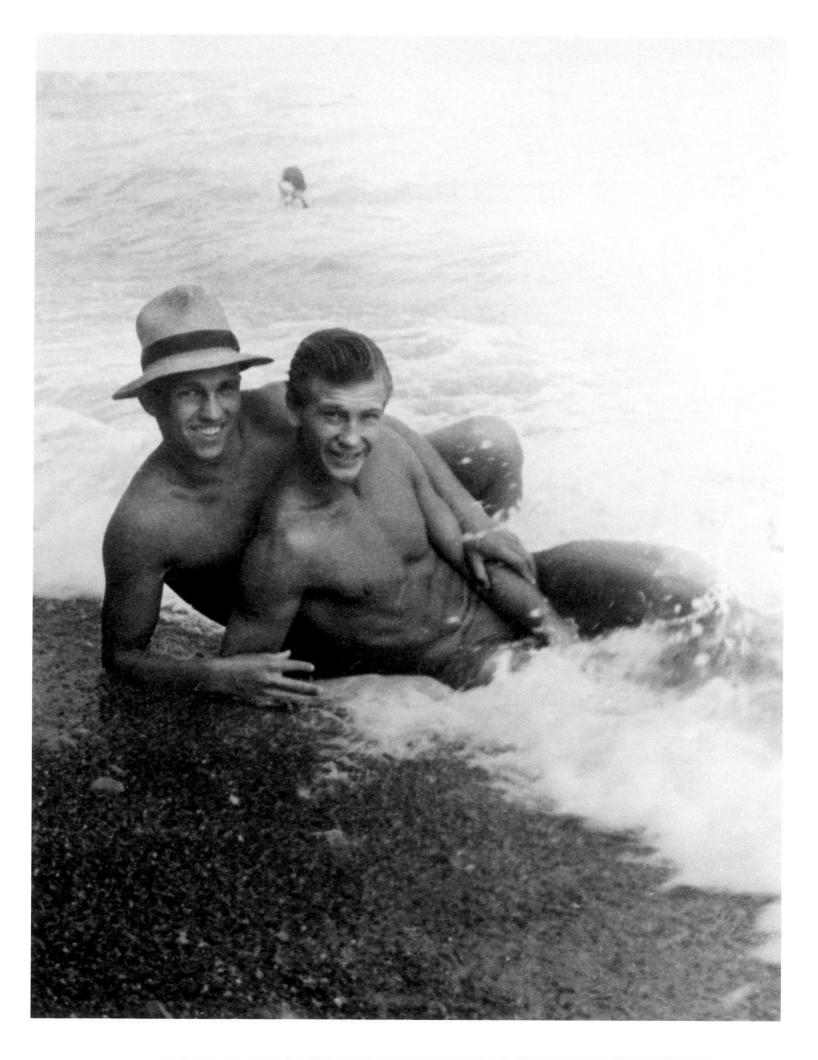

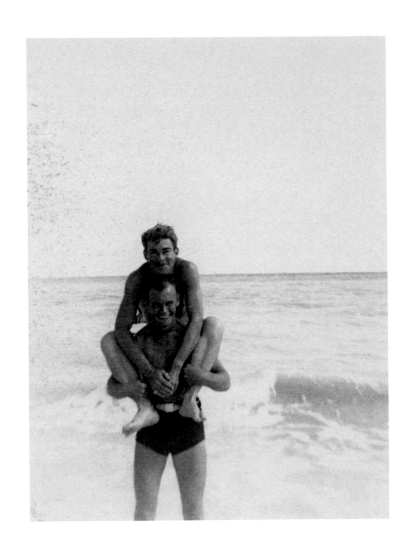

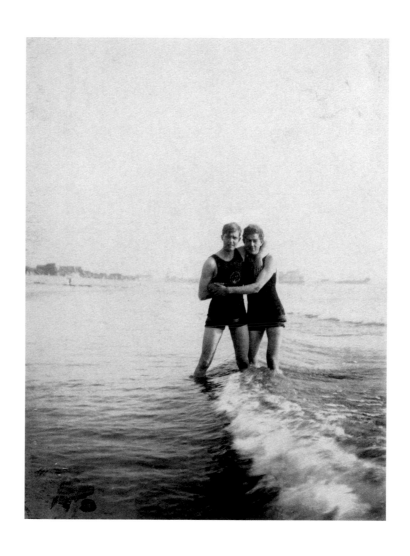

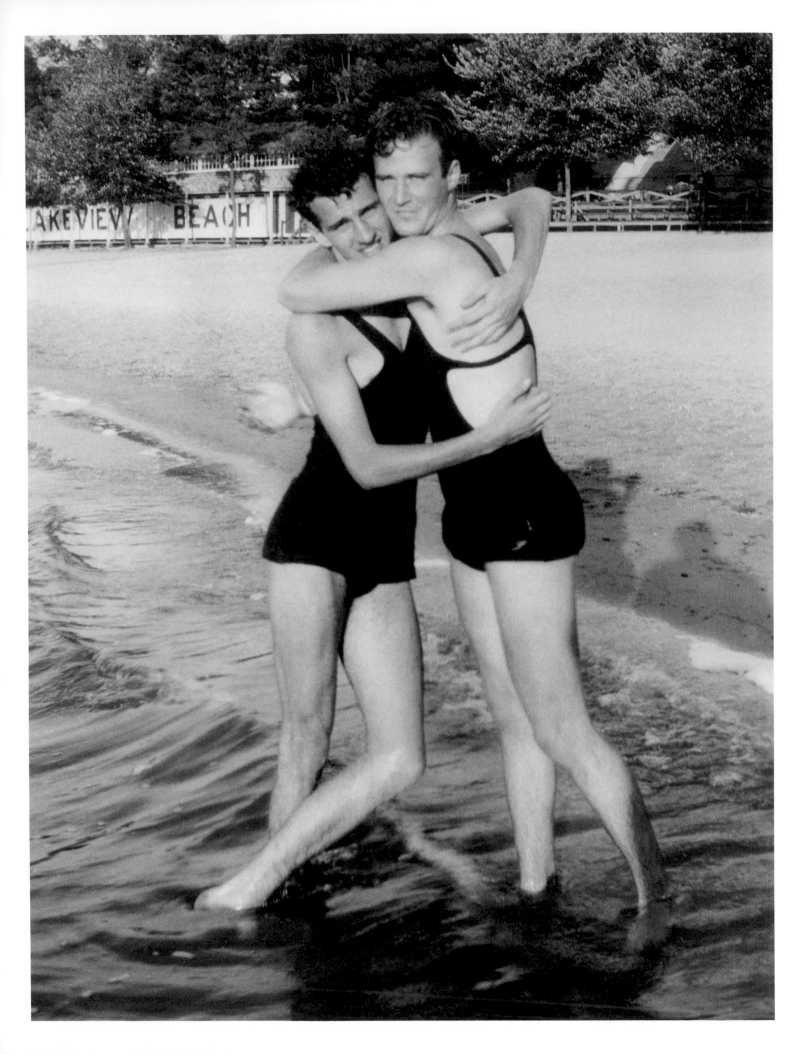

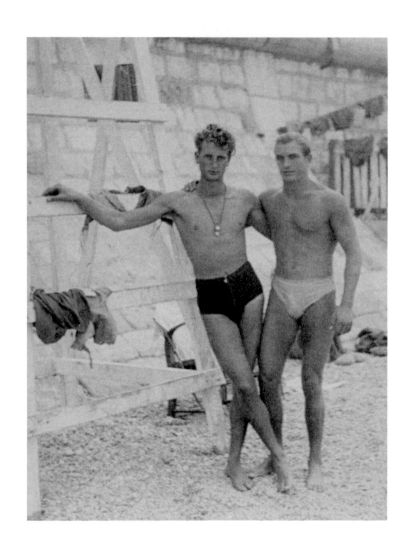

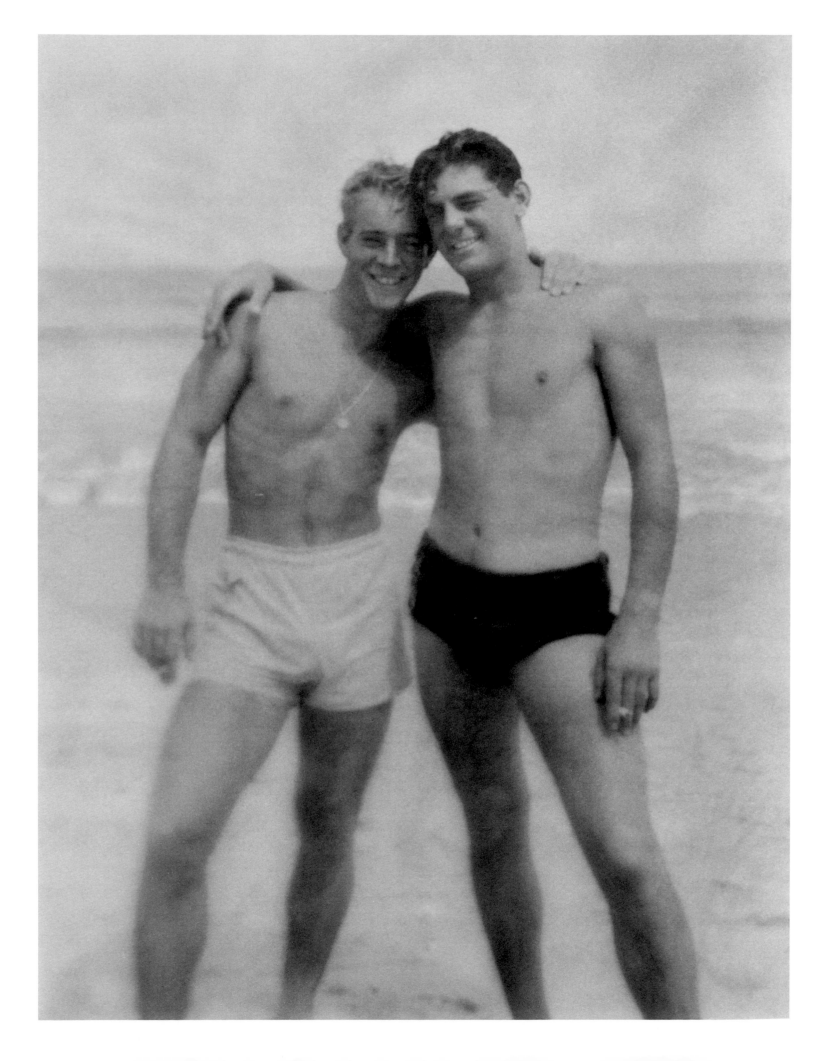

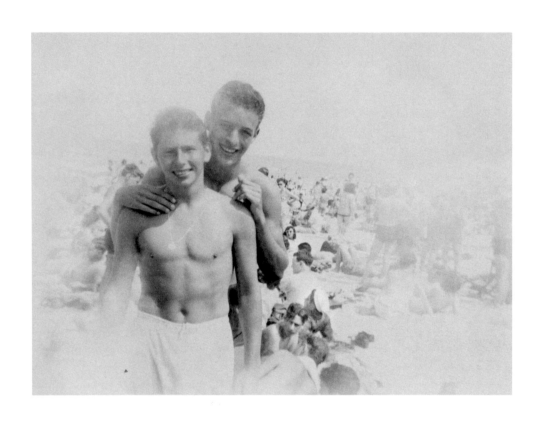

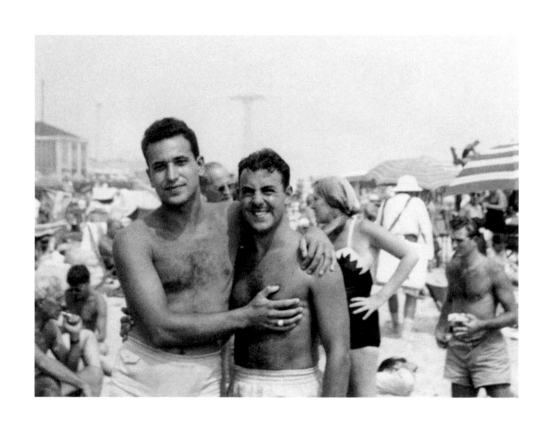

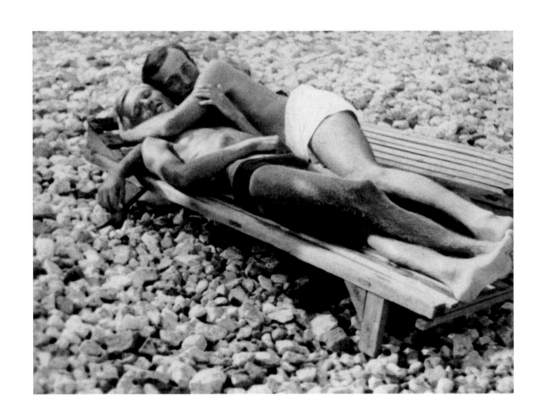

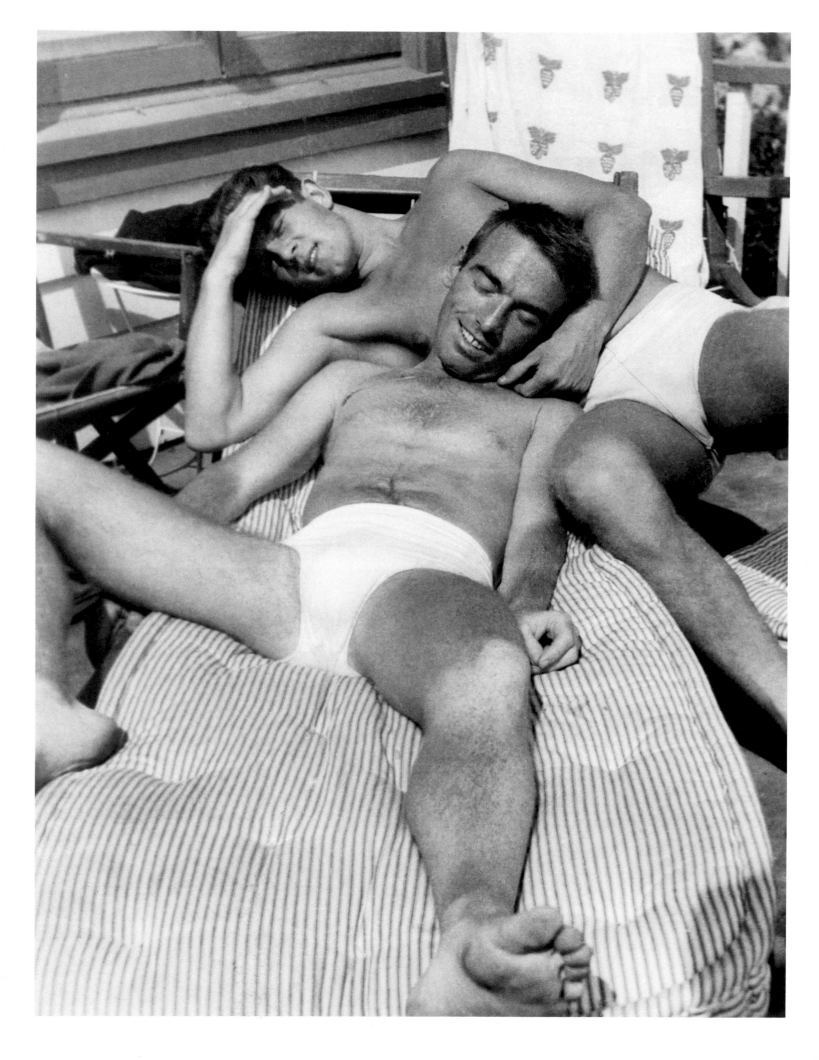

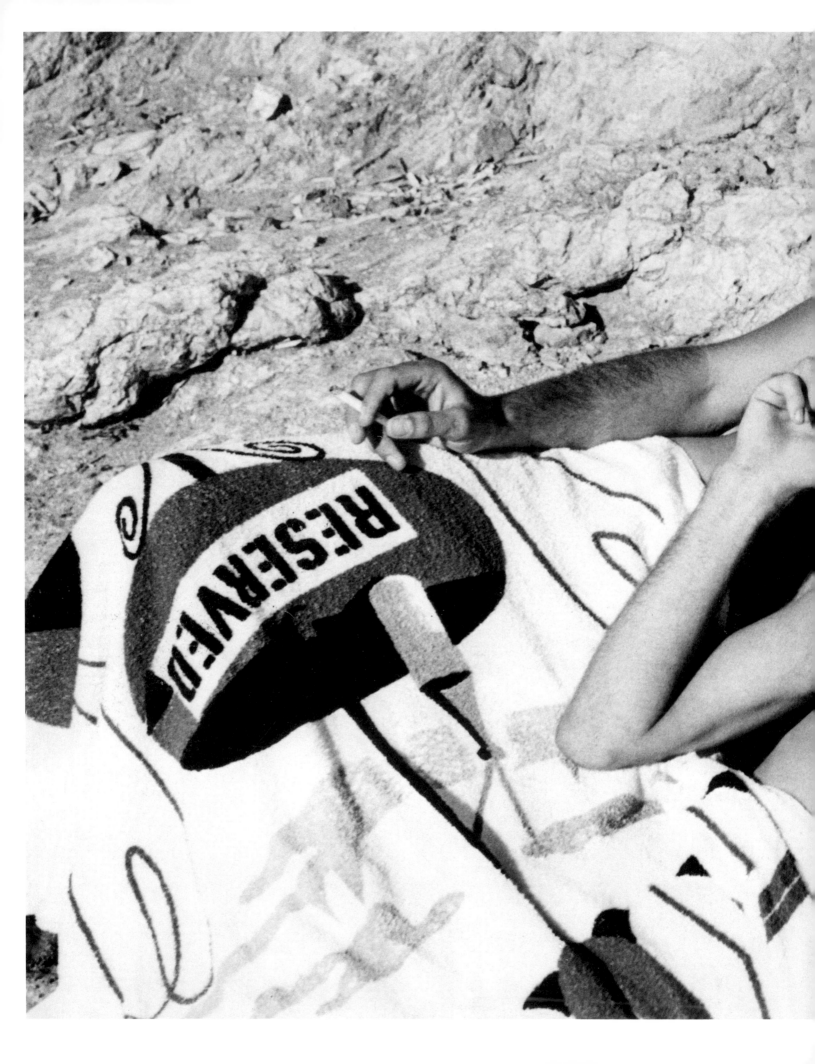

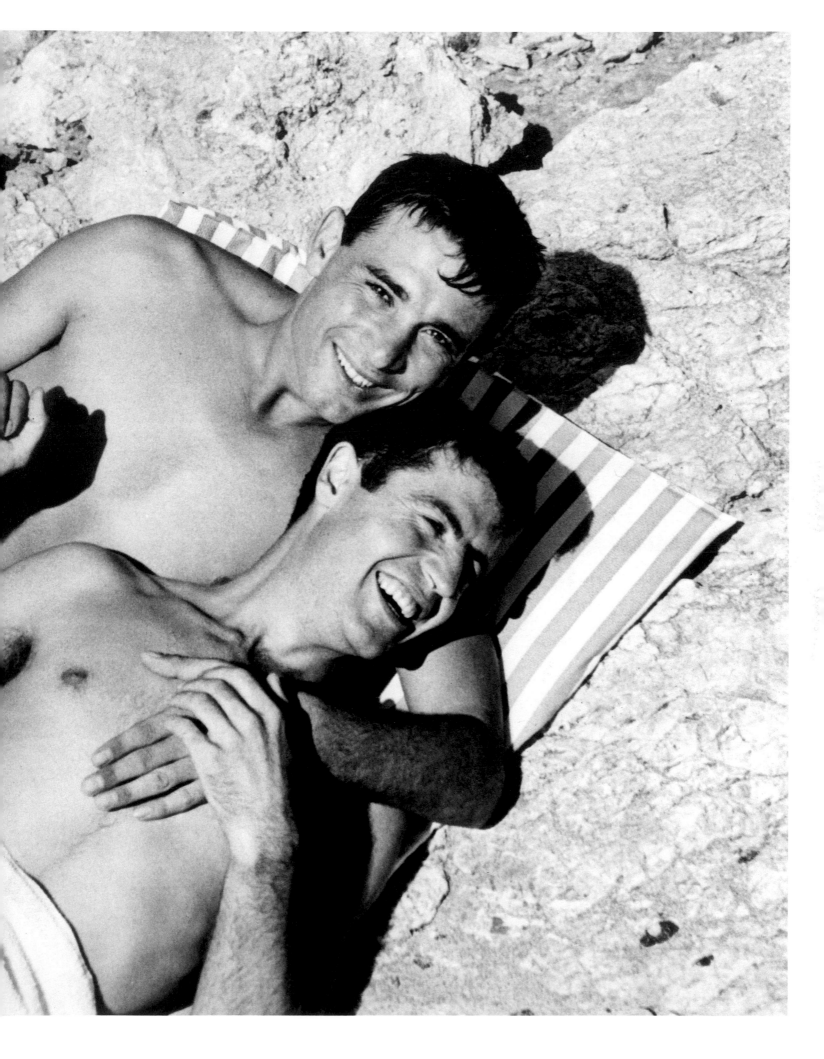

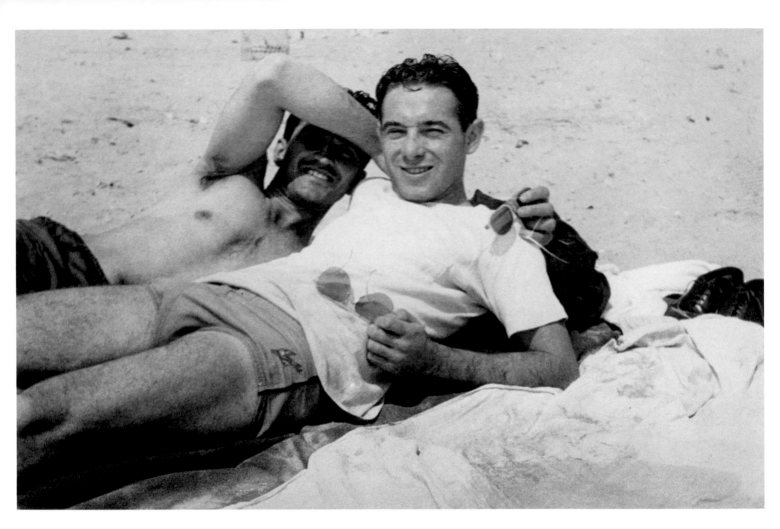

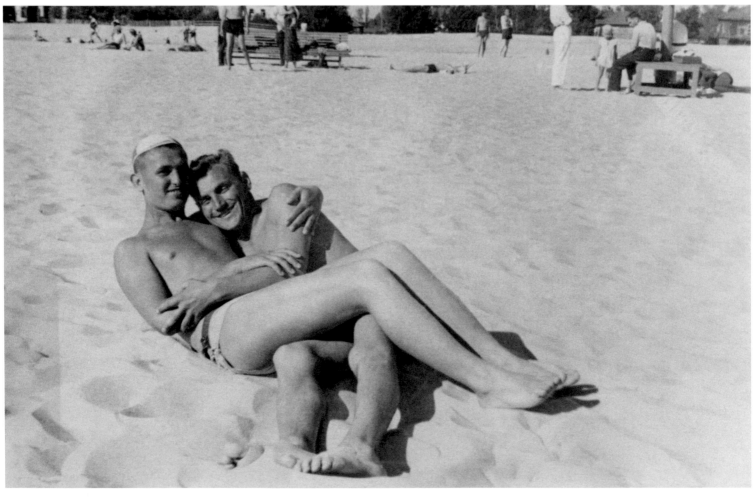

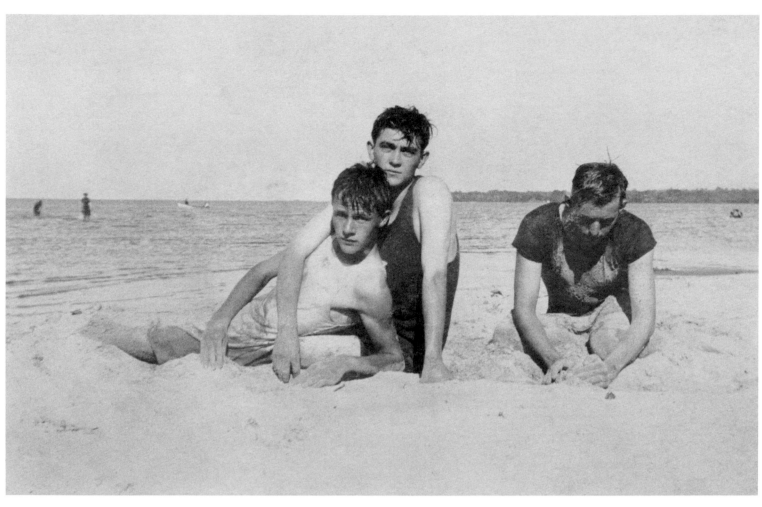

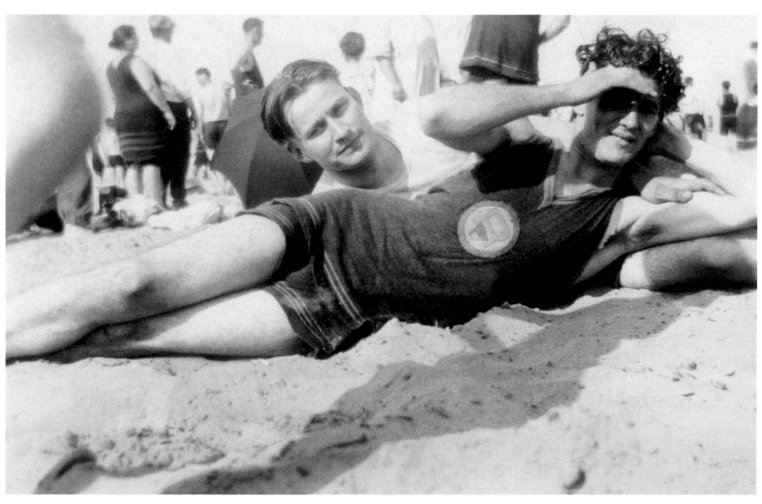

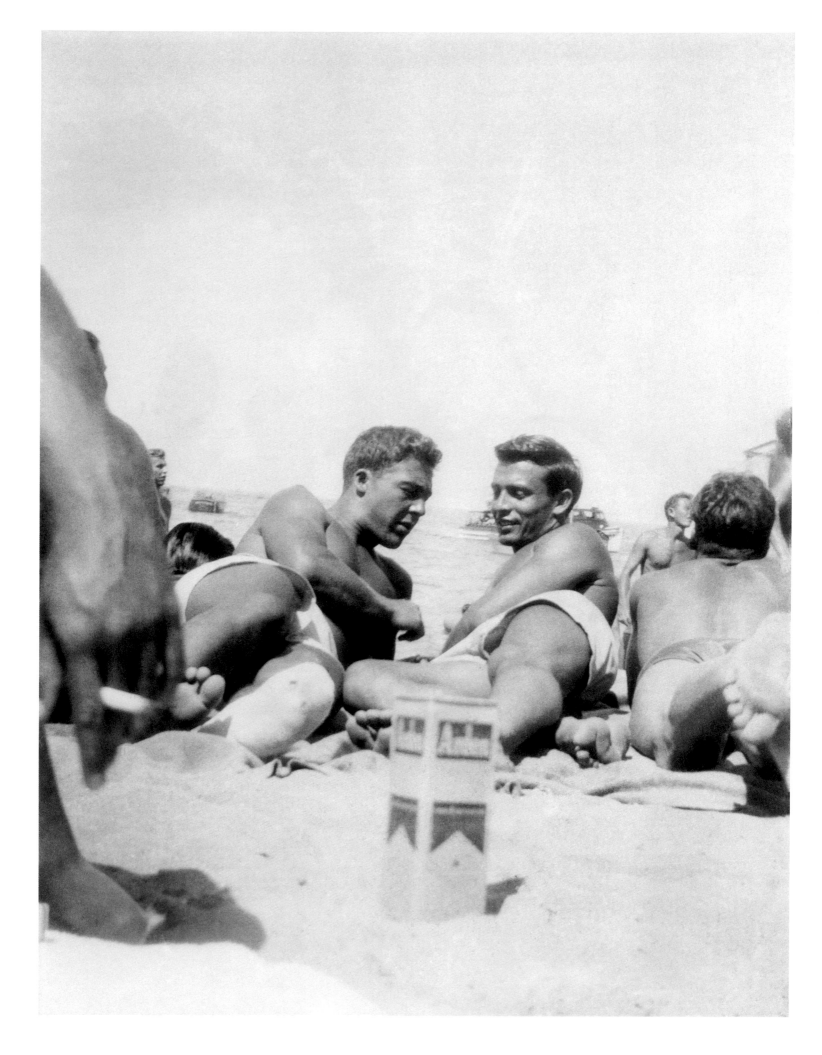

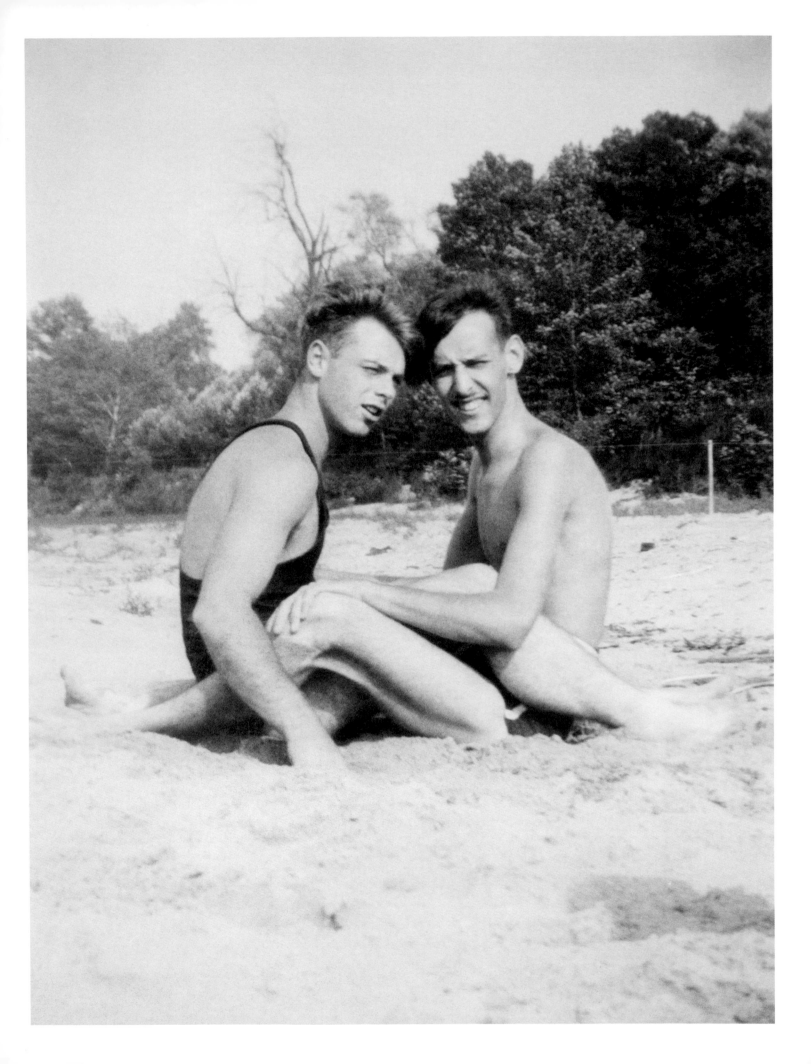

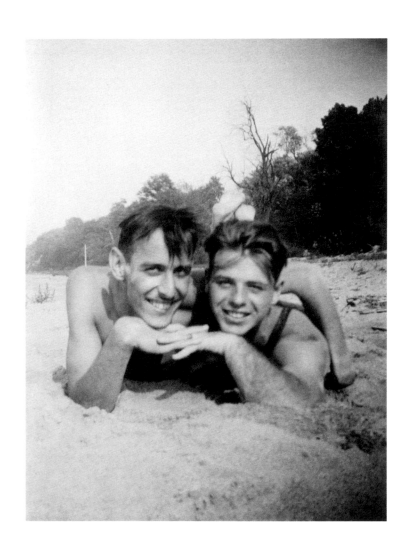

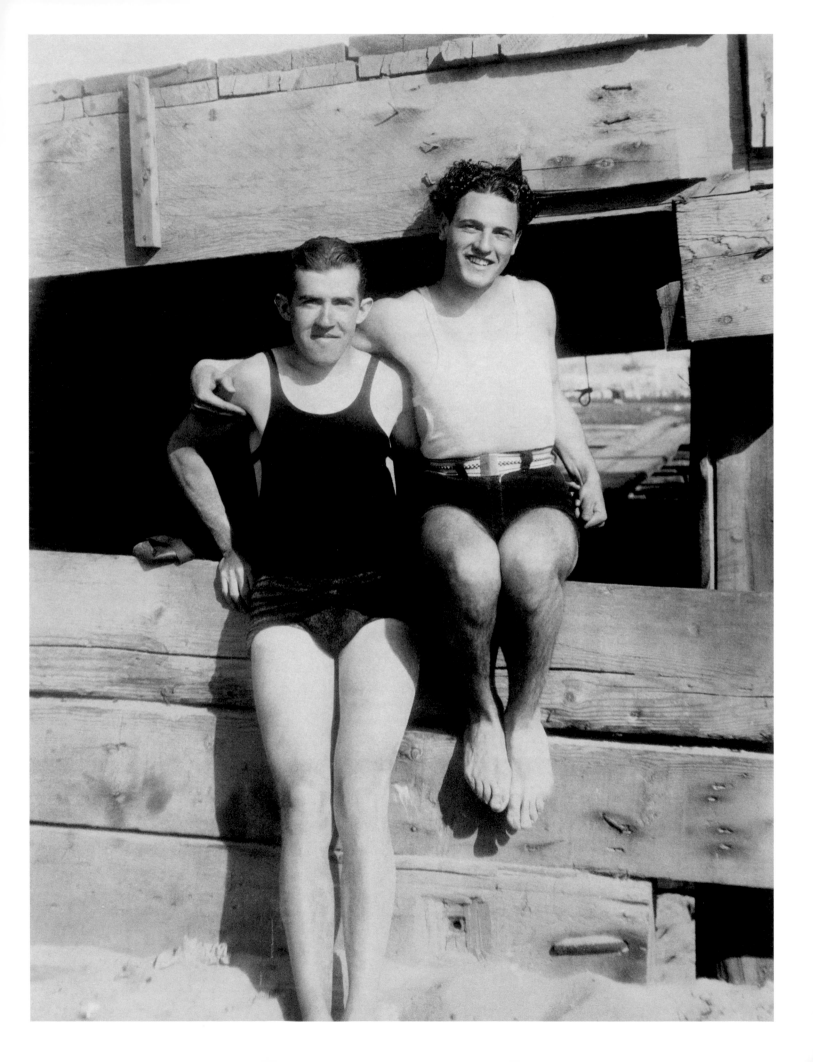

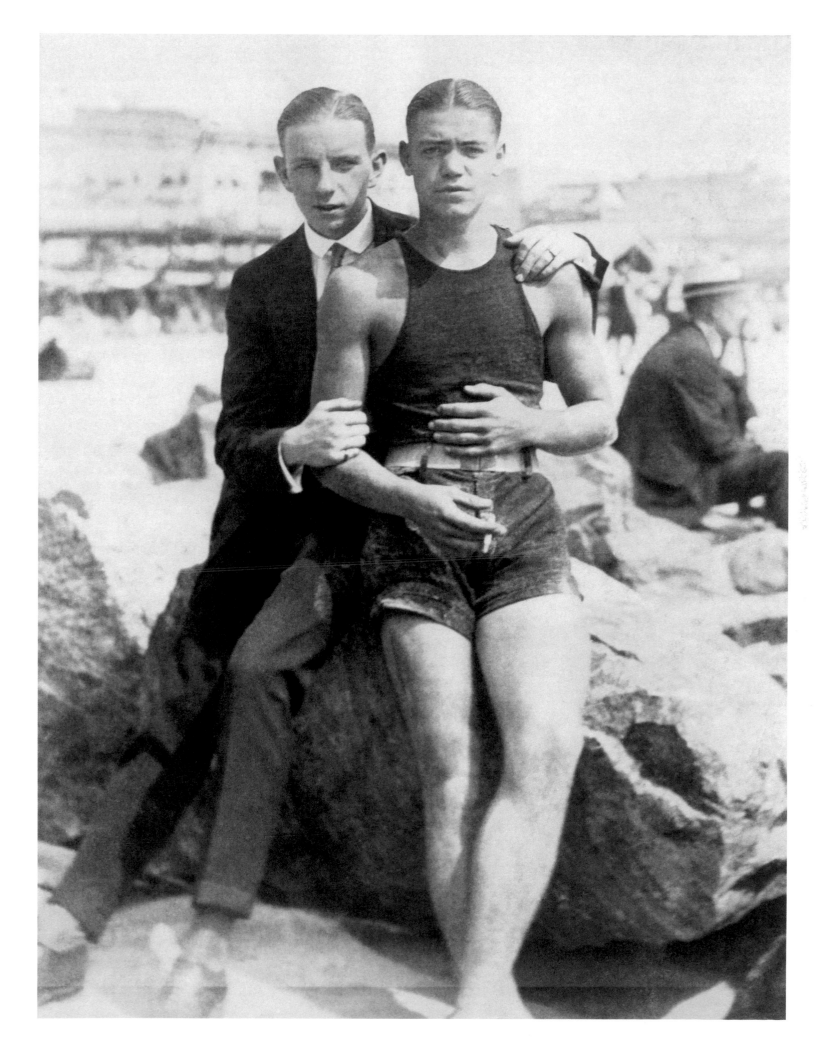

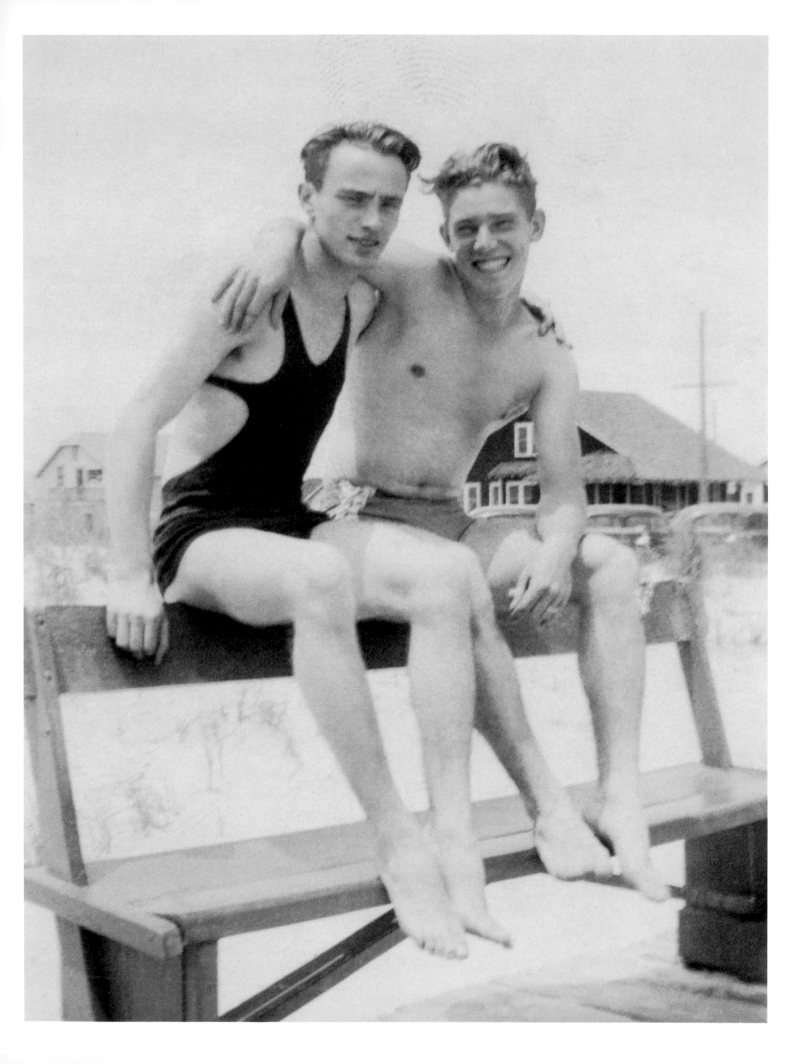

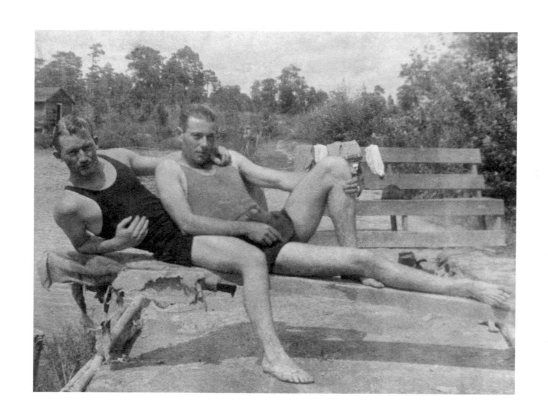

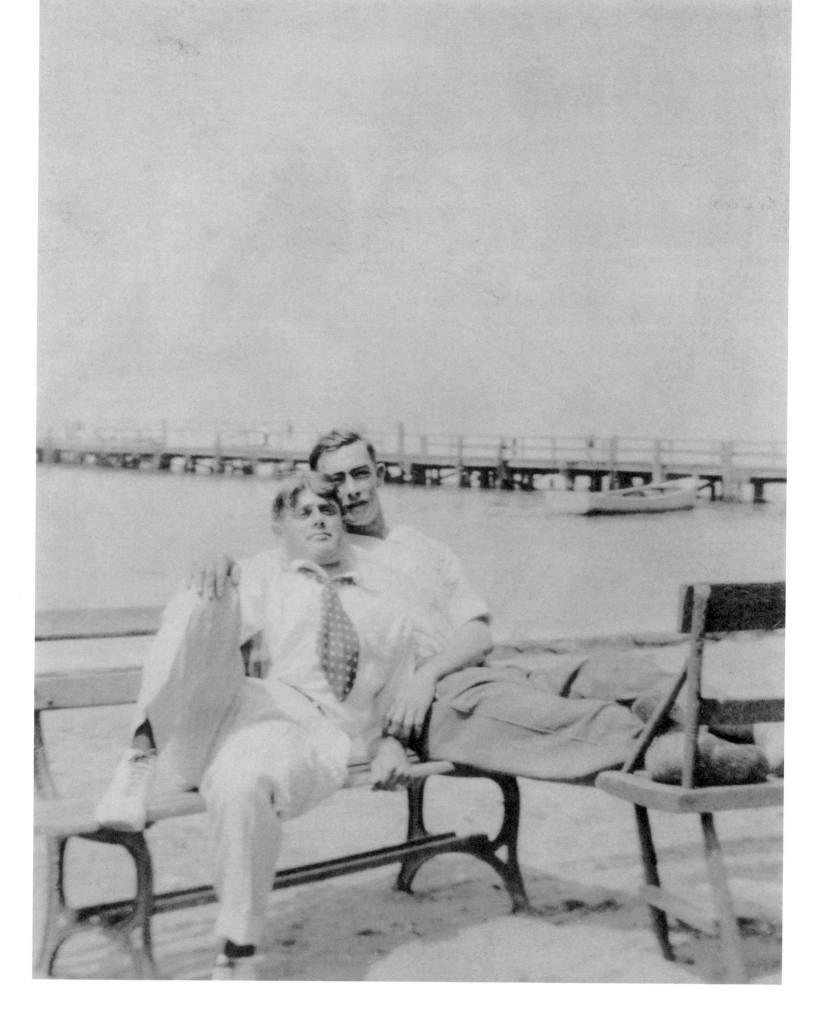

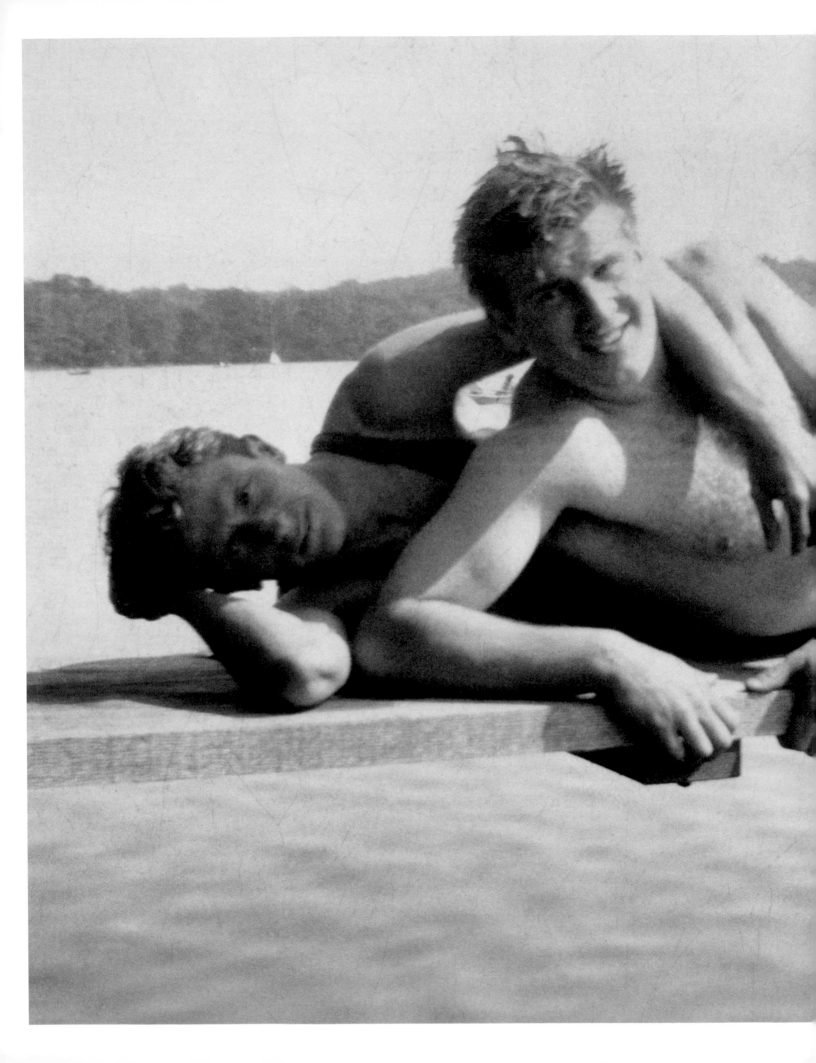

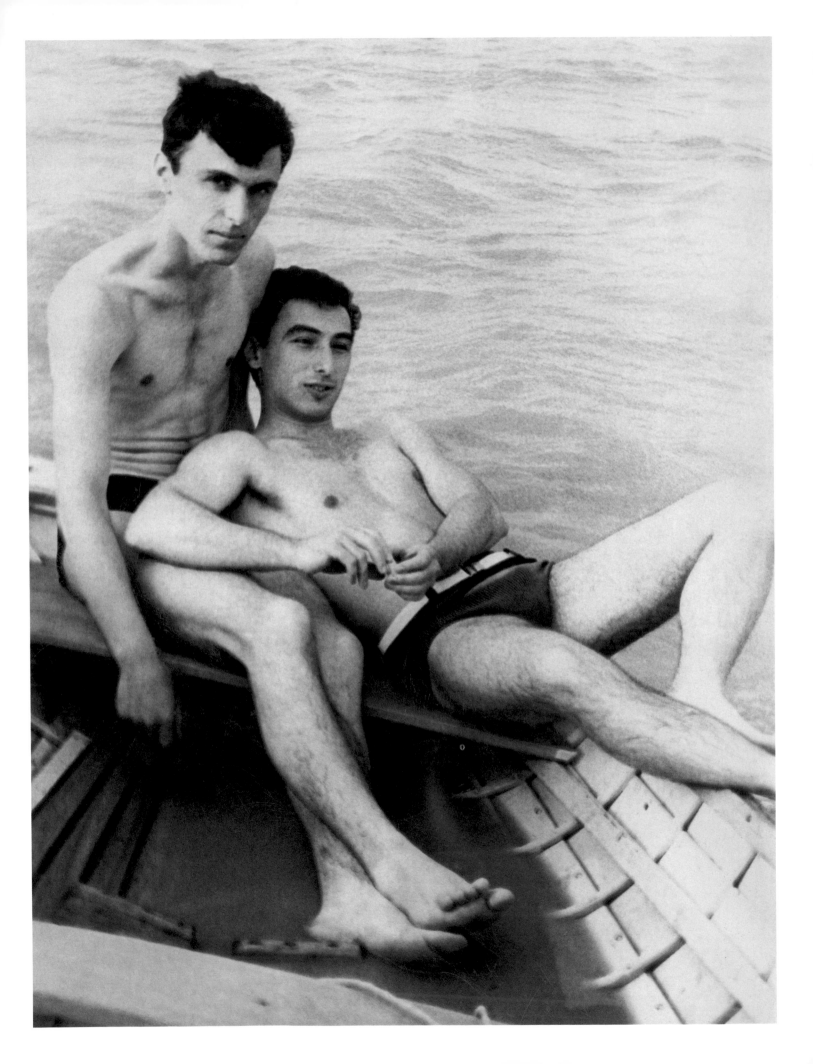

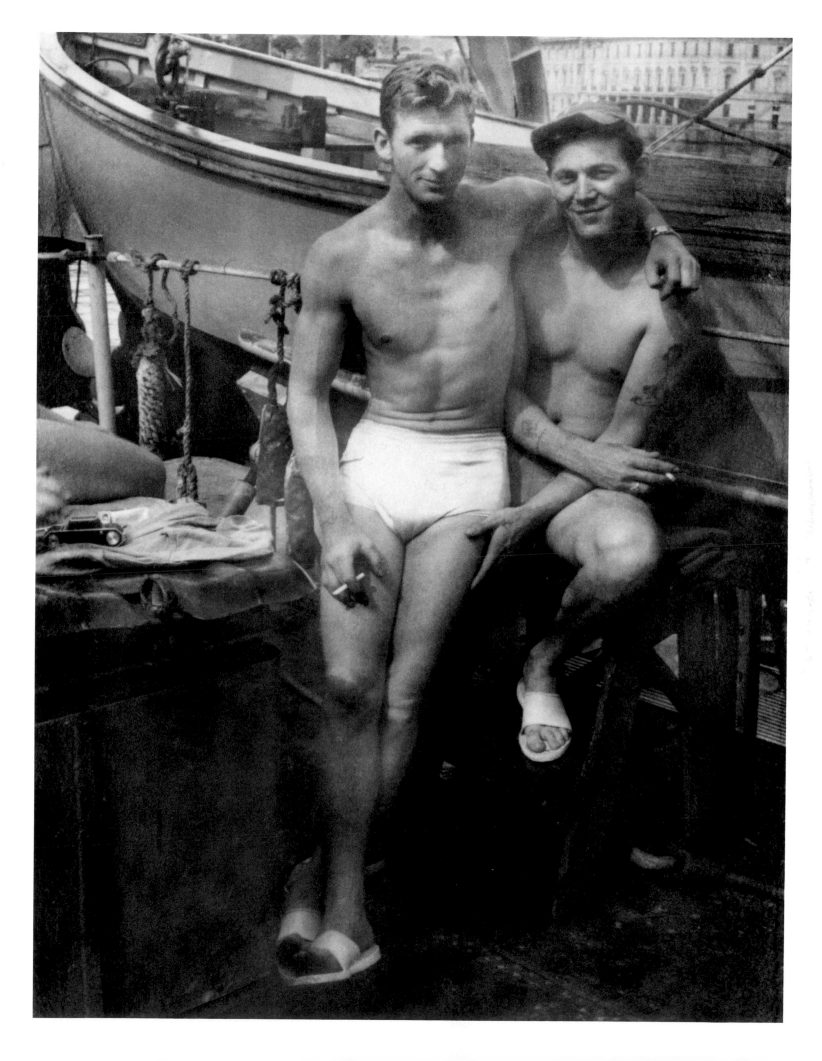

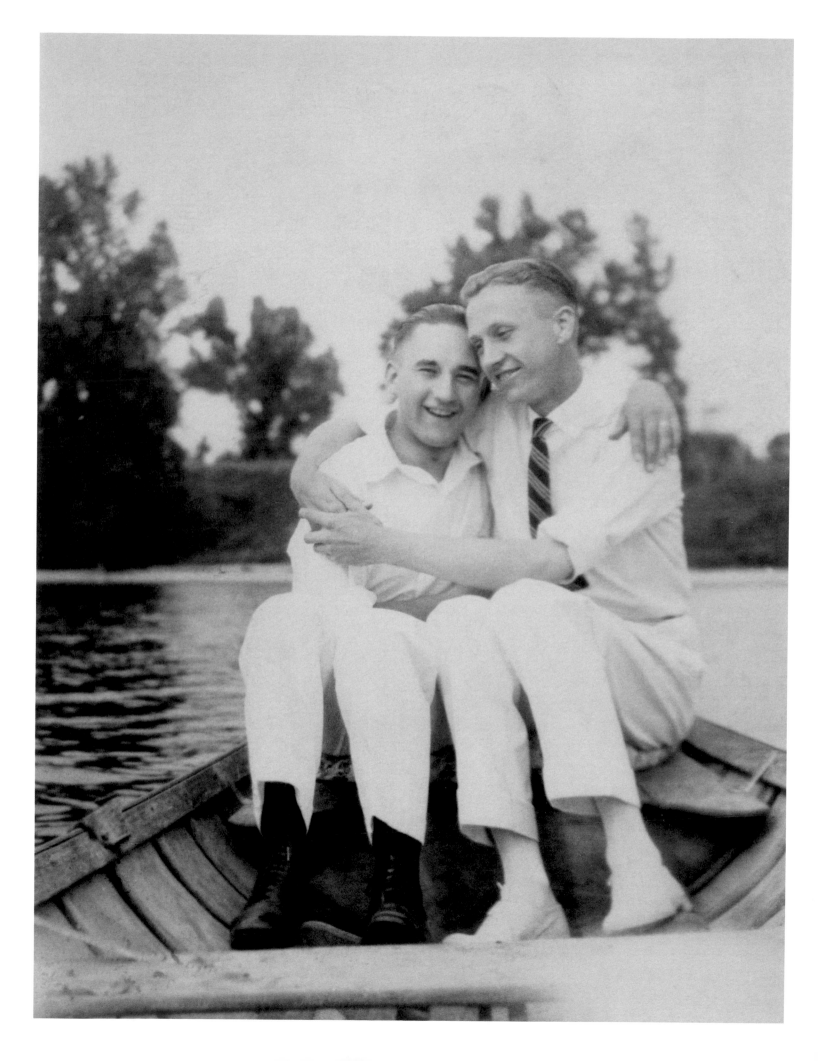

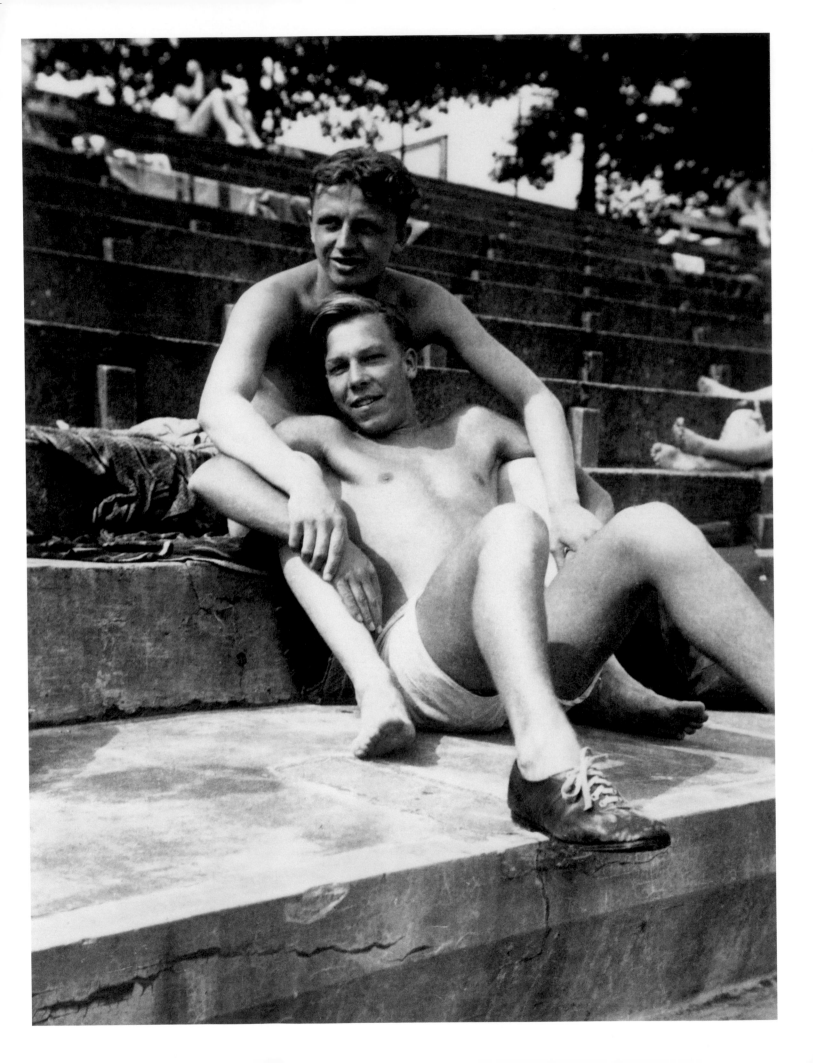

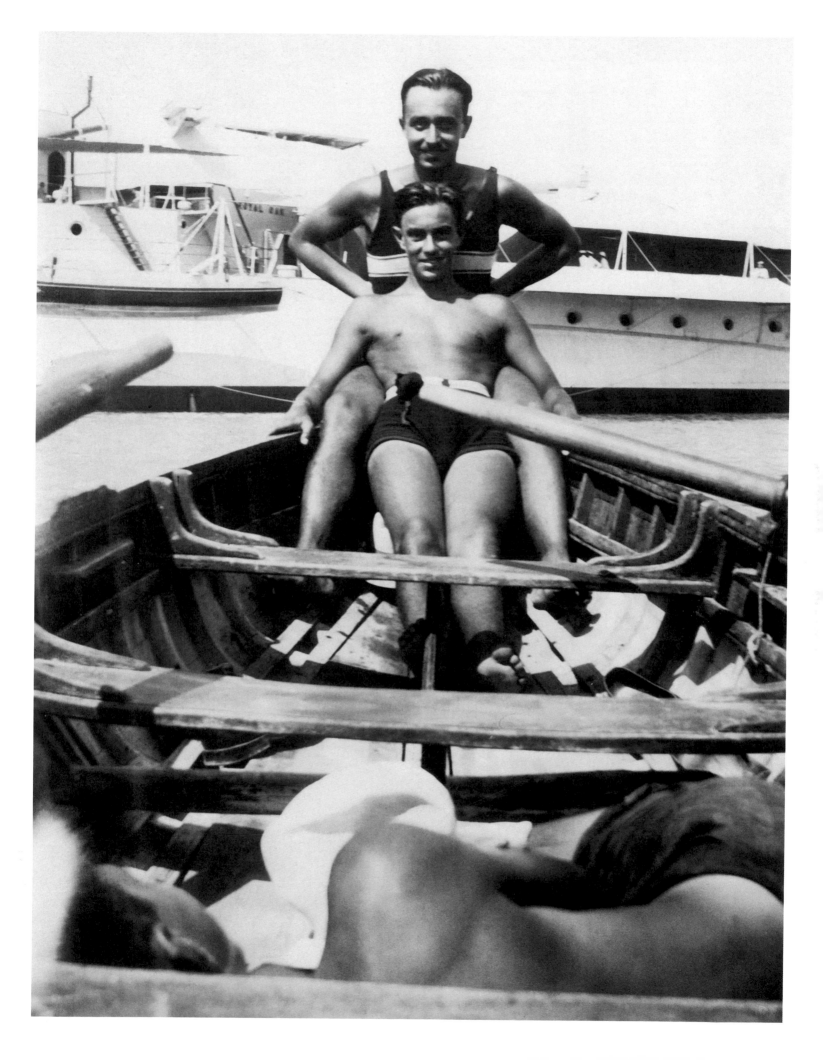

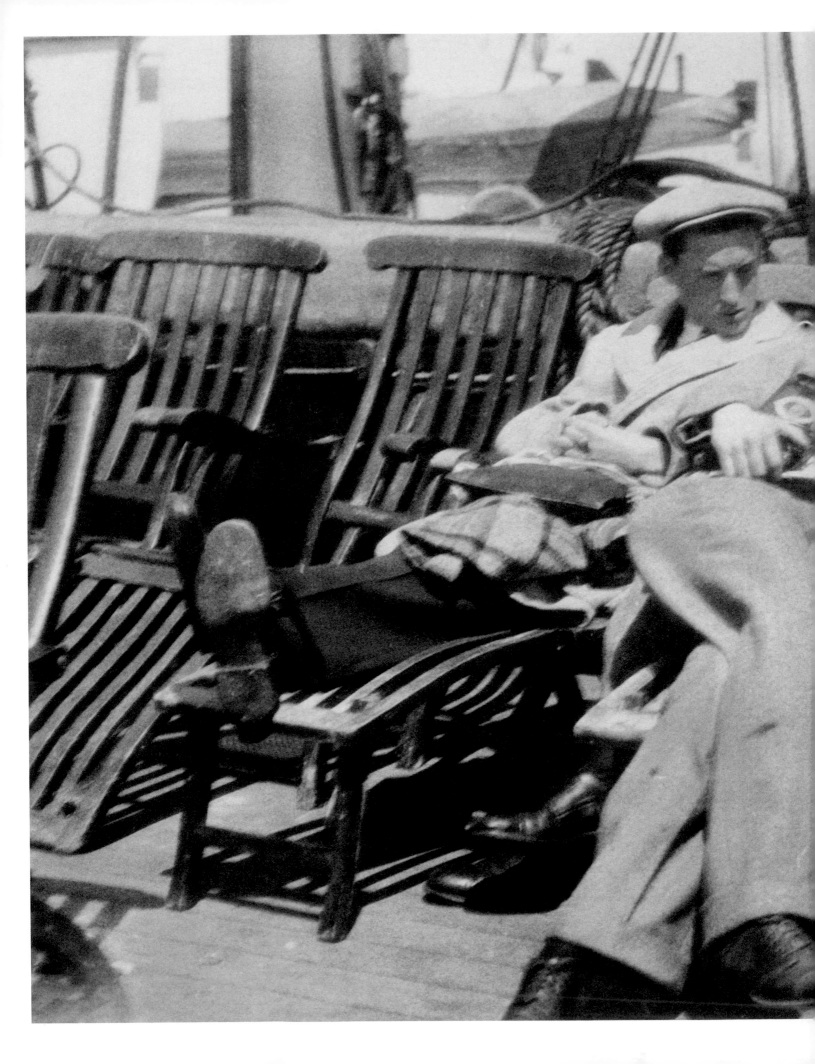

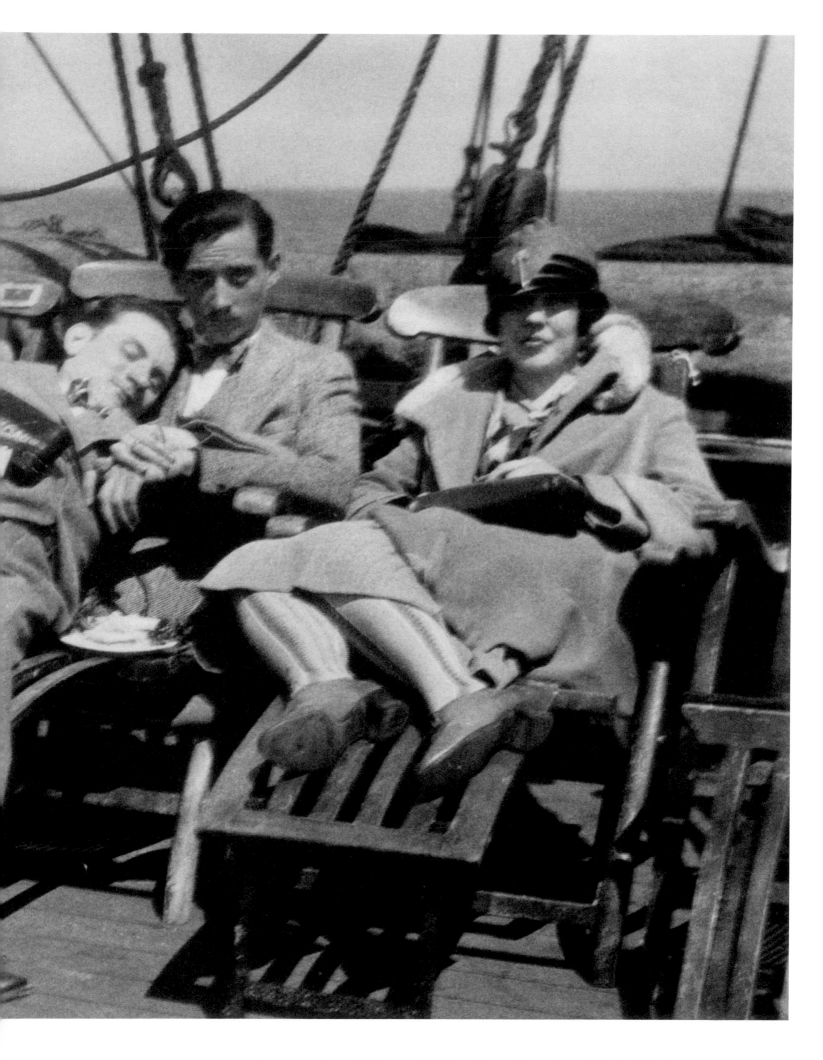

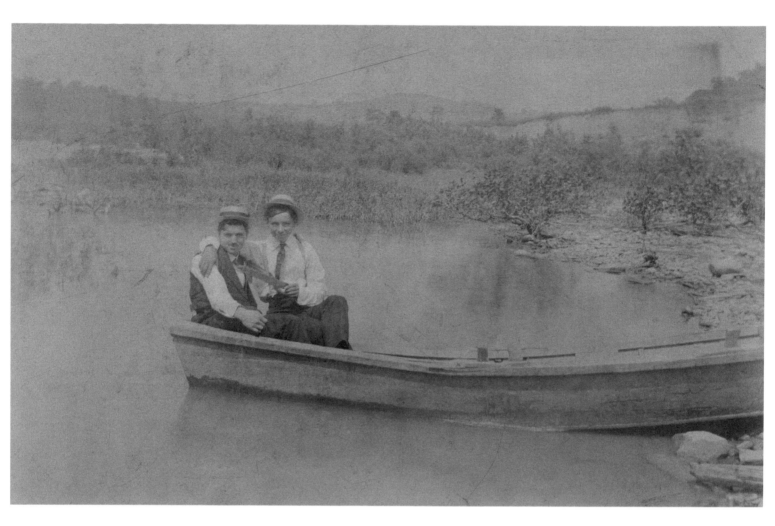

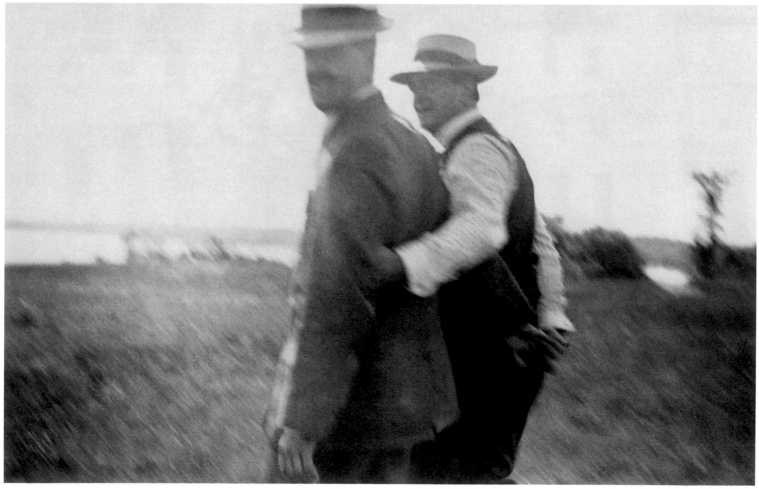

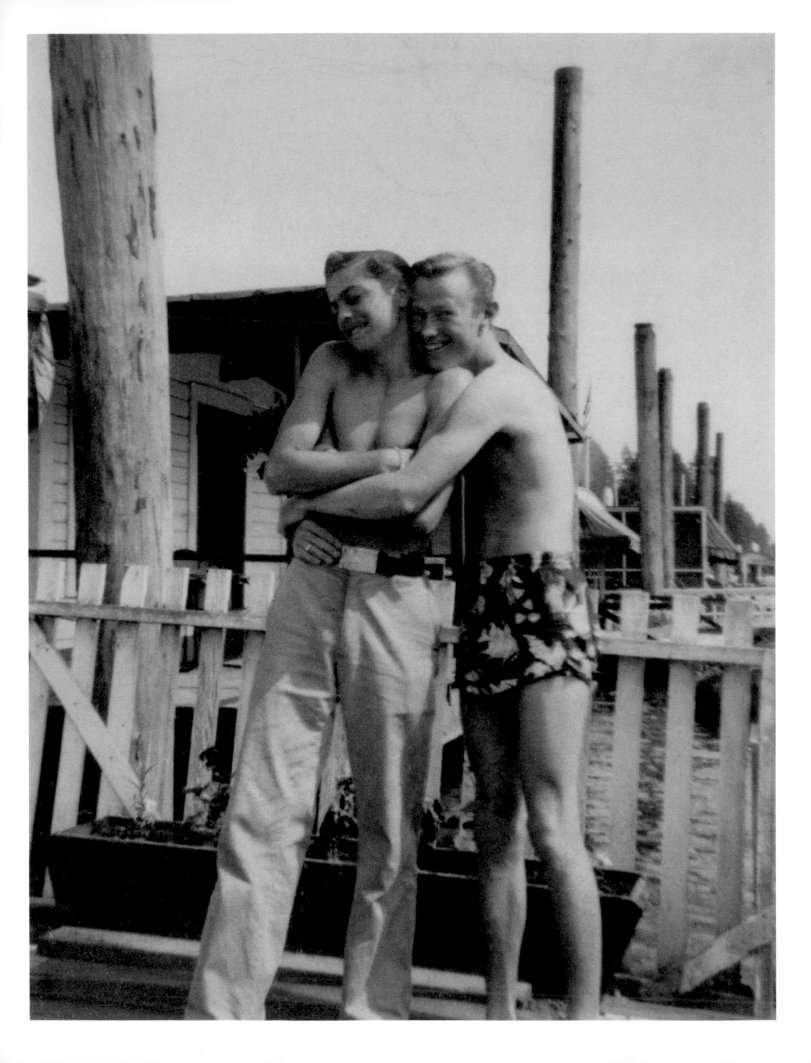

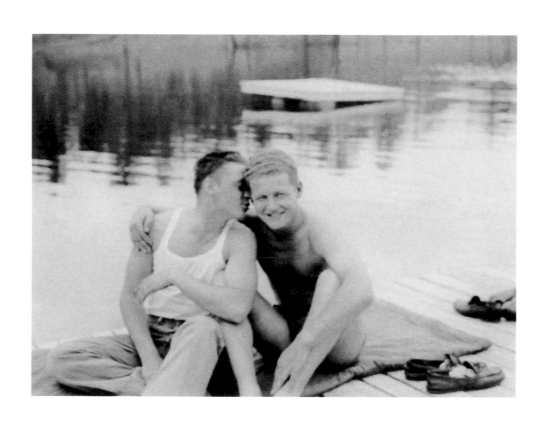

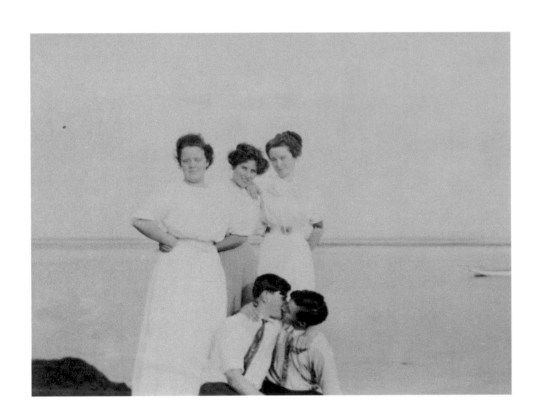

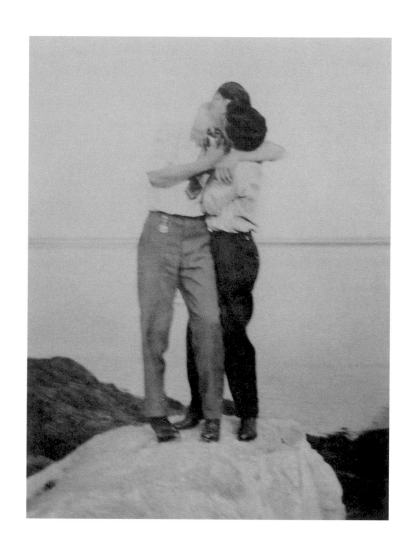

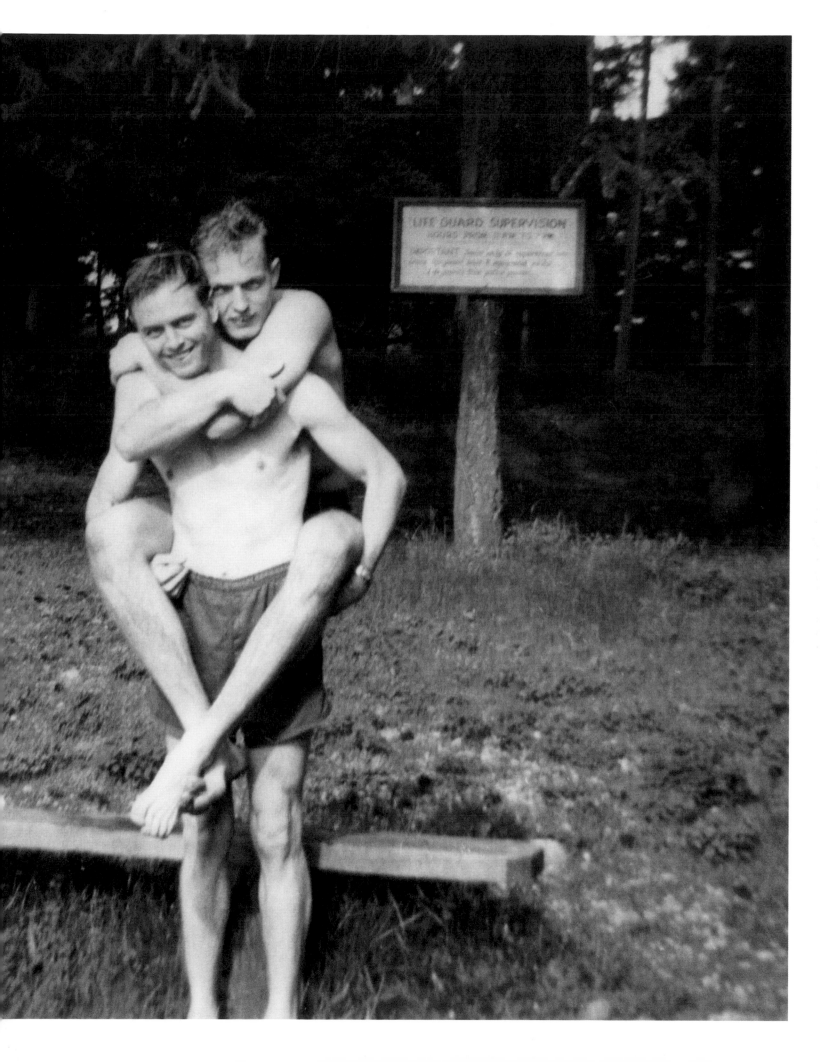

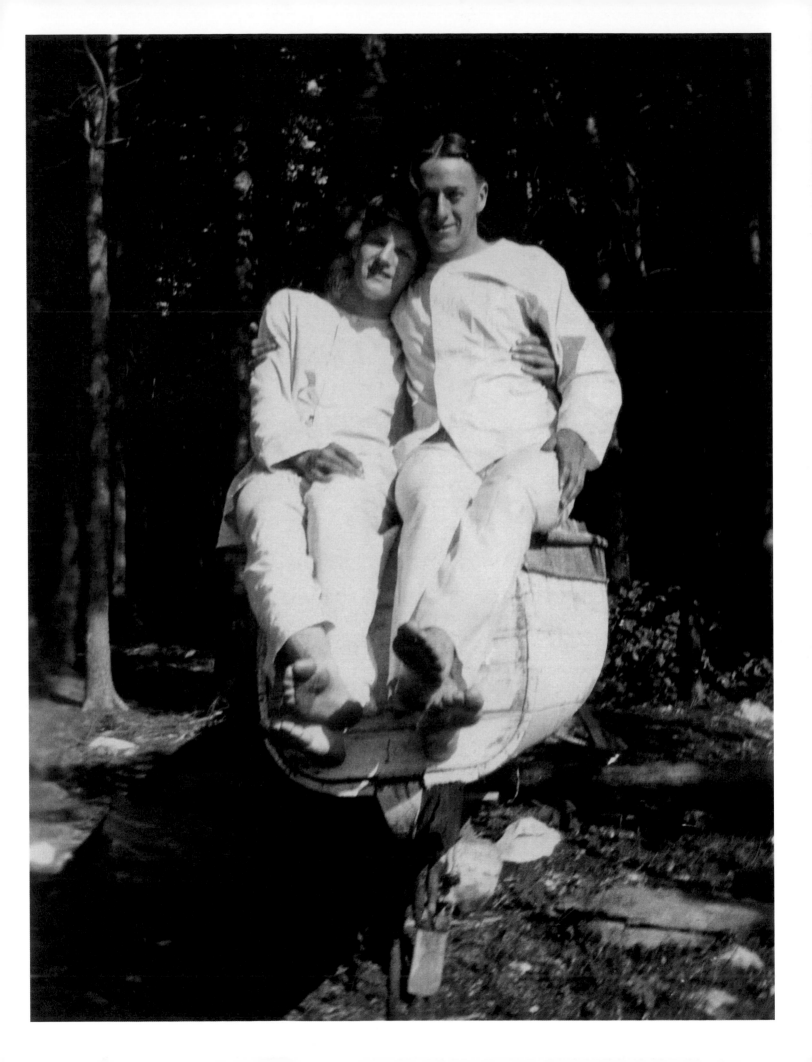

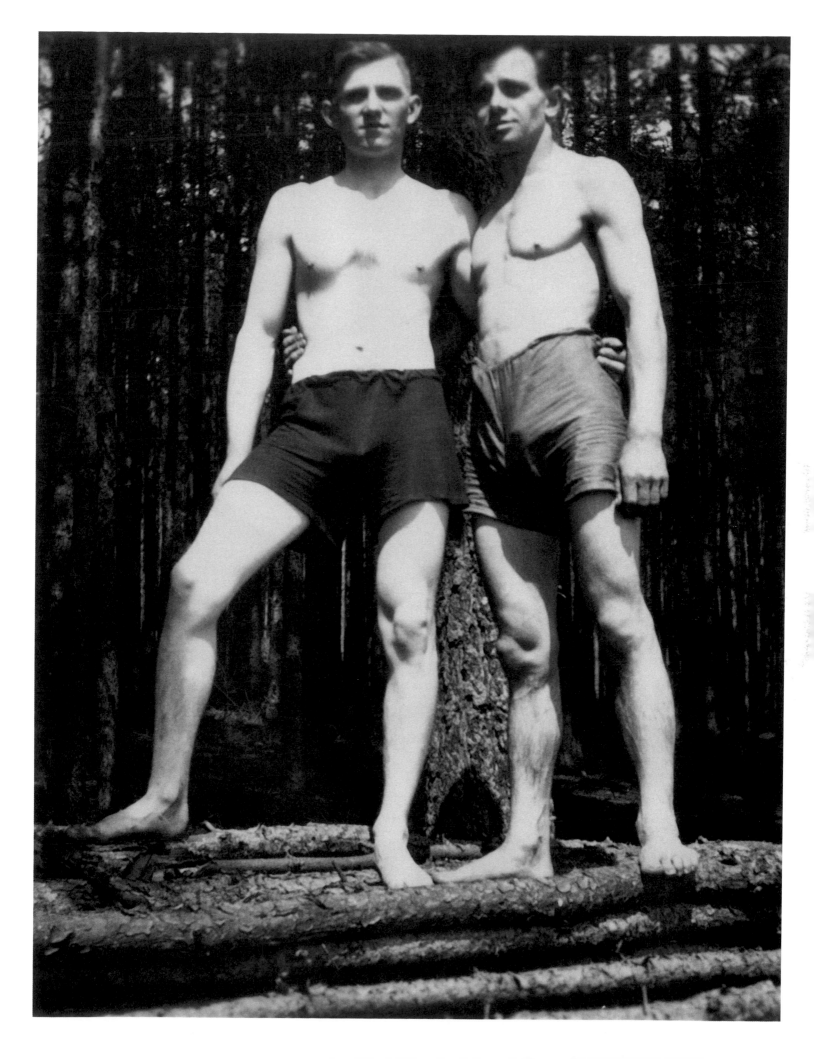

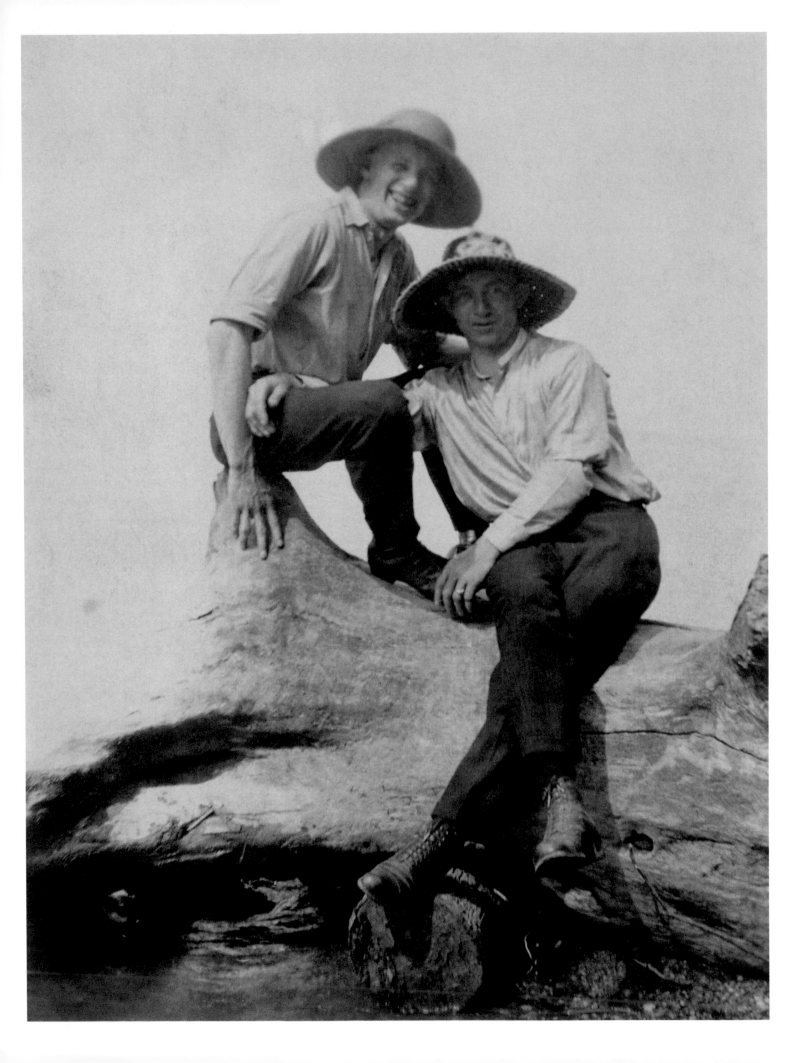

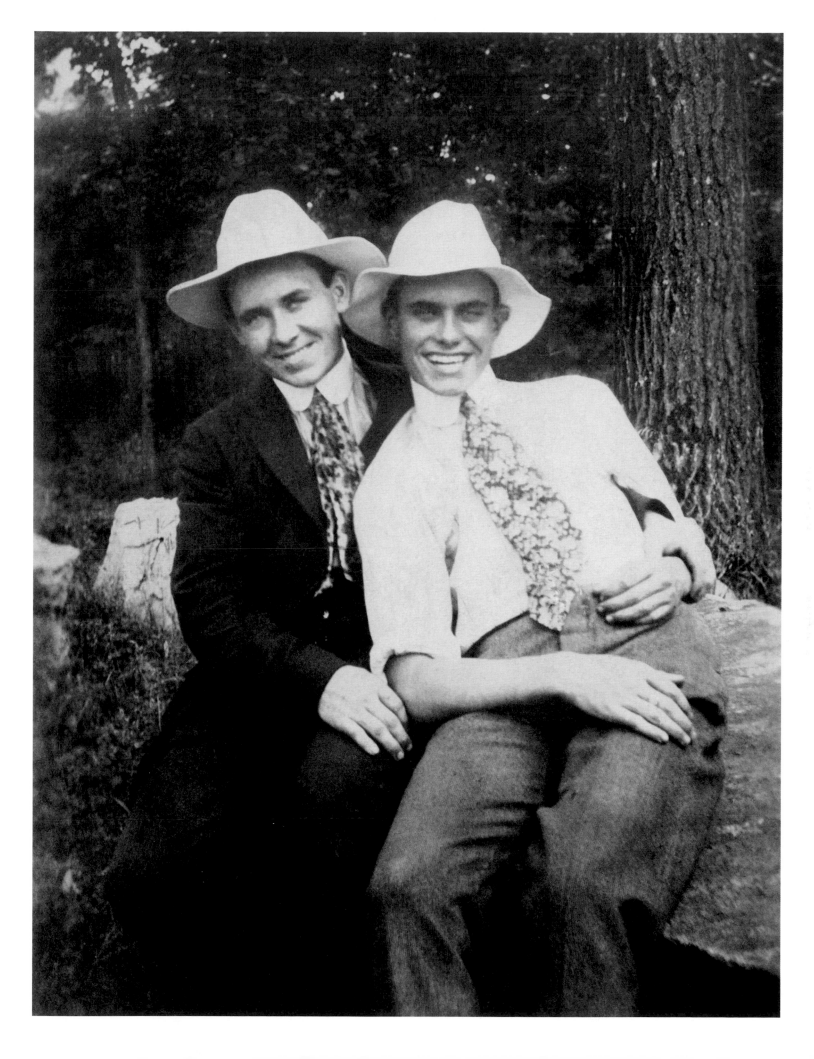

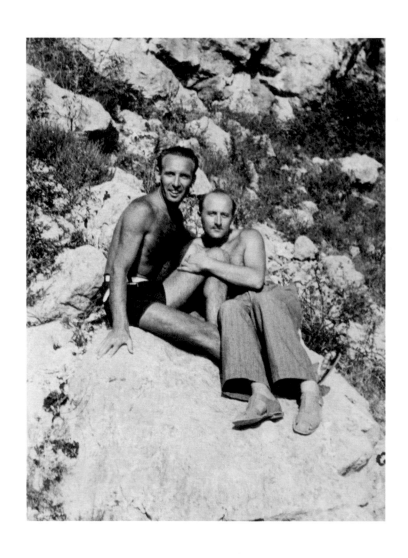

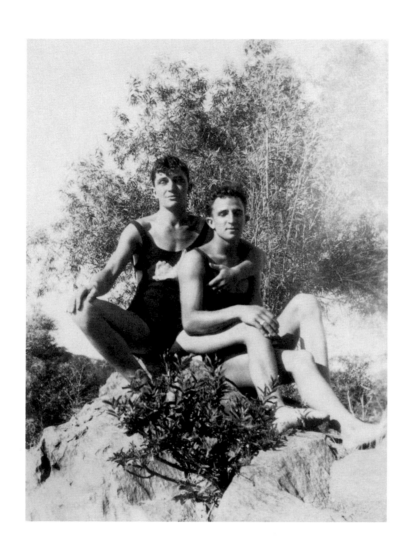

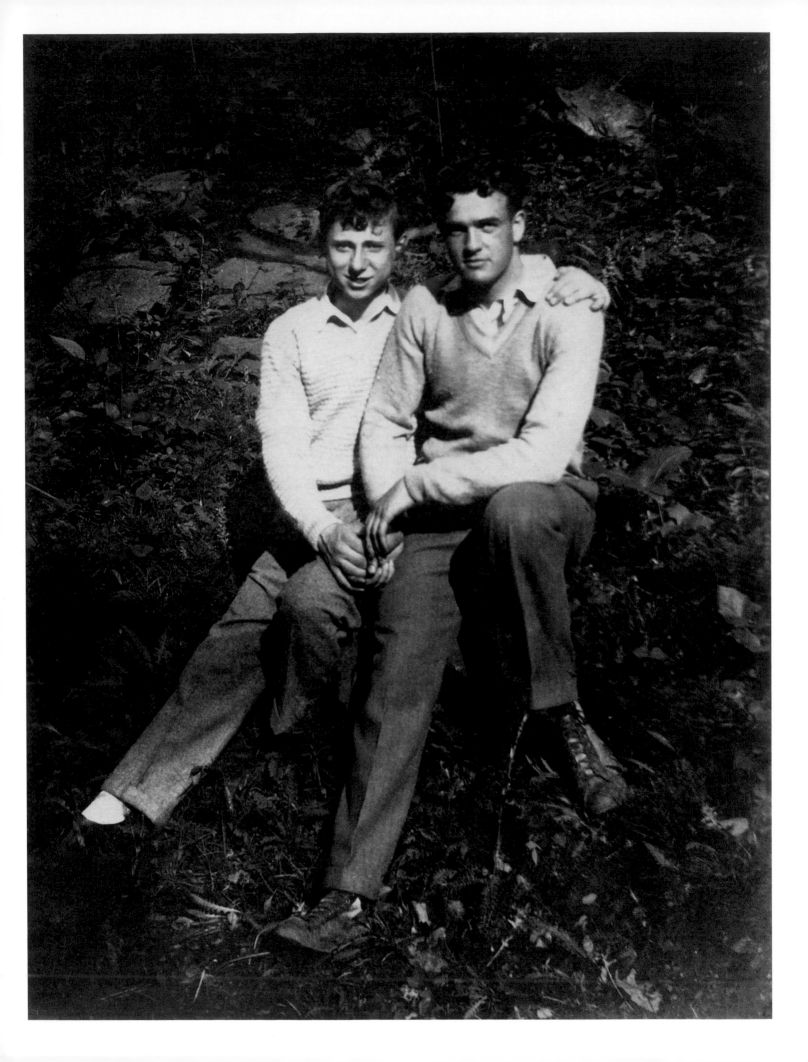

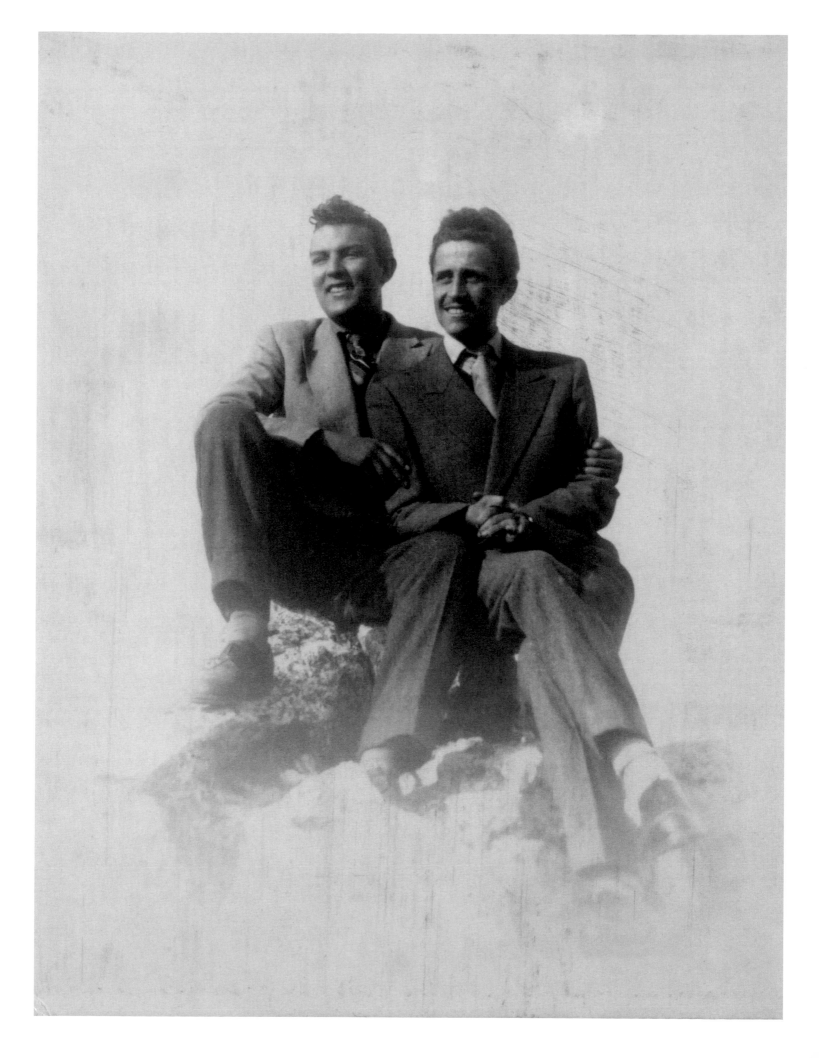

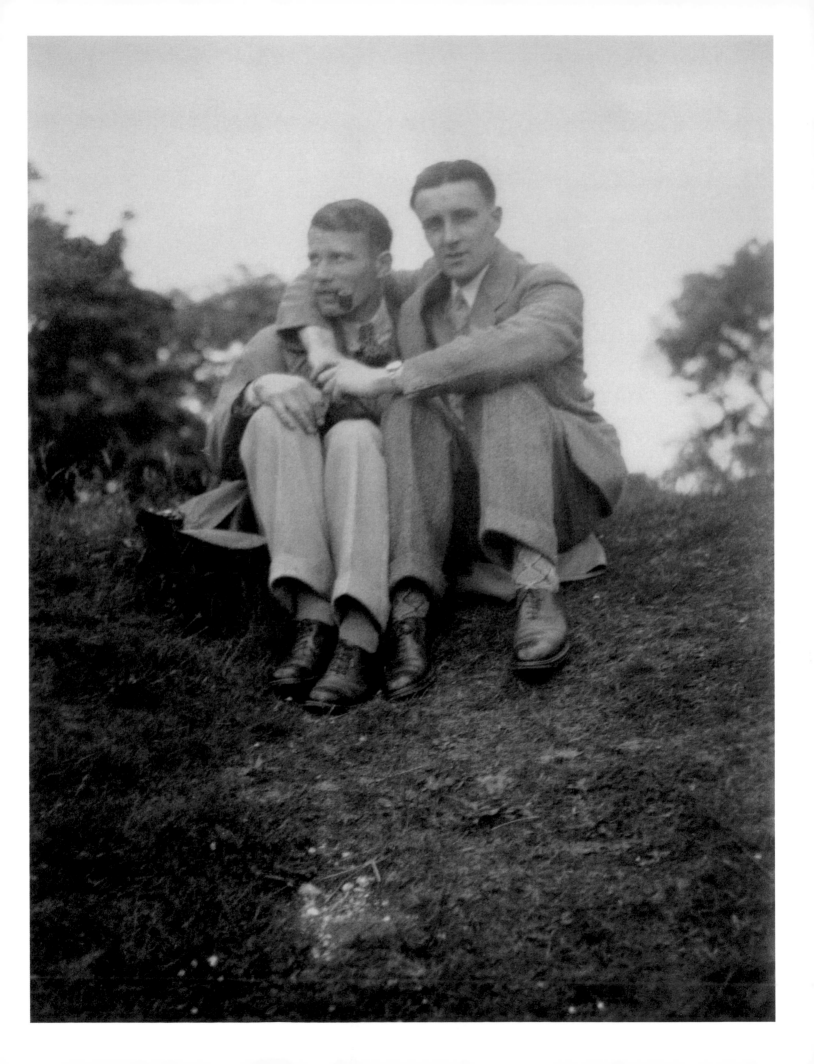

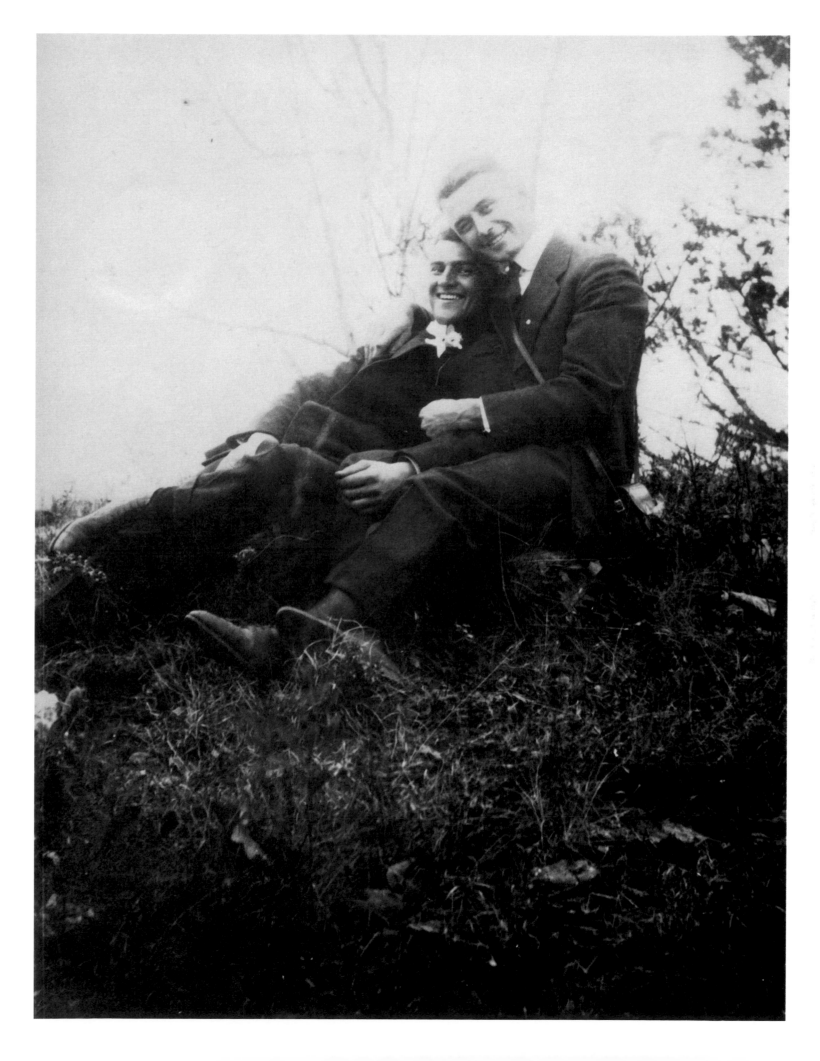

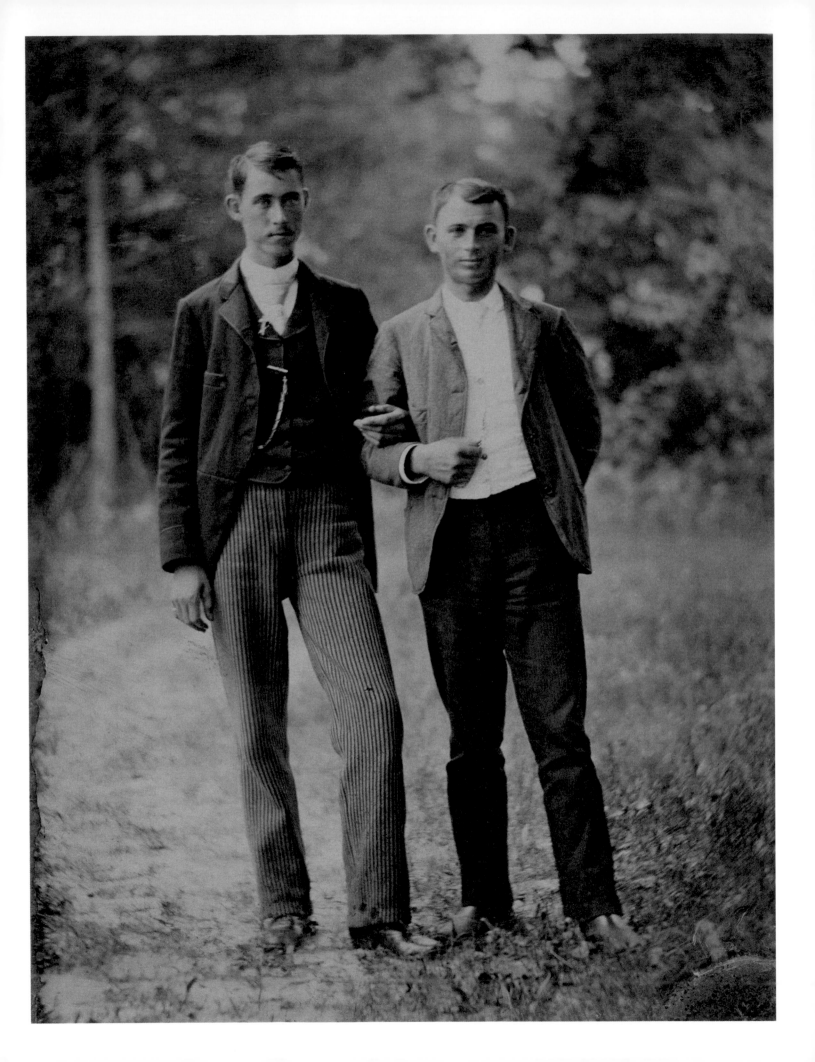

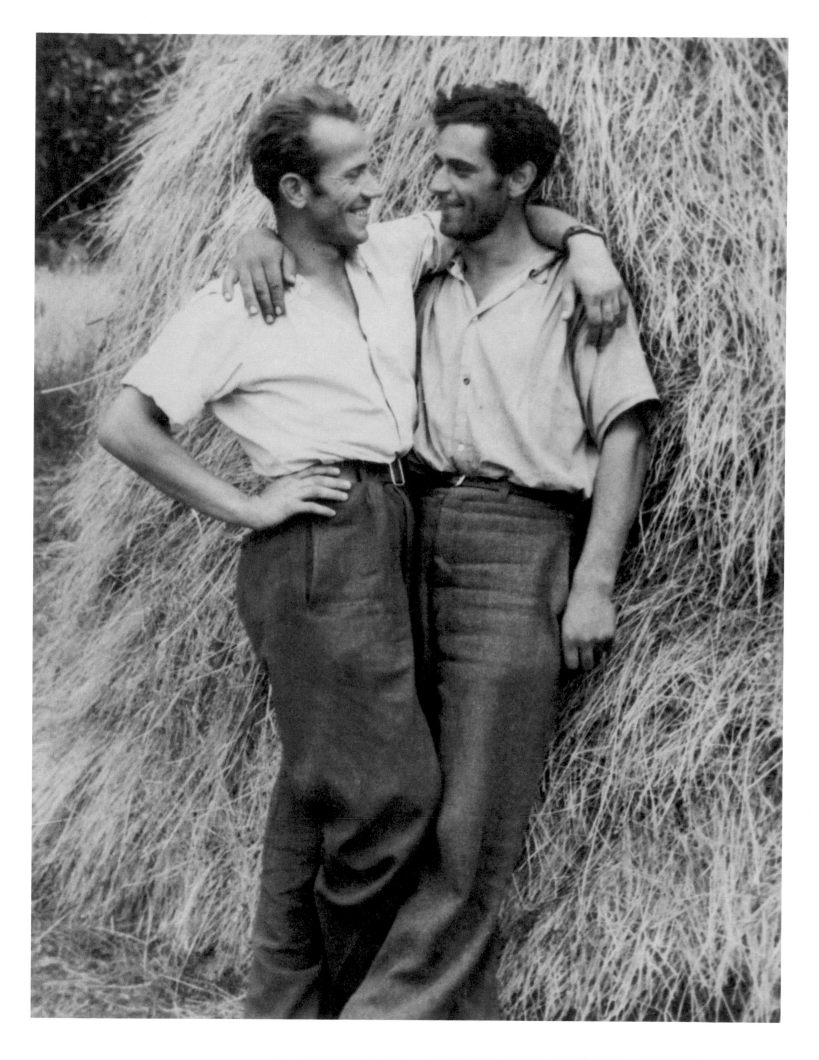

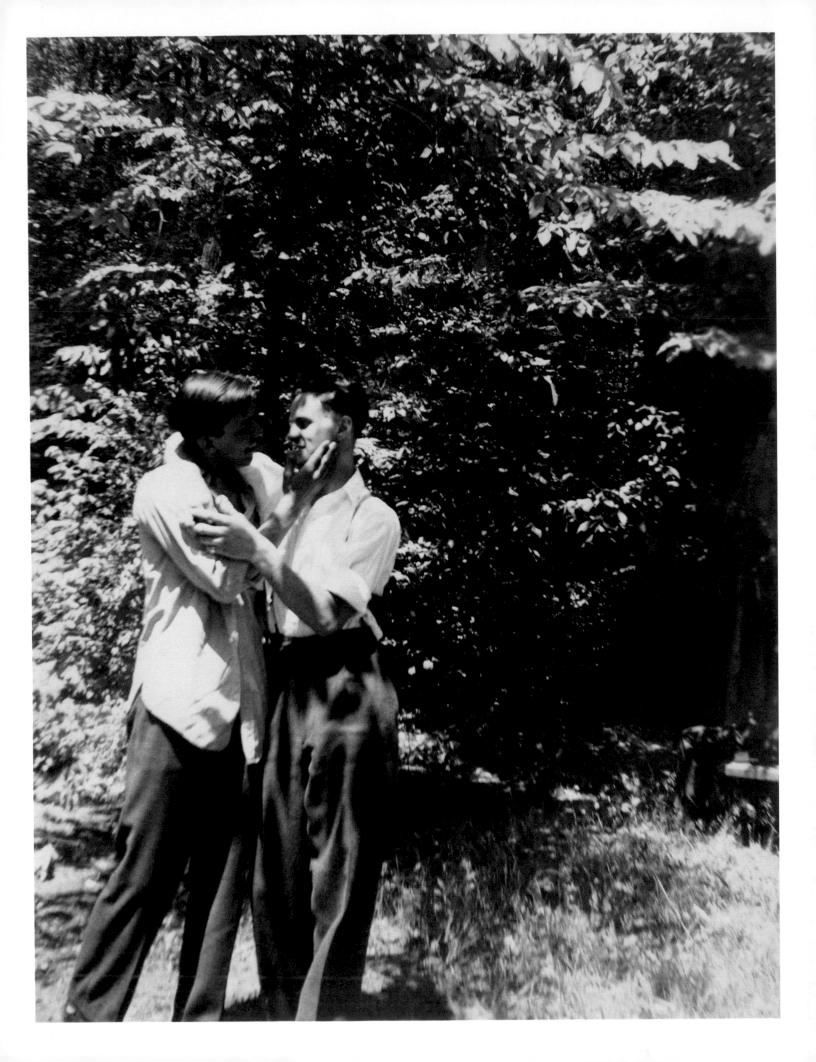

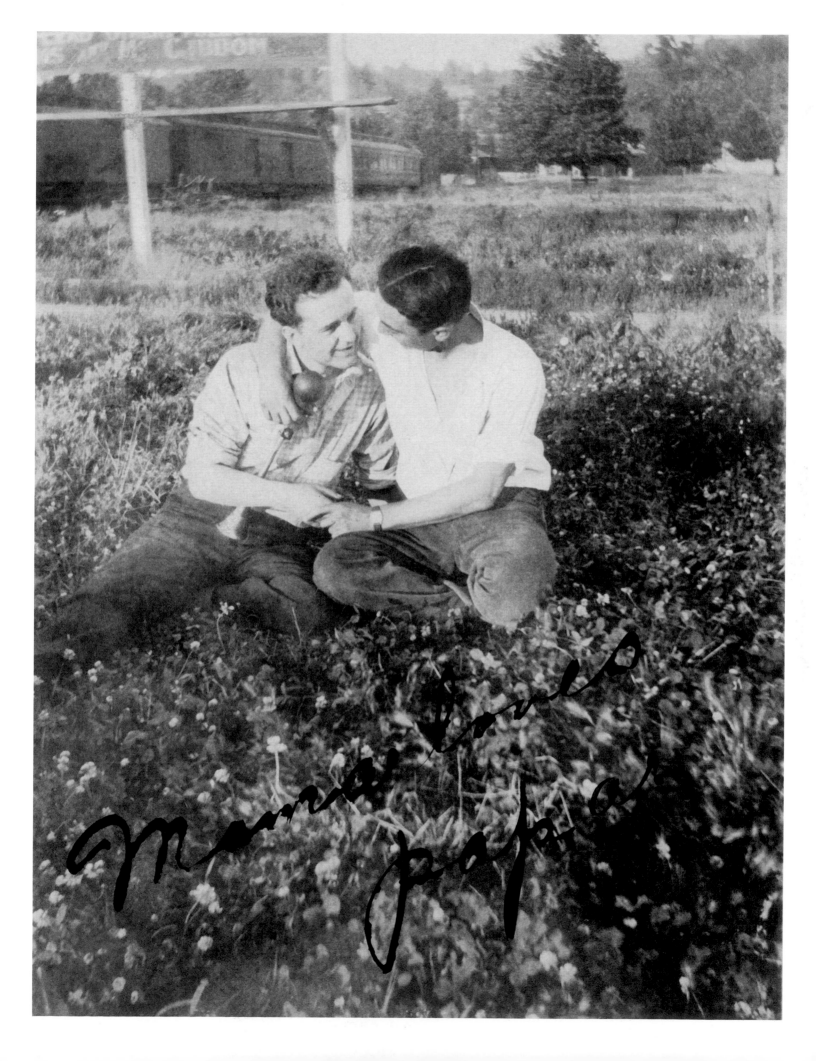

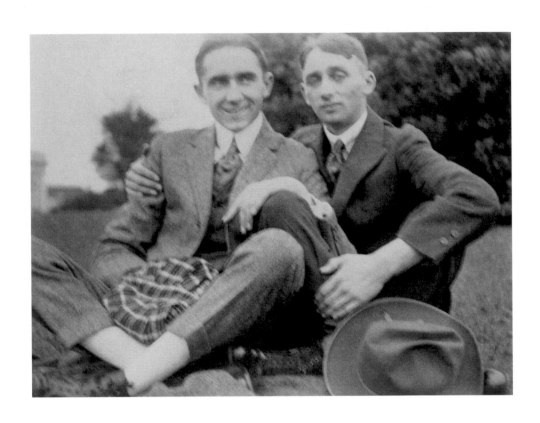

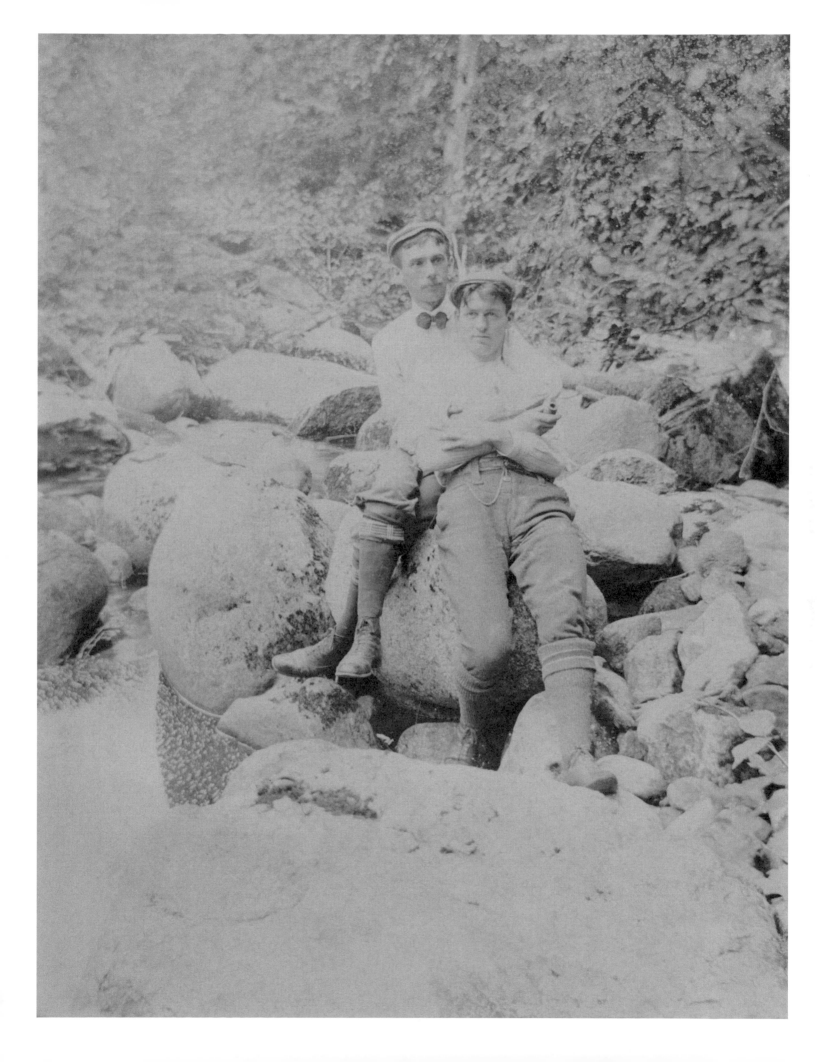

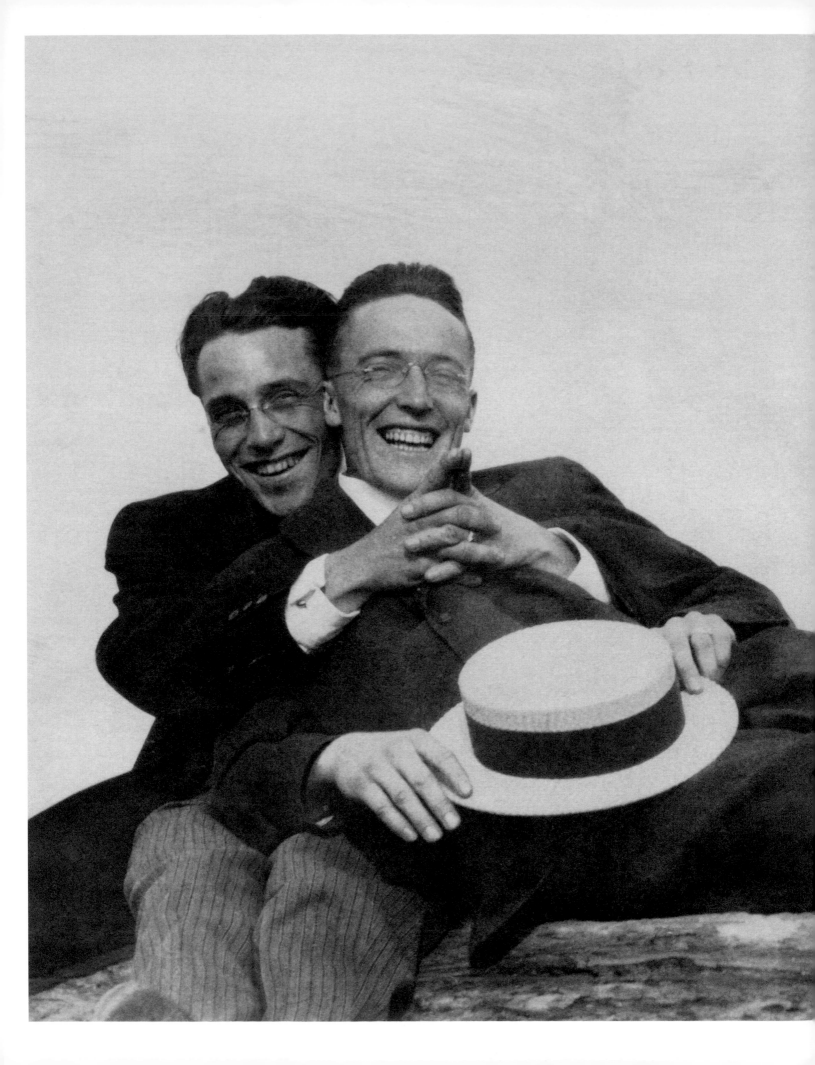

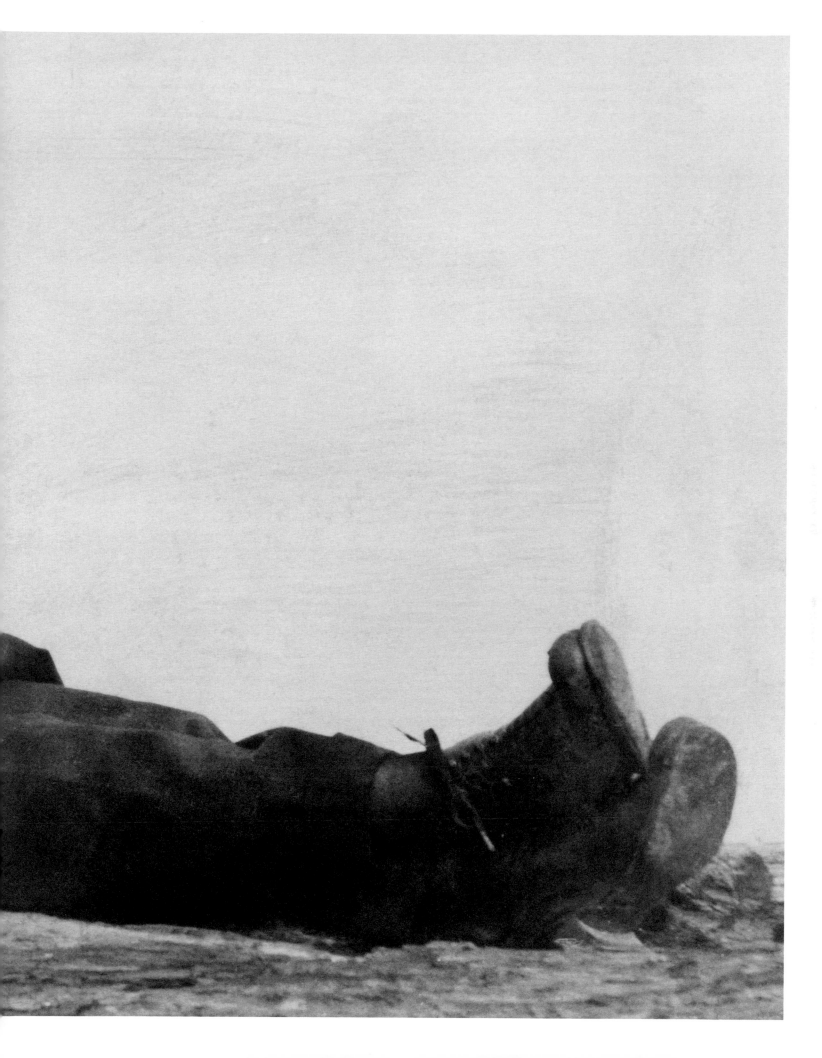

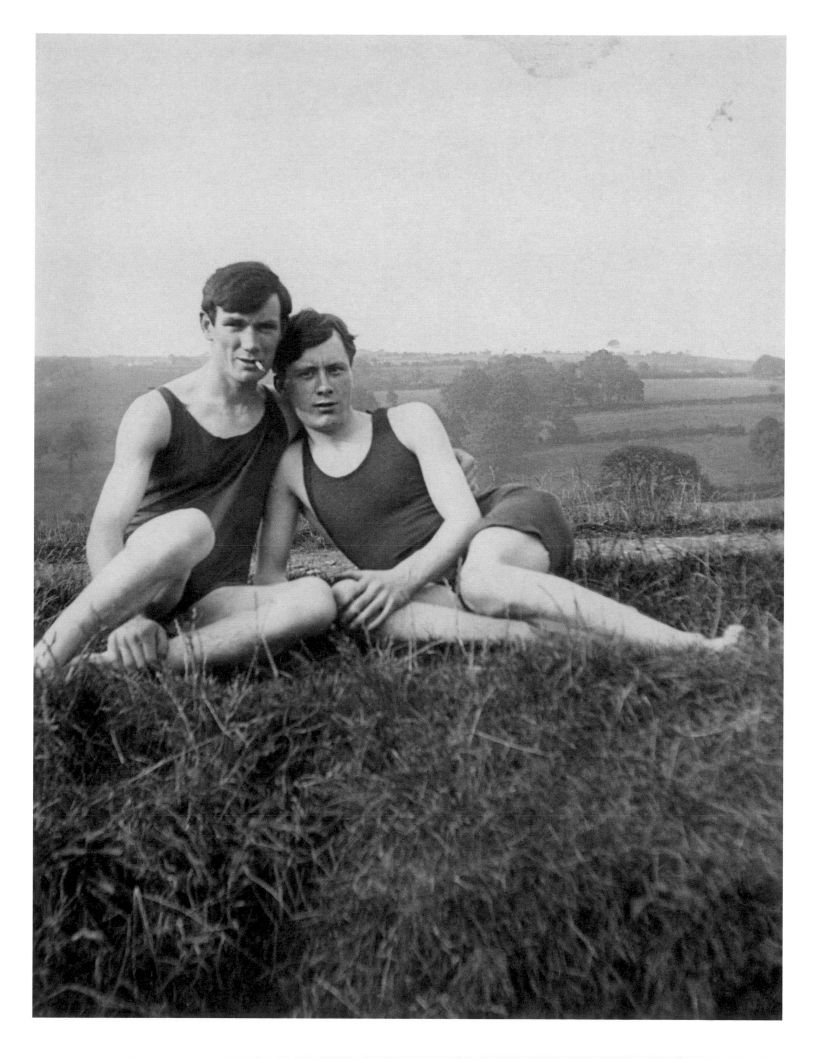

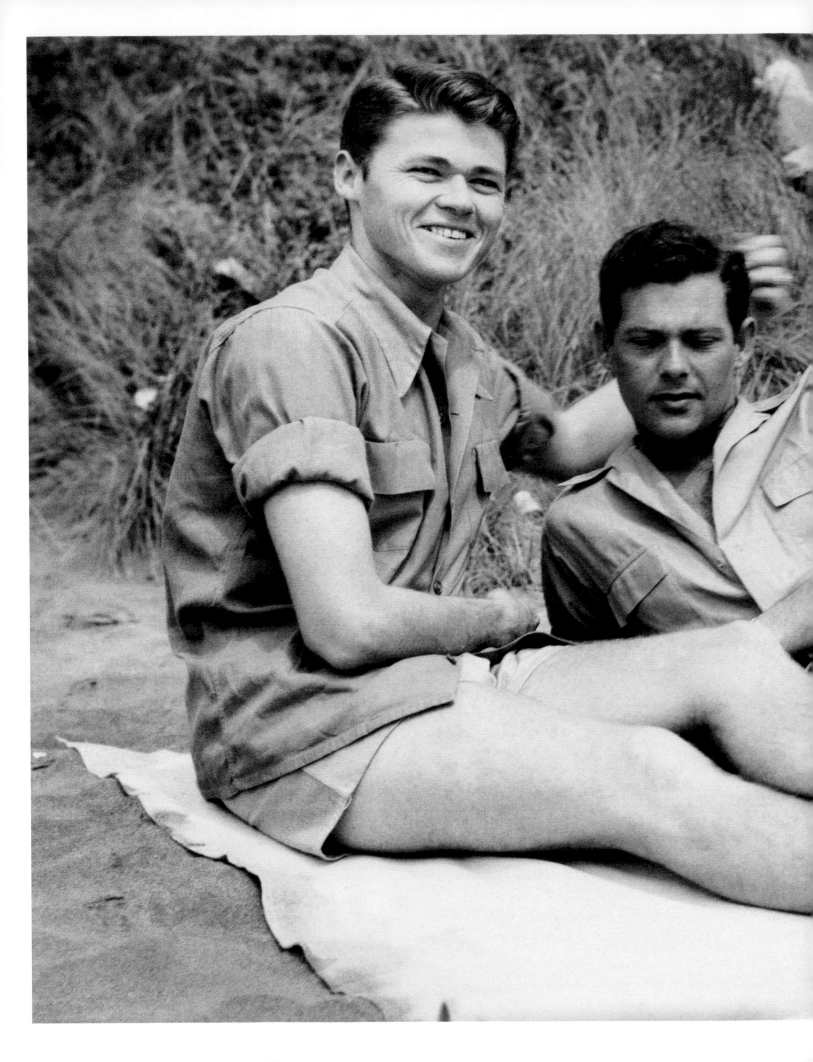

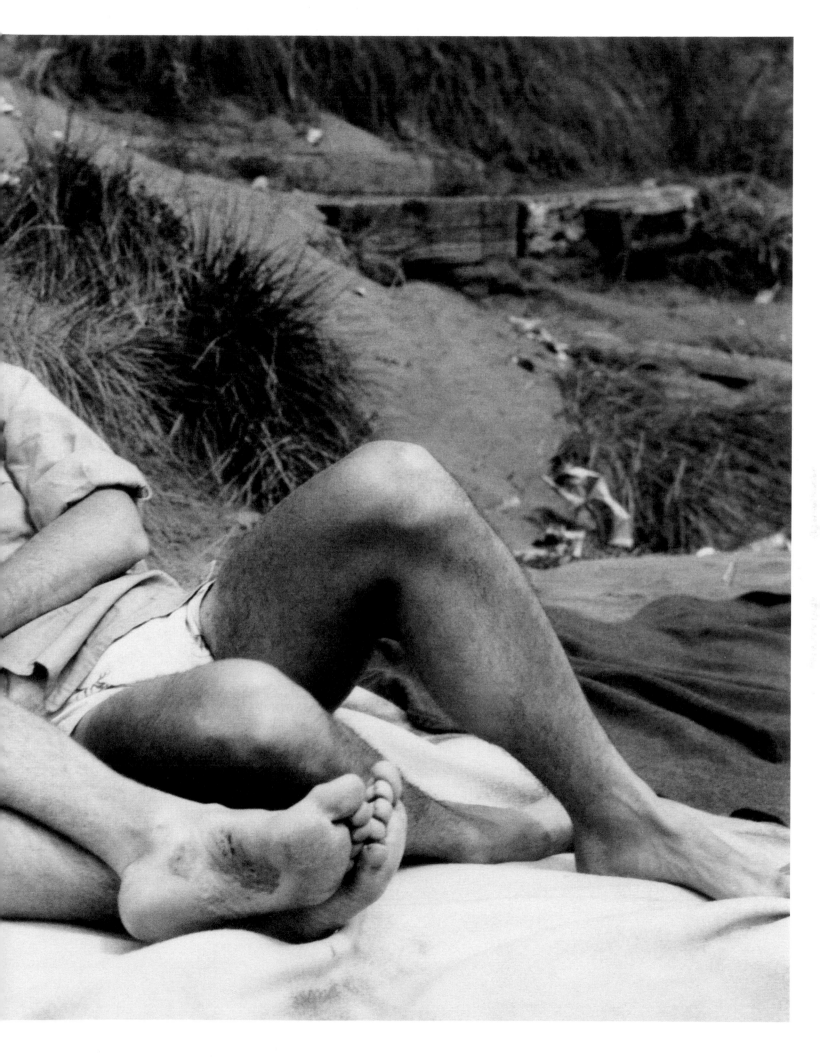

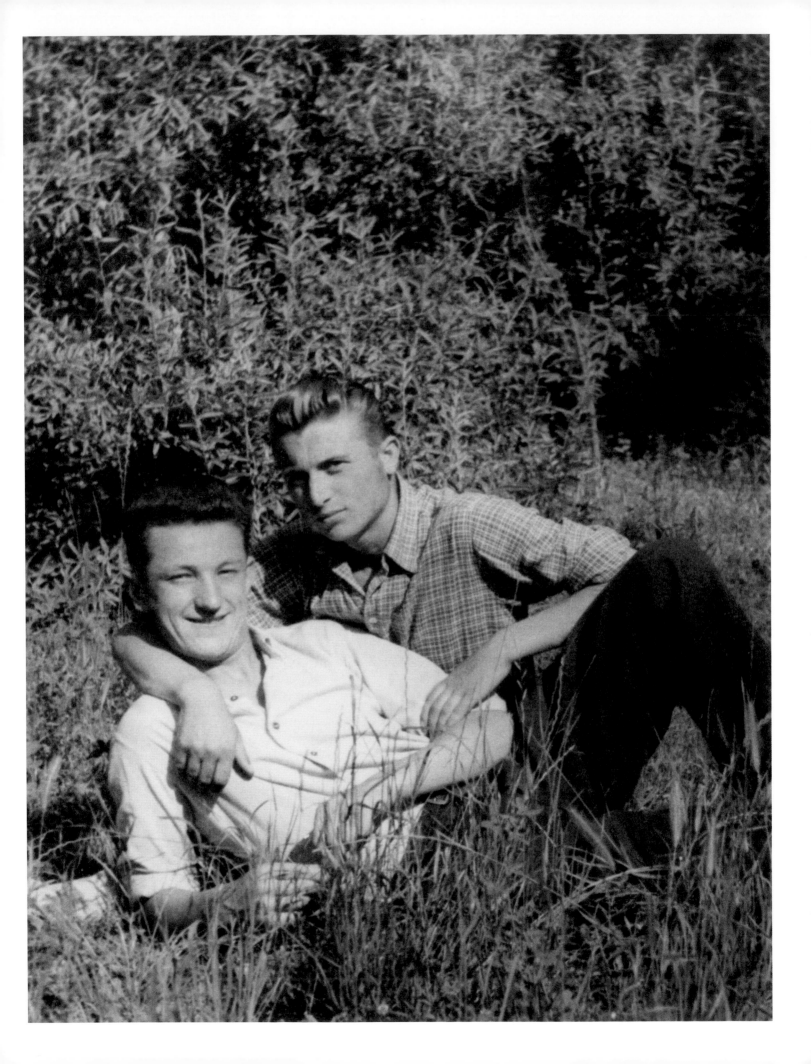

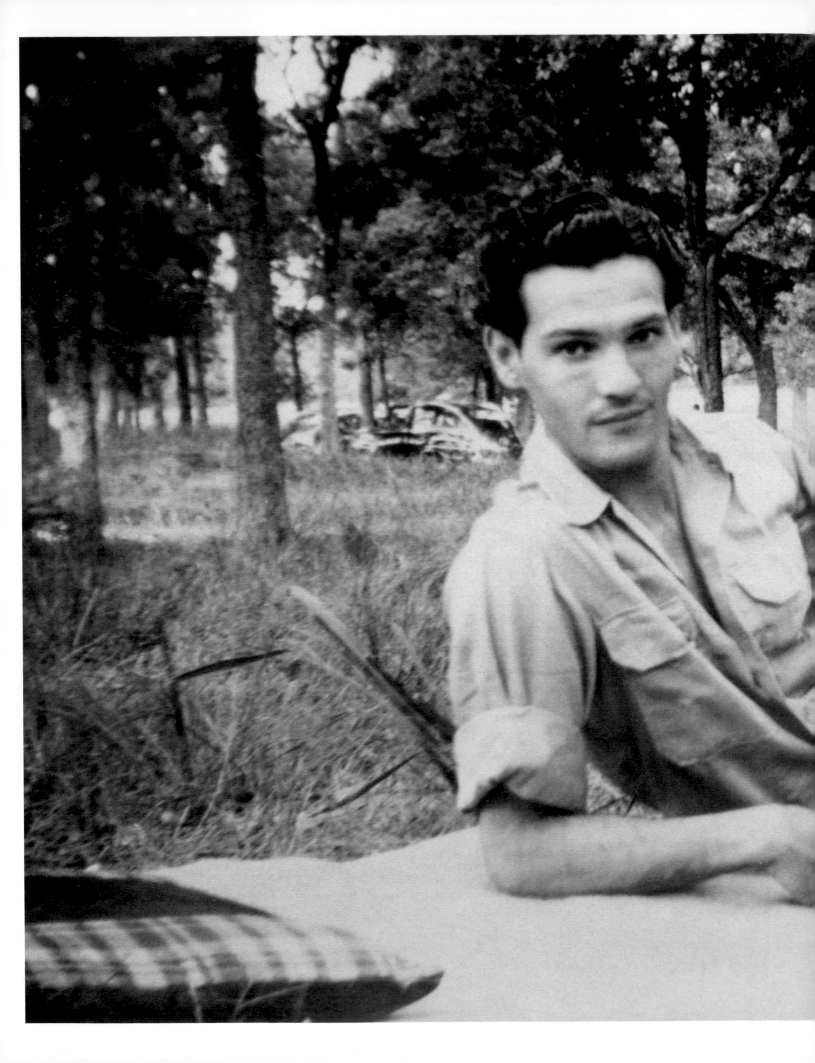

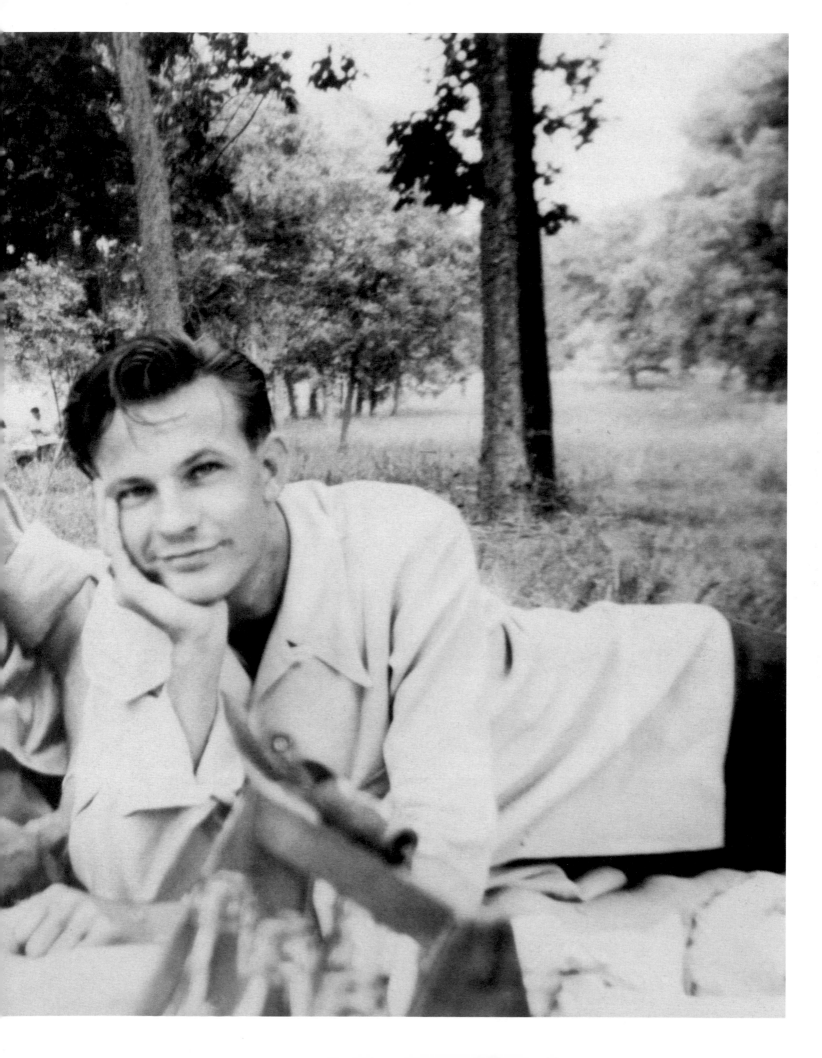

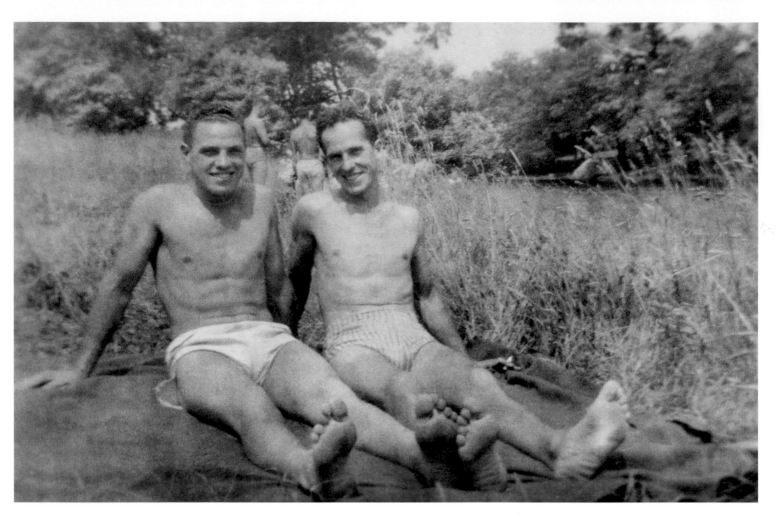

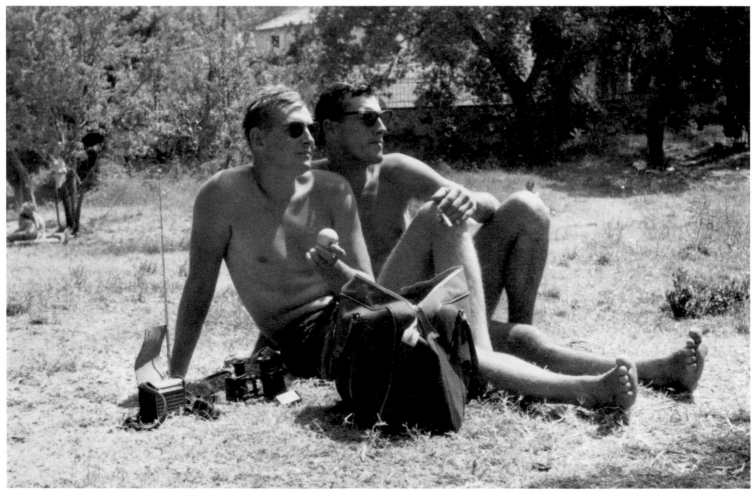

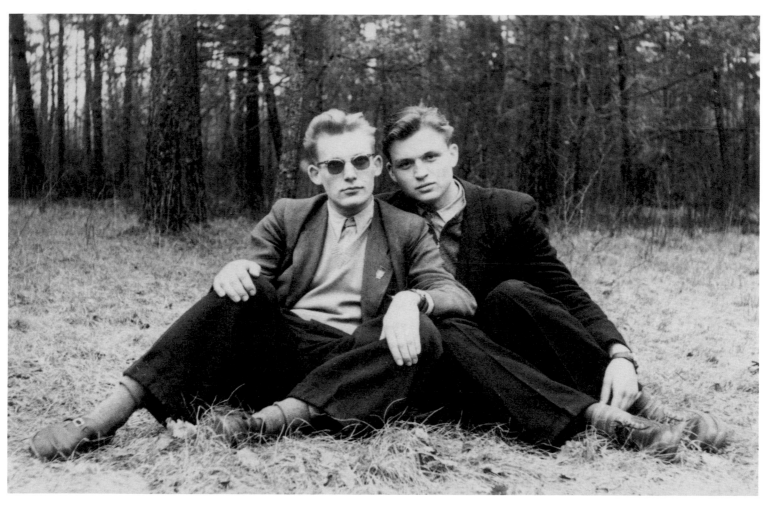

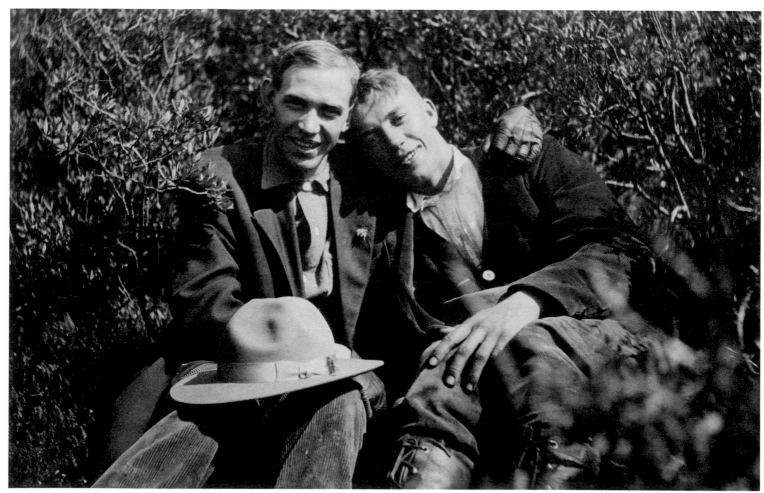

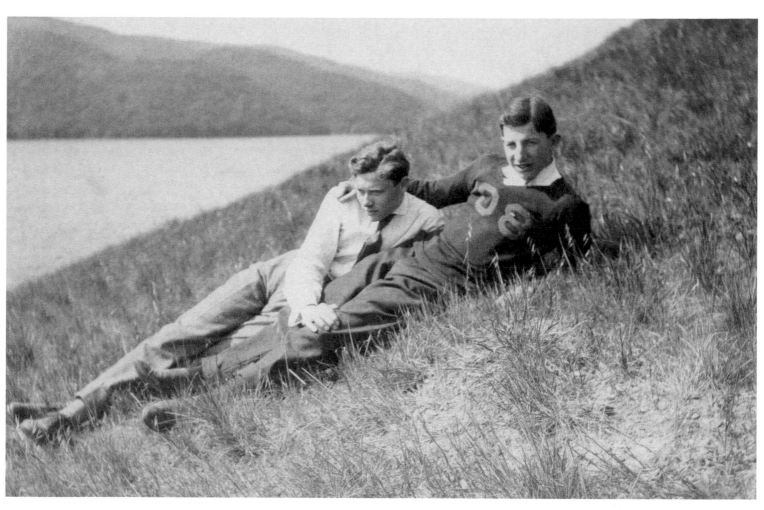

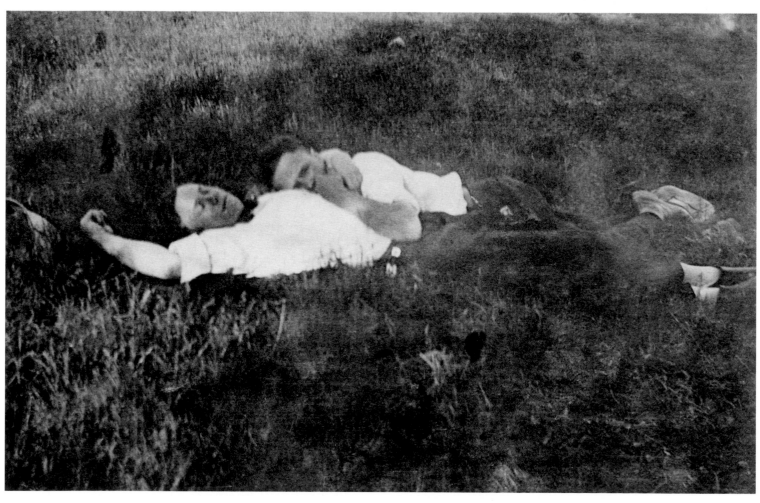

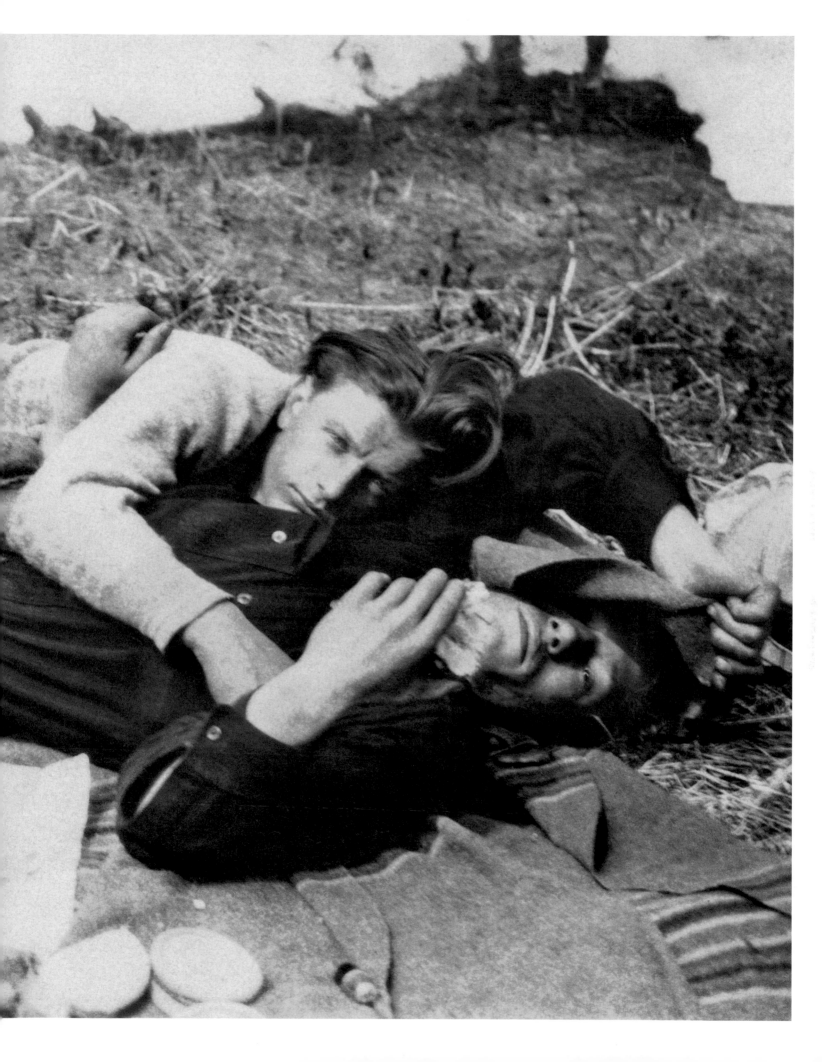

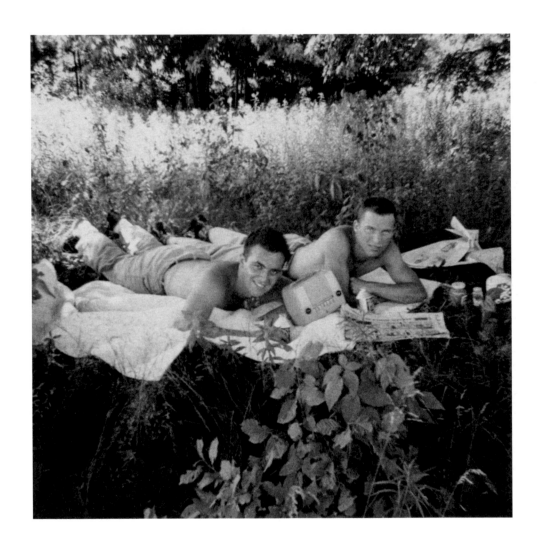

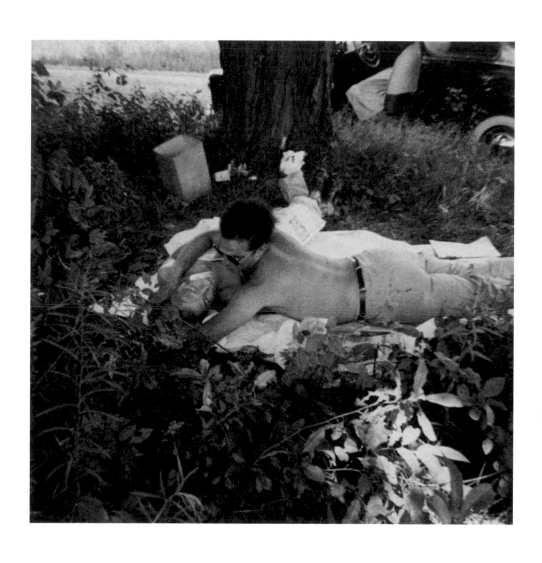

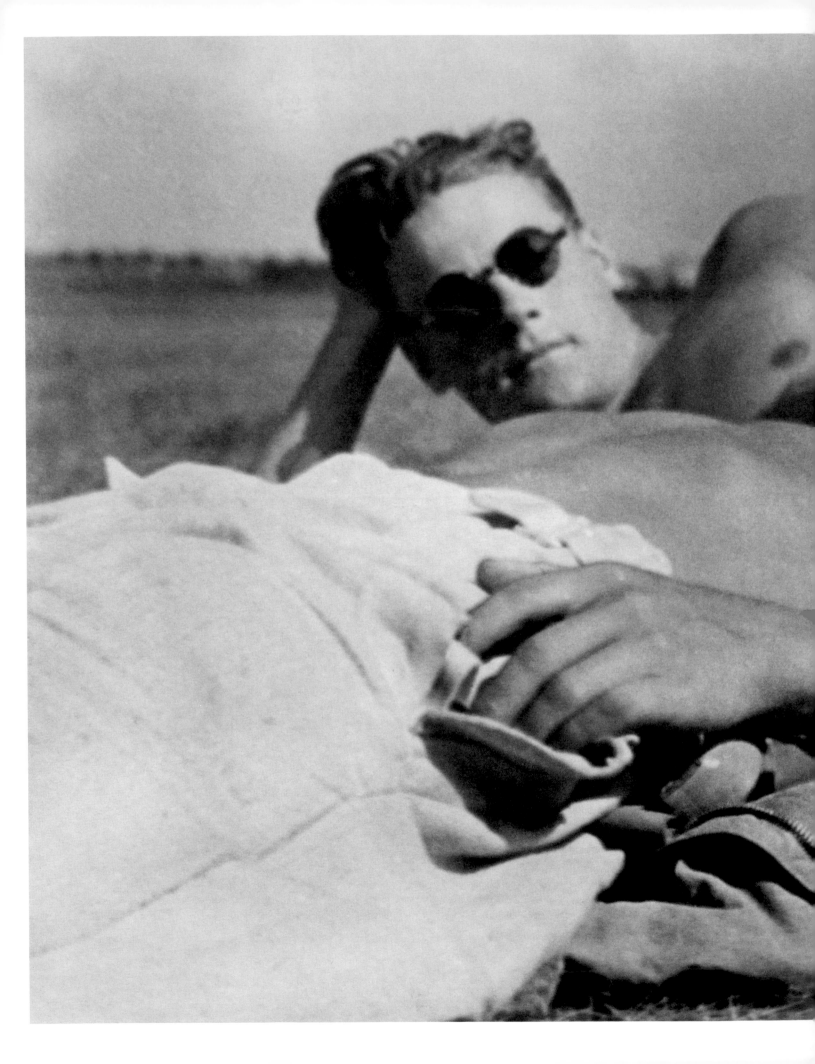

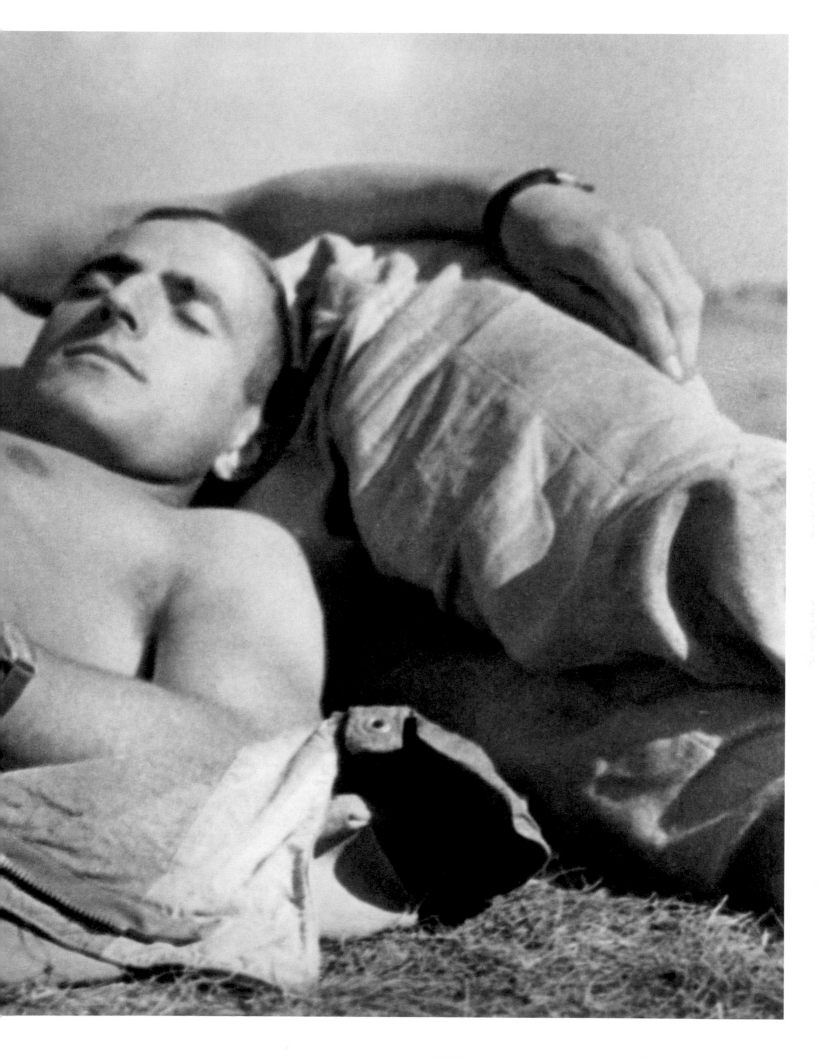

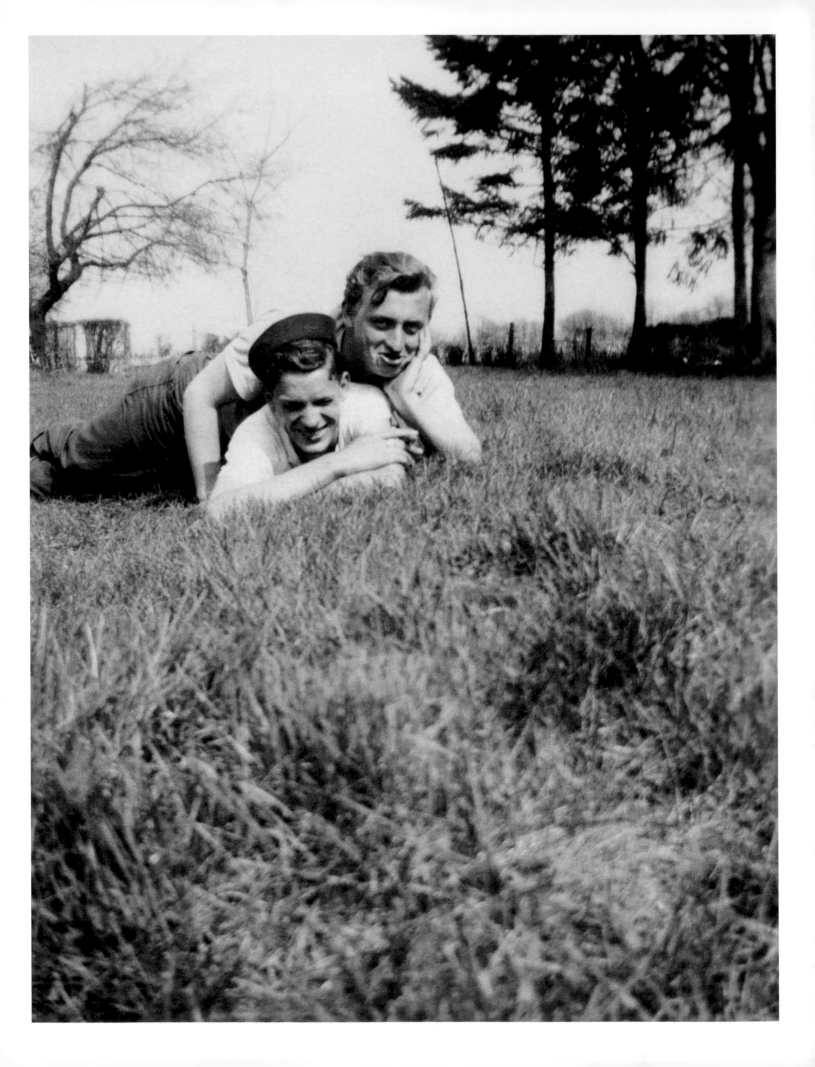

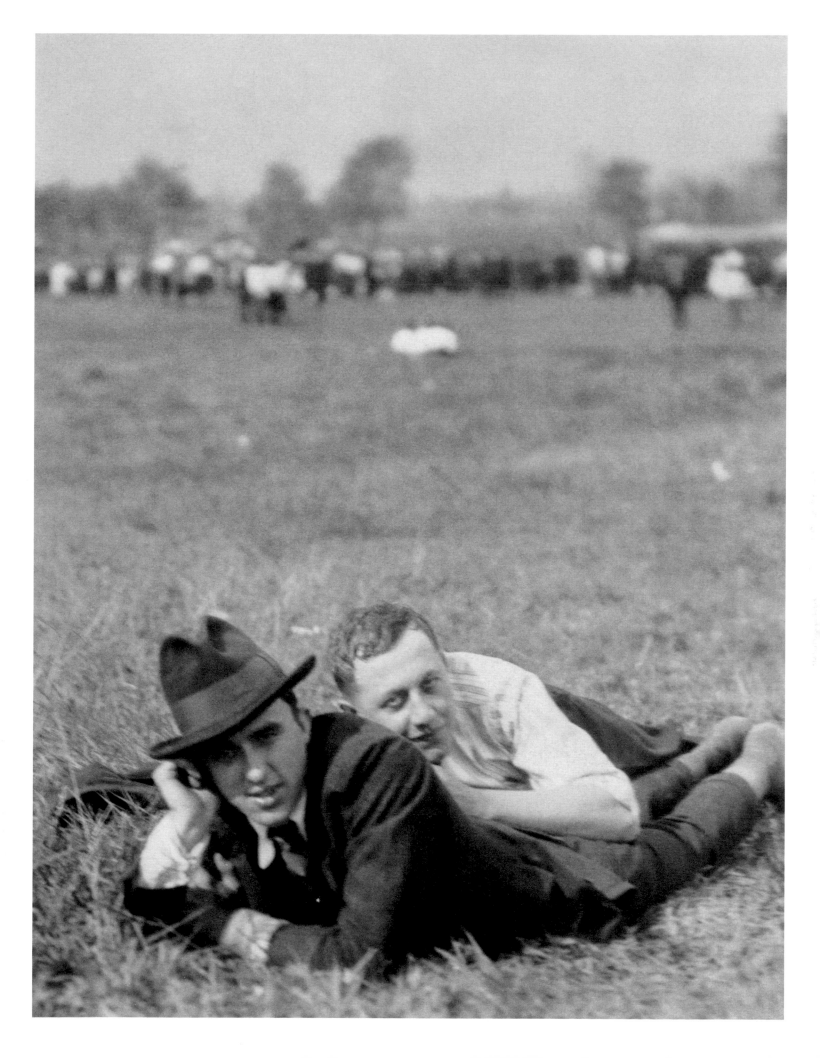

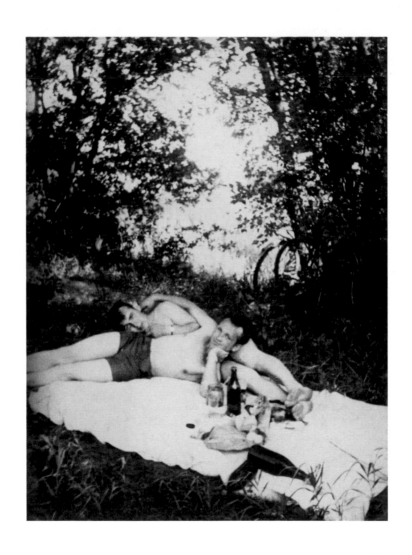

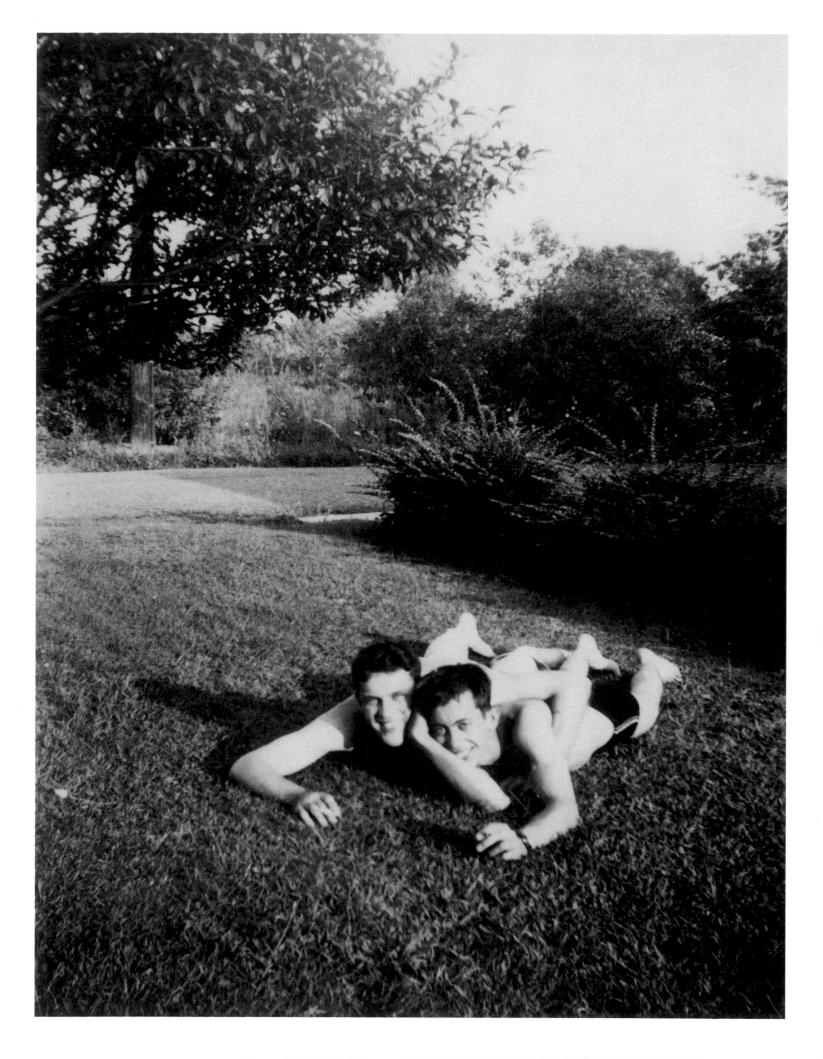

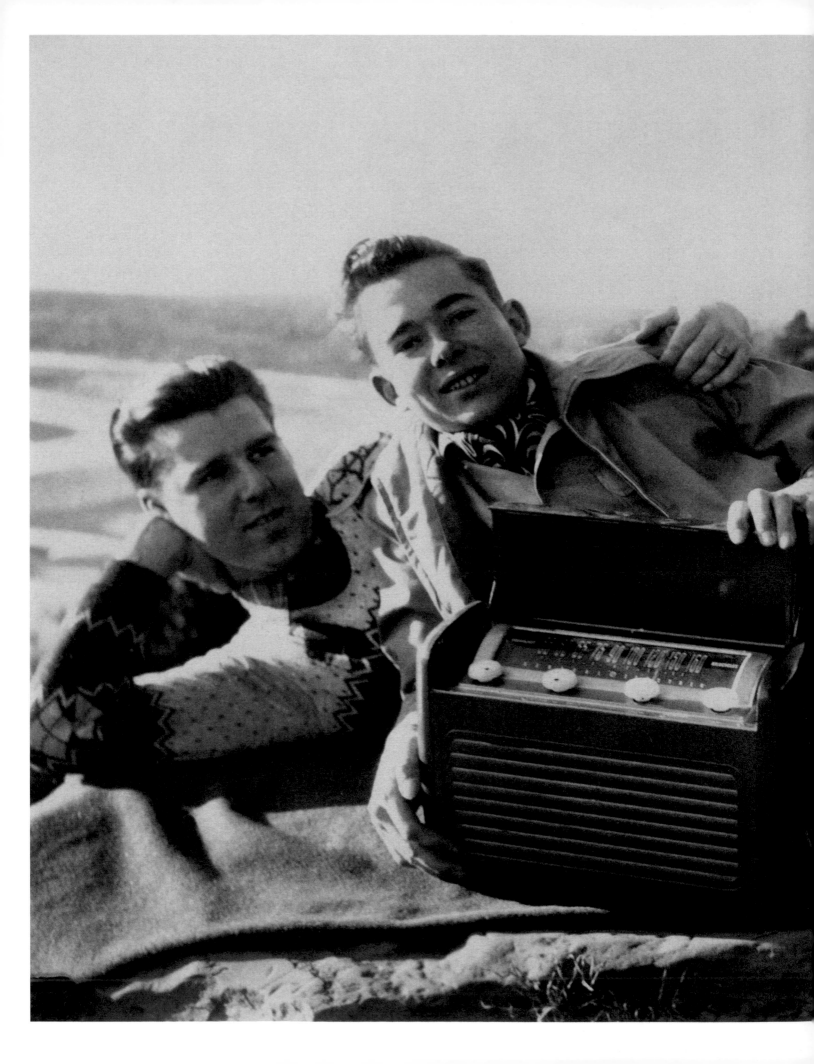

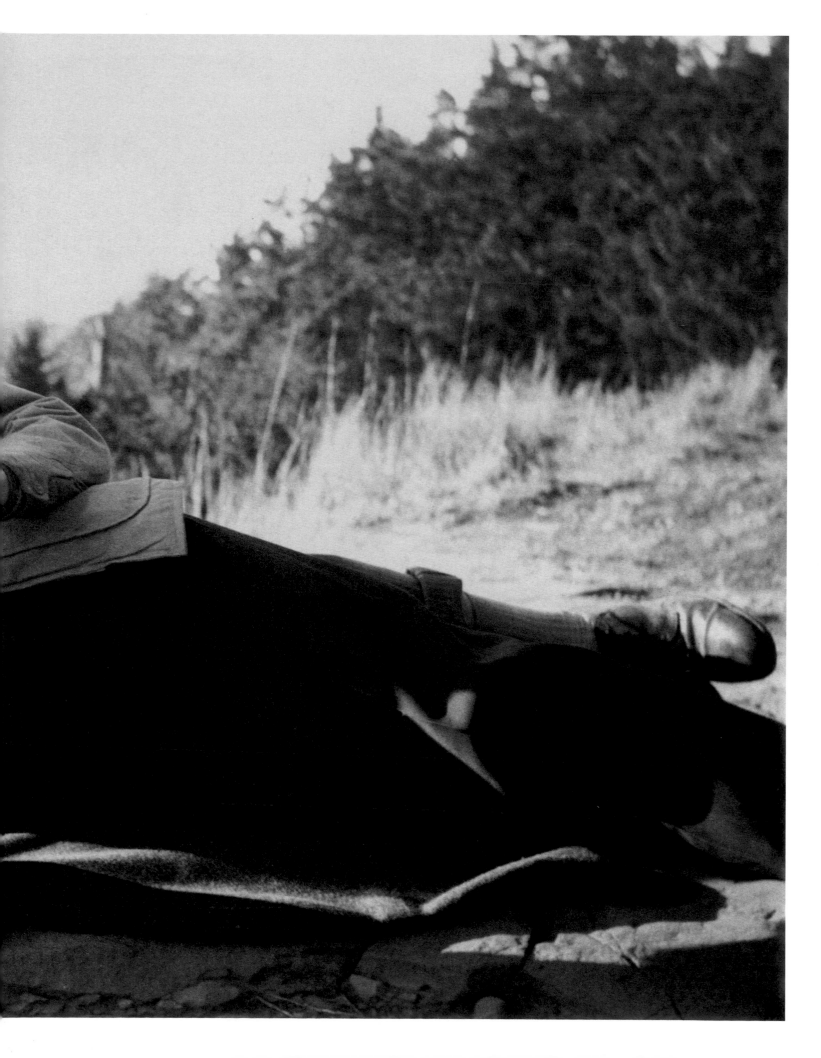

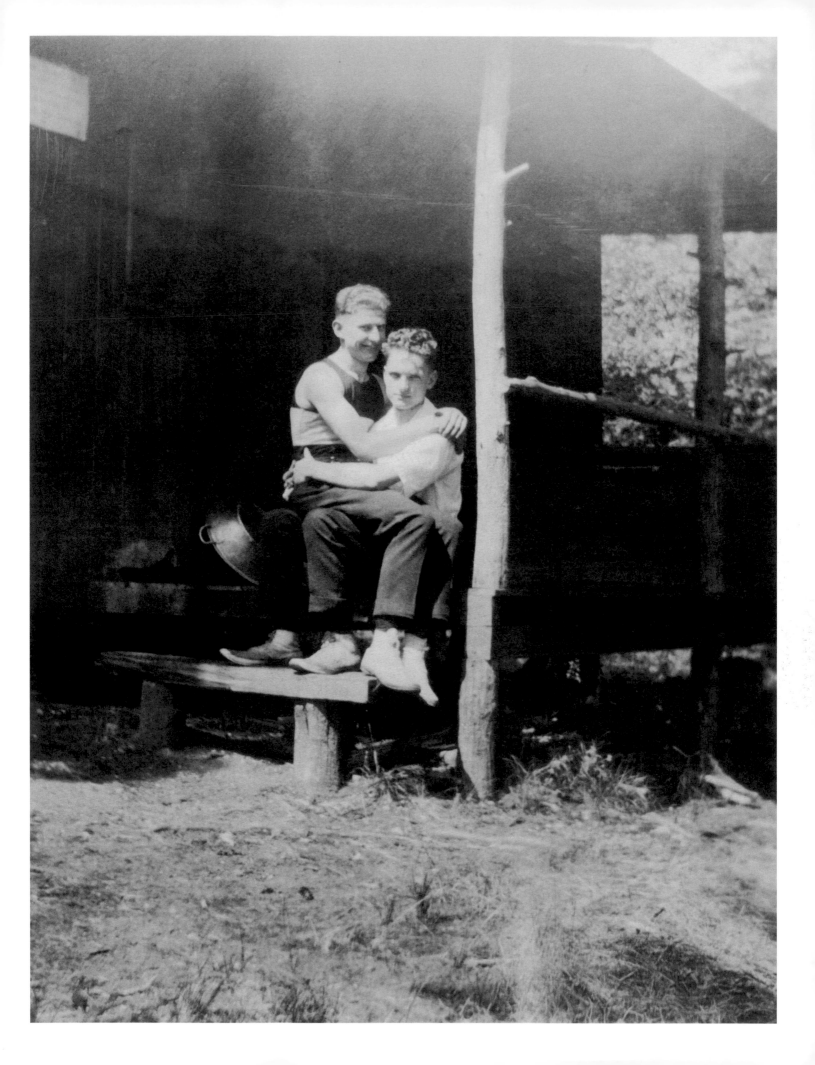

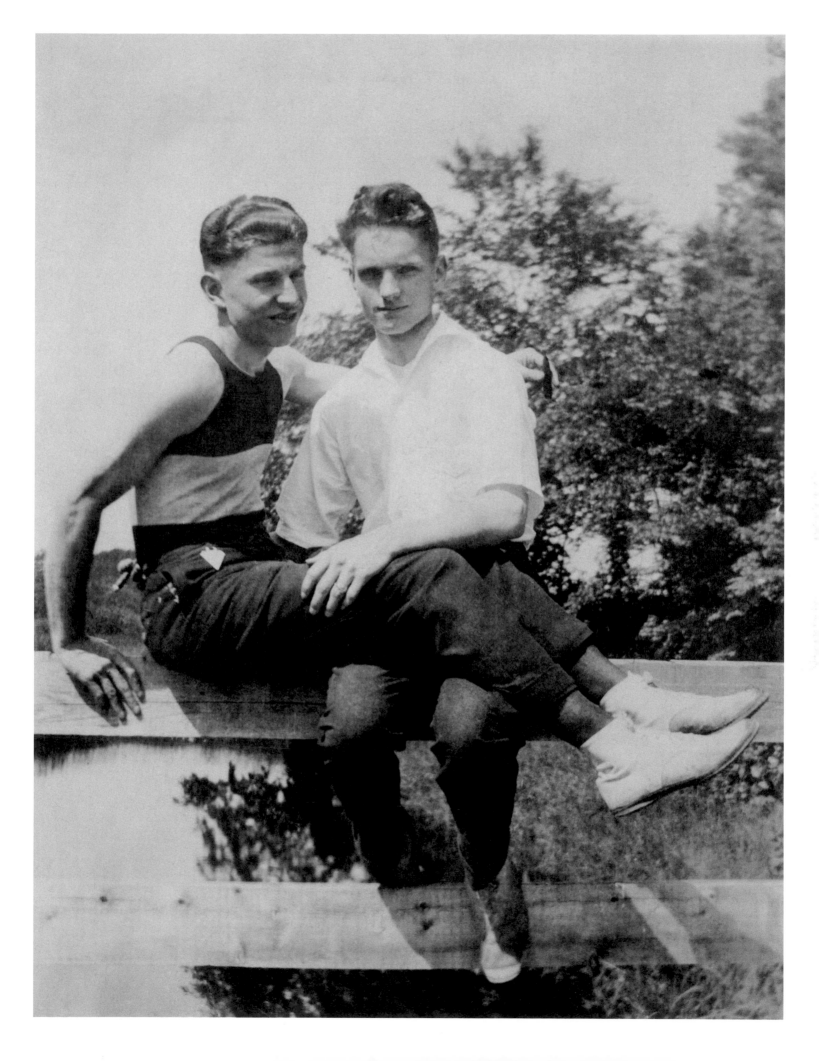

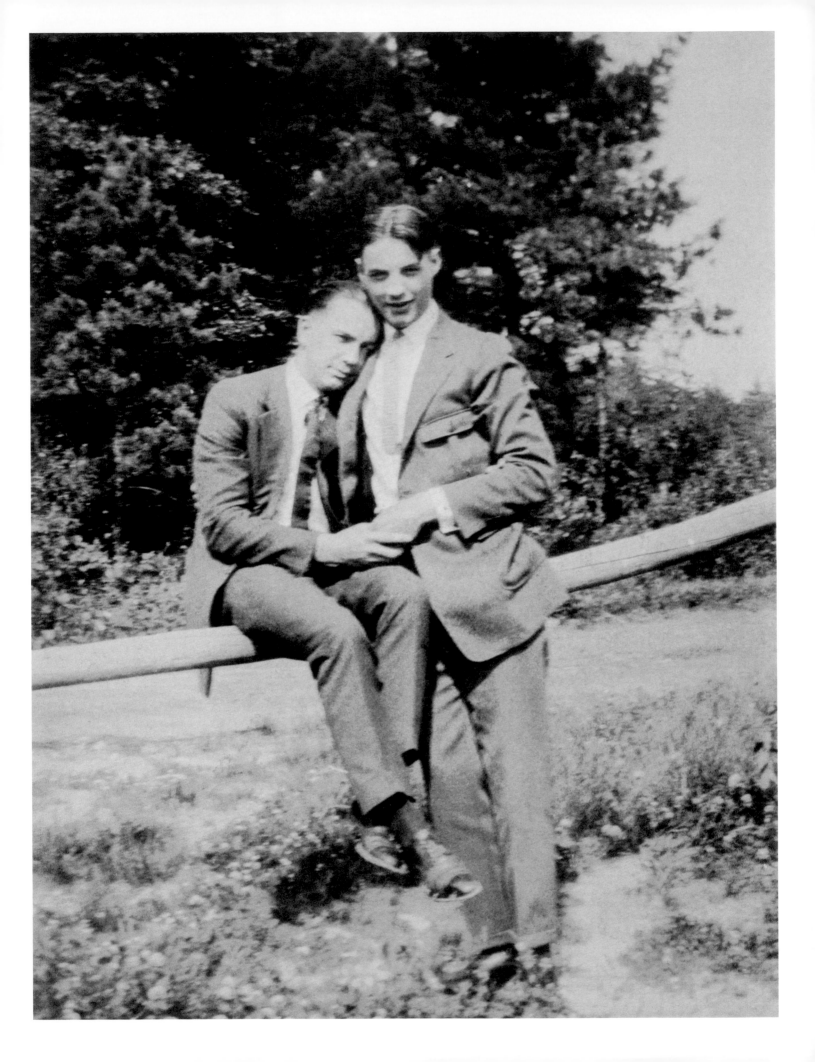

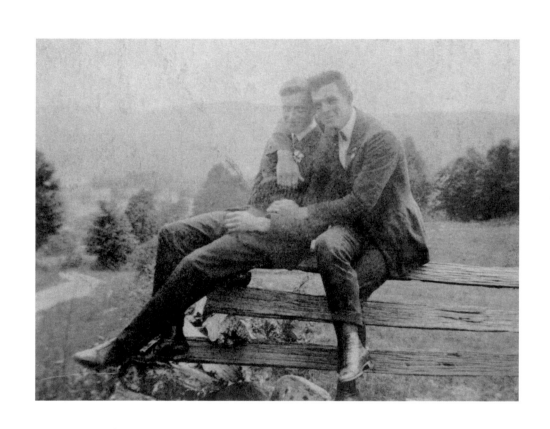

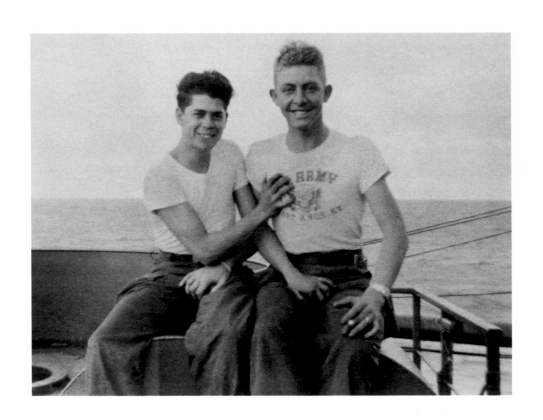

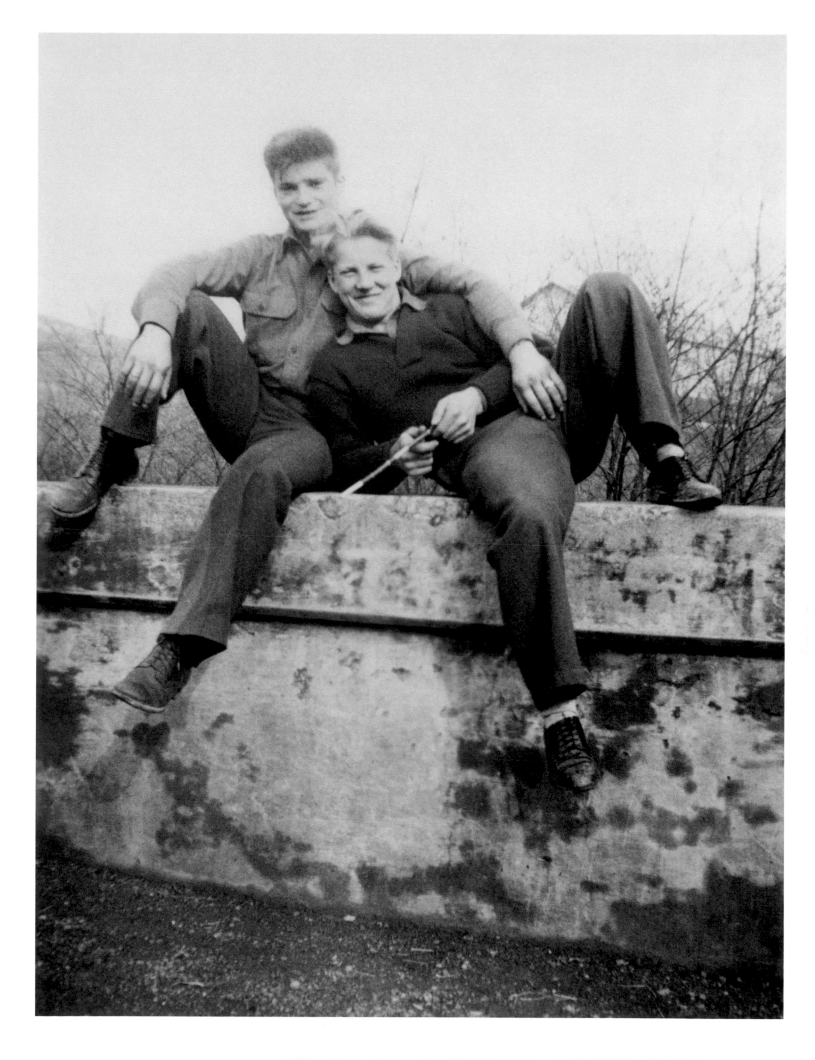

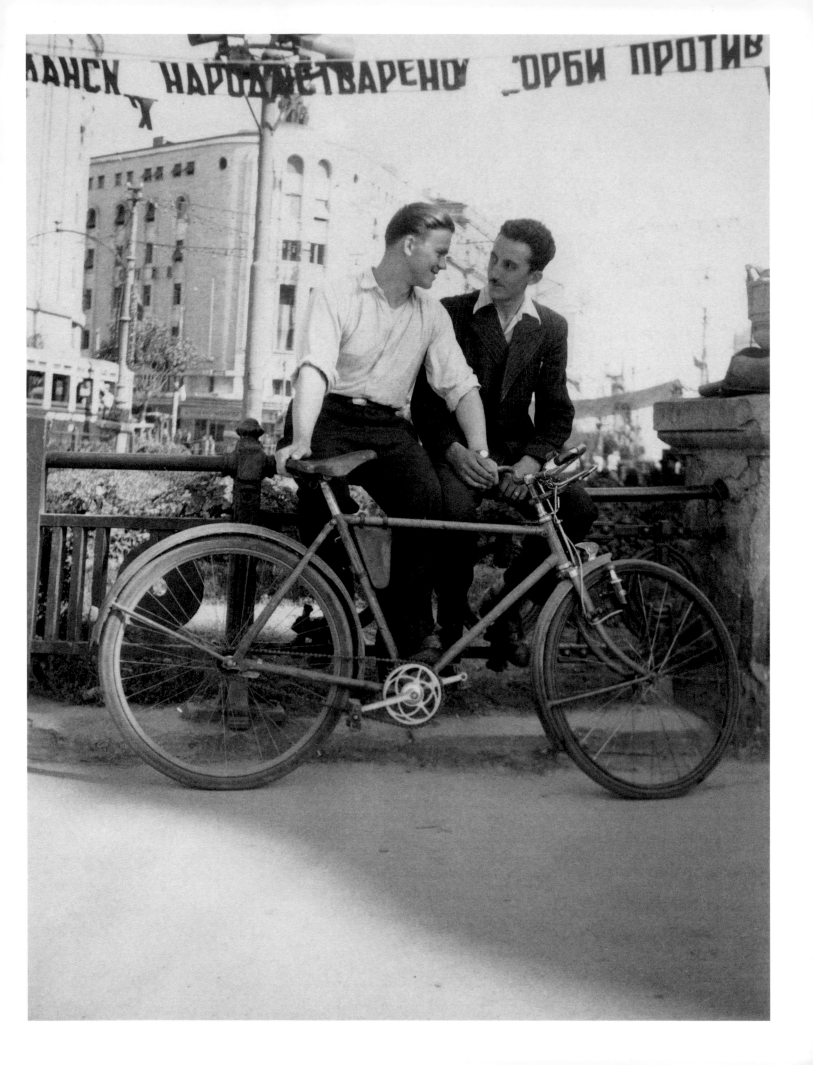

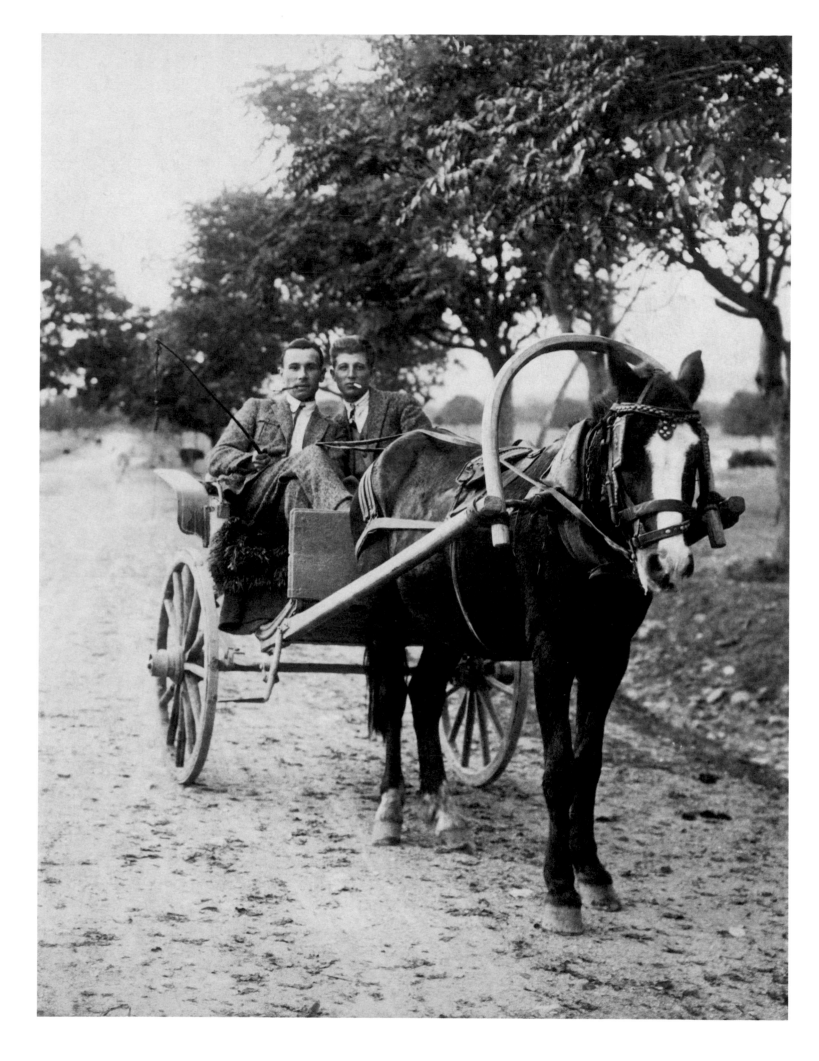

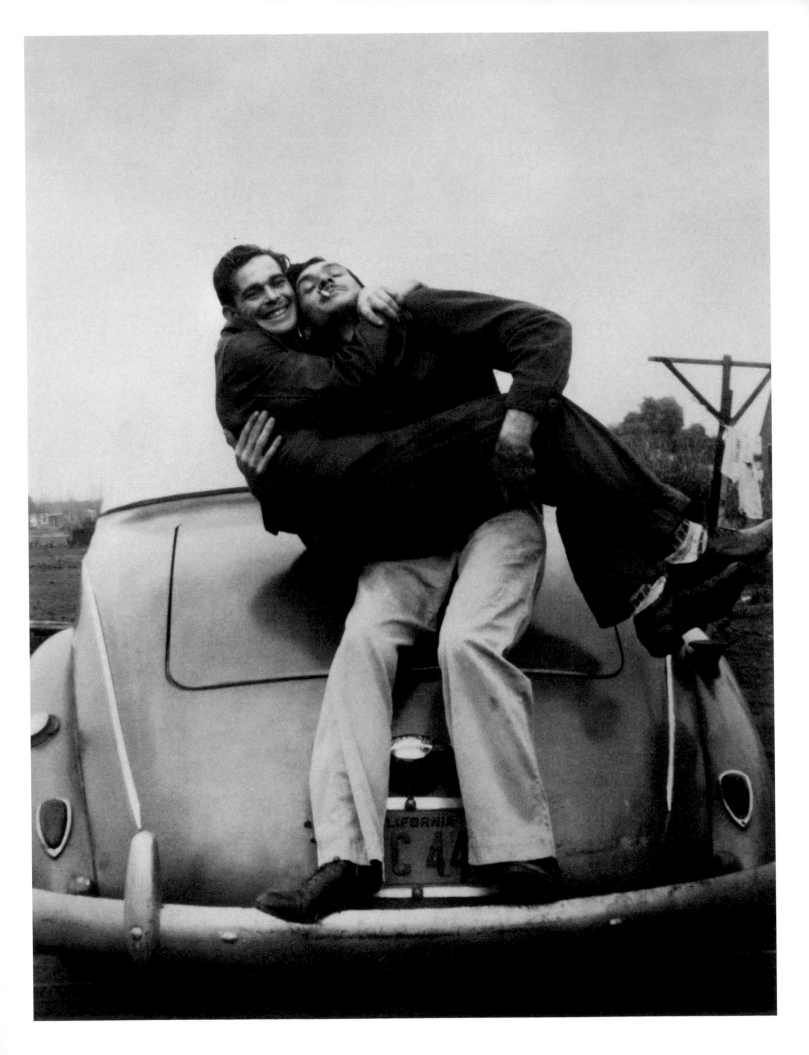

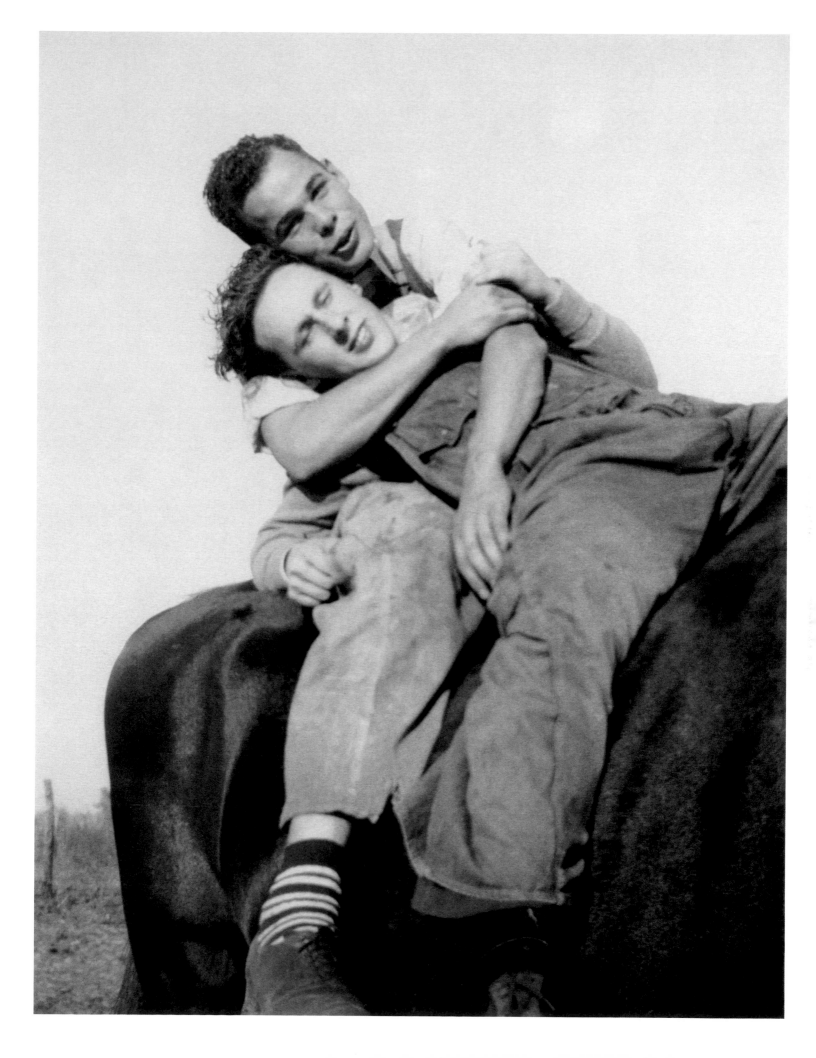

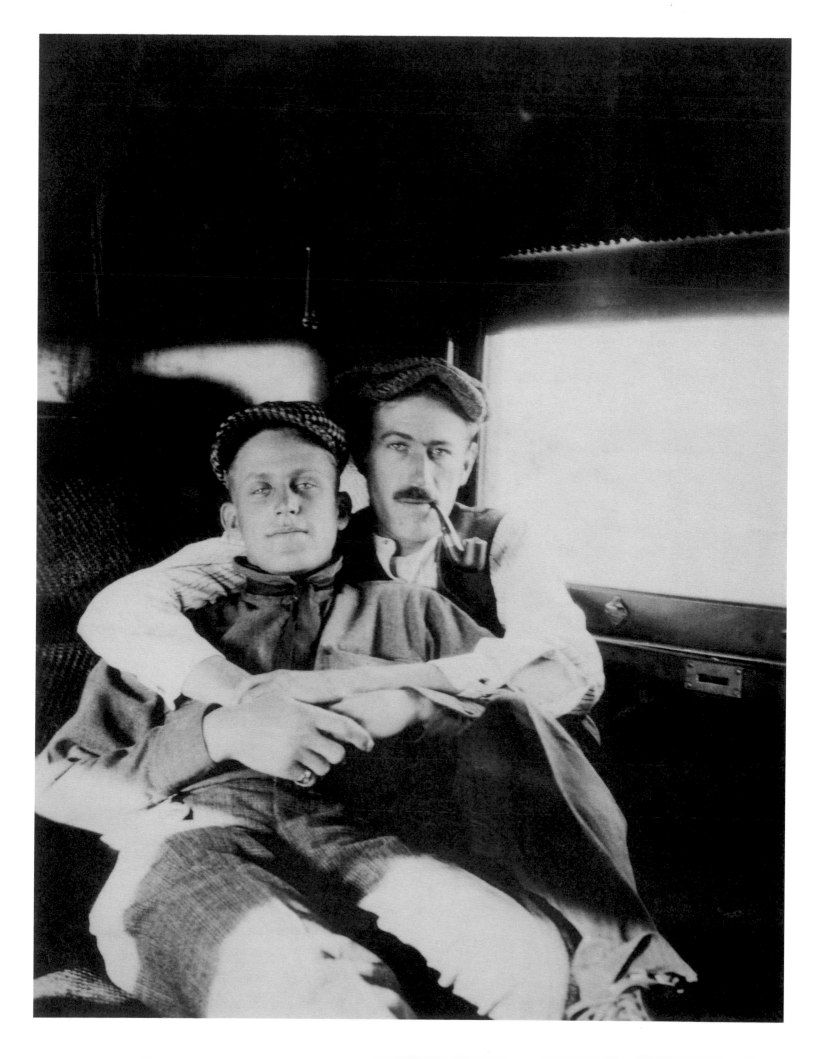

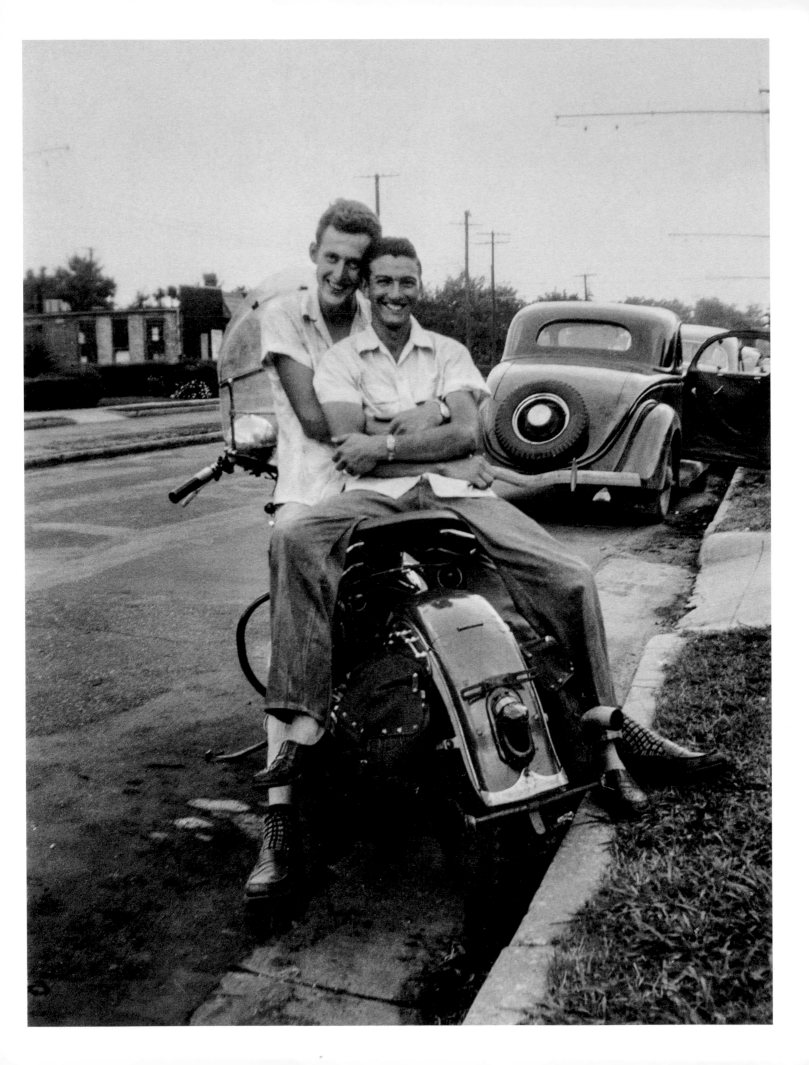

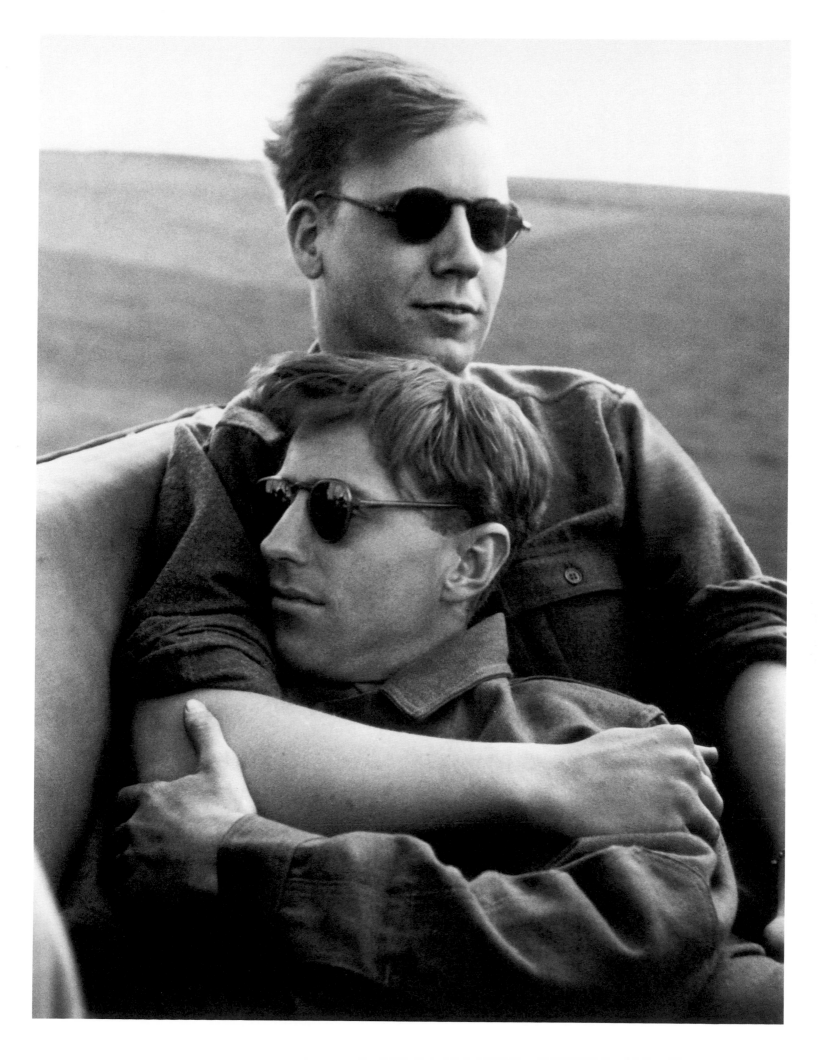

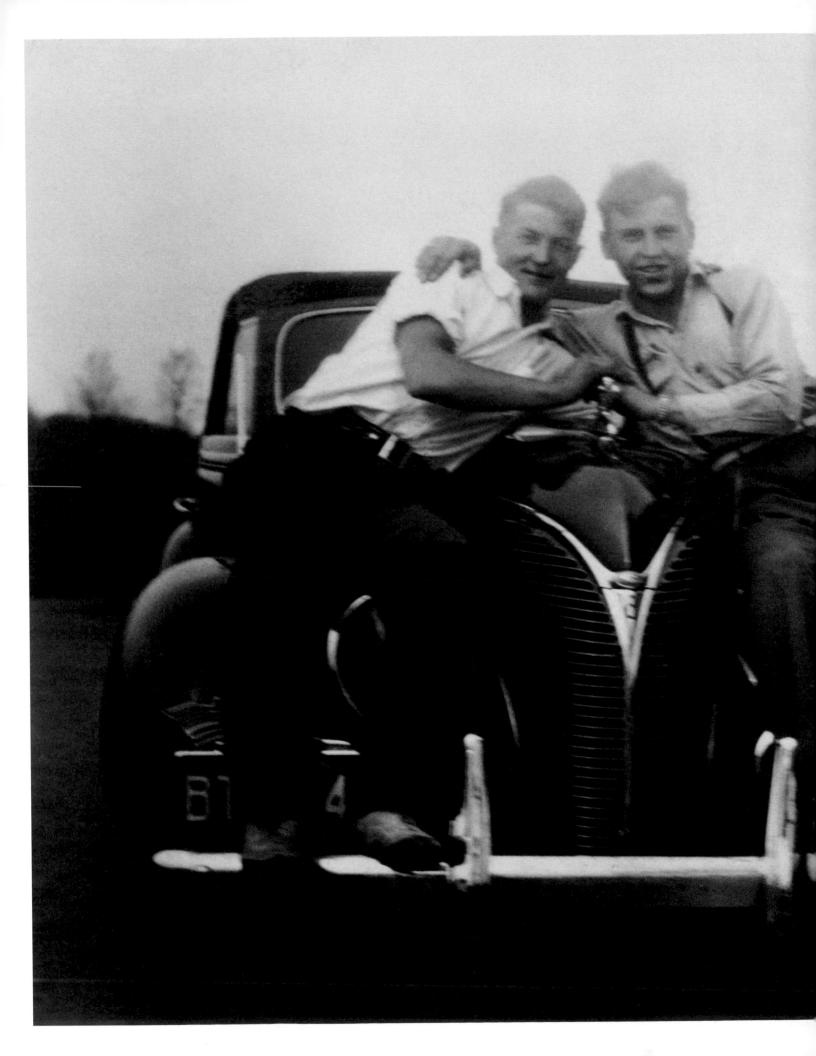

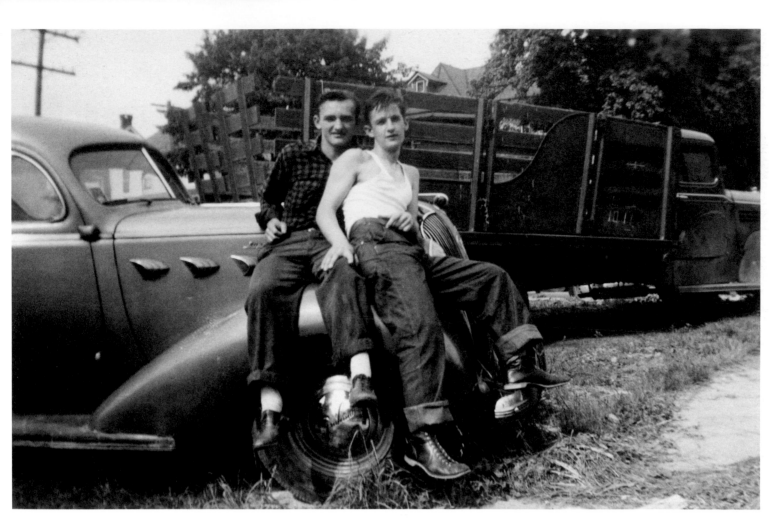

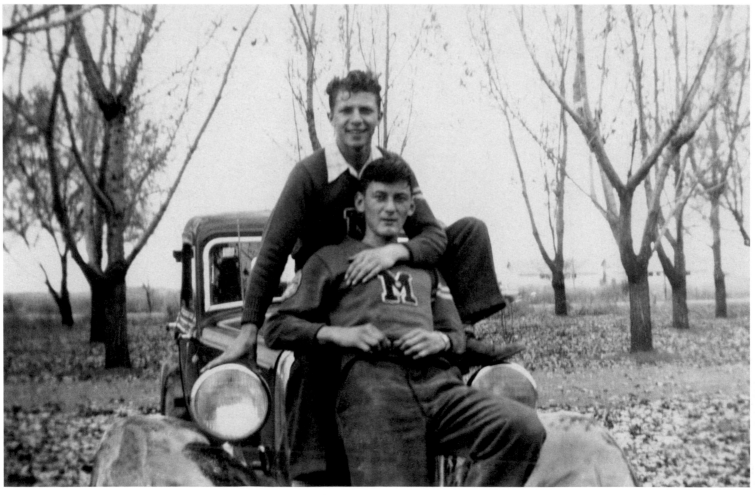

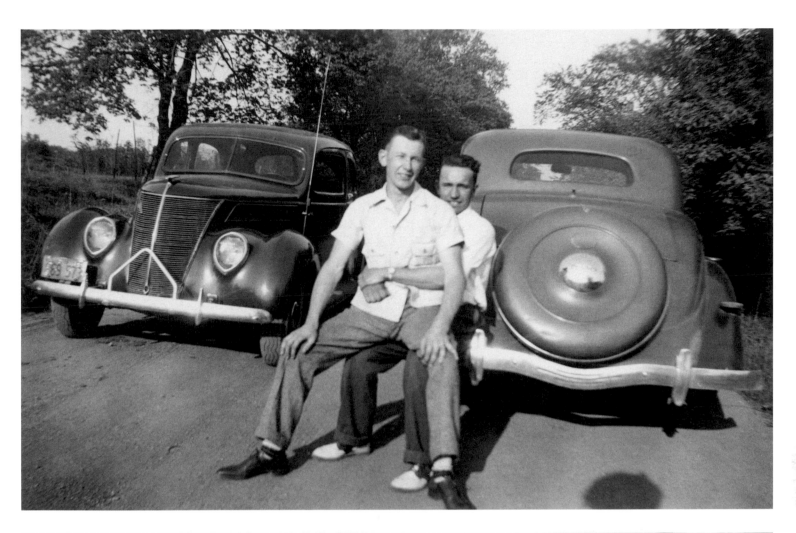

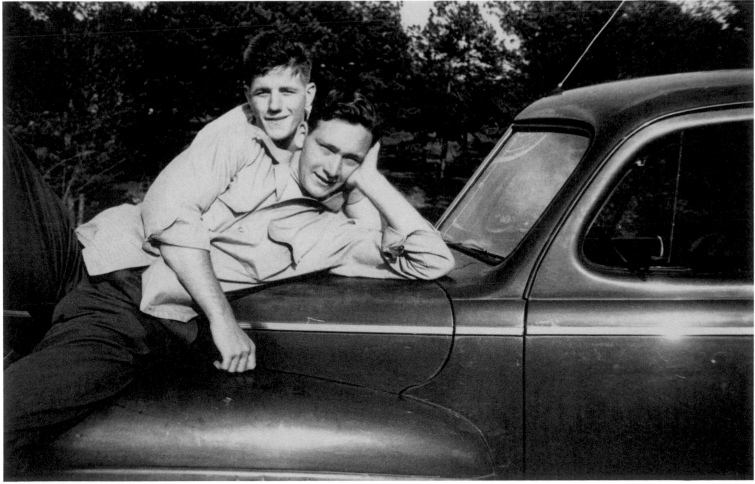

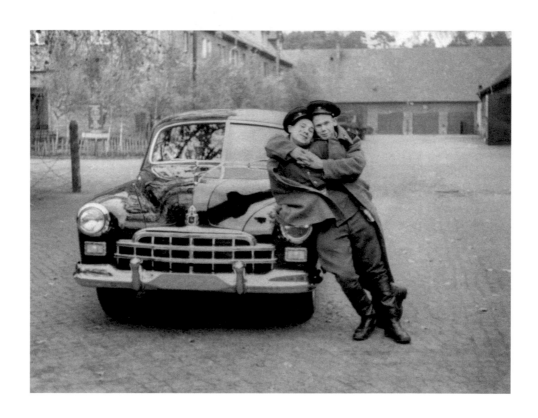

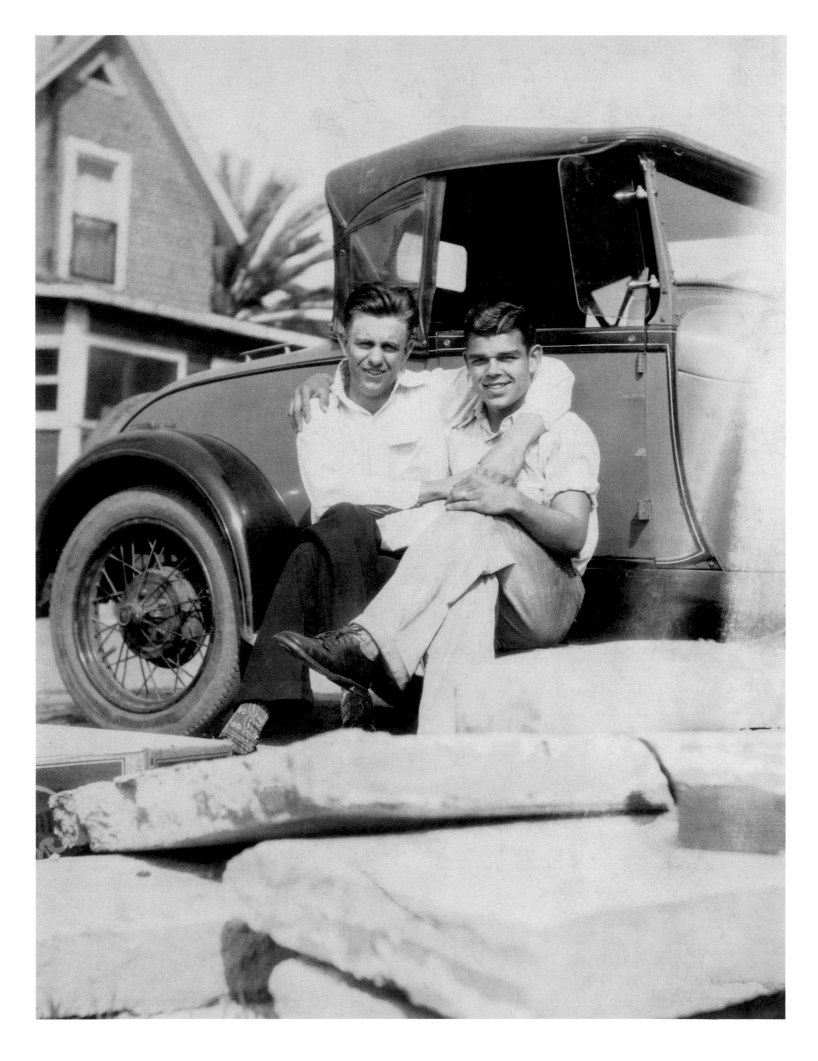

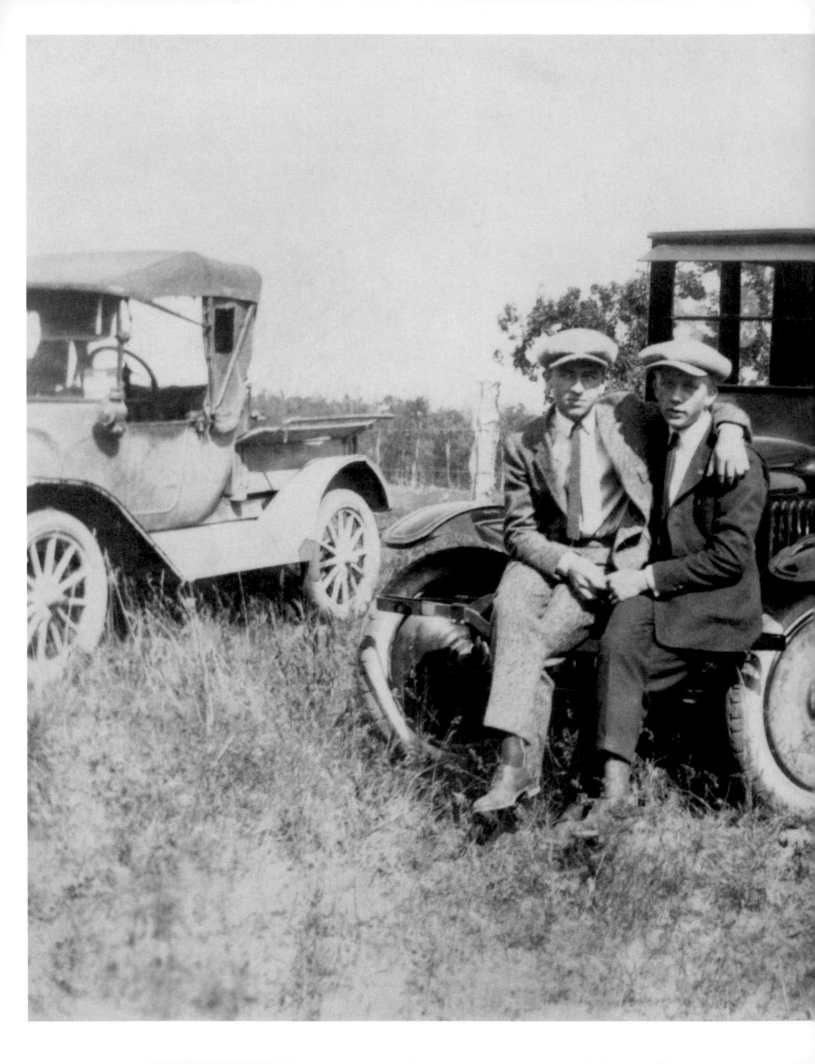

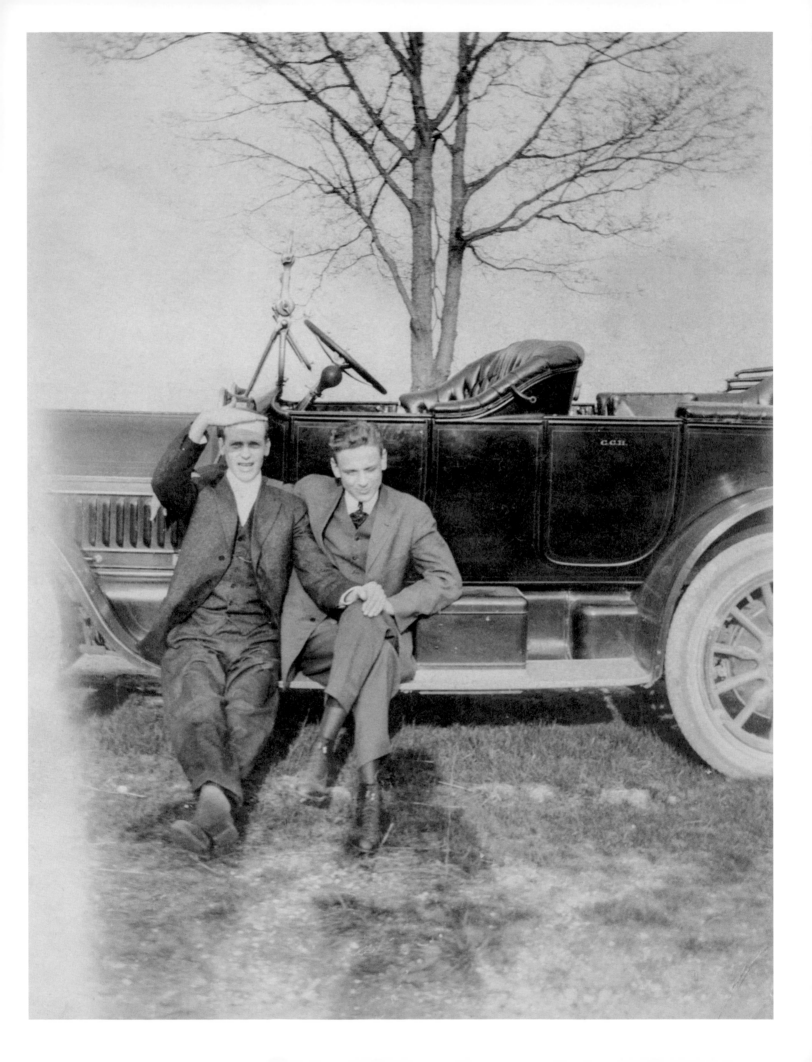

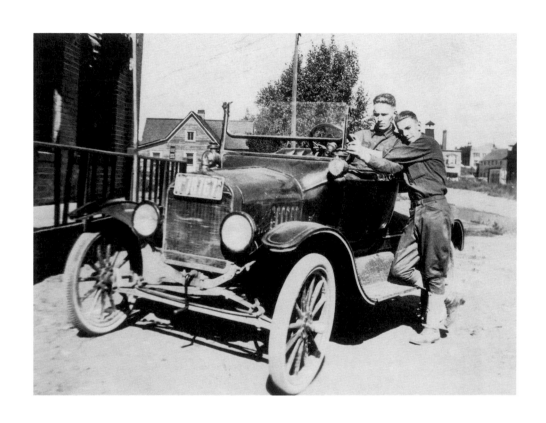

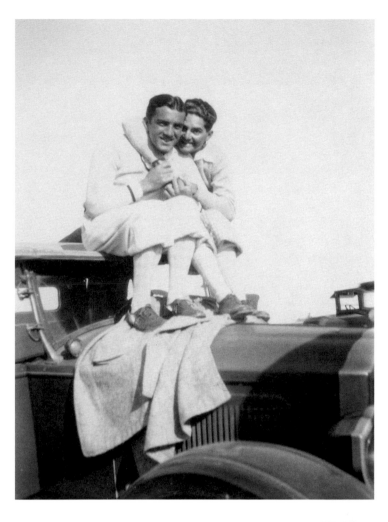

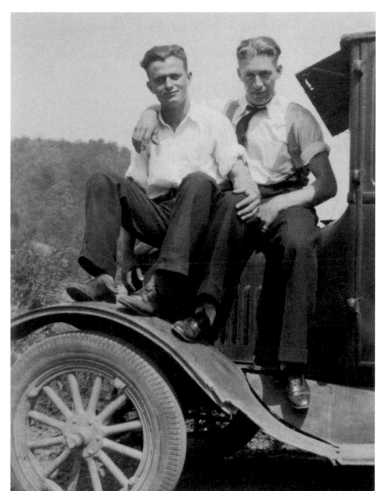

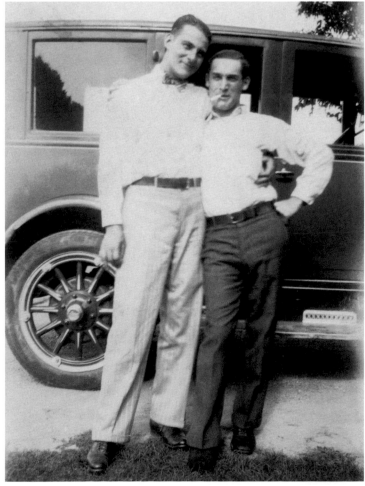

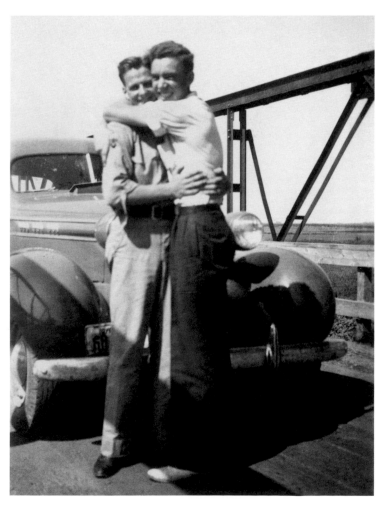

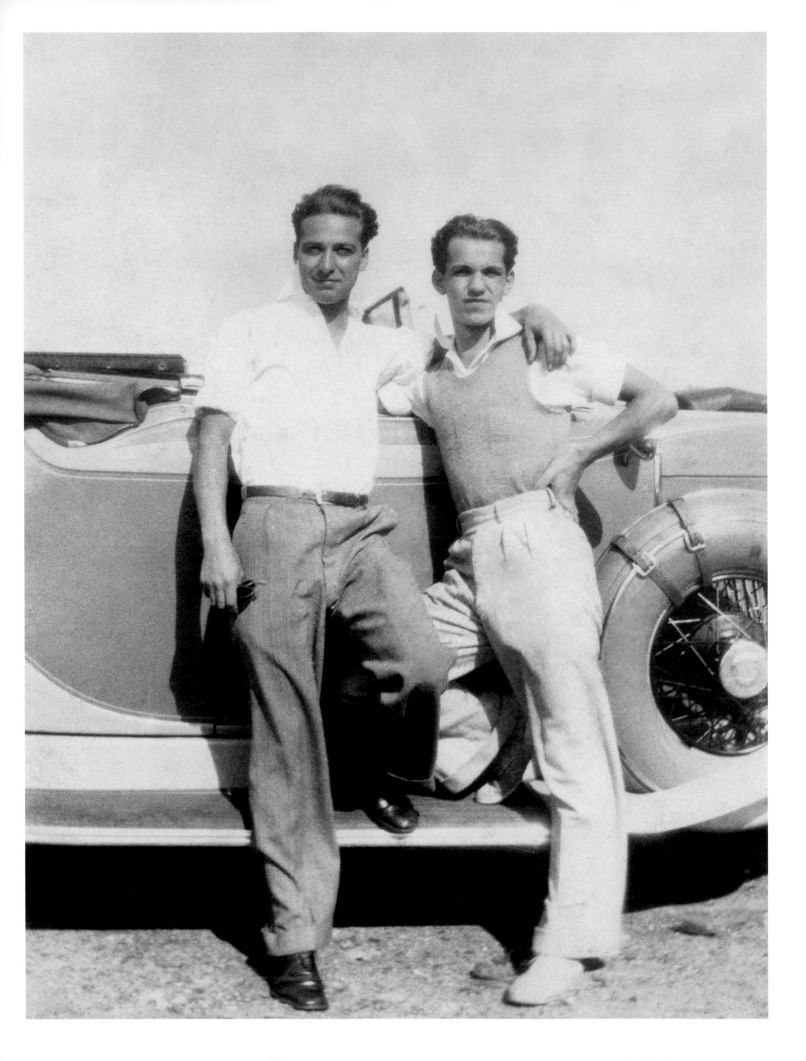

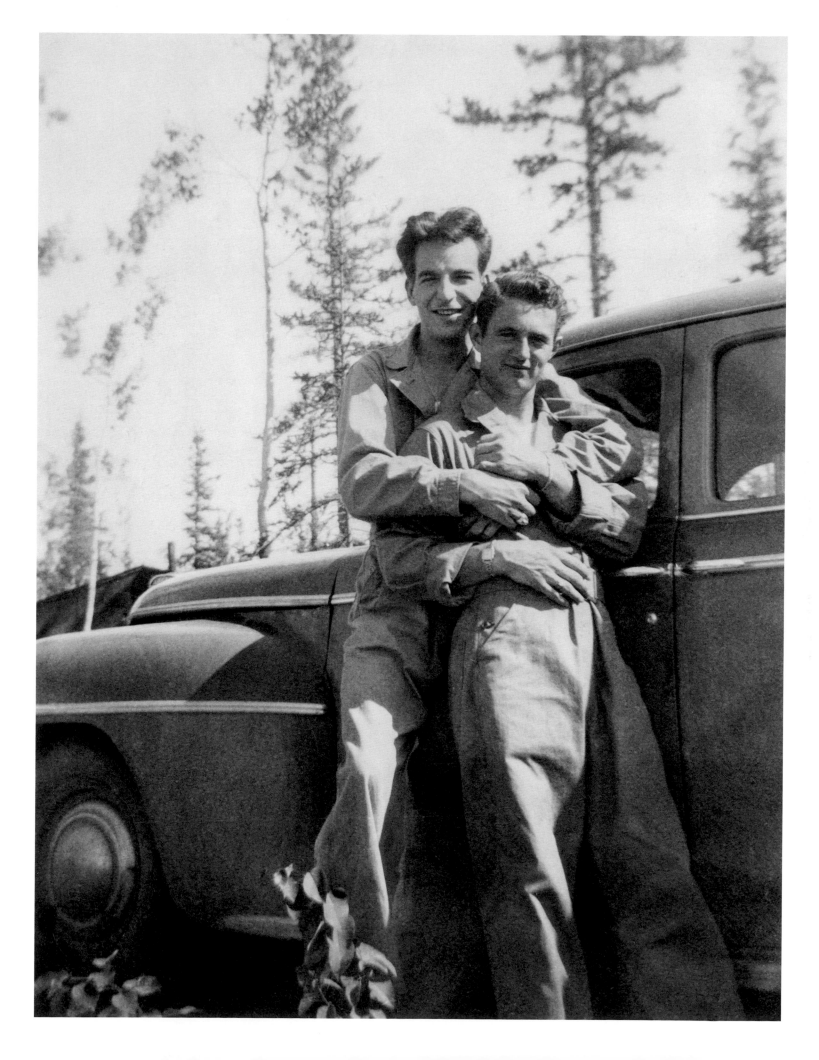

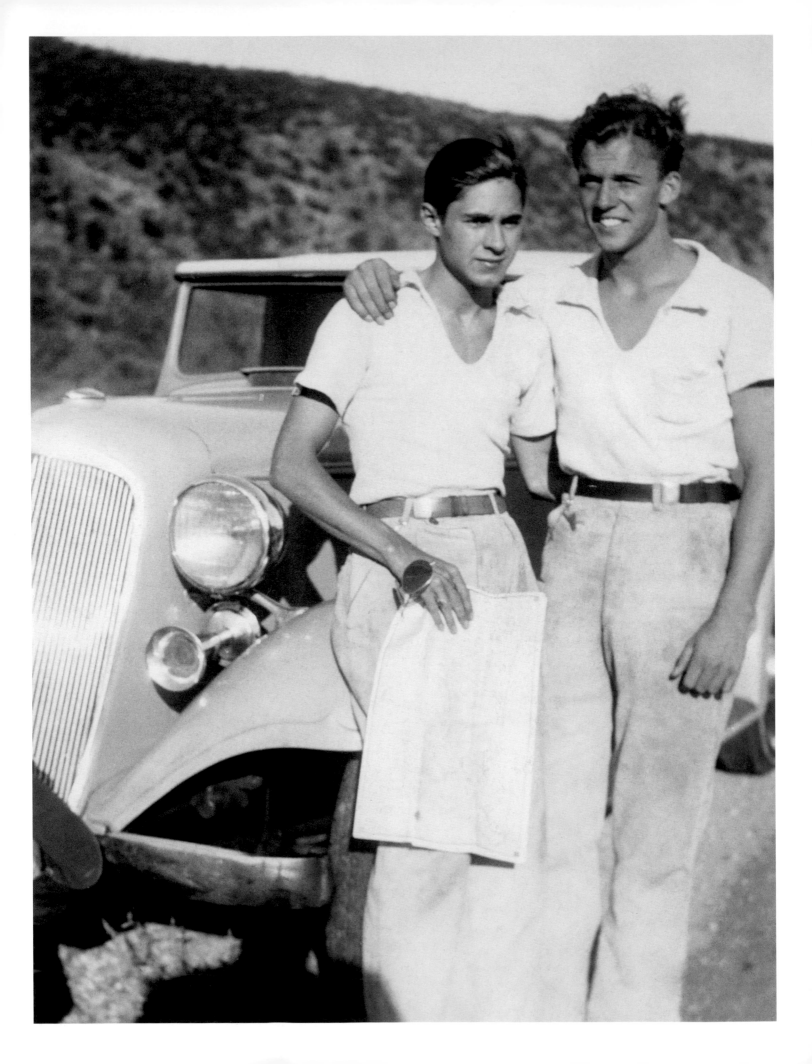

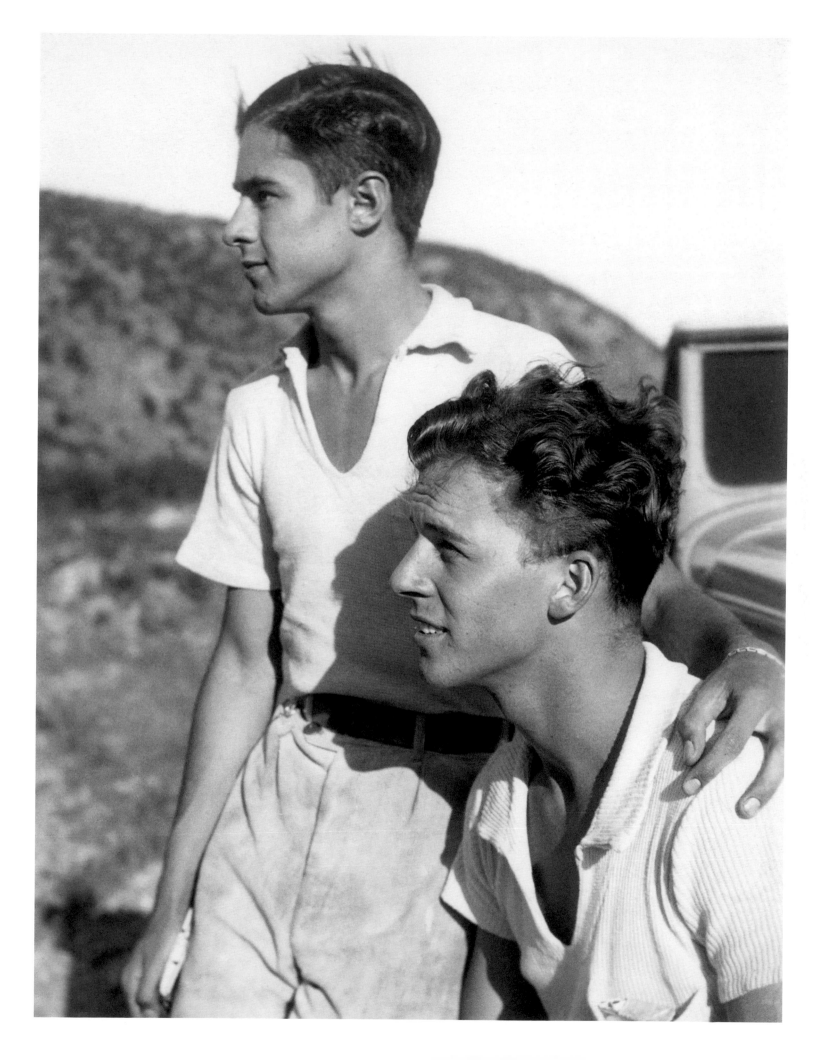

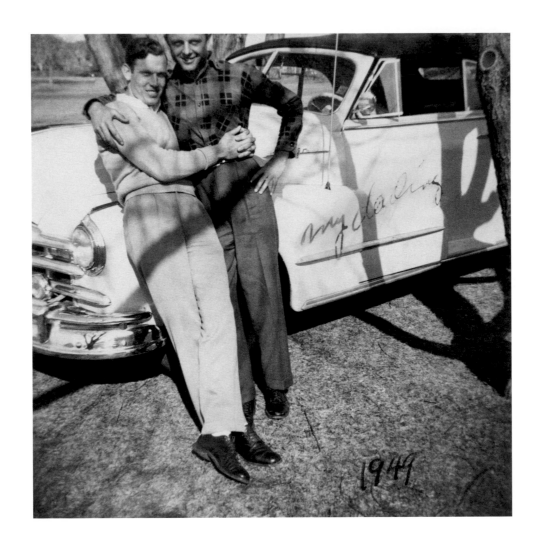

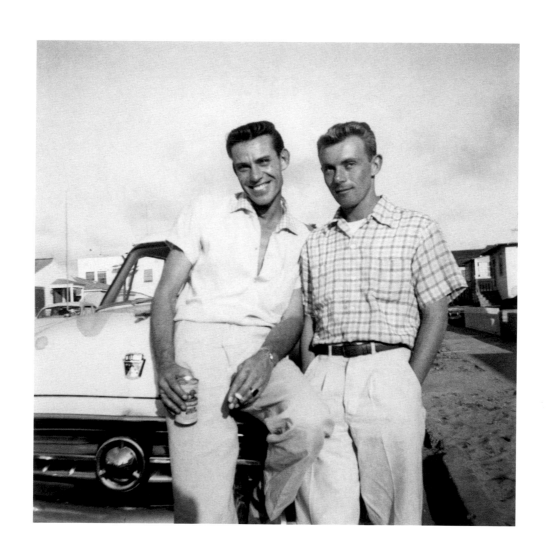

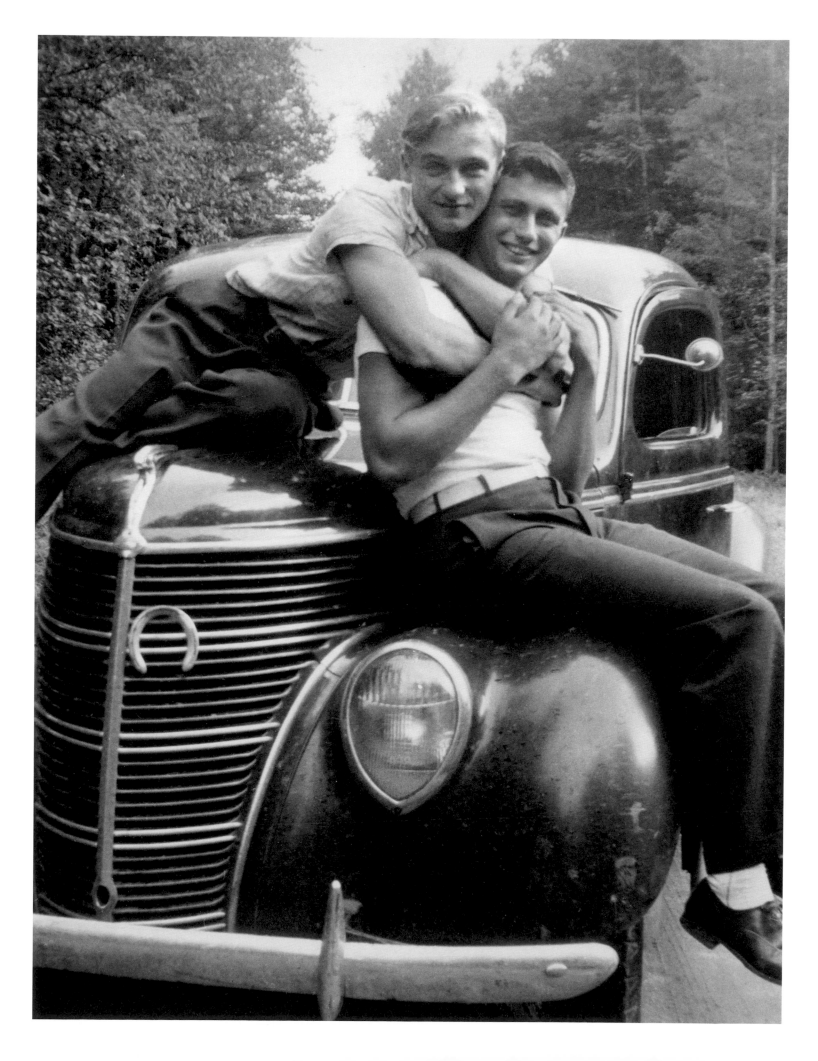

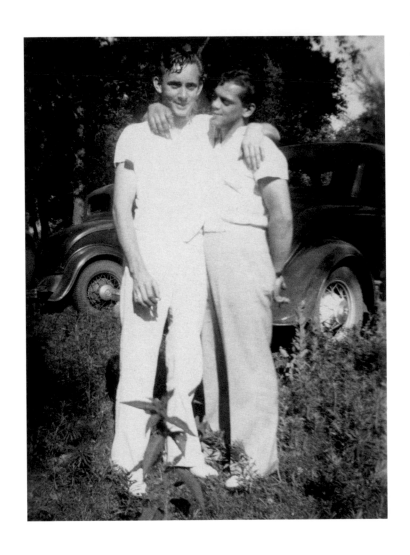

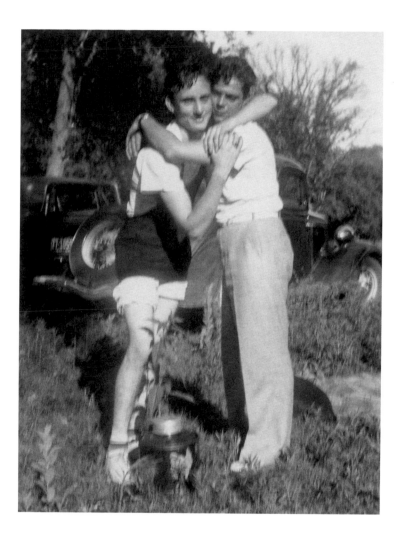

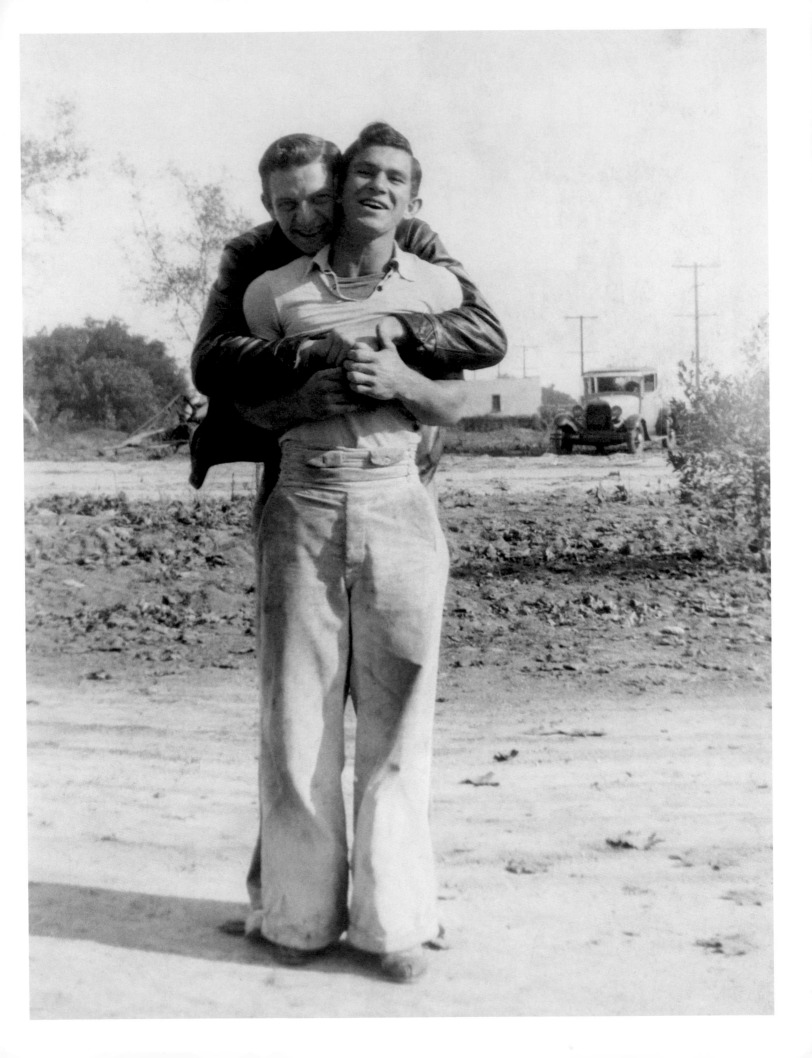

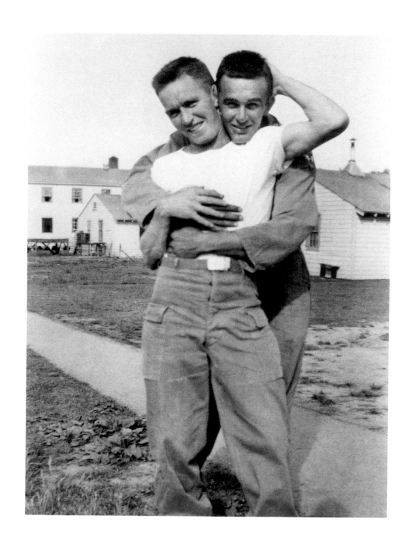

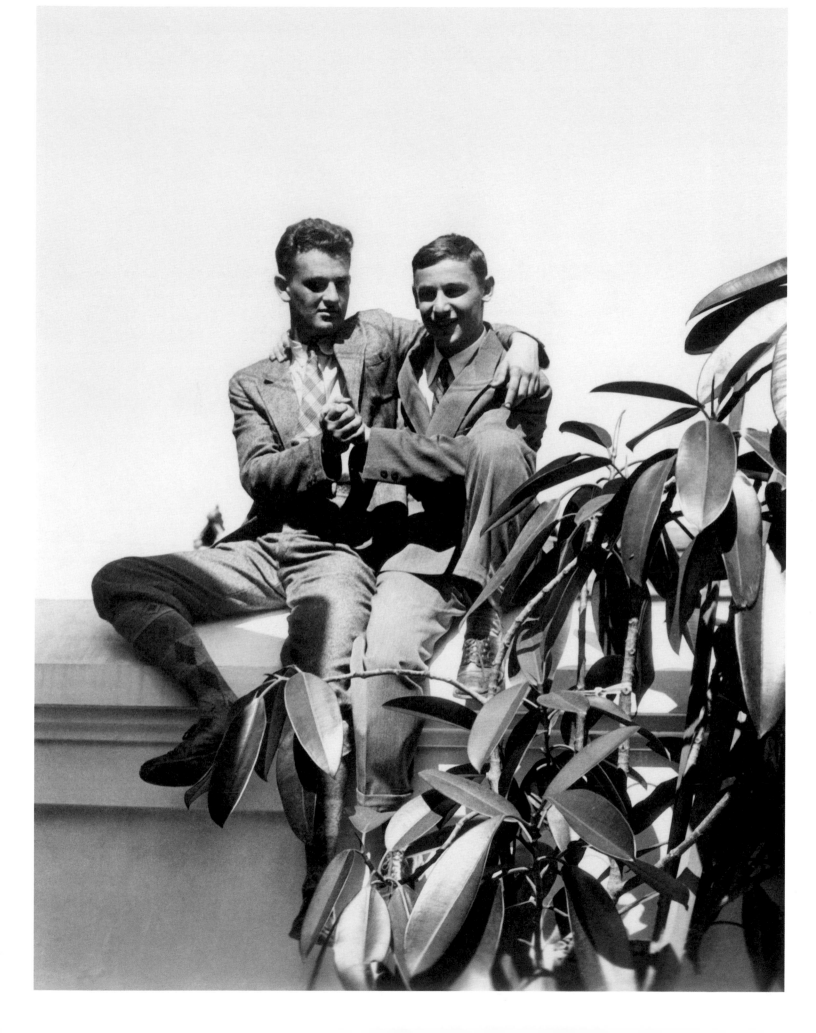

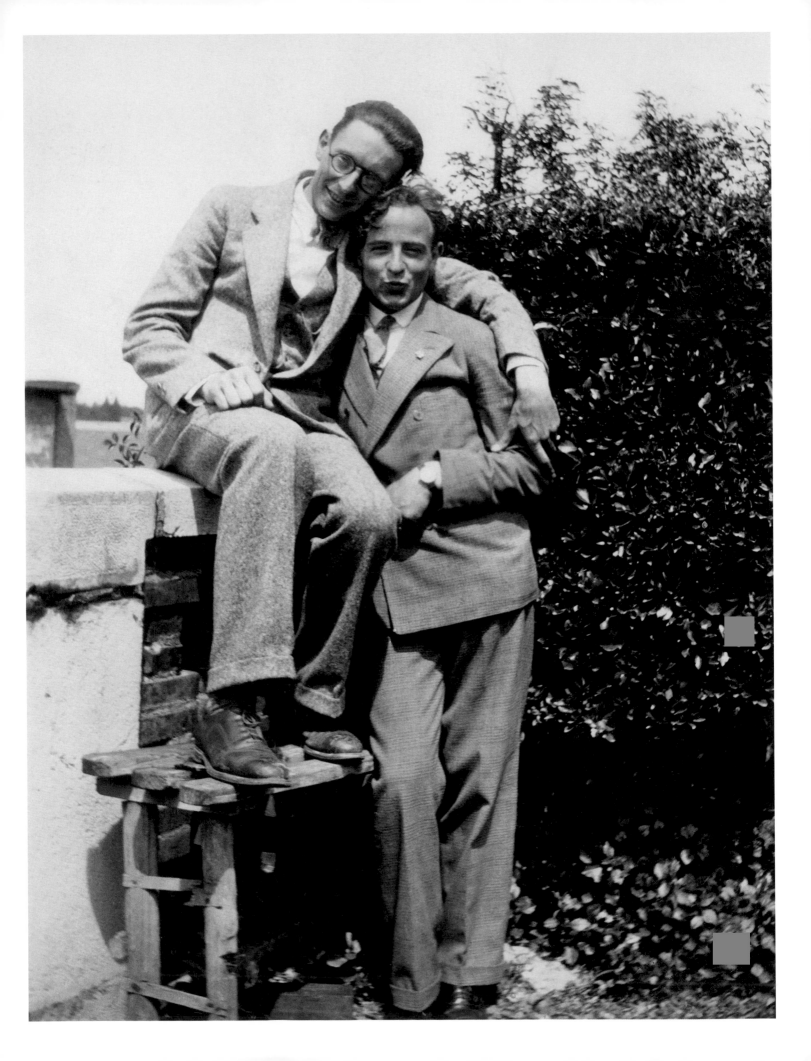

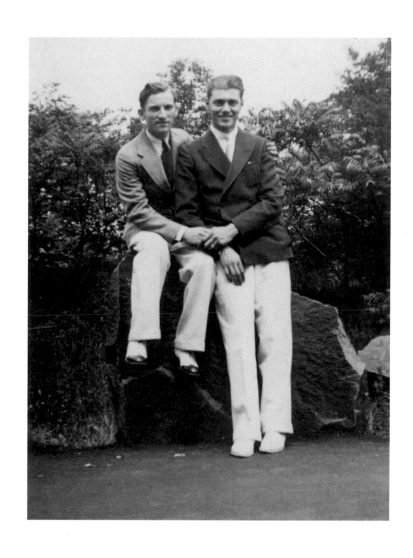

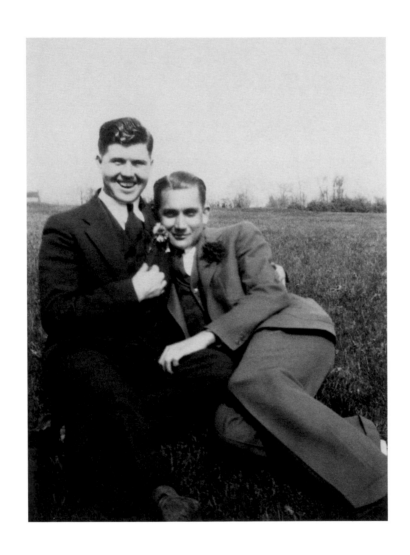

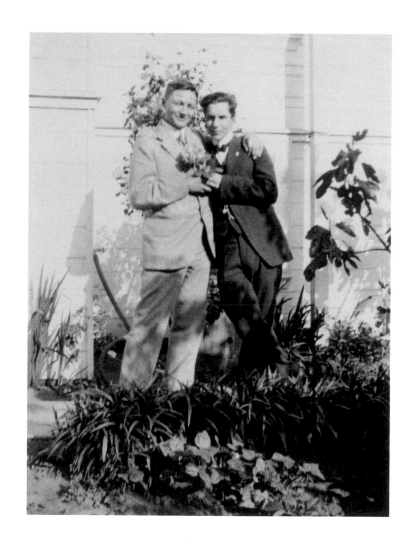

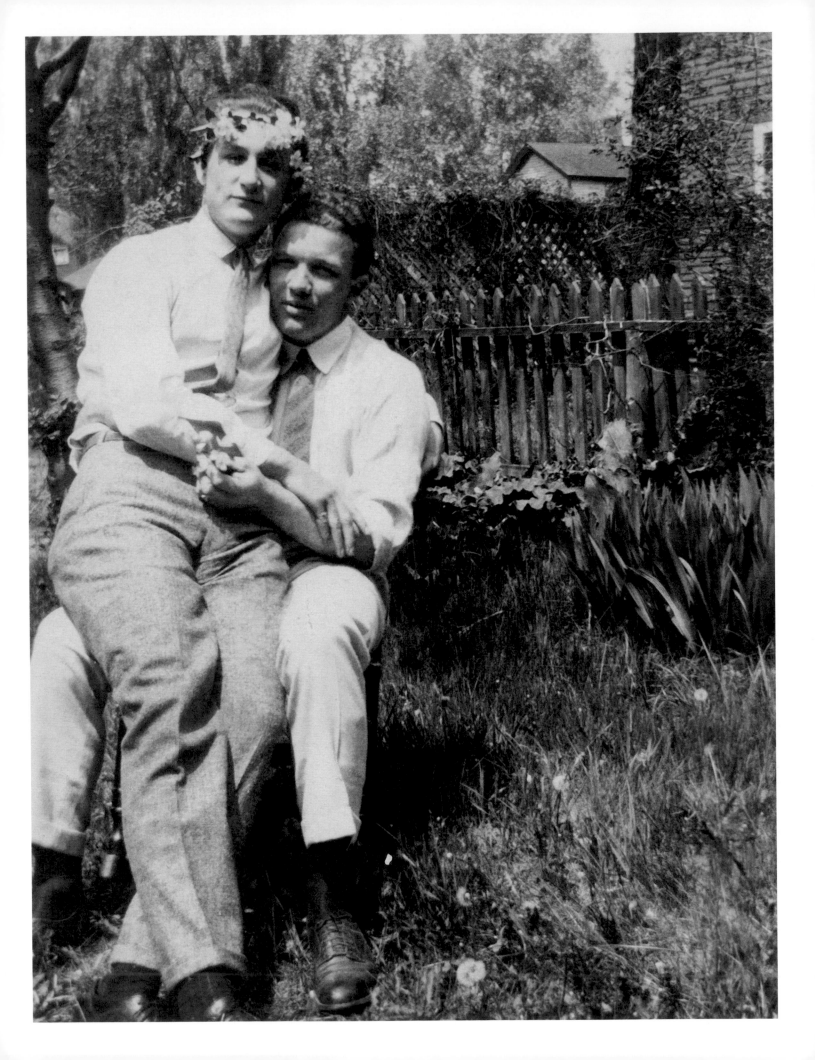

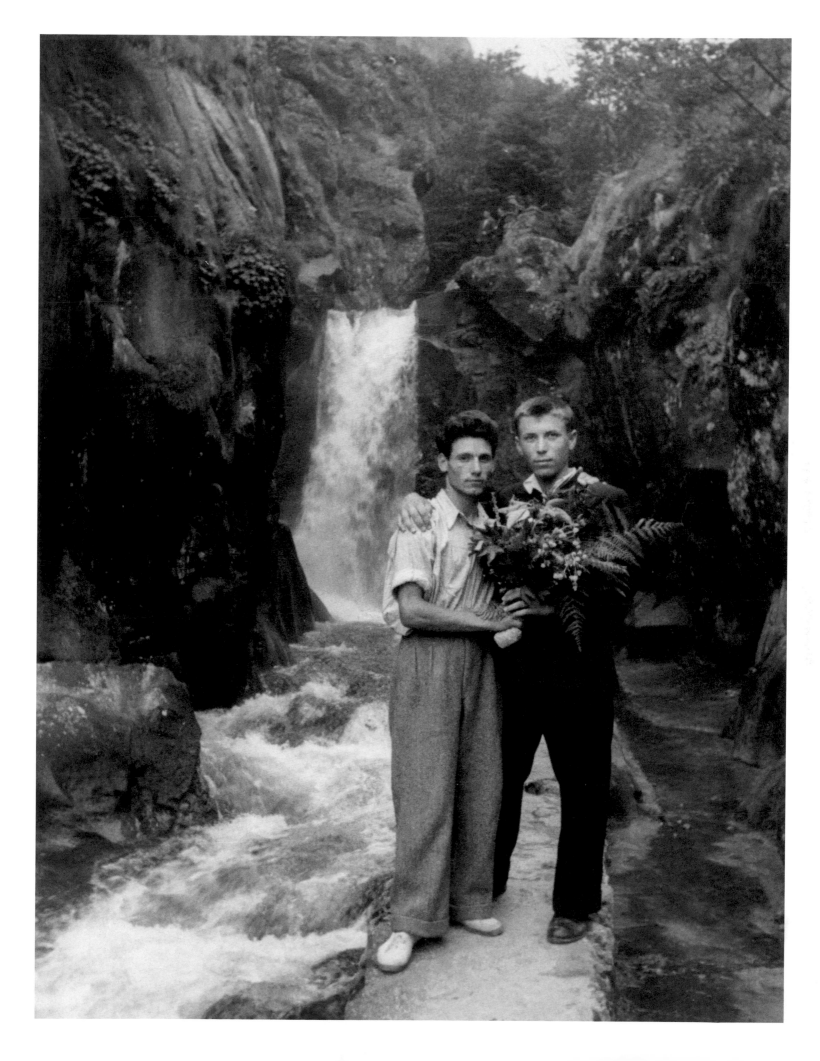

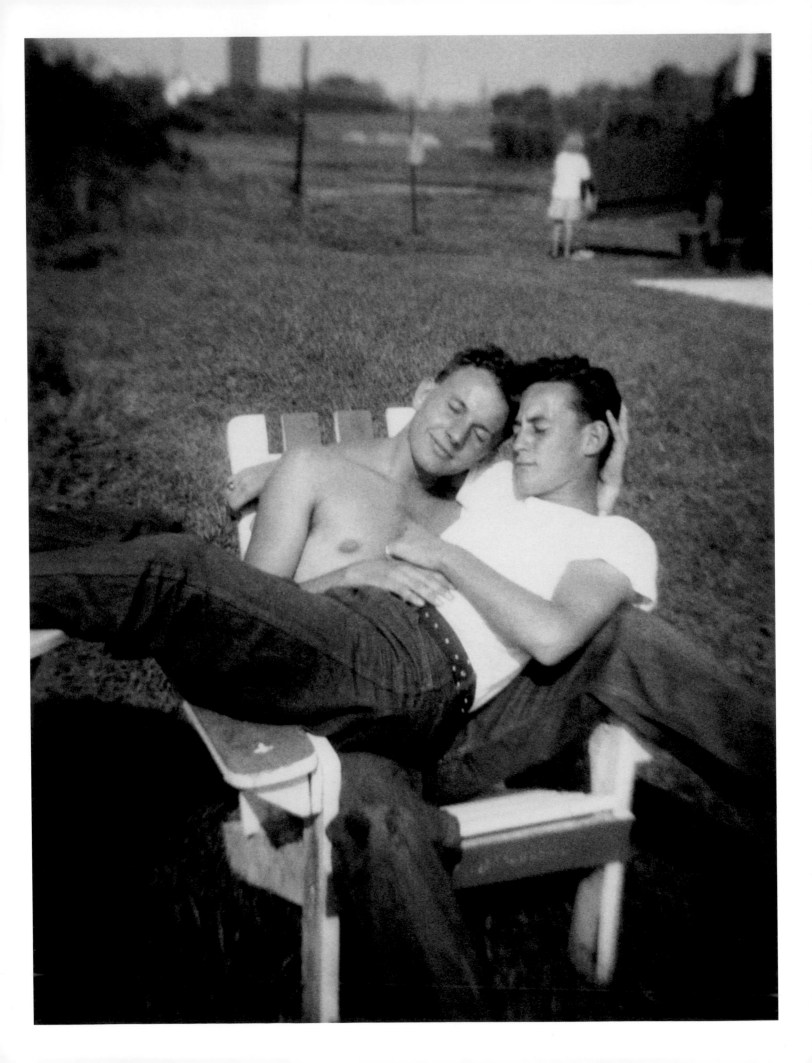

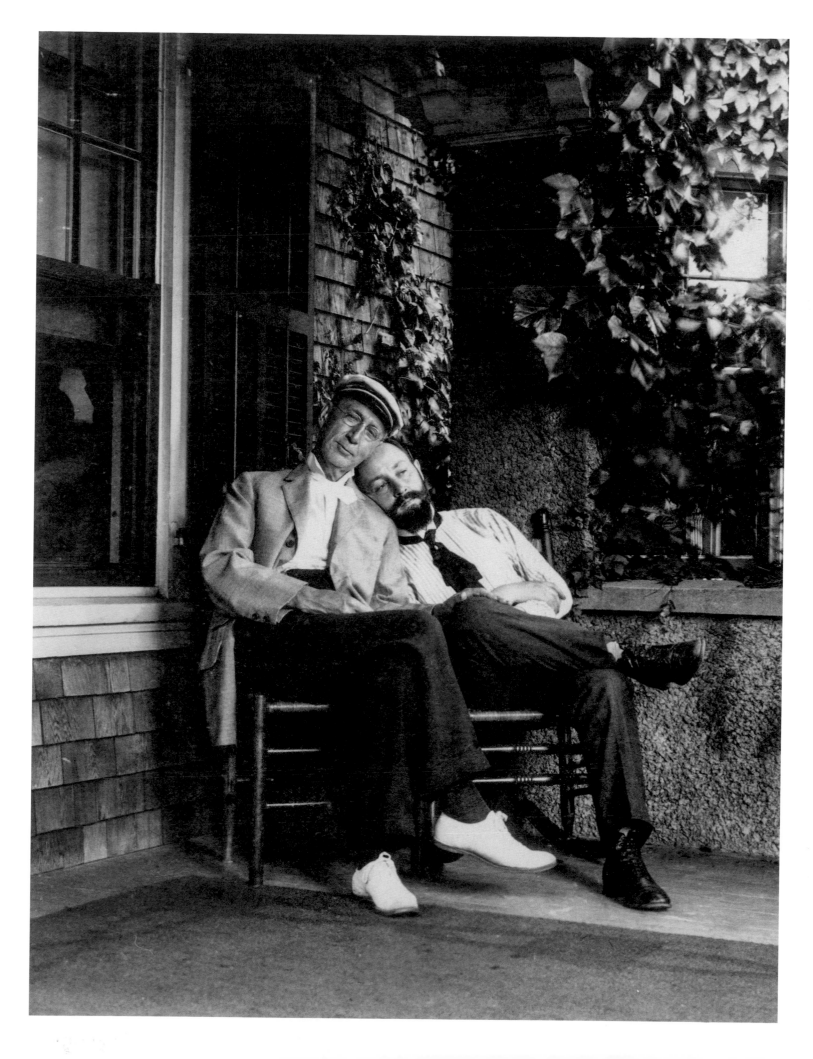

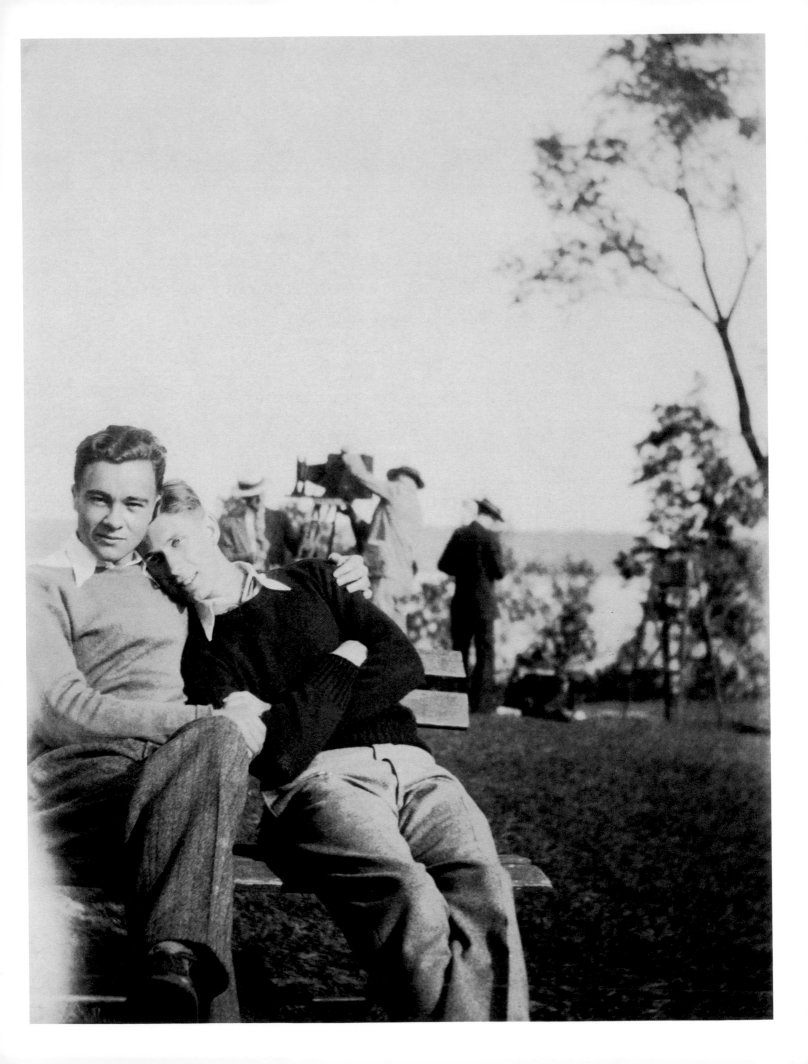

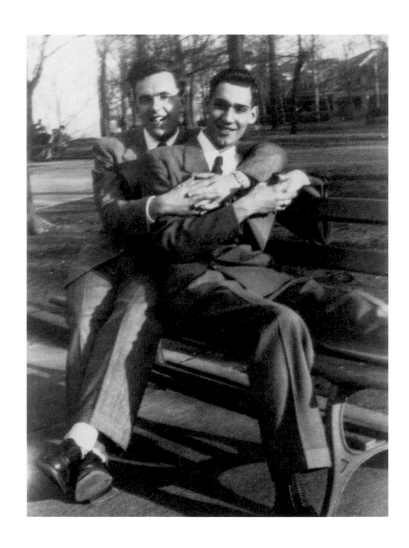

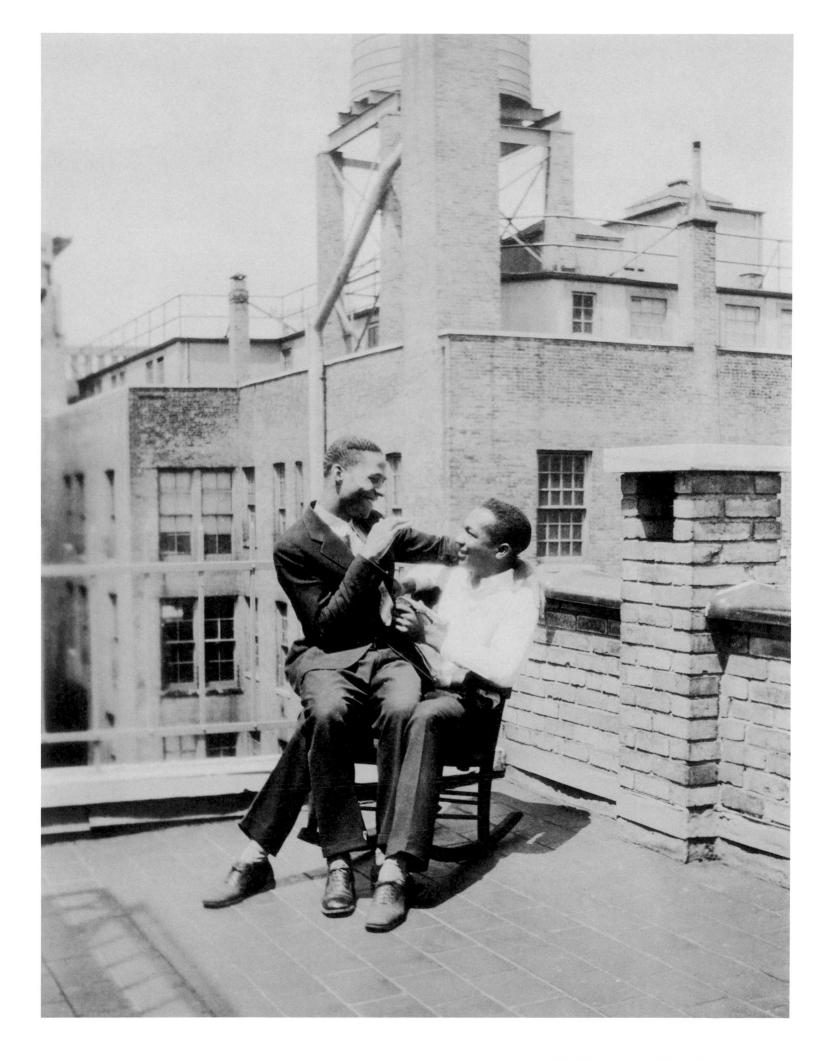

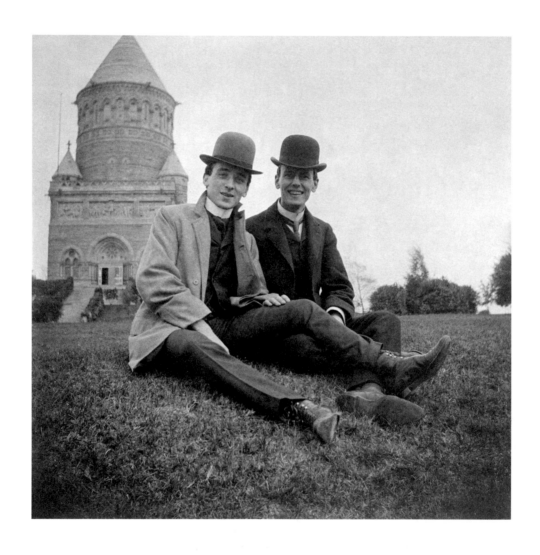

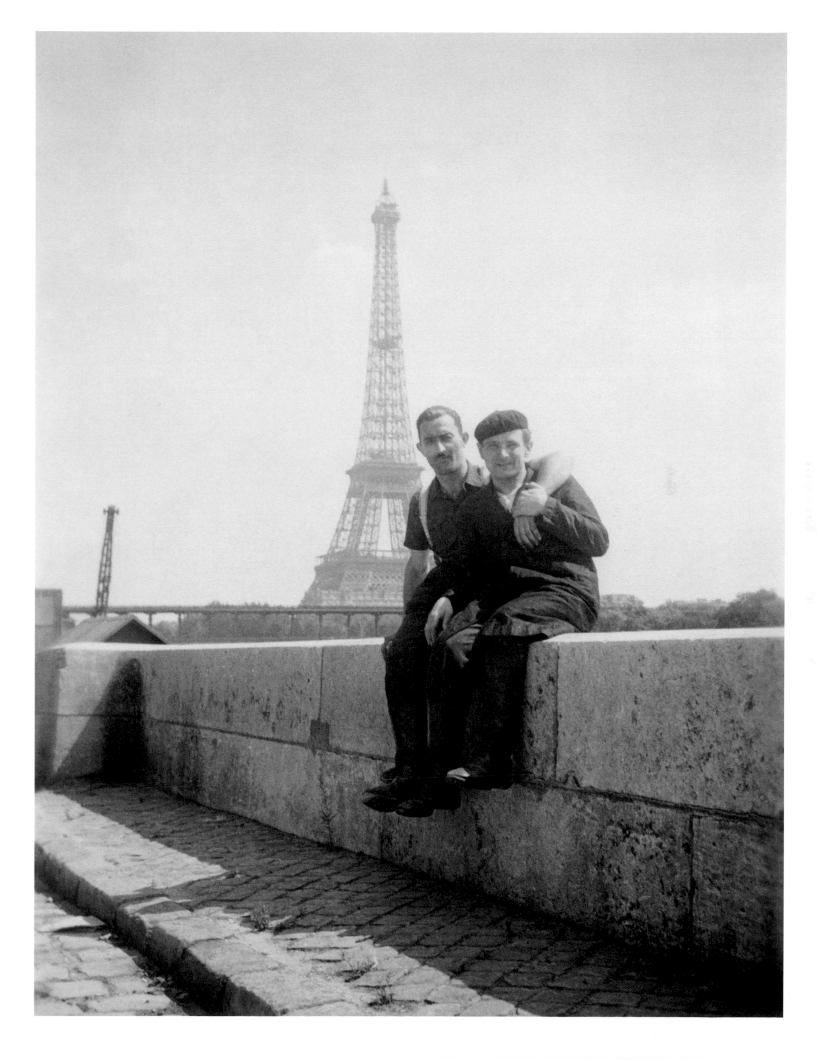

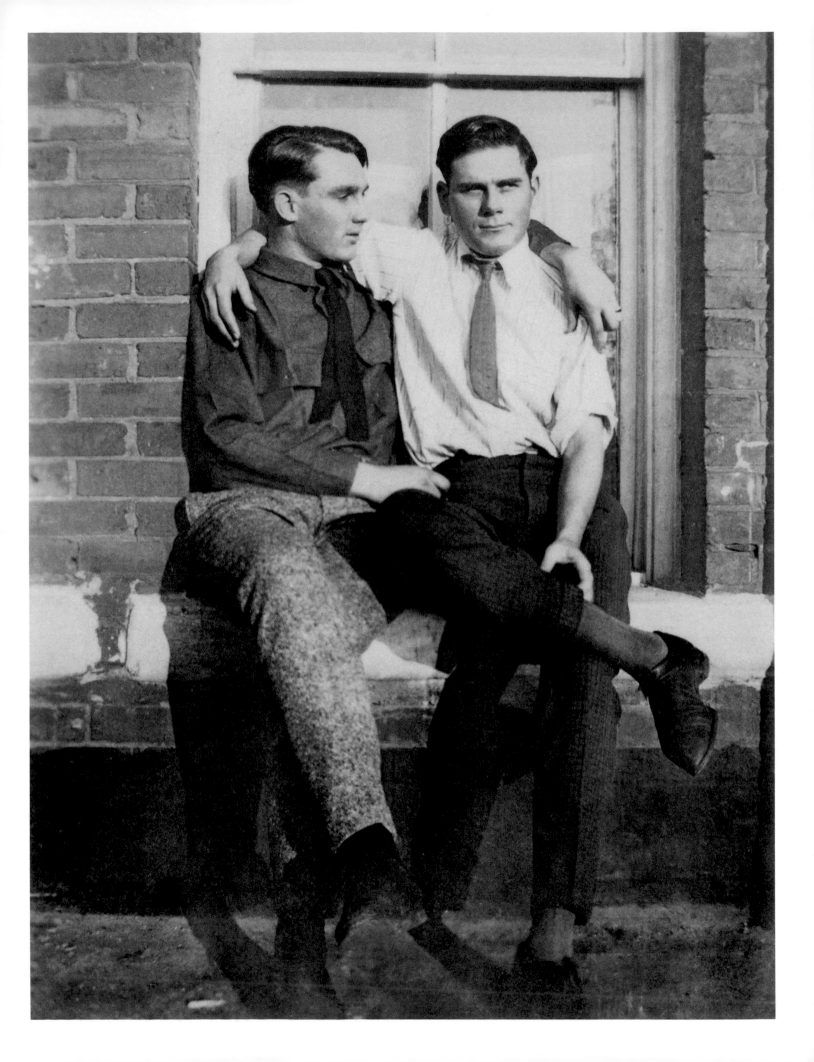

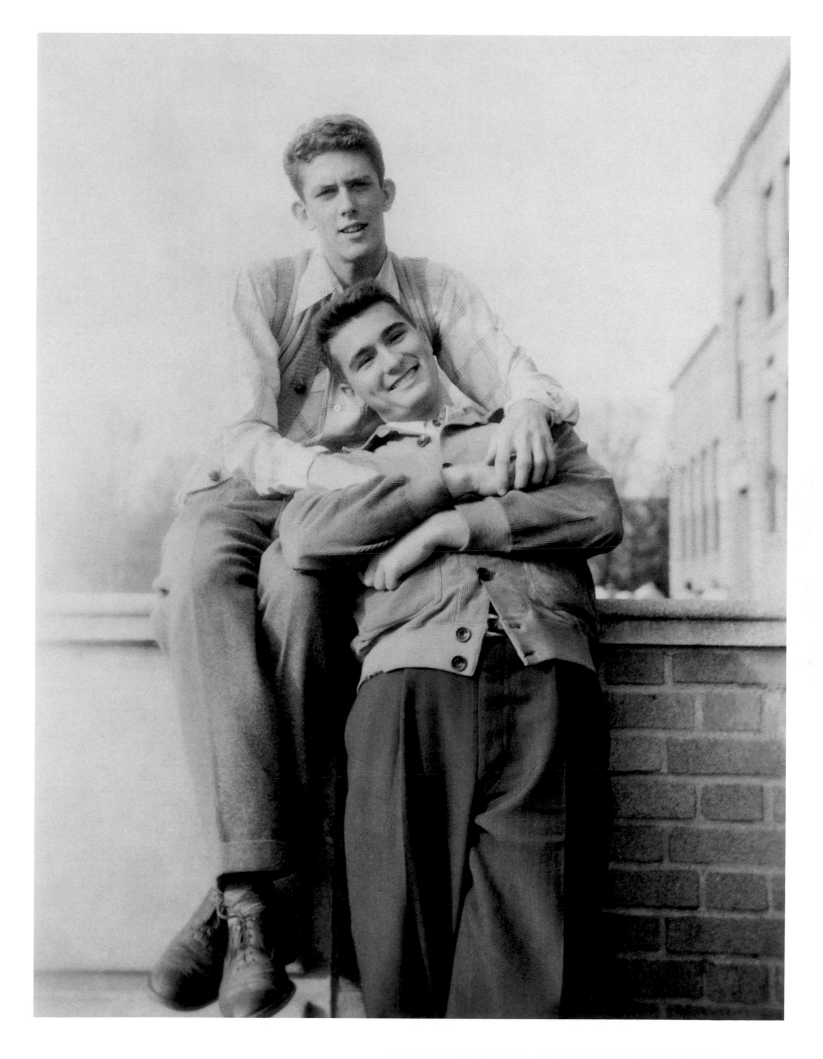

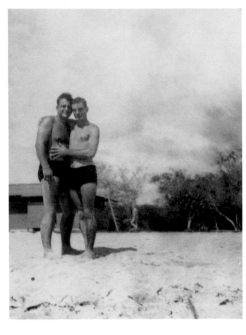
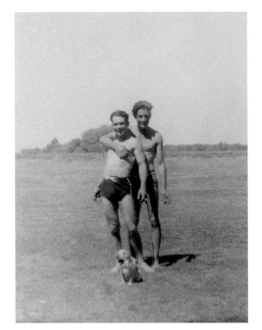
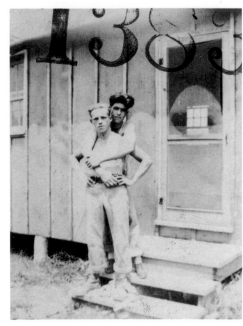
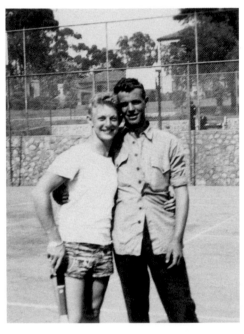
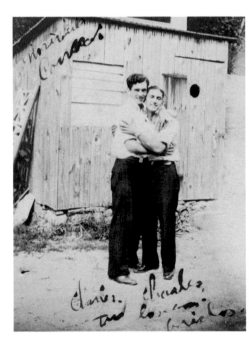
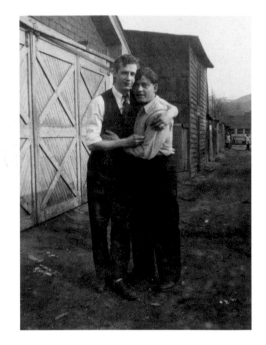
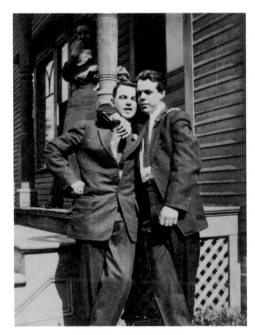
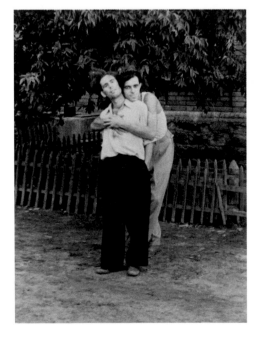
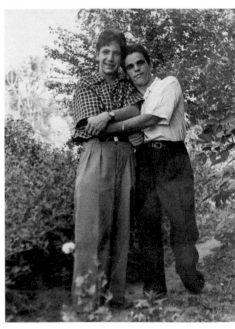

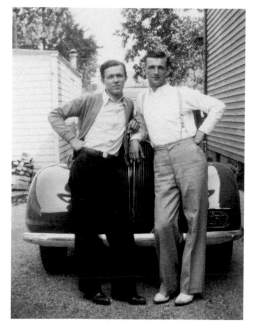 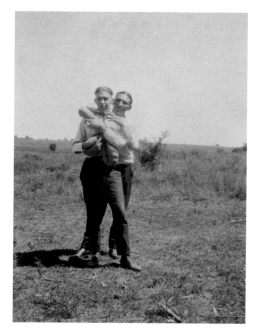 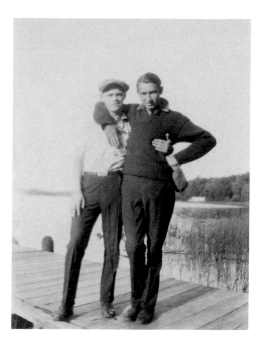

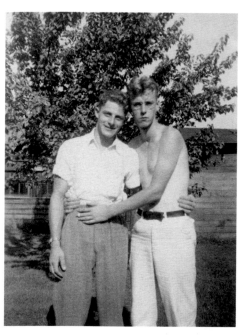 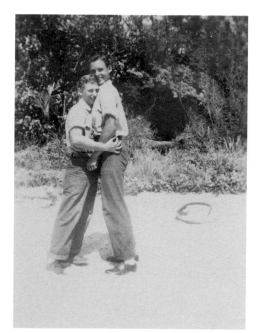 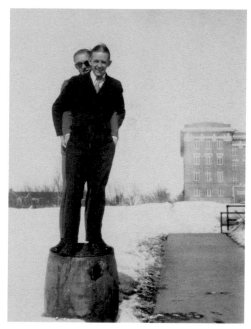

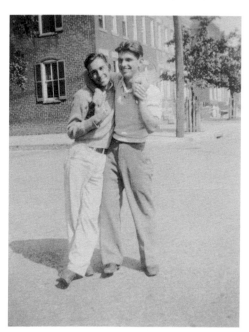 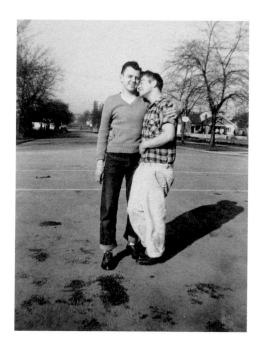 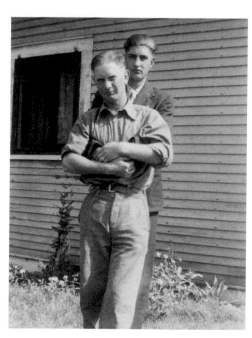

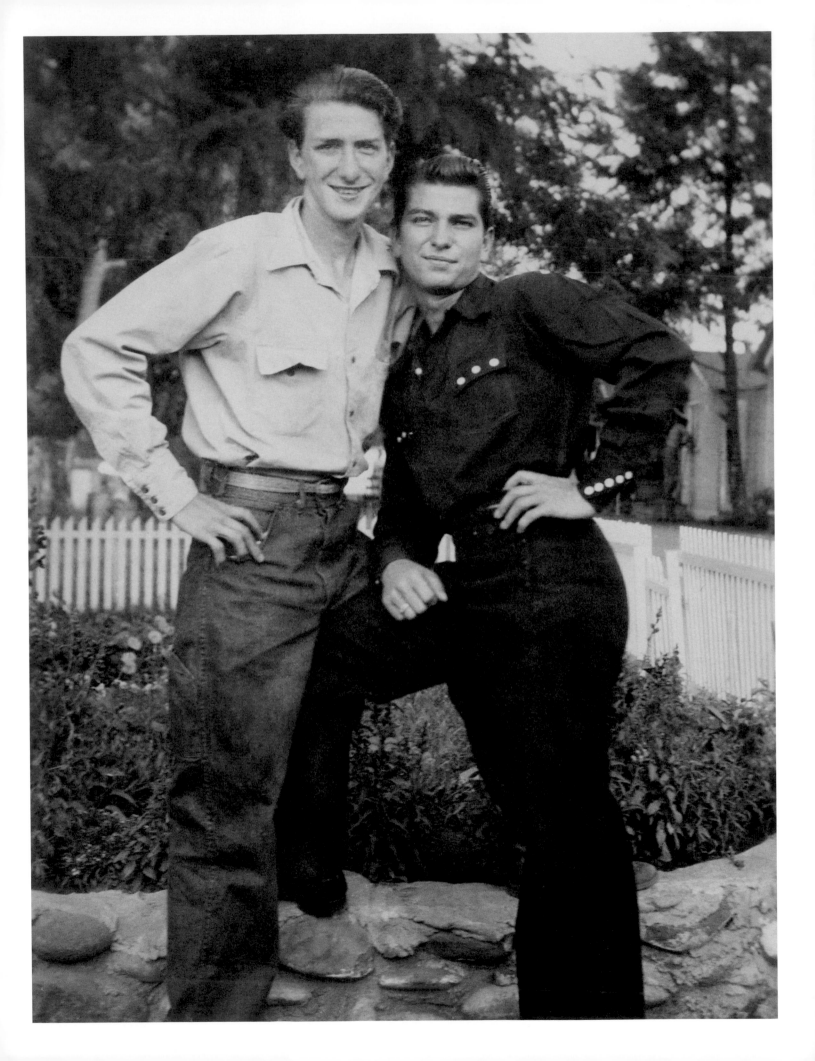

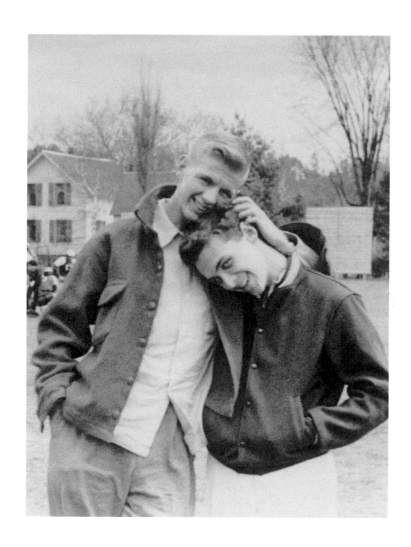

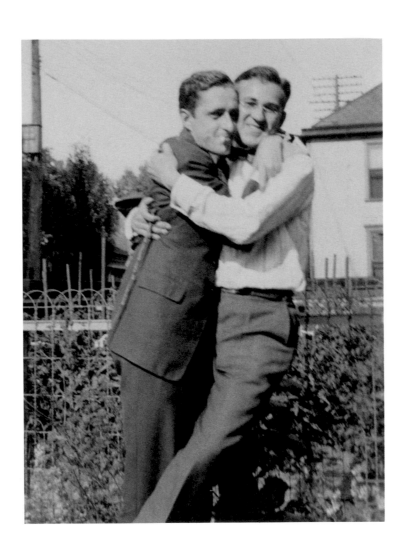

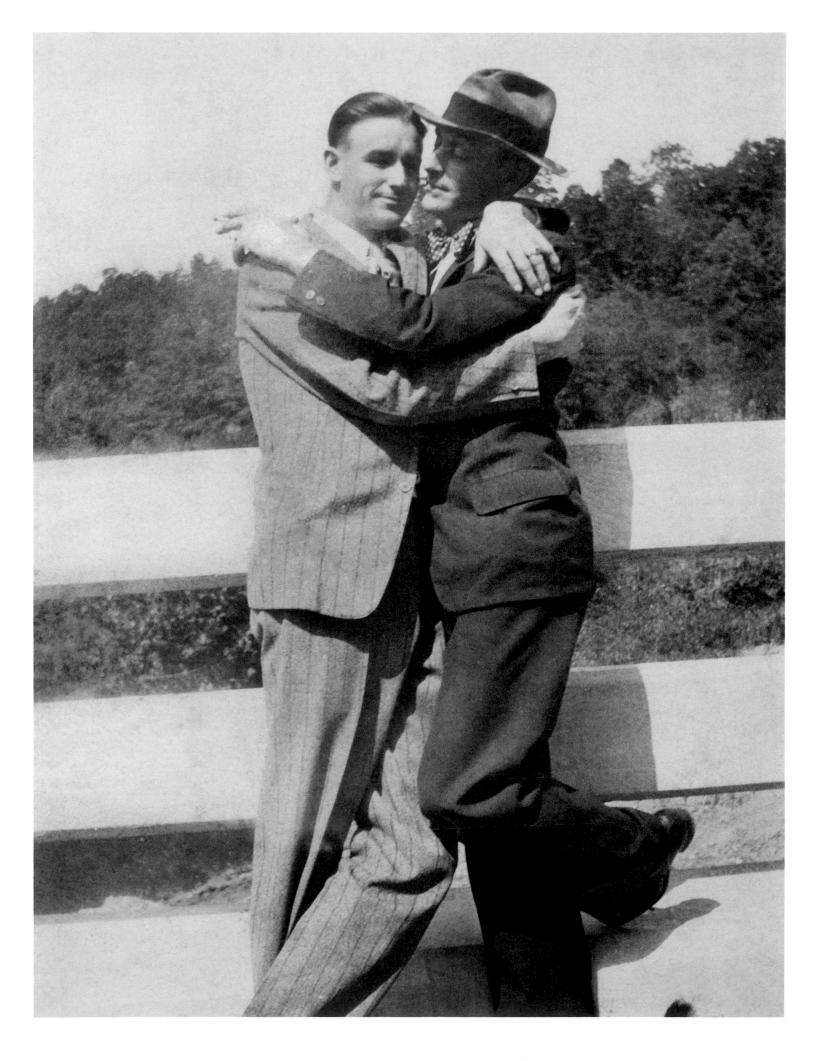

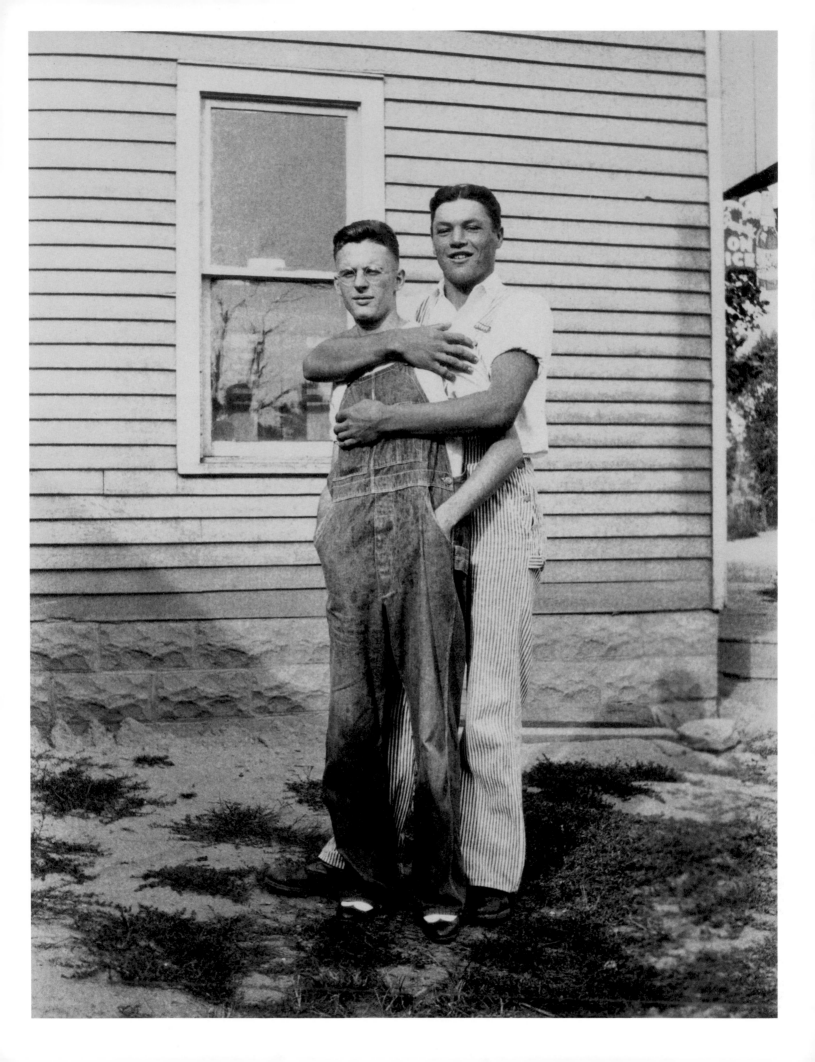

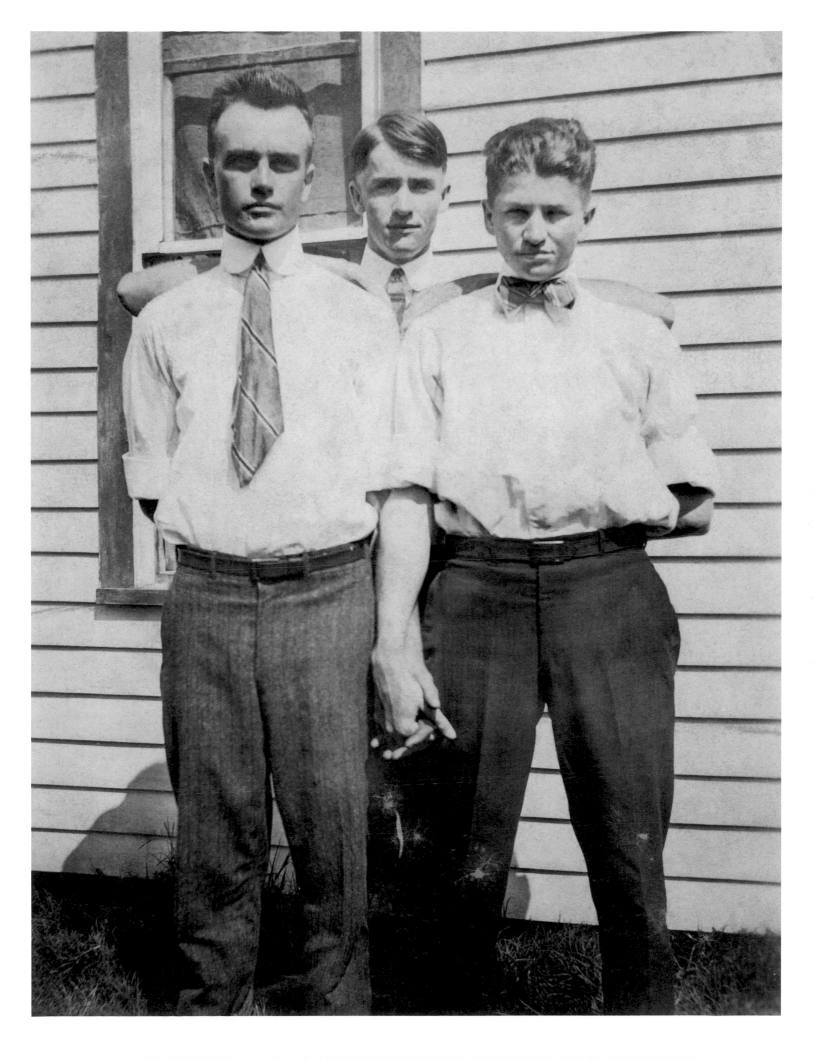

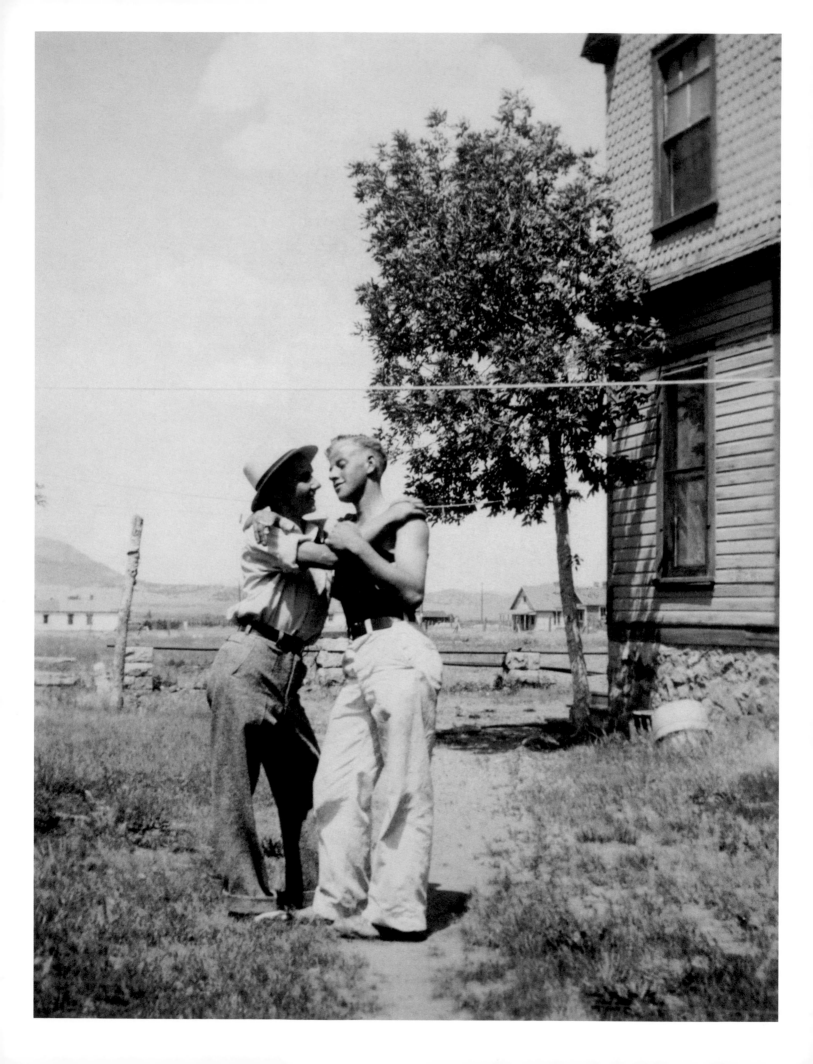

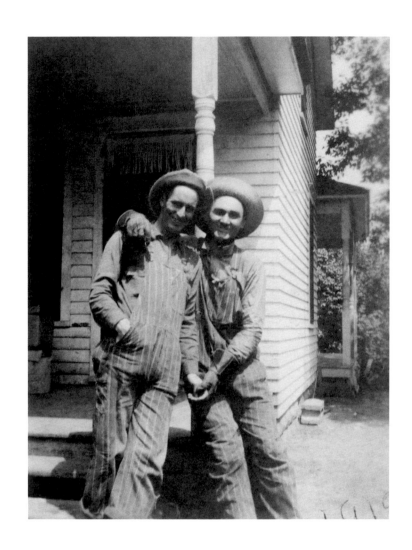

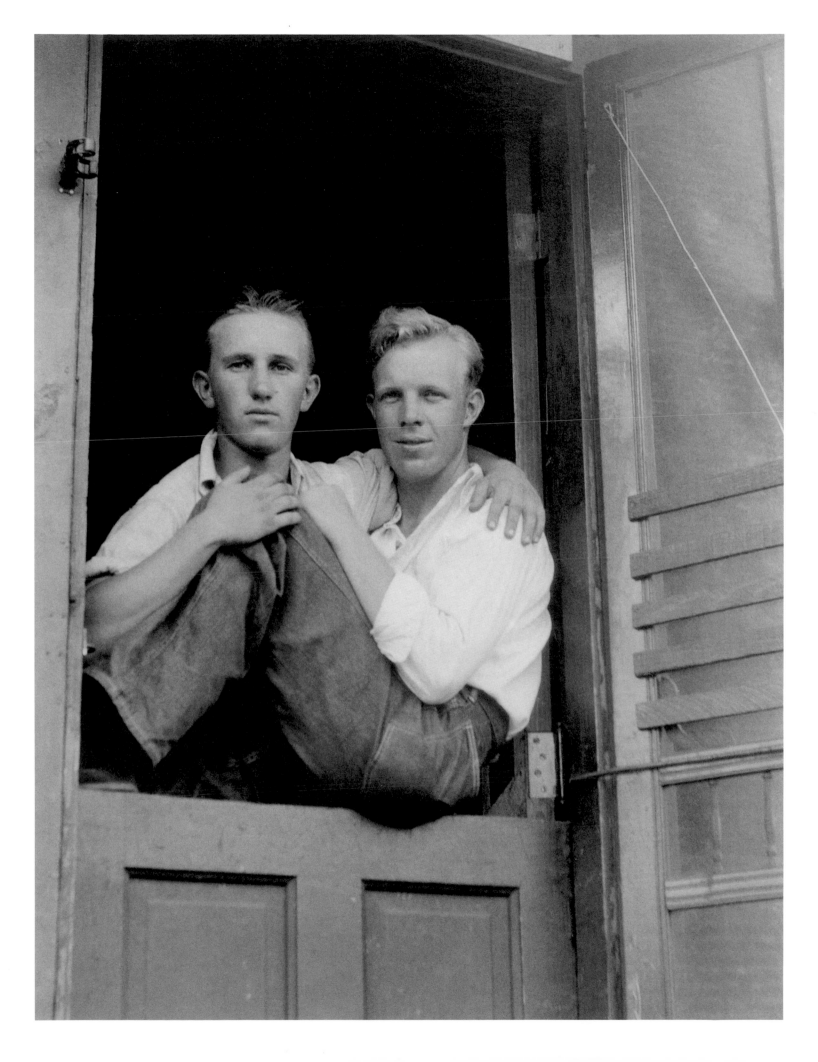

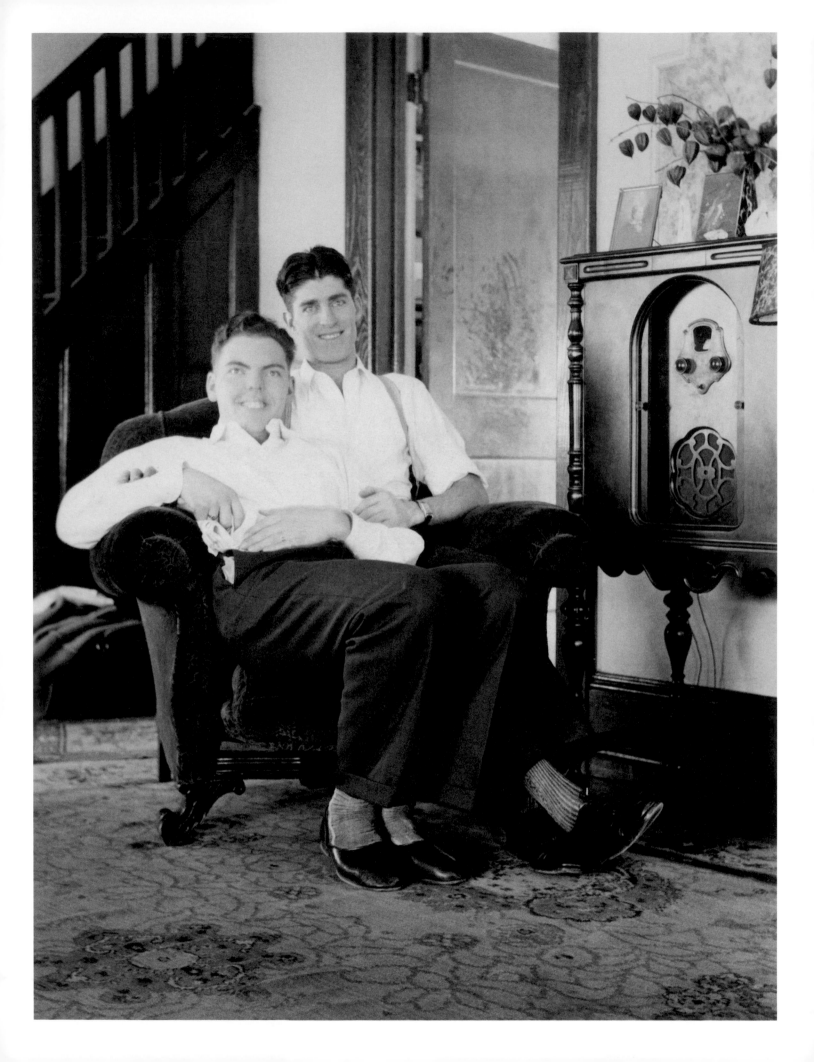

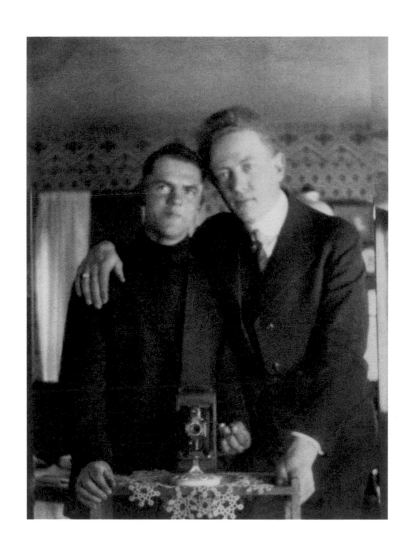

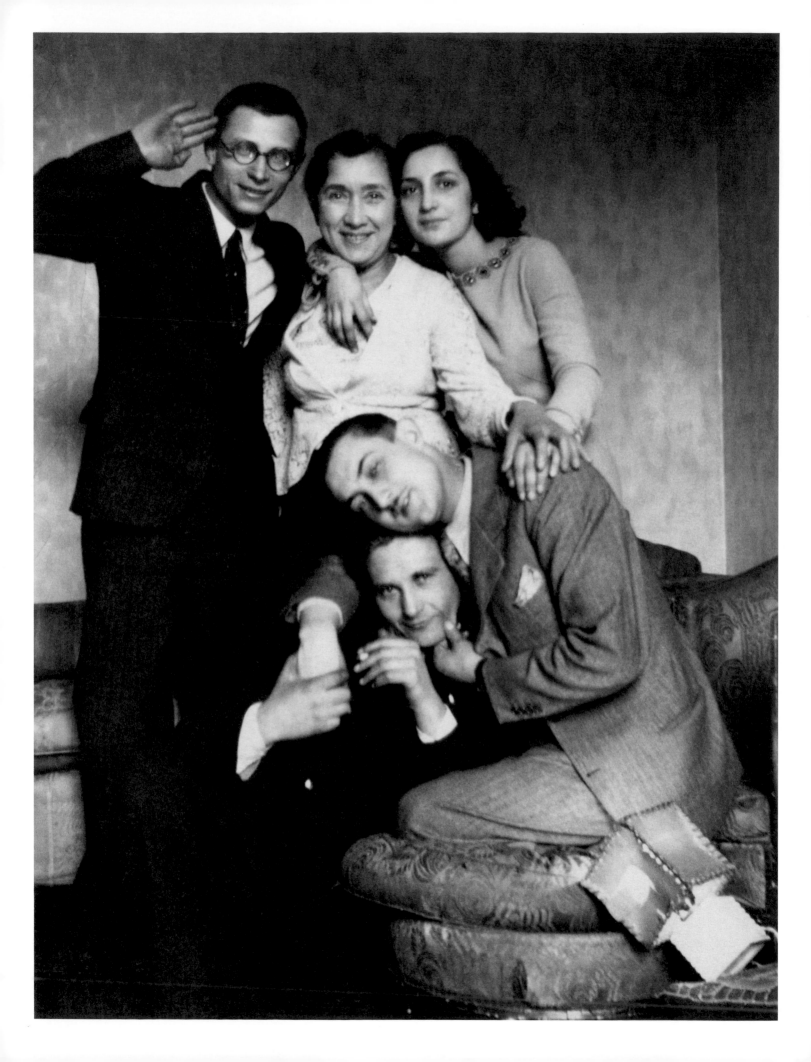

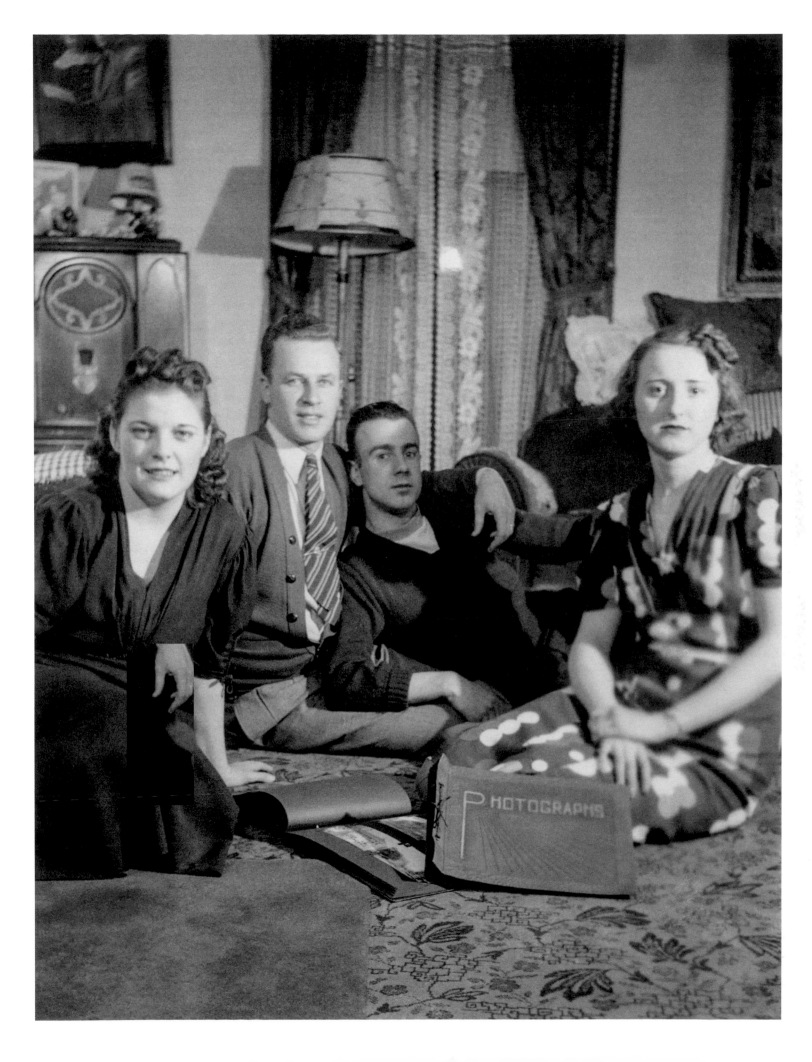

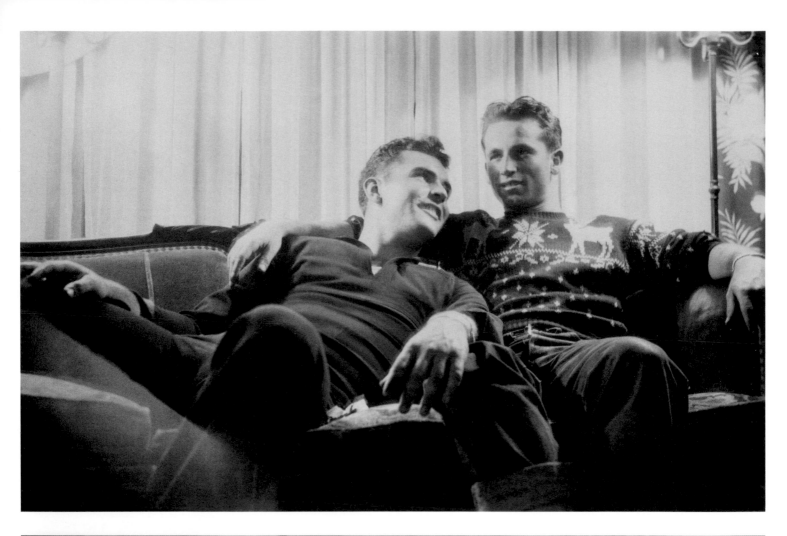

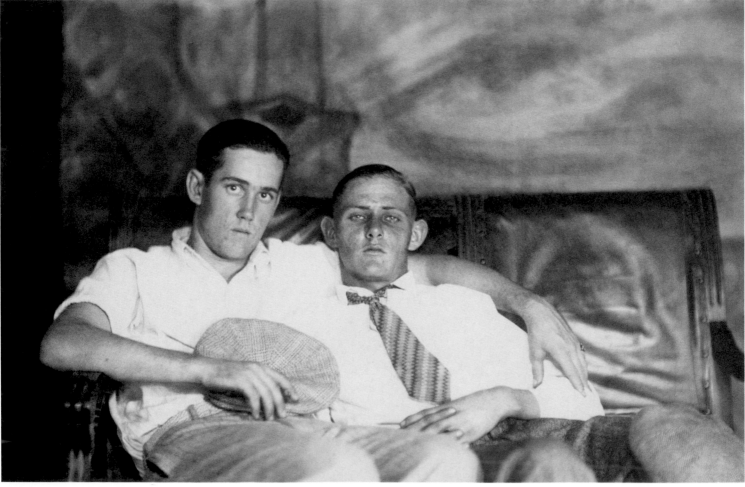

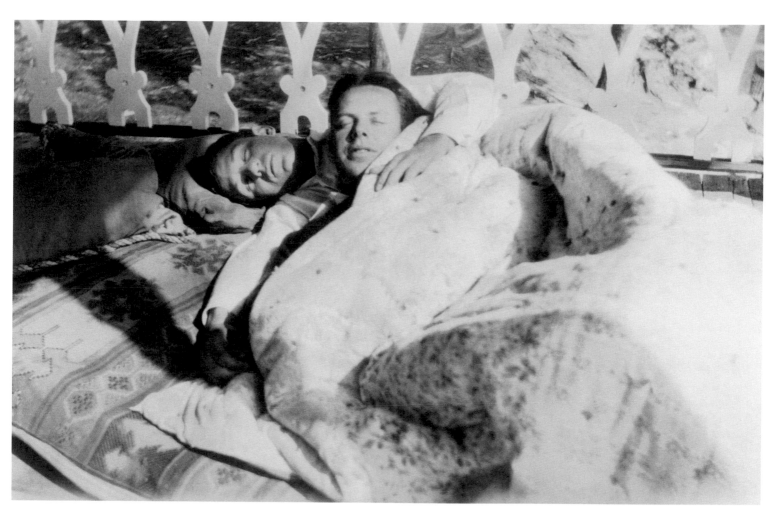

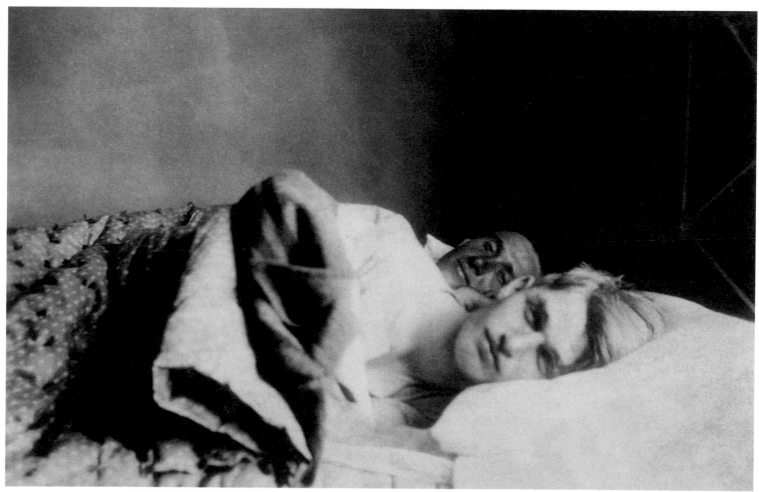

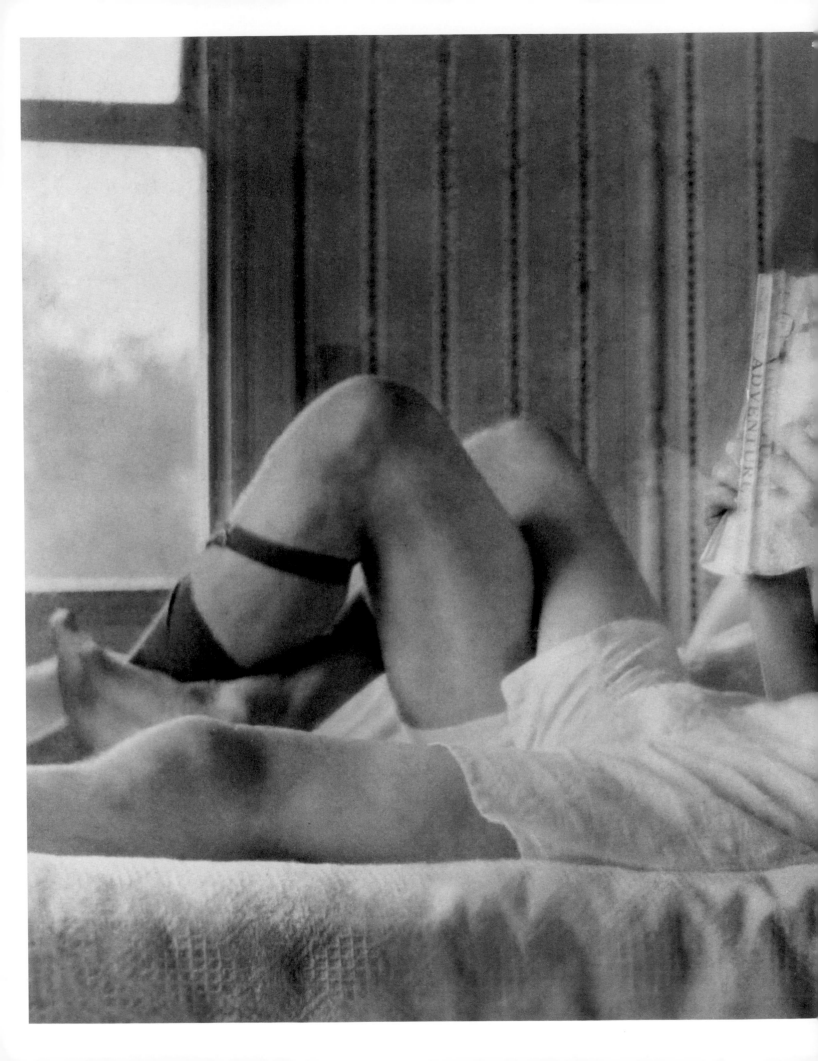

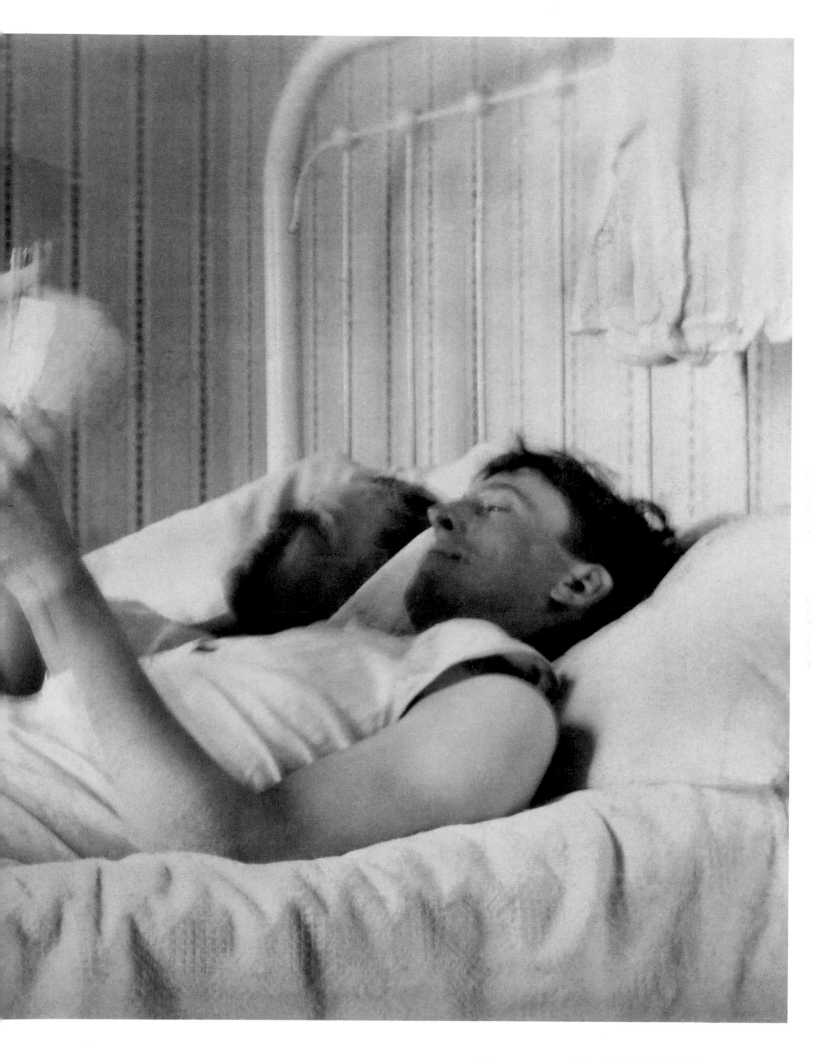

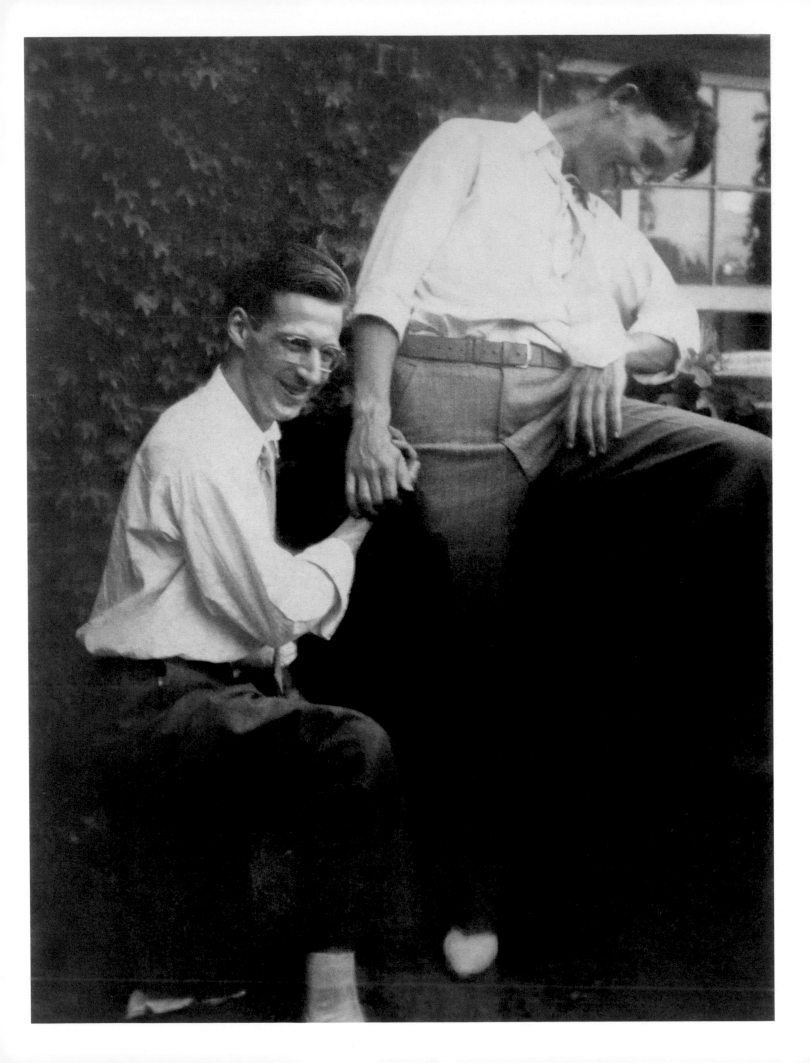

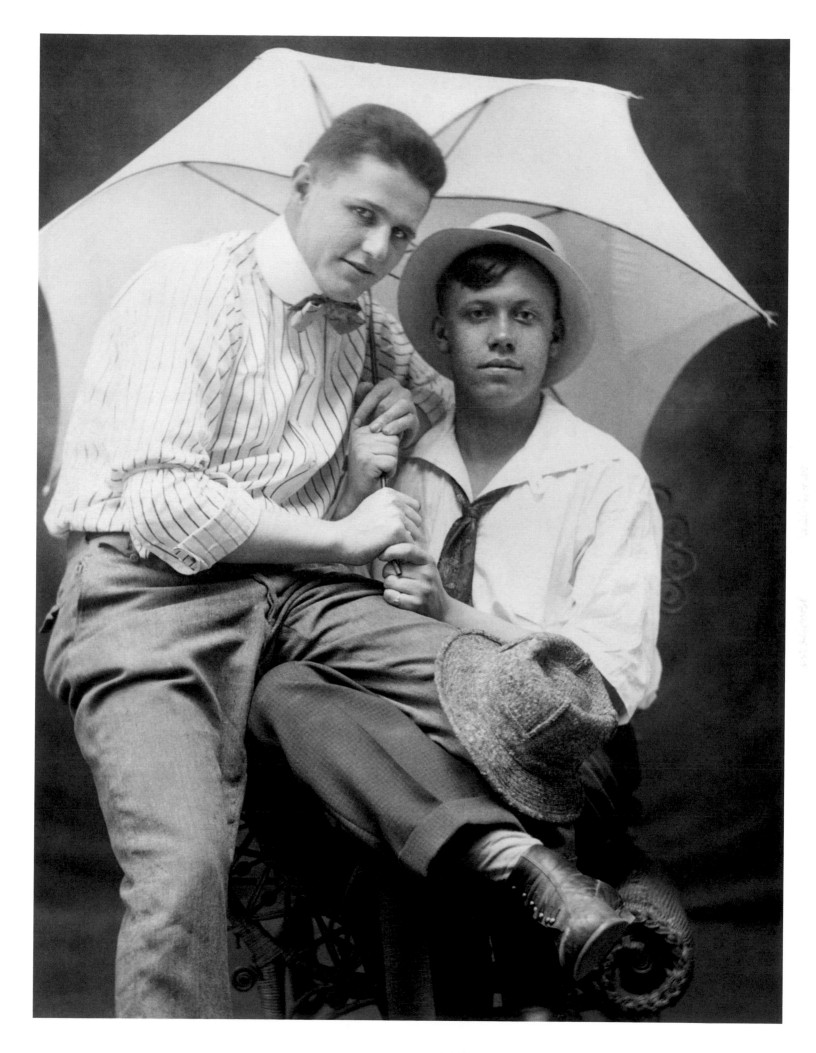

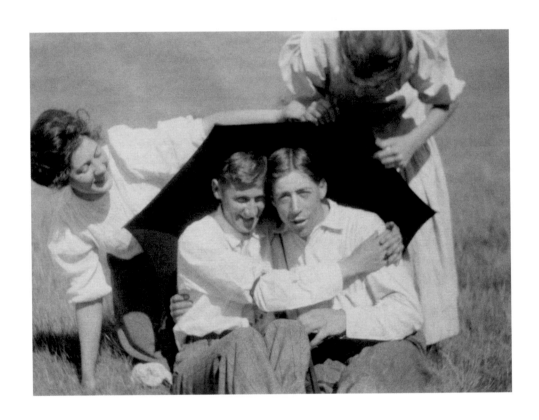

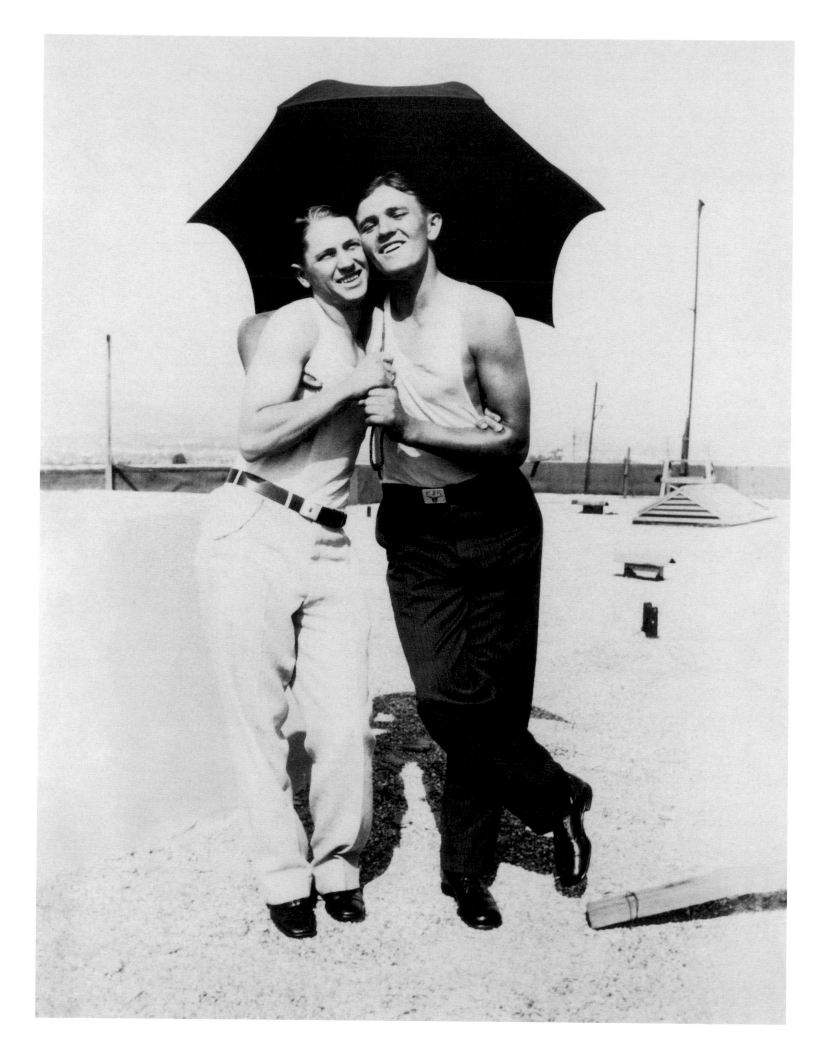

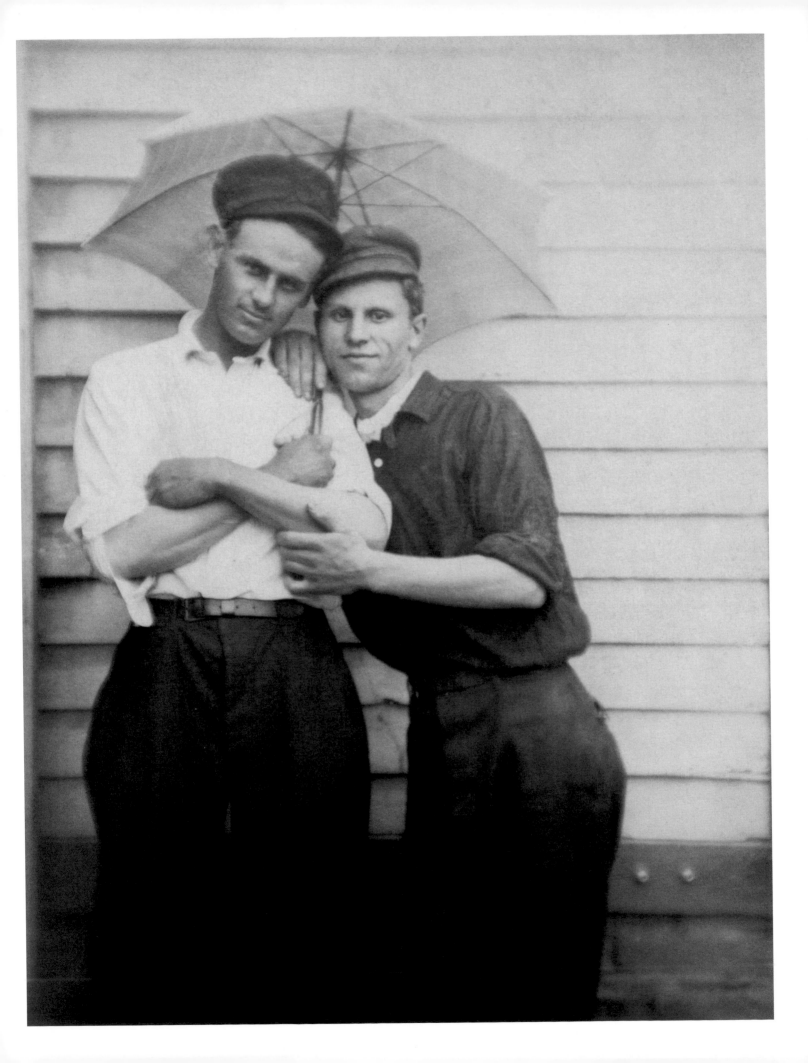

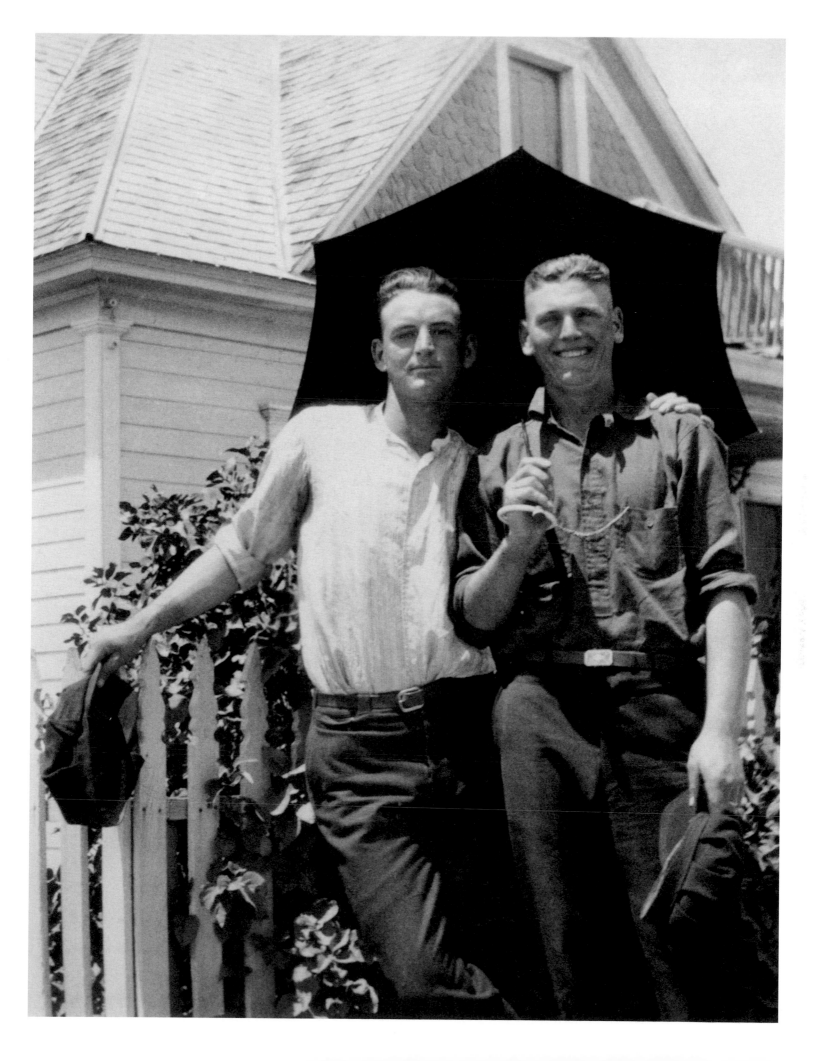

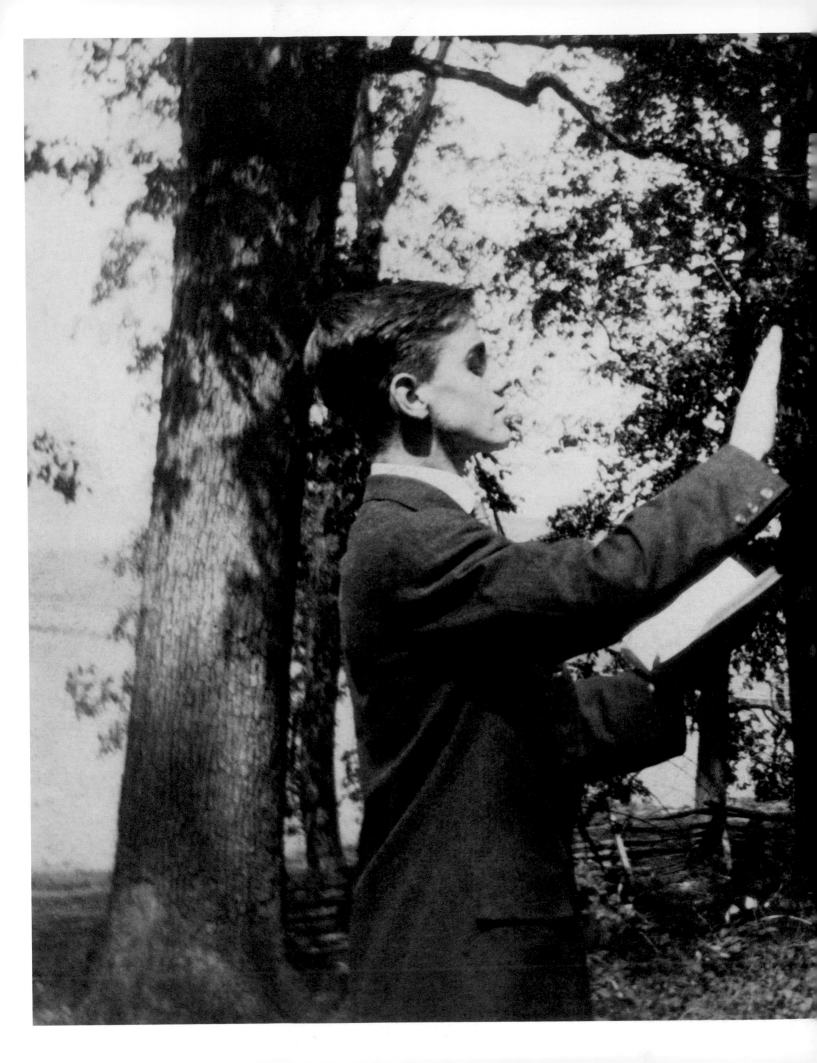

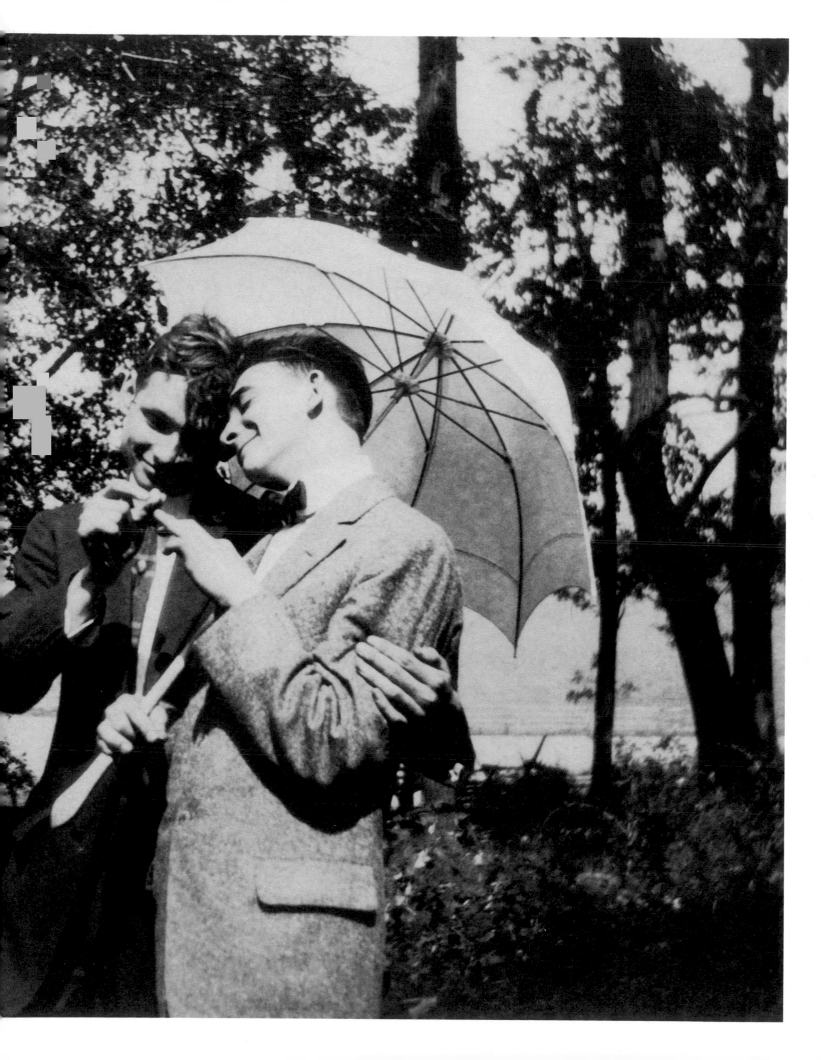

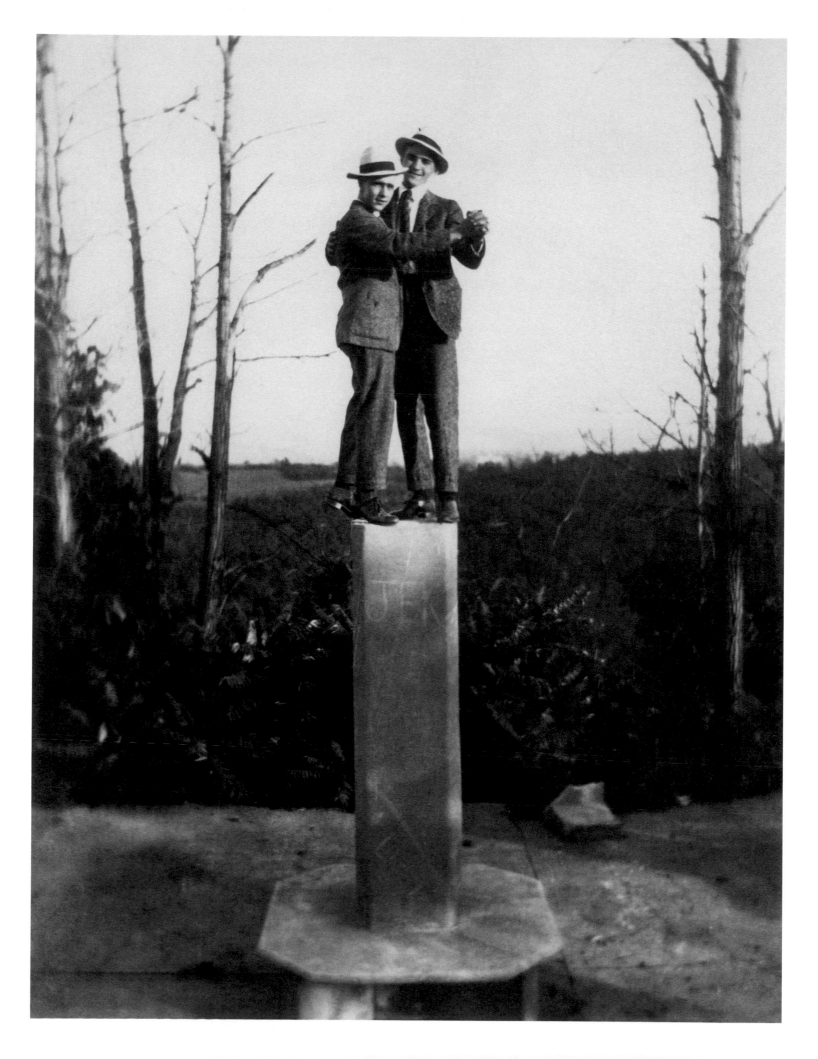

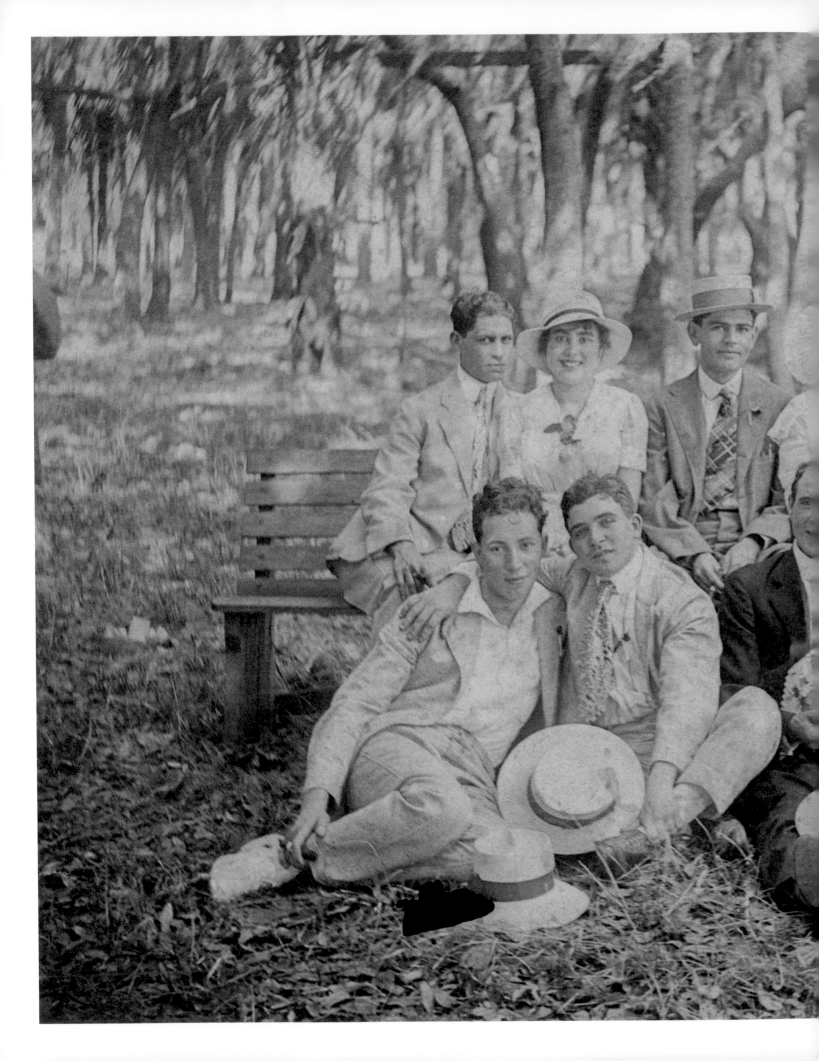

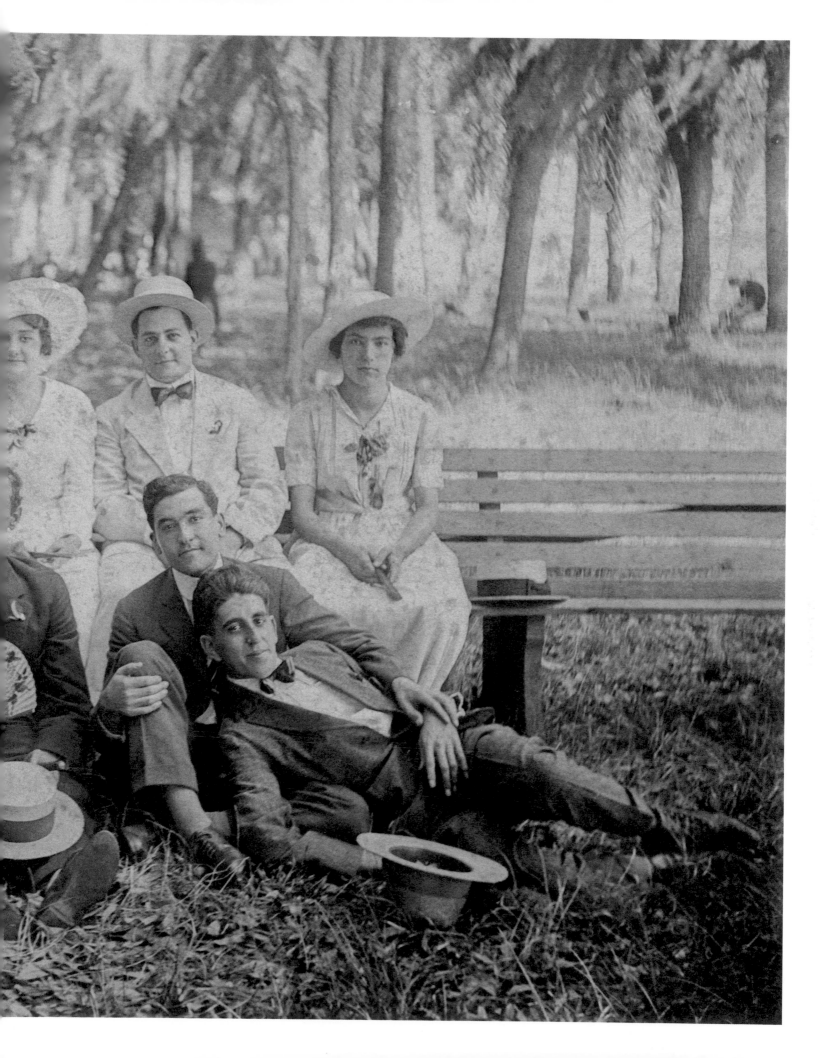

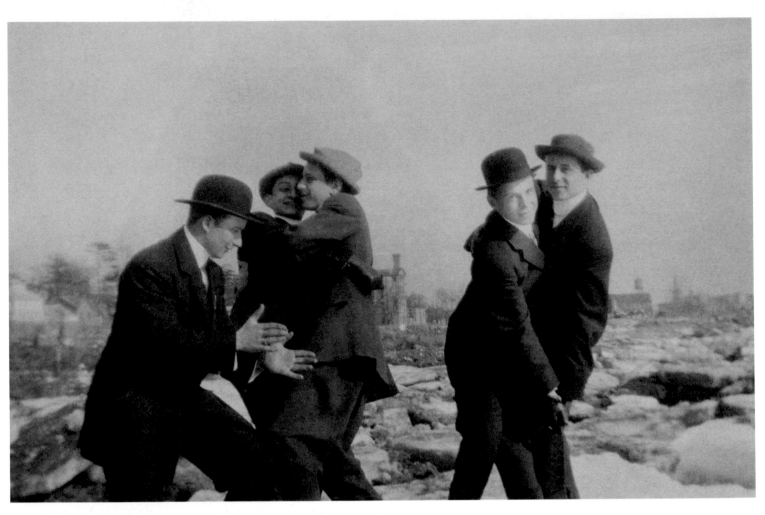

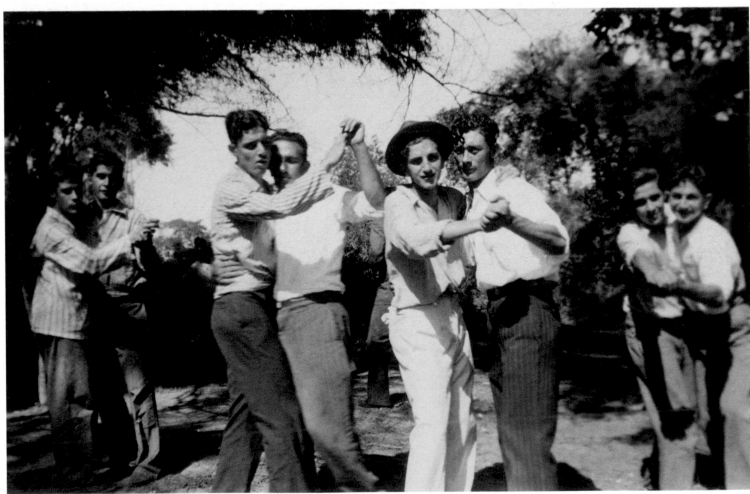

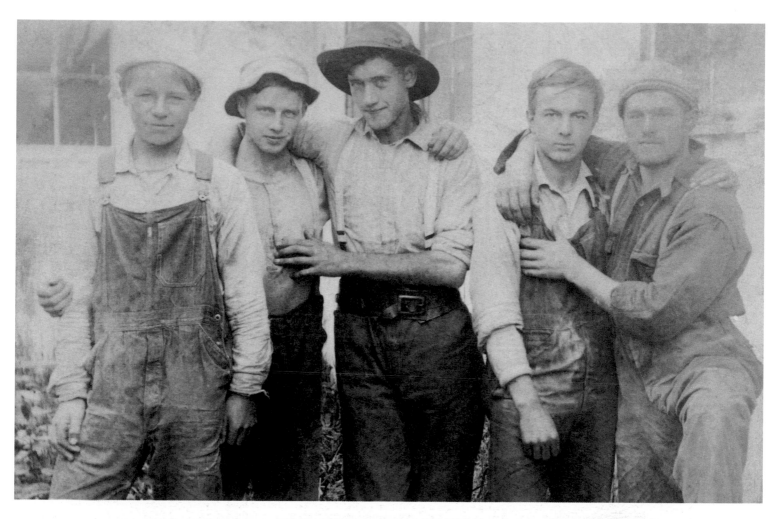

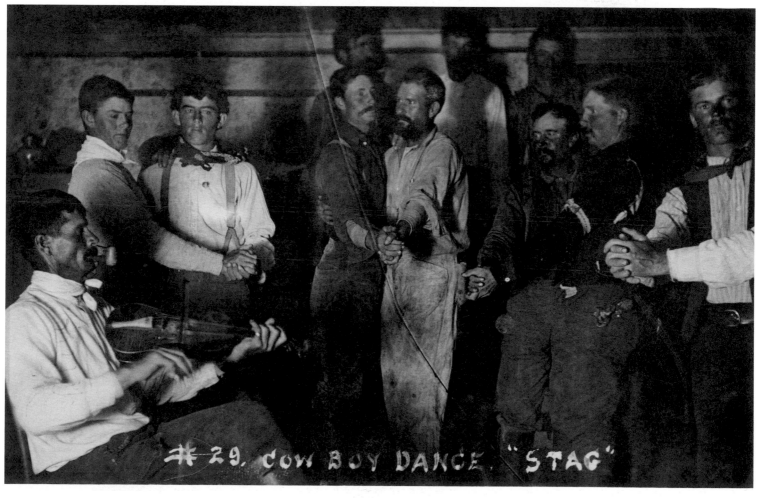

#29. COW BOY DANCE. "STAG"

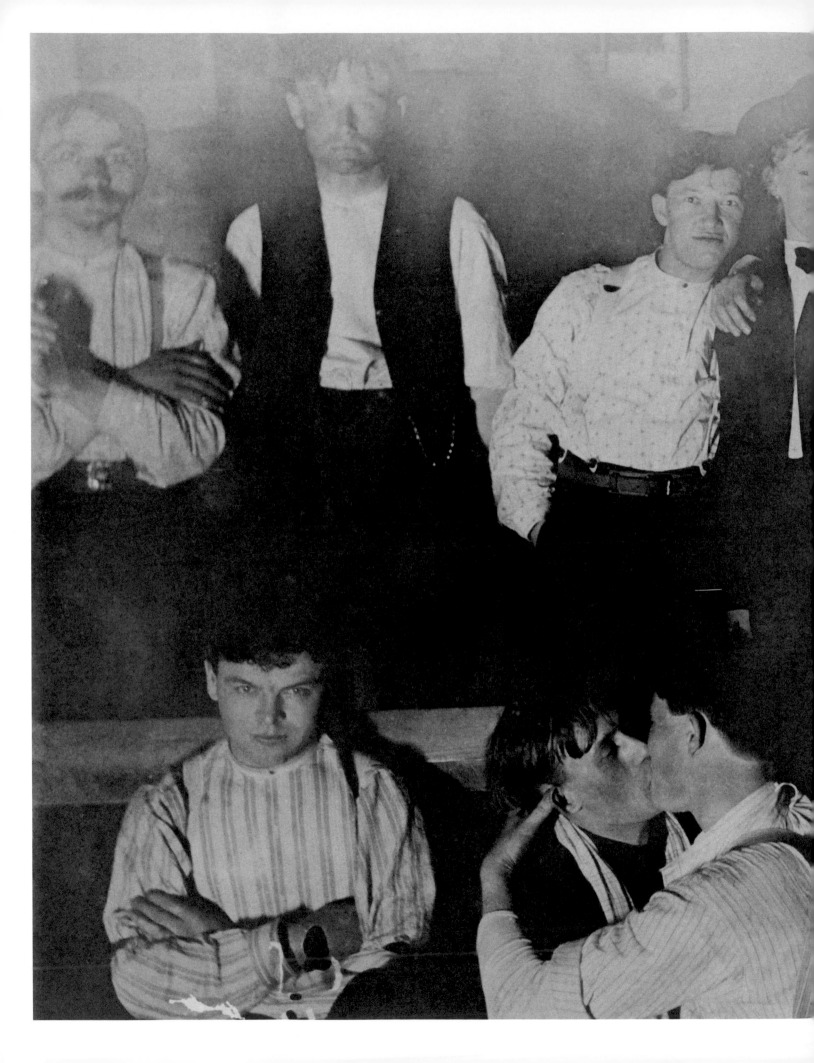

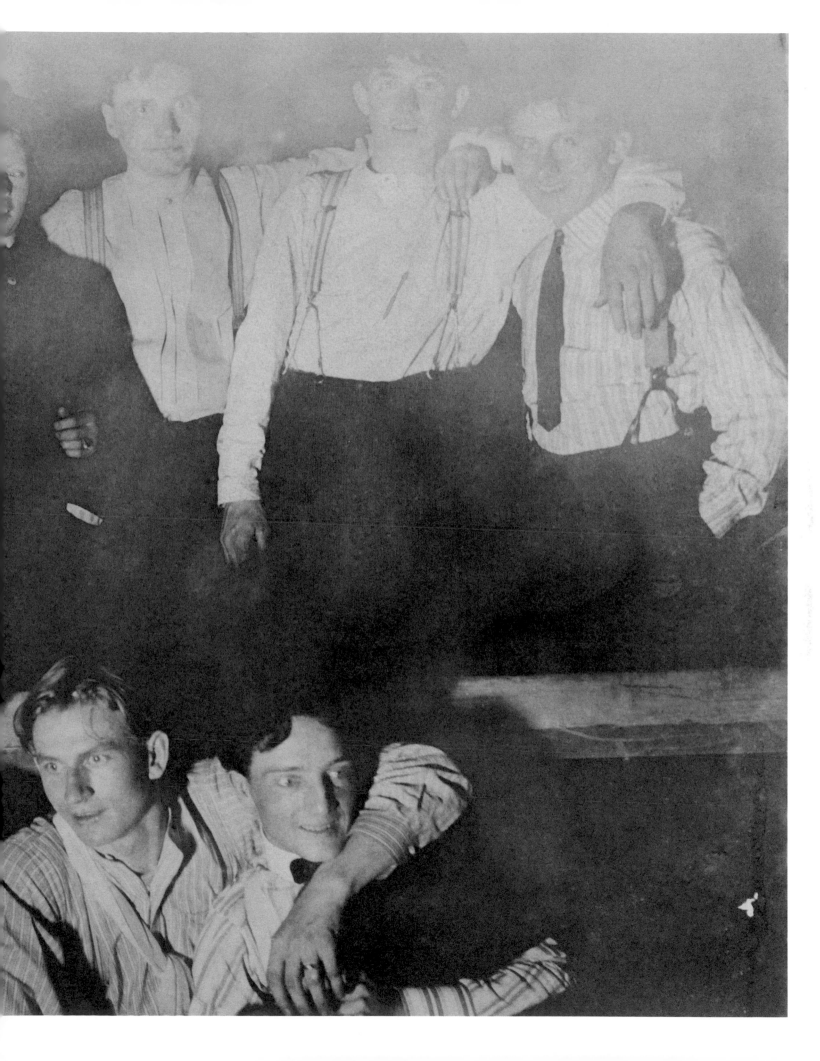

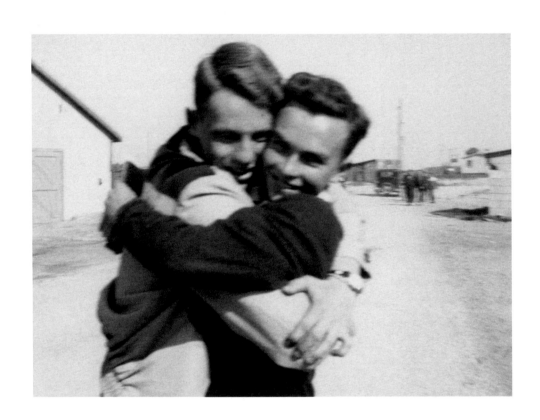

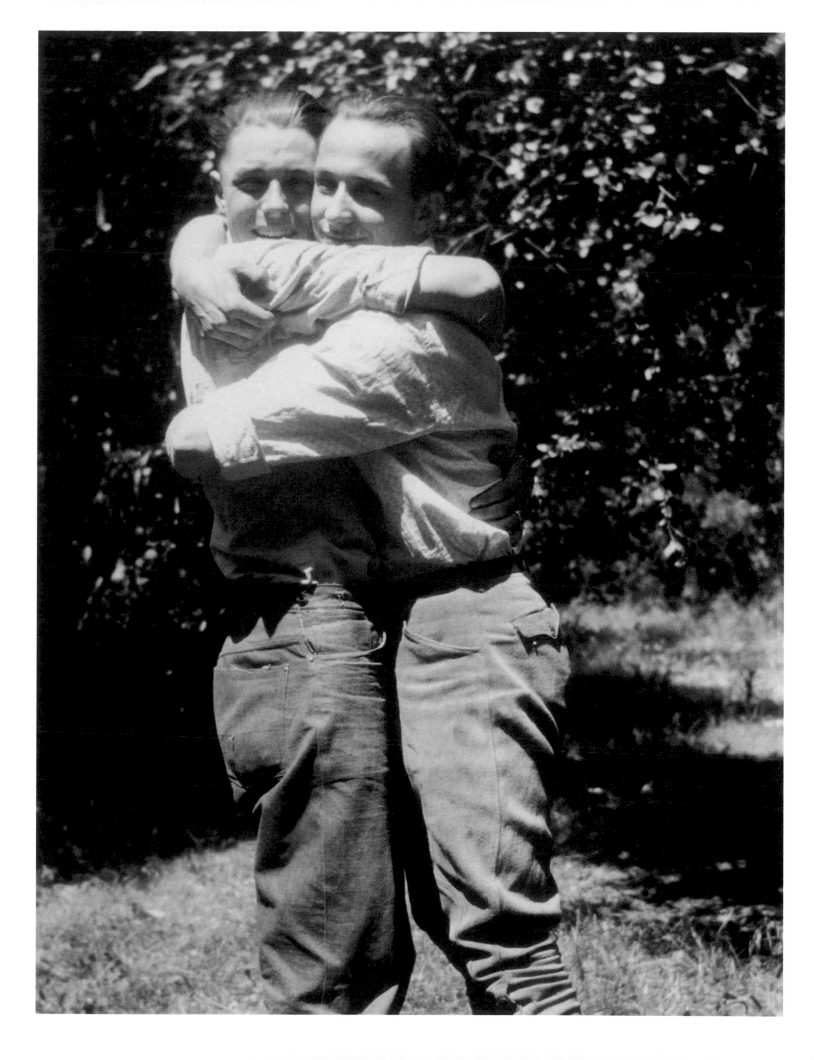

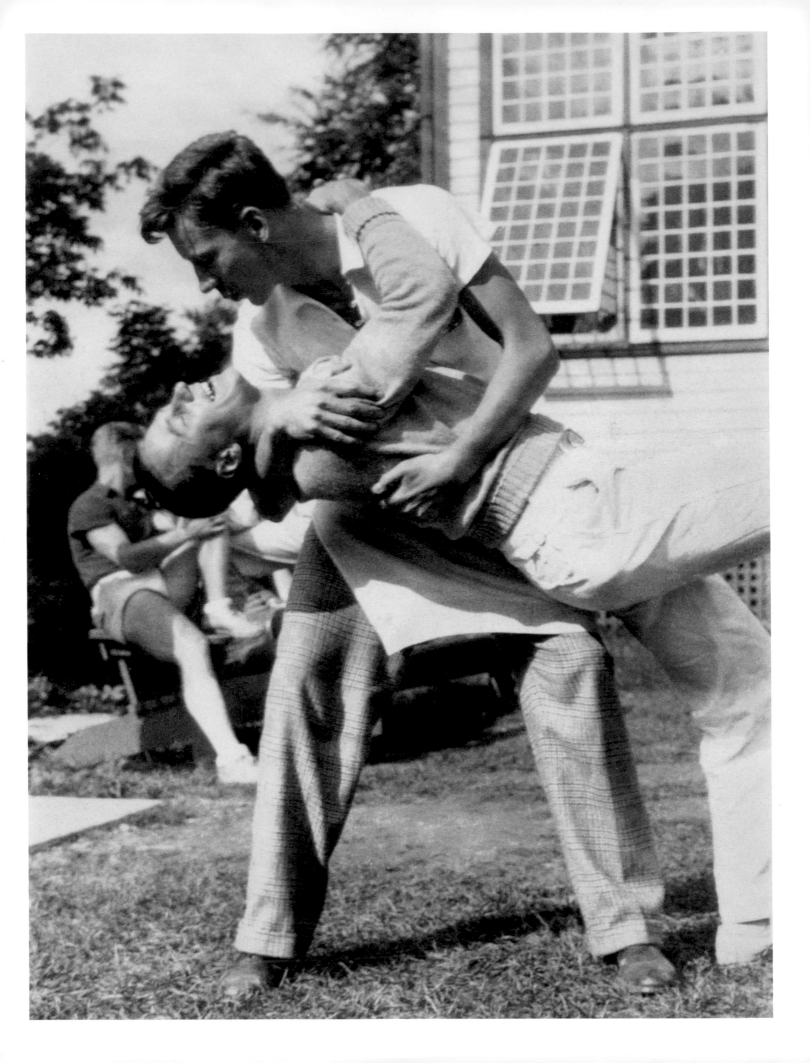

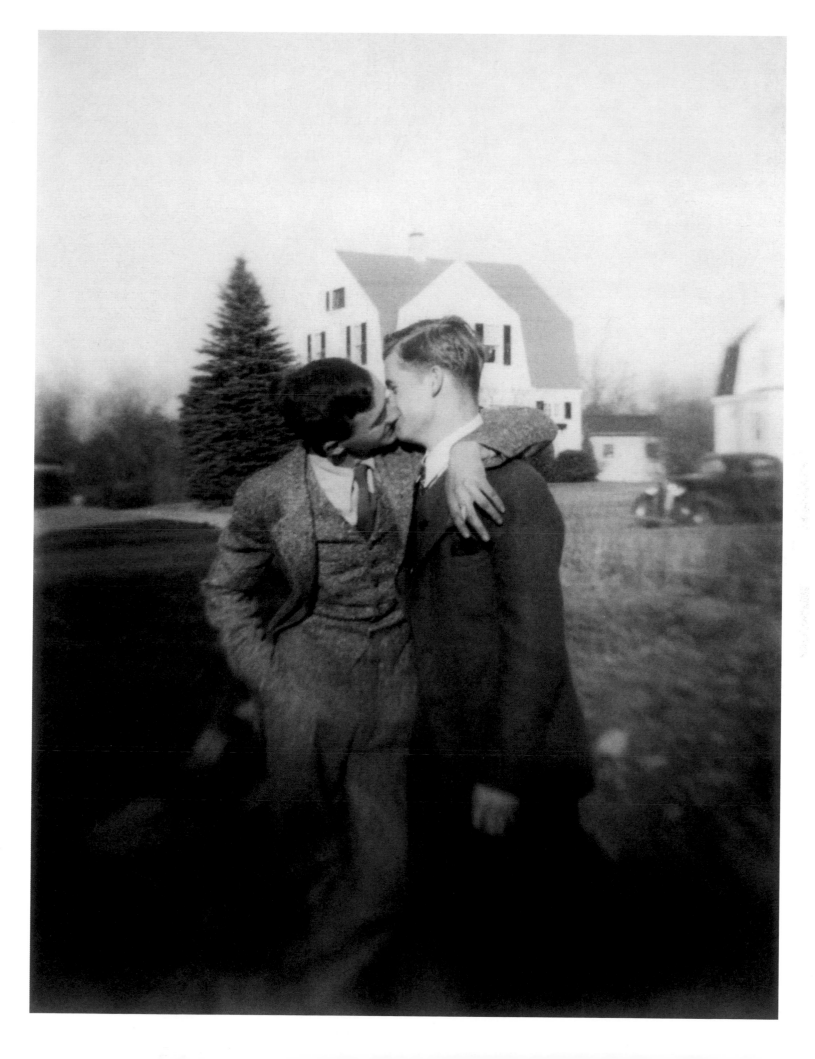

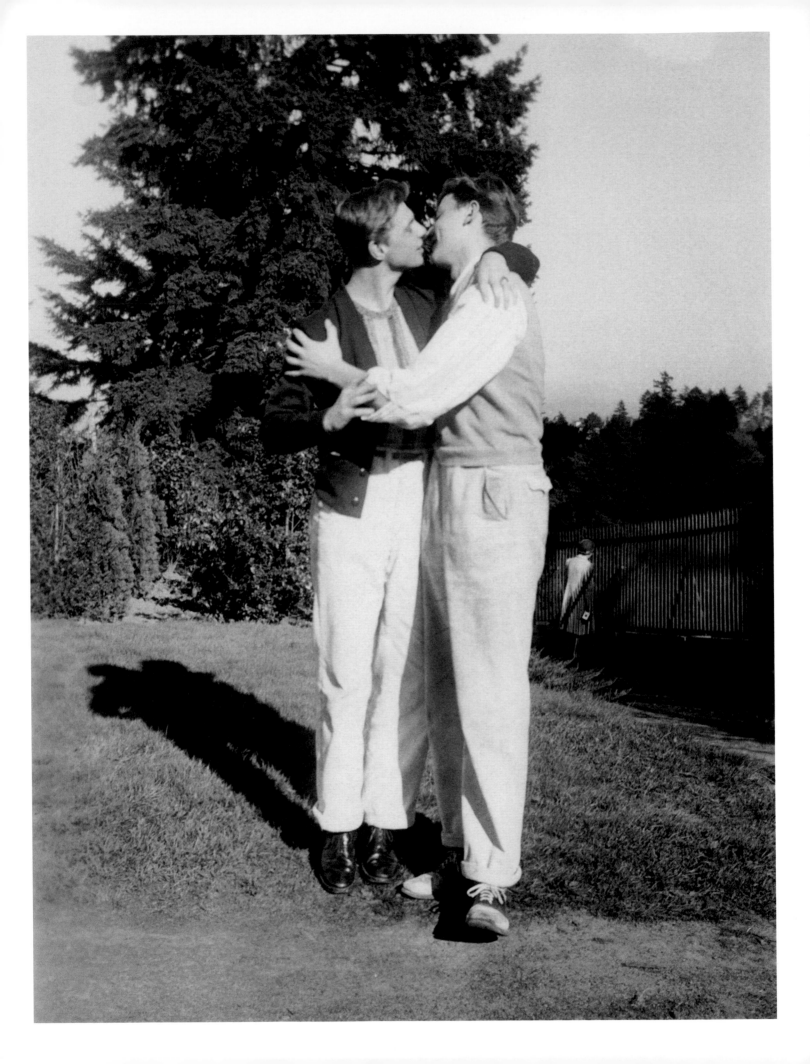

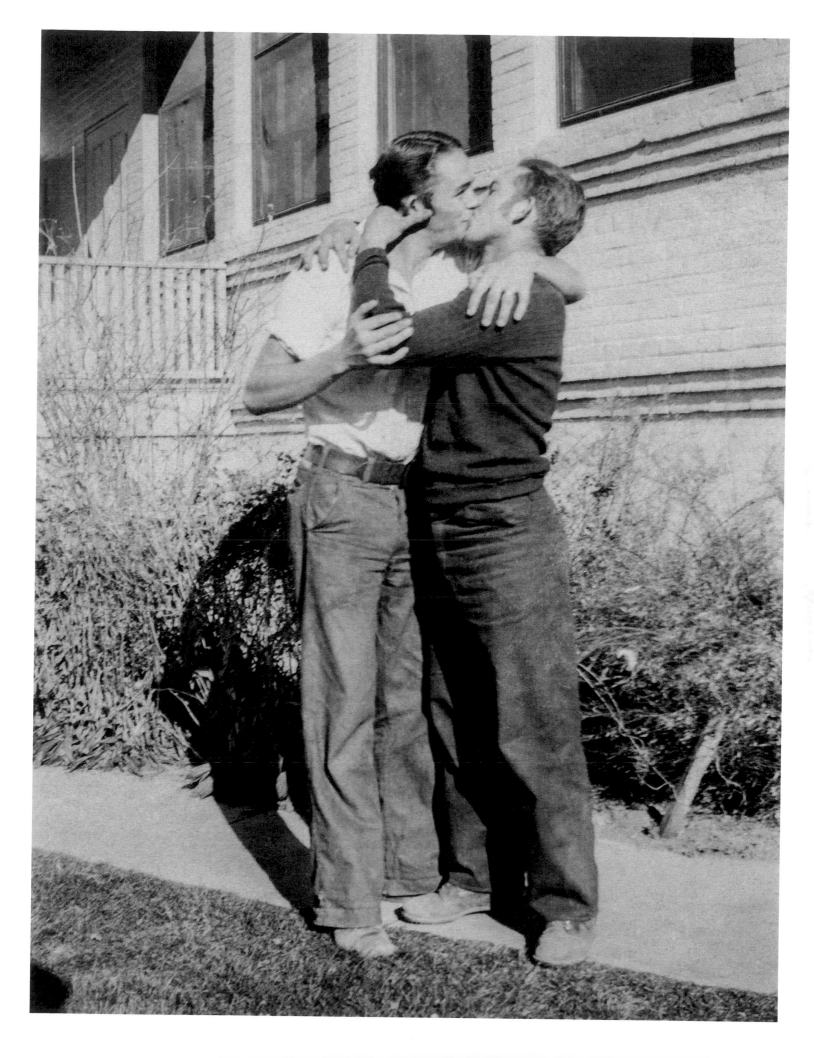

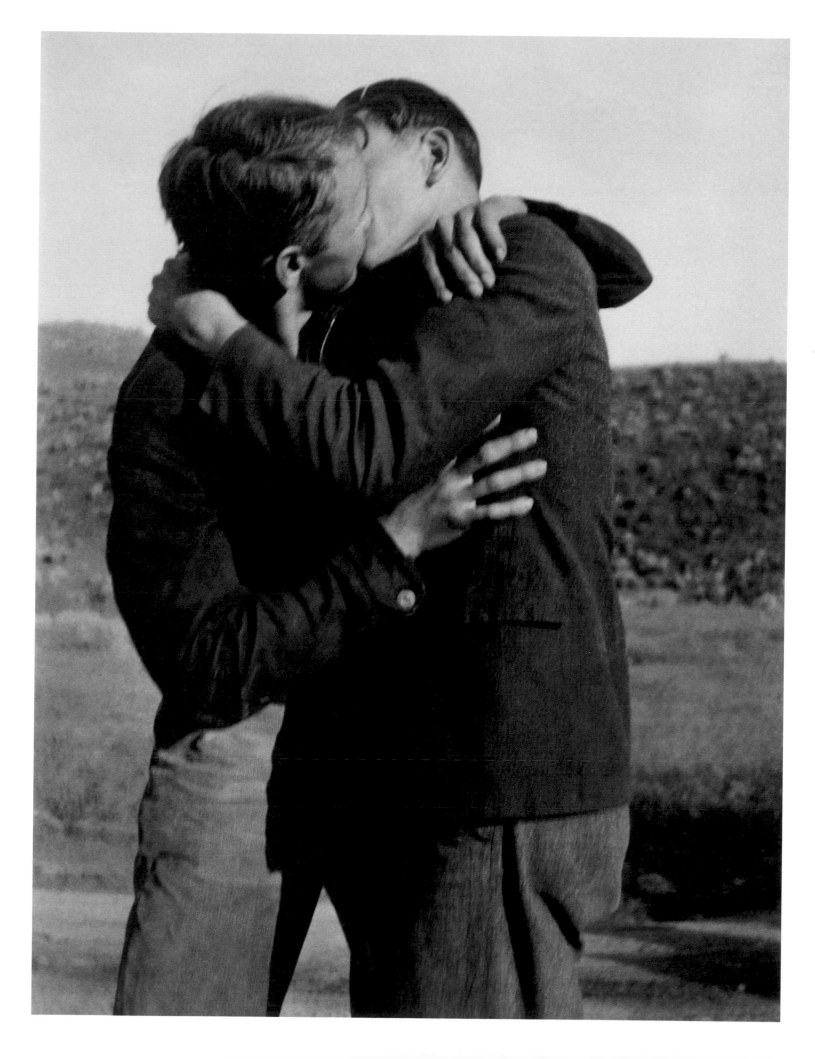

Entries

All dimensions indicated in this list reflect the original format of the photographs. Some images in this publication have been cropped.

p. 25
Tintype
Undated
95 × 63 mm

p. 26
Tintype
Undated
86 × 63 mm
Provenance: US

p. 27
Tintype
Undated
95 × 59 mm
Provenance: US

p. 28
Tintype
Undated
93 × 65 mm
Provenance: US

p. 29
Tintype
Undated
87 × 64 mm
Provenance: US

p. 30
Tintype
Undated
104 × 71 mm

p. 31
Tintype
Circa 1870
86 × 61 mm
Provenance: US

p. 32
Tintype
Circa 1860
28 × 20 mm
Provenance: US

p. 35
Cabinet card
Circa 1880
167 × 109 mm
Provenance: US
Note: "McInturff, Steve Book, Delaware O."

p. 36
Photo card
Undated
231 × 173 mm

p. 37
Cabinet card
Undated
204 × 153 mm

p. 38
Postcard
1904–18
138 × 87 mm
Provenance: US
Note: "John Uptergrove"
"Jess Bull"

p. 39
Tintype
Undated
92 × 66 mm
Provenance: US

p. 41.1
Tintype
Circa 1870
50 × 38 mm
Provenance: US

p. 41.2
Ambrotype
Circa 1850
82 × 71 mm
Provenance: US

p. 41.3
Tintype
Undated
84 × 53 mm

p. 41.4
Tintype
Undated
87 × 63 mm
Provenance: US

p. 42
Tintype
Undated
91 × 61 mm
Provenance: US

p. 43
Tintype
Undated
90 × 71 mm

p. 44.1
Tintype
Undated
90 × 68 mm
Provenance: US

p. 44.2
Tintype
Undated
166 × 117 mm
Provenance: US

p. 44.3
Tintype
Undated
90 × 64 mm
Provenance: US

p. 44.4
Tintype
Undated
89 × 62 mm
Provenance: US

p. 47
Tintype
Undated
86 × 62 mm
Provenance: US

p. 48
Postcard
Circa 1910
139 × 87 mm
Provenance: US

p. 49
Postcard
Circa 1920
139 × 87 mm
Provenance: US

p. 50
Postcard
Circa 1900
140 × 89 mm
Provenance: US

p. 52
Postcard
Circa 1910
138 × 88 mm
Provenance: US

p. 53
Card photo
1909
138 × 87 mm
Provenance: US
Note: "Have you found out where they are going to play sum" "Say kid how did you get over the ball game I feel just fine over it say you ought to see the cards us fellows got from them they are humtuter it is my best friend with me on the other side 'ya ya'"

p. 55
Tintype
Undated
118 × 94 mm
Provenance: US

p. 56
Tintype
Undated
90 × 62 mm

p. 57
Tintype
1898
90 × 60 mm
Provenance: US
Note: "98" scratched into the image

p. 58
Postcard
Circa 1910
138 × 87 mm
Provenance: US

p. 59
Postcard
Circa 1910
139 × 88 mm
Provenance: US
Note: "Henry Lorah – Friend"

p. 60
Postcard
1916
139 × 87 mm
Provenance: US
Note: "Taken July 5, 1916"

p. 62
Cabinet card
Undated
107 × 66 mm
Provenance: Germany
Note: "Ludw. Orth Giessen"

p. 63
Photo card
Undated
51 × 39 mm
Provenance: US
Note: "Elbridge Gaines and Sam Zazel Shirley Ind"

p. 64
Postcard
1910
141 × 90 mm
Provenance: US
Note: "Oct 19, 07 The village cut-ups Just as crazy as we look. Scott and Todd" (front of postcard); "Hazel, Scott and I were out riding this morning when we had this taken. Let me hear from you soon" (back of postcard)

p. 65
Photograph
1918
59 × 107 mm
Provenance: US
Note: "1918" (black mount paper)

p. 66
Postcard
Circa 1910
139 × 89 mm

p. 67
Postcard
Circa 1910
139 × 88 mm
Provenance: US
Note: "S. Witte & Art Schwartz"

p. 69.1
Postcard
Circa 1910
121 × 88 mm
Provenance: US

p. 69.2
Postcard
1911
137 × 89 mm
Provenance: US

p. 69.3
Postcard
Circa 1910
139 × 88 mm
Provenance: US

p. 69.4
Postcard
Circa 1910
140 × 89 mm
Provenance: US

p. 70
Postcard
1930–40
116 × 75 mm
Provenance: US

p. 72
Cabinet card
Undated
164 × 109 mm
Provenance: US

p. 73
Postcard
Undated
139 × 89 mm
Provenance: Bulgaria

p. 74
Cabinet card
Undated
101 × 72 mm
Provenance: US

p. 75
Cabinet card
Undated
167 × 109 mm
Provenance: US

p. 76
Photograph
Undated
37 × 49 mm
Provenance: US

p. 77
Cabinet card
Circa 1920
93 × 93 mm

p. 78
Postcard
Circa 1910
90 × 141 mm
Note: "E. Thieniann & M. Hunter" (front)

p. 79
Photograph
Undated
77 × 64 mm
Provenance: US
Note: "John & Geo"

p. 80
Cabinet card
Undated
70 × 70 mm
Provenance: US

p. 81
Cabinet card
Undated
84 × 84 mm
Provenance: US
Note: "Wylie Weaver Ed Fisher"

p. 82
Photograph
Circa 1940
87 × 119 mm
Provenance: Russia
Note: "The Blue Shawl, 1940" (complete poem on back)

p. 83
Photograph
1943
89 × 61 mm
Provenance: US
Note: "Rod Jenkins & Andrew Cerveleon, CO. 497, Barracks 1103, 1943, Akron, O."

p. 85.1
Photo strip
Undated
32 × 29 mm
Provenance: US

p. 85.2
Photo strip
Undated
32 × 29 mm
Provenance: US

p. 85.3
Photo strip
Undated
33 × 30 mm
Provenance: US

p. 85.4
Photo strip
Undated
34 × 29 mm
Provenance: US

p. 207.2
Postcard
1909
88 × 139 mm
Provenance: US
Note: "Pikes Peak
Aug. 19, 1909"
(front); "Hellow
Walt. Dick said
he thought you
would like one
of these cards
so I'm sending
it as an answer
to yours which
I received some
years ago. Have
been busier
than a cat on
a tin roof, trying
to keep warm,
or would have
answered before.
Bill" "Mr Walt
Schriver Victor
Colo. 1111
Portland Ave."
(back)

p. 209.1
Photograph
Undated
92 × 117 mm
Note: "Edward
and his chum"

p. 209.2
Photograph
Undated
70 × 99 mm
Provenance: US

pp. 210–11
Photograph
Undated
70 × 117 mm
Provenance: US

p. 212
Photograph
1949
91 × 93 mm
Provenance: US
Note: "Frank & I"
"Conneaut Lake,
July 4, 1949"

p. 213
Photograph
1949
91 × 93 mm
Provenance: US
Note: "Frank & I"
"Conneaut Lake,
July 4, 1949"

pp. 214–15
Photograph
Undated
63 × 89 mm

p. 216
Photograph
1940
91 × 64 mm
Note: "Apr 1940"

p. 217
Photograph
Undated
84 × 89 mm

p. 218
Photograph
Undated
130 × 93 mm
Provenance:
Russia

p. 219
Photograph
1942
97 × 73 mm
Provenance: US
Note: "Bud & Roy,
July 5, 1942"

pp. 220–21
Photograph
Undated
64 × 88 mm
Provenance: US

p. 222
Photograph
1920s?
88 × 96 mm
Provenance: US

p. 223
Photograph
Undated
94 × 88 mm
Provenance: US
Note: "split fence
embrace"

p. 224
Photograph
Undated
82 × 58 mm

p. 225
Photograph
1919
67 × 89 mm
Provenance: US
Note: "A passing
fancy. Just a
dodge but oh the
rides. Summer
1919"

p. 226
Photograph
Undated
66 × 108 mm
Note: "Jackson
& Paul"

p. 227
Photograph
Undated
96 × 72 mm
Provenance: US
Note: "Standard
Photo Service,
Box 188,
Minneapolis,
MINN."

p. 228
Photograph
Undated
97 × 63 mm
Provenance:
Serbia

p. 231
Postcard
Undated
90 × 140 mm
Provenance:
Plovdiv, Bulgaria
Note: "I send
you a photo
that probably
will raise the
curtain of a little
part of my life"
(translation)
Bulgarian copy
on back

p. 232
Photograph
Undated
75 × 65 mm
Provenance: US

p. 233
Photograph
Undated
92 × 64 mm
Provenance: US

p. 235
Photograph
Undated
104 × 77 mm
Provenance: US

p. 236
Photograph
Undated
119 × 71 mm
Provenance: US

p. 239
Photograph
Undated
129 × 84 mm

pp. 240–41
Photograph
Undated
71 × 117 mm
Provenance: US

p. 242.1
Photograph
Undated
71 × 117 mm
Provenance: US

p. 242.2
Photograph
Undated
78 × 123 mm
Provenance: US

p. 243.1
Photograph
Undated
71 × 117 mm
Provenance: US
Note: "Lorraine"

p. 243.2
Photograph
Undated
83 × 118 mm
Provenance: US

p. 244
Photograph
Undated
74 × 104 mm

p. 245
Photograph
Undated
120 × 87 mm
Provenance: US

pp. 246–47
Photograph
Undated
72 × 114 mm
Provenance: US

p. 248
Photograph
Undated
106 × 67 mm
Provenance: US

p. 249
Photograph
Undated
59 × 83 mm
Note: "Two of a
kind, Red and
Frank, just a
remembrance"

p. 251.1
Photograph
1928
94 × 72 mm
Provenance: US
Note: "Santa
Barbara July 4,
1928"

p. 251.2
Photograph
Undated
110 × 66 mm
Provenance: US

p. 251.3
Photograph
Undated
116 × 70 mm
Provenance: US
Note: "This is my
boy friend again"

p. 251.4
Photograph
Undated
104 × 73 mm
Provenance: US

p. 252
Photograph
1932
97 × 65 mm
Provenance: US
Note: "July 6,
1932, I snapped
Fred Miller, 3721
N. Kenneth,
Chicago, Ill &
Otto"

p. 253
Photograph
Undated
97 × 71 mm
Provenance: US

p. 254
Photograph
Undated
101 × 60 mm
Provenance: US

p. 255
Photograph
Undated
107 × 63 mm
Provenance: US

p. 256
Photograph
1949
76 × 76 mm
Provenance: US
Note: "My Darling
1949"

p. 257
Photograph
1955
90 × 91 mm
Provenance: US
Note: "Stan Smith
& Bill Davies.
Brighton Ave,
June 1955"

p. 259
Photograph
Undated
179 × 130 mm
Provenance: US

p. 260
Photograph
Undated
107 × 79 mm
Provenance: US

p. 261
Photograph
Undated
126 × 84 mm
Provenance: US

p. 262
Photograph
1937
152 × 97 mm
Provenance: US
Note: "Gale
Jenkins and Virgil
Simpson, 1937,
Dec., Woodrow
Wilson"

p. 263
Photograph
1952
124 × 78 mm
Note: "Jul 1952"
(stamp)

p. 265
Photograph
Undated
79 × 100 mm
Provenance: US

p. 266
Photograph
Undated
114 × 70 mm
Provenance: US

p. 267
Photograph
1931
53 × 90 mm
Provenance: US
Note: "May 31,
1931 Sal and
Cliff taken
at I look Mt."

p. 268
Photograph
Undated
89 × 65 mm
Provenance: US

p. 269
Photograph
Undated
88 × 65 mm
Provenance: US
Note: "Two
Chums" (front)

p. 270
Photograph
Undated
100 × 60 mm

p. 271
Photograph
Undated
117 × 86 mm
Provenance:
Bulgaria

p. 272
Photograph
1948
117 × 84 mm
Provenance: US
Note: "Sept NEVR
FADE 1948"
(stamp on back)

p. 275
Photograph
Undated
83 × 108 mm
Provenance: US
Note:
"Rubenstein and
Whiskers, AHK-"

Acknowledgments

From Hugh Nini & Neal Treadwell

Our greatest thanks go to our publisher, Eric Ghysels of 5 Continents Editions, who believed in *Loving* from the first time we met, and brought together a world-class team to create this magnificent publication. To his team at 5 Continents Editions, Valentina De Pasca, and Elena Carotti. To our US distributor, ACC Art Books, in particular Mary Albi, whose guidance and commitment have been unwavering and generous from the start. To Jean Doyon, and René Clément whose expert and sensitive design has given *Loving* the poetry it called for. Thank you to Paolo Maria Noseda, Andrea Smith, Alessandra de Antonellis, and Ilaria Bolognese for communicating the message of *Loving* to the printed and electronic world.

We would like to thank Jackie Hoegger of Hoegger Communications and her team: Matt Hamilton, Abel Petrik, Andrew Bell, Eric Crosslin, Hayden Gerstner, Erica Sawyer, and the entire team, for creating the short film documentary that tells the story of *Loving*, our collection, and us, in a beautiful and creative way. Their commitment to detail and excellence, both artistically and technically, is without equal. We knew that their work would be astonishing, but even that didn't prepare us for what was presented to us. Their film is inspiring, visionary, and most importantly, up-lifting.

Thank you to Tony Yearwood who was the first person we showed our collection to in 2013, and the first person to utter the words: "You have to publish these." Thank you to Jennifer Hessel for being the second, but not the last, to say: "You have to publish these." Thank you to Rayna Fagen for her invaluable input for web design and marketing. To Hollie Domingue, Ellen Ritscher Sackett, Robin Underdahl, Elaine Richard, and Amy Nini, thank you for your invaluable expertise with our essay.

Our sincere thanks to Georges Charlier and Joost Kooreman, of Salto Ulbeek, whose reproduction and color separating process brought our photographic artifacts back to their glorious youth and beauty—the beauty they had when they first came to life, and were held lovingly in their subjects' hands.

Thank you to David Henry who generously shared the story of his beloved uncle, and World War II soldier, John W. Moore, thereby providing us with the only first-hand account of one of the subjects in our collection. His uncle's life has been liberated from the shoebox where it spent nearly seventy years, and now adorns this loving publication.

Thanks to our co-publishers Elisabeth Sandmann (Elisabeth Sandmann Verlag), Laurent Beccaria, and Jean-Baptiste Bourrat (Les Arènes).

We thank our families for their unconditional love and support, and for believing in us in all ways. Thank you to our friends and our church community, Cathedral of Hope in Dallas, Texas, for their love and support and for being the "village" that made it possible for us to thrive. Thank you to Bill Westmorland, who introduced us to Edward Gómez, who then introduced us to our publisher, Eric Ghysels.

Finally, and most importantly, none of us would be here today celebrating this beautiful publication if not for the brave, committed, prescient, and loving men of *Loving. A Photographic History of Men in Love*: Rod Jenkins and Andrew Cerveleon, Woody and Bob, Fred Miller, Mama and Papa, Gene and Friend, Davis and J.C., Benson and Privatt, Bill Sherham and George Holliday, Bud and Brandy, Bud and Roy, E. Thieniann and M. Hunter, Edward and his chum, Elbridge Gaines and Sam Zazel, Fleet and Geo, Floyd W Gillespie and Friend, Scott and Todd, Frank and I, Fuller and I, Gale Jenkins and Virgil Simpson, Garry and Eddie, George and Herb, George Thompson and a buddy, Glen Crofoot, Harry and Ernie, Henry Lorah, Smith and Wade, J.M. Parker and Berton L. Thomas, Jack Anderson and Vernon Phillips, Jackson and Paul, Vladimir and Kolya, Vitya and Sasha, Misha and Kolya, Vasya and Ivan, Bill Presant and Jack La, Yurdan and Radoi, Pierre and Jules, "Bogolusa" and Itala, Luis and Vicente, Dusko and Jojo, Lesha and Vitya, Roza and Honzo, Warier and Erich, Petar and Friend, Jerry and Bob, Joe and I, John and Geo, Kariol and Gene, Lee and Hank, Marty and Blacky, Me and Albert, Me and Harvey, Pete and Getvoghan, Rat Porter, Roddy and me, Rubenstein and Whiskers, S. Witte and Art Schwartz, Claude Kappinger and Sam Samuels, Stan Smith and Bill Davies, Red and Frank, Walter and Mike, Wylie Weaver and Ed Fisher, Harley P. Humphrey and I. D. Huff, John and Jess, David and Eddie, Melvin and Russell, Ned Powers and Pete Lamats, Willie and A. Sandin, Petor Petrov, Charles Tunget and Arthur Lewis, Charles L. Vasquez and Arther Eugene Ruiz, Karl Eaton and Phil Sweetsar, Louis, Charles Samuel Kirby and friend, Dootie and I, Gilliand and Martin, me and Schmidt, Miller and Klaus, Clark and Frank, T.E. Hansen and "Keiser, Vine and me," Bucky Walters and Eddie Parker, Lewis and Wayne, Frank and Mack, Herman Gibbson and Charlile Elden, Bobby Mann and Charlie Elden, Andy and Ken, George Martin and Herb Hagenan, Paul and I, Bob Schultz and Bob Dodgins, Roland and John, Travis Schlwart and Max Johnson, Lynch and me, Reilly and Carson, Johnny Mccandleuss and Rex Young, Marston and Niederer, Paul Popowych and Mike Billisiki, Other and Curtis, Dale and Allen, Anonymous, and most importantly, John W. Moore and Dariel F. Burnes.

Perhaps, someday, these beautiful photographs of these couples will find a home in an exhibition or museum where everyone can see what they saw when they held them in their hands.

From 5 Continents Editions

First of all, the Publisher would like to thank Edward Gómez for making the initial connections, which were pivotal in transforming the *Loving* project into something concrete.

We also thank Hugh Nini & Neal Treadwell for having entrusted us with an important part of their lives: we are proud to be the custodians.

5 Continents Editions is also grateful to Jean Doyon, René Clément, Georges Charlier, Joost Kooreman, Andrea Benedetti, Paolo Maria Noseda, Mary Albi, Andrea Smith, Renato Salvetti, Mauro Frigerio and the Emme Promozione team, Flavio Zuin, Maria Letizia Zuccaccia, Chiara Boccardini and Claudio Vandini, Alessandra De Antonellis and Ilaria Bolognesi, Jerôme Latteur, Jackie Hoegger, and Antonella Trotta not only for having believed in the project from its inception, but also for their invaluable contribution that has enriched this publishing adventure with professionalism and humanity.

In closing, we offer our well-deserved thanks to the German and French co-publishers of *Loving*: Elisabeth Sandmann (Elisabeth Sandmann Verlag), Laurent Beccaria and Jean-Baptiste Bourrat (Les Arènes); without the least hesitation, they showed great enthusiasm in becoming our international partners.

*Project Manager
and Coordination*
Jean Doyon

*Creation
and Graphic Designer*
René Clément

5 CONTINENTS EDITIONS
Editorial Coordination
Elena Carotti
in collaboration with
Lucia Moretti

Production Direction
Annarita De Sanctis

Translation
Alan Taylor

Copy Editing
Emily Ligniti

Color Separation
Salto Ulbeek

Original Title
Loving
International Copyright © 2019
handled by 5 Continents Editions
S.r.l., Milan
All rights reserved

5 Continents Editions S.r.l.
Piazza Caiazzo 1
20124 Milan, Italy
Ph.: +39 02 33603276
info@fivecontinentseditions.com
www.fivecontinentseditions.com

Nini-Treadwell Inc.
info@ninitreadwell.com

ISBN 978-88-7439-928-4

Italian Edition
by 5 Continents Editions:
ISBN 978-88-7439-929-1

French Edition by Éditions Les Arènes
and 5 Continents Editions:
ISBN 979-10-375-02551

German Edition
by Elisabeth Sandmann Verlag:
ISBN 978-3-945543-82-5

Spanish Edition by Duomo Ediciones
and 5 Continents Editions:
ISBN 978-84-18538-05-6

Distributed by ACC Art Books
throughout the world

Printed on Sappi Magno Volume
paper and bound in Italy in October
2020 by Tecnostampa – Pigini Group
Printing Division, Loreto – Trevi
for 5 Continents Editions S.r.l., Milan

—

Hoegger Communications
produced the video
that accompanies *Loving*

Connect at TeamHoegger.com